MARKETING THE ARTS

General Editor
Steven E. Permut

Praeger Series in Public and
Nonprofit Sector Marketing

MARKETING THE ARTS

Edited by
Michael P. Mokwa
William M. Dawson
E. Arthur Prieve

PRAEGER

PRAEGER SPECIAL STUDIES • PRAEGER SCIENTIFIC

Library of Congress Cataloging in Publication Data
Main entry under title:

Marketing the arts.

 Bibliography: p.
 1. Arts--Marketing. 2. Arts--Management.
I. Mokwa, Michael P. II. Prieve, E. Arthur.
III. Dawson, William M.
NX760.M37 380.1'457 79-26603
ISBN 0-03-052141-6

Published in cooperation with the Association of College, University and
Community Arts Administrators, Inc., with the cooperation of The Cen-
ter for Arts Administration, University of Wisconsin-Madison.

This project is supported in part by a grant from the National Endowment
for the Arts in Washington, D.C., a federal agency.

Published in 1980 by Praeger Publishers
CBS Educational and Professional Publishing
A Division of CBS, Inc.
521 Fifth Avenue, New York, New York 10017 U.S.A.

Printed in the United States of America

CONTENTS

PART II

STRATEGIC ARTS MARKETING: PLANNING
AND PRODUCT POLICIES

Series Editor's Foreword

Marketing the Arts is the first volume in the Praeger Series in Public and Nonprofit Sector Marketing. It marks a time of considerable interest in the application of marketing theory and practice to nonbusiness situations. This volume, along with the Series itself, reflects a strong scholarly commitment to explore the limits of marketing thinking far beyond its traditional boundary in the private, for-profit world.

The Praeger Series was created to foster in-depth scholarly research and pragmatism in a wide variety of areas of pressing contemporary concern. Volumes currently in progress, for example, focus on marketing of government programs and services, urban transportation, higher education, and ideas and social issues. In each volume, authors have attempted to push marketing thinking to the so-called leading edge in the public and nonprofit world. In doing so, they have sought to define the real and potential contributions of marketing thinking, while, at the same time, "map" the rather extensive unexplored domain which has just begun to grab the imagination of marketing professionals.

While marketing has well served the for-profit sector for many years, there are those who feel that its greatest and most meaningful contributions are likely to be found in the public/nonprofit arenas. This is not to suggest that concepts, theories, and marketing practice can simply be transferred in wholesale form to these other sectors. Rather, it is to explicitly recognize that we are only beginning to sense the benefits of translating marketing in new and unusual ways to problems and challenges which affect our public institutions, social systems, and very way of living in a modern world.

The Series will publish scholarly work which contributes in a meaningful way to the theory or practice of marketing in nonbusiness sectors. It will not offer textbooks, case books, or books of readings, although we hope that volumes in the Series will find their way into the classroom and onto the desks of practicing managers.

Foreword
by Philip Kotler

It is a widely shared belief that the fine arts are essential to civilization. This is not based on their "usefulness," since one could live without theater, ballet, and museums. It is not based on their popularity, since most people do not get involved with the arts. There are other reasons why almost everyone believes that the arts should exist and be supported. The arts uplift our vision of mankind's higher capabilities and finer sensibilities. They provide incomparable opportunities to experience the divine and sublime.

As the level of education increases in this society, the demand for cultural experiences grows. So does the supply. There has been an explosive growth in the number of theater companies, art museums, and other cultural institutions. Since 1950, $561 million has been spent in the construction of over 10.2 million square feet of total space at 123 U.S. art museums and visual arts centers. Using the figure of 750,000 square feet for the total size of the Louvre, this is equivalent to building 13.6 Louvres—or for sports fans, the equivalent of building 1,643.7 football fields (Meyer 1979).

Arts organizations come in all sizes, from the giant Metropolitan Museum of Art to the struggling local theater company. In Chicago alone there are 164 arts and cultural organizations employing 6,800 artists and other paid personnel and approximately 14,000 volunteers. In 1977 an attendance of over 12.5 million was reported at over 13,000 performances, 1,200 exhibits, and other activities. These art and cultural activities make a direct and indirect economic contribution to Chicago of about $470 million each year (Danilov 1977).

In spite of the size and growth of culture in the United States, arts and cultural organizations are themselves not thriving: most are in desperate shape financially and, in many cases, artistically. Their costs have been rising much more rapidly than their revenues. In Chicago, for example, an "earnings gap" of $35 million existed in 1977 between the earned income and escalating expenses for arts and cultural organizations. Attendance revenue has not kept up with expense growth, and these organizations must find new ways to attract money from government, corporations, foundations, art patrons, and the general public.

Looking into the management of arts organizations provides some insight into part of the problem. Most arts administrators are not trained as managers. They are artists, performers, art scholars, and others who became

managers by happenstance. Often the only business-trained person in the organization is the accountant. Except for some board members, who usually do not get involved in the direct management of the organization, no one has trained skills in strategic planning, marketing, personnel, and other managerial functions.

One of the central needs facing arts organizations is to develop and organize their marketing activities. They continuously face four major marketing challenges:

1. Attendance stimulation—one measure of an arts organization's success is how many people it annually draws to its performances and exhibits. This signals how much value people place on its offerings. Marketers are increasingly participating as consultants in helping art organizations attract larger audiences. Some outstanding successes have been achieved in helping performing arts companies throughout the country increase their attendance (Newman 1977).

2. Audience development—the real challenge to the arts organization is not to attract the occasional attender but to build a loyal audience ("a heavy-user segment") for its artistic services. This requires the organization to define carefully its target markets in terms of demographic and psychographic characteristics, study their cultural needs and preferences, and develop artistic offerings that excite and satisfy them. Paul Fromm (1978) has suggested that there is a choice between trying to bring serious art to more people and developing a more coherent experience for those people who are already interested in the arts. He favors the latter. He would educate a more knowledgeable and devoted minority of arts patrons who would serve as a nucleus from which a healthy arts culture could grow. Each organization has to face this choice—between broadening and deepening the audience with its offerings.

3. Membership development—most arts organizations offer people the opportunity to become supporting members. Over time museums have been enlarging the benefits that go with membership, such as free admission, special events, and premiums for joining. Different membership levels are distinguished, such as individual, family, student, associate, sustaining, life, and corporate memberships. Each membership group can be treated as a market segment giving distinctive types of support to the organization and receiving a certain package of benefits in return. Membership development, however, is not a simple activity but one calling for solid marketing skills. One museum found itself spending $17 to attract each $20 membership. Another museum sent out 300,000 copies of an attractive brochure soliciting new members and got only 40 new members.

4. Fund raising—arts organizations are finding that attendance and membership revenue are accounting for a declining percentage of their total revenue needs, and the gap must be made up by creative fund raising. This is

not simply a matter of bright ideas, such as art auction sales, art happenings, and "paint-a-thons" but something calling for a more basic long-run strategy. Each organization must clarify its basic mission and develop a vision of its future that excites the imagination and elicits the enthusiastic support of corporations, foundations, government agencies, and the general public. Marketing plays a central role in helping the organization discover its purpose and natural markets, uncover the motivations that potential donors have, and prepare successful communication programs for attracting widespread and loyal support.

The four marketing problems of an arts organization are all interrelated. The challenge is to attract occasional attenders, convert them into a loyal audience, move them into membership, and finally stimulate them to donorship. Each organization needs to know how to move its publics to successfully higher relationships and levels of involvement. This involvement should lead to greater commitment and, in turn, greater satisfaction for all involved. Marketing becomes the critical mechanism for building enduring and satisfying relationships between the arts organizations and its target audience.

Arts organizations should view marketing as a set of management systems for effectively carrying out the organization's mission. However, there currently is a problem of "marketing technology transfer." Marketing scholars, marketing consultants, and arts administrators must work together to find the most useful applications of marketing ideas. This volume represents one of the first comprehensive attempts to expound marketing ideas in the context of arts organizations. The papers present useful perspectives on arts marketing. Their purpose is to contribute to the ability of arts organizations to survive and grow in a rapidly changing environment. While change is always threatening, in the eyes of marketers, change is opportunity.

REFERENCES

Danilov, Victor. 1977. *A Survey of Arts and Cultural Activities in Chicago—1977*. Chicago: Chicago Council on Fine Arts.

Fromm, Paul. 1978. "The Arts in the Seventies." Unpublished lecture, The Peabody Institute, Baltimore, Maryland, April 19.

Meyer, Karl. 1979. *The Art Museum*. New York: William Morrow.

Newman, Danny. 1977. *Subscribe Now!* New York: Theater Communications Group.

Preface

In September of 1978, the Association of College, University and Community Arts Administrators (ACUCAA) and the Center for Arts Administration, University of Wisconsin at Madison, convened an invitational seminar at the Spring Hill Center in Wayzata, Minnesota. Supported in part by the National Endowment for the Arts and the Spring Hill Center, the meeting was attended by marketing scholars, practitioners, and arts administrators. The purpose of the conference was to identify marketing problems faced by arts organizations and develop pragmatic marketing policy frameworks for use by those organizations. It was viewed as a first step in a systematic and comprehensive approach to marketing the arts. The philosophical and theoretical foundations for such an approach were explored at the conference; the contributors wrote the following chapters as a result of workshop discussions dealing with the specific marketing issues.

ACUCAA believes that the discussions and the resulting papers represent a major step toward providing future development and implementation of sound principles and practices for marketing the arts. It is hoped that the substance of this book will serve as a springboard for academicians, practitioners, arts administrators, and consultants to work together in furthering the cause of the arts.

The text has been divided into four parts. Part I, Managing the Arts Market, deals with fundamental issues. The environmental context of the arts is described. The state of arts marketing is explored. The dynamics of arts consumer behaviors are investigated, and a basic framework elaborating the scope of marketing management in the arts is presented. Part II, Strategic Arts Marketing: Planning and Product Policies, focuses on the content and processes of strategic decision making. The elements of marketing strategy and planning are carefully outlined, and normative guidelines for formulating strategies for distinctive arts organizations are discussed. Special attention is directed to product policy making, a very delicate decision area in the arts.

Marketing Research and Arts Market Analysis is the topic of Part III. The growth of marketing research in the arts is noted, but the problem of an expansive "utility gap" is a more important theme. A discussion of the systematic process of marketing research is presented. Also, substantive market analysis problems are outlined in the areas of consumer segmentation and channels of distribution. Exemplary research studies are presented. Part IV, Elaborating and Controlling the Arts Marketing Program, specific decision frameworks are generated to guide promotion and pricing policy making. To conclude, the concept of strategic marketing control and

evaluation through an auditing approach is proposed and advocated as a point of leverage to raise marketing consciousness and precision in the arts.

All of the participants in the Spring Hill seminar brought special insights to this volume. The writers' works must stand by themselves, ultimately, but gratitude is due those consultants and administrators listed in the Appendix whose experiences and concerns helped sharpen the focus of the writers.

The excellent secretarial assistance provided by Sharon Leslie, June DeBardeleben, and Monique Armer helped throughout this project, and special thanks go to them. Mark Hanna, Kathi Levin, and Louis Spisto, graduate fellows of the Center for Arts Administration at the University of Wisconsin at Madison, also were of great assistance.

Beyond these people, the continuing concern for the arts by all at the National Endowment for the Arts deserves special recognition. The support of Nancy Hanks, Michael Straight, and Livingston Biddle bears witness to their belief that the arts in this country will endure and prosper.

I

MANAGING THE ARTS MARKET

INTRODUCTION TO PART I

Managing the arts—artists, organizations, constituencies, and arts environments—has become an increasingly demanding and challenging task. Social, economic, political, and aesthetic pressures characterize the climate. Arts administrators face tough decisions that often must balance conflicting interests in a context of tightening resources, more intense competition, and greater demands for accountability. Thus, arts administrators are studying their situations more critically and making their decisions more carefully. Conscious management has come to the arts. It generates new ideas, philosophies, theories, and techniques—offering insights and some answers; yet, it raises new issues and questions.

Marketing is a vital dimension of the evolving management consciousness in the arts. Simply, marketing is an exchange of values; marketing management is concerned with developing, facilitating, and executing exchange relationships that are mutually accommodating and satisfying.

Traditionally, marketing has been studied as a commercial activity focusing on selling practices. Today, marketing is viewed as a fundamental organizational activity. Its scope extends far beyond selling. All arts organizations practice marketing—often implicitly, seldom skillfully. The purposes of Part I are to explore the state of marketing in the arts and begin outlining the task of managing the arts market.

In Chapter 1, "The Arts and Marketing," William M. Dawson describes the turbulence of the arts environment, noting the persistent theme of the need for greater financial stability. The author outlines the challenge of adopting marketing as a concrete approach addressing fundamental problems faced by arts administrators. Dawson argues that developing the core arts audience is a responsible, necessary strategy to increase support and

earned income. He advocates the use of marketing planning built upon a realistic definition of the arts product.

In Chapter 2 Michael P. Mokwa, Kent Nakamoto, and Ben M. Enis propose a basic framework for understanding "Marketing Management and the Arts." The authors discuss the nature of marketing as an exchange of valued offerings and information. They suggest that arts organizations can be characterized by different administrative philosophies; these affect an organization's approach to policy making. According to the authors, a marketing philosophy can be consistent with well-developed goals of any arts organization. The authors elaborate the management process of arts marketing, providing a rich perspective of its scope and strategic role.

Managing an artistic exchange requires knowledge of the consumer market—the perceptions, attitudes, and behaviors of the audience and "nonaudience." Sidney J. Levy, in Chapter 3, "Arts Consumers and Aesthetic Attributes," incorporates the results of an exploratory research study in a lucid discussion of consumer behavior and the arts. He identifies factors that inhibit aesthetic appreciation and consumption, provide avenues for aesthetic participation, and appear to be socially preferred. The author concludes with an insightful commentary on the marriage of the arts and marketing.

In "A Survey of Marketing Perspectives of Performing Arts Administrators," Chapter 4, Steven E. Permut concludes that there is a very low level of explicit marketing involvement among arts administrators. The author found that many administrators perceived marketing as a commercial tool with limited applicability in the arts. Most arts administrators equated marketing with advertising, sales promotion, and the "hard sell" to increase audiences and subscribers. A genuine concern about the possible conflict between artistic integrity and the adoption of marketing was a pervasive theme in the study.

Paul M. Hirsch and Harry L. Davis expand upon the adoption of the marketing theme in Chapter 5, exploring the question, "Are Arts Administrators Really Serious about Marketing?" Based upon consulting projects and research in the Chicago arts community, the authors found that the dominant decision structure in most arts organizations excludes marketing personnel and their activities. These organizations attempted to isolate their core decision structures, usually controlled by artists, until external pressures force change. The authors note that marketing became important to an arts organization as it shifted more of its financial responsibilities to consumers. The authors propose that, initially, marketing concepts are adopted at a tactical level and given minimum support. Strategic marketing, a more radical policy innovation, is adopted only as the arts organization becomes increasingly desperate, coping with its environment.

To conclude Part I, P. D. Searles, deputy chairman for Policy and Planning at the National Endowment for the Arts, evaluates the appropri-

ateness of "Marketing Principles and the Arts" in Chapter 6. Drawing upon his experiences as a young man, working in consumer goods marketing at Proctor & Gamble, the author outlines a set of fundamental marketing principles. He relates these to arts administration, concluding that most basic marketing concepts make eminent sense for the arts world. Yet, Searles is deliberate to affirm that the basic business of the arts organization is art. As such, marketing decisions must play a supportive role.

1

THE ARTS AND MARKETING

William M. Dawson

MONEY, NEED, AND PARADOX

There is a persistent theme in discussions among arts administrators from producing and presenting organizations, boards of directors, and government officials in arts agencies: the need for more money in order to maintain or improve the arts offerings. In some cases it is needed to reduce deficits; in other instances it is for sheer survival; for some it is to improve the quality or increase the quantity, and in other cases it is to provide more arts opportunities for more people.

Among those in arts circles there is general agreement that the infusion of more dollars would solve many of the problems confronting the arts. As one board member of an opera company stated in testimony before the House Subcommittee on Education, Arts and Humanities regarding a White House conference on the arts: "We . . . know that the problems basically are financial. . . . even the very gut artistic issues eventually get translated down into dollars and cents."

Yet, there are a series of paradoxes underlying this theme. Simultaneously, arts administrators want increased subsidy and financial independence; they will not charge appropriate admissions but desire increased revenues; they are unwilling to allocate sufficient resources, although they know more effective promotion is necessary; they seek more government programs and more administrative autonomy; they call for independence from public opinion and intervention but for more public support. One other paradox might be cited: the missionary effort to develop arts audiences from those marginally interested and the near exclusion of effort to develop the fullest possible response from that segment of society most likely to support the arts.

Thus, arts administrators urge all levels of government to increase

support for the arts and resist the legislation that holds them accountable for its use. They continue to provide admission to events at no or minimal charge, seem to operate with the belief that low price dominates the decision to purchase, and are fearful of driving present consumers away if prices are increased; yet the gap between income and expenses grows yearly. It is known that new and better efforts are needed to become visible and attractive to the public, but the issue becomes confused as a choice between artistic and promotional expenditures, and they shrink from that decision. They blur their objectivity in determining primary and secondary audiences.

Few people will deny that limited financial resources have a pivotal role in the dilemma facing the arts. Many more may deny that the ultimate causes of that financial dilemma rest with artists, artistic directors, and administrators who have pursued "art" blithely through the years with no, or very little, concern for actual public needs, wants, and realities. Most might deny that the arts have lived too long in a world comprised of faith, hope, and charity—the quicksand of the arts. Faith—that the arts have values. Hope—that someone will recognize the values and come to view them. Charity—that someone will pay for them, absorb the deficits. The faith is valid and must be kept, but the hope is of a blind nature and the charity is not forthcoming as fully as it is needed.

If this view seems too harsh, the chastisement may be the result of too many programs, performances, and exhibits where insufficient effort or inappropriate action has been taken to determine who the primary support-ing audience should be and how to reach them. It may stem from too many programs in the name of audience development, where the major effort has been devoted to attracting the culturally disenfranchised and negligible effort made to attract those who can and will provide support. It may derive from the lack of documented evidence proving that the "arts demand" is realized in actual people participation and the lack of analysis to determine if the "demand/realization" is static, growing, or declining. It may result from misleading and often contradictory glowing reports of arts explosions, public *opinion* polls indicating enthusiastic support, and specious audience development programs. All of these factors have raised expectations and misled many to believe that the money needed will soon be here. The Promethean hope that tomorrow will be better and someone, somewhere, will provide is not borne out by reality.

On one hand, one wants to support and applaud those who seek to share the civilizing, humanizing, and purely pleasurable arts with the broadest spectrum of people. The social conscience that motivates adminis-trators, corporate and foundation funding sources, and government officials strikes a responsive chord in anyone of a populist bent. One would not want those programs or efforts diminished; in fact, one would want to see them enhanced. One can only approve of sharing Beethoven and Bach, Monet and Calder, Shakespeare and Beckett with people whose cultural tastes, educa-tion, and income do not make them, or have not afforded them the

opportunity to become, our regular audiences. Such efforts should not, however, be confused as a means to reduce financial difficulties or build regularly attending audiences. There is no evidence or documented study that indicates that the amounts of effort, talent, and money devoted to such audience development have resulted in significant changes in attendance demographics. Indeed, the evidence points in the opposite direction.

The need of most, perhaps all, arts organizations and institutions is one of survival, and the financial demands on current resources are greater than those available. Yet, the most obvious source of increased funding has been one of the least developed. Few performances are sold out throughout the country; few museums enjoy optimum attendance, and the unrealized revenue from unsold seats and empty halls could certainly lessen the gap and reduce the problem.

Several surveys support the possibility for increasing attendance. A study of 895 performance events indicated that attendance as a percentage of capacity was only 68.17 percent. While one museum extended its hours and had attendance of 69,000 people at a "Tut" exhibit, it reported that only 16,000 came to a Mexican exhibit. A study of resident theaters indicated that for the 49 groups average attendance as a percentage of capacity was 78.8 percent. To be sure, there were sell-outs in the 895 performances, and there were undoubtedly capacity houses for the theater groups. The "Tut" exhibit was not only sold out but strained space and personnel resources to the limit. The point to be made is that sold-out performances and capacity attendance remain an anomaly rather than the rule.

If the halls for the 895 performances had a median capacity of 1,257 seats and played to only 68.17 percent of their capacity, an additional 400 seats were available to be sold for each event. If this figure were multiplied by an admission rate of $5 per person $2,000 in potential revenue for each performance was not realized.

Assume that optimal capacity for the museum, operating its regular schedule, was 31,000 people a week. In the Mexican exhibit cited, another 15,000 people might have attended. If a donation or admission of $2 per person had been charged, an additional $30,000 in revenue might have been achieved in that single week.

The average capacity for the resident theaters studied was 680 seats, and 206 performances were given. Performing to an average capacity of 78.8 percent, there were 129 empty seats available at each performance; multiplied by $7, an average revenue of $903 per performance was lost.

Essentially, the point is that opportunities for additional revenue are being lost on a daily basis. Rather than turning first to donors, corporations and foundations, and government agencies for financial support, administrators must first utilize the resources most immediately at their disposal. Booker T. Washington's story may have some application here. He told of a ship lost at sea for weeks—its crew dying of thirst because of no fresh water. Finally, sighting another vessel, the thirsty captain signaled: "Water, wa-

ter . . . dying of thirst!" The other ship signaled back: "Cast down your bucket where you are." Thinking he was misunderstood, the first captain repeated: "Water, water . . . send us water!" "Cast down your bucket where you are" came the response again. The same messages were repeated again before the first captain thought to cast down his bucket. It came up full of fresh, drinkable water. Although adrift on the ocean, the ship was in a sea of fresh water forming the nearly shoreless mouth of the Amazon River. Like the captain, arts administrators tend first to look elsewhere for their help, rather than looking at current audiences and their expansion as the most available resource. What must be done is to ensure that audience's fullest participation and maximum capacities at all times, charging appropriate admission prices and narrowing the deficit gap.

Easily said; how is it to be accomplished? The balance of this book begins to suggest one concrete way—marketing. Marketing more efficiently, skillfully, and knowledgeably may be a major step toward a goal of greater financial stability.

MARKETING AS AN ANSWER

The evolution of response to the word *marketing* in arts circles is interesting. Less than five years ago one was denounced for breathing "marketing" at arts meetings. Many people responded emotionally by equating marketing only with selling soap, sausage, or commercial products of the most utilitarian nature. Others assaulted those venturesome enough to suggest we might learn something from marketers, saying no hucksterism nor crass hard-sell techniques at the lofty levels of *ART* would be tolerated and no cheap tricks would be allowed to besmirch the frock of the muse. Exploitation. Hucksterism. Hard sell. Cheapening the art. These were but a few of the negative connotations that many in the arts had regarding marketing. It was interesting because comments such as these came from artists in search of an audience (and a living), artistic directors who never thought of audiences until performance nights and wondered why the house was so small, and arts administrators whose deficits were growing greater each year and for whom grantsmanship was becoming a way of life. These were the same administrators who were using some marketing techniques (albeit badly) but never associated advertising. publicity stories, interviews, posters, etcetera with marketing. What was not recognized by many was that marketing success in the arts, no less than in the commercial sector, was utterly dependent upon creative and product excellence and upon truth in advertising. What was and is needed can be described as the recognition that one markets issues, people, beliefs and causes just as surely as any other product form. Just as United Fund campaigns, multitudes of illness and handicap drives, and environmental concerns are marketed, so must the arts be brought to the fore of people's thinking.

Today, as inflation continues its ascent, foundation giving declines, corporate spending focuses more heavily on media exposure, competition for discretionary spending intensifies, and many governmental arts budgets barely hold even with the rate of inflation, the word *marketing* has become less sinister and more a part of the arts vocabulary. In truth, arts administrators have used synonymous terms over the years. In many ways, it is only the point of view and the limited means employed that have distinguished their efforts from being "market plans."

What is the difference between audience development and marketing? There is no certainty about a single meaning for the former term, and it seems to have nearly as many meanings as users. To many it appears to mean those efforts made to attract to the arts people referred to previously as the culturally disenfranchised. Thus, residency programs, arts in public places, outreach programs, special performances in prisons and hospitals, and similar nontraditional efforts have been designed to bring the arts to more people and thereby increase the size of a regular-attending public. "Broadening the base" has been another popular catchword—but broadening what base? Does it mean to widen it to include a greater spectrum of people generally, or does it mean to increase the number of people from the current and most obvious segments of society who already are the mainstays of arts programs and institutions? Can it and should it mean intensifying penetration of that market segment that by measures of education, occupation, and income forms the most immediately receptive and potential base for development?

As noted earlier and as pointed out throughout the following pages, all evidence points to the singular lack of success of efforts made to attract and retain a significant number of arts supports from what must be called "marginal segments" of the population. Even those segments have been marketed inadequately.

To some people the phrase *audience development* by any other name is marketing; as defined throughout the discussions at the seminar preceding this book the terms were used synonymously. As used here, *marketing* means an exchange of a product of value in return for something of value; it does not say to whom nor for what price. Let us be clear; marketing is *not* a guaranteed and final solution to the financial problems confronting the arts. It does *not* ensure sold-out houses or capacity attendance. It is *not* an attempt to take a shoddy product and foist it upon an unaware, trusting consumer. It does *not* attempt to create false expectation levels by avoiding truth in advertising.

Marketing *can* help understanding more fully the nature of the arts product. It *can* help identify the viable customer market. It *can* assist finding the appropriate means by which to reach that market. Marketing research and knowledge *can* bring better understanding of the desires, makeup, and needs of customers, both real and potential. It *can* help more clearly define goals and objectives and, as a result, provide measurable steps by which to

evaluate effectiveness. It *can* do these things because it is a manageable process.

Arts administrators have always worked in some of the various areas of marketing in the past with varying degrees of success. Much of that effort has been intuitive and, in some instances, coupled with developed skills and knowledge. But, as the arts world has expanded with more artists, theaters, sponsors, orchestras, and dance companies, the average administrator has come to the task at a younger age, having spent less time in apprenticeship and in need of a host of new skills to compete successfully for an audience's attention, time, and money. Even the experienced administrator is in need of new skills to cope adequately with a rapidly changing arts world, a vastly different social climate, and an increasingly complex macroenvironment.

Administrators know that they have problems when deficits grow, when attendance is less than capacity, and when memberships or subscriptions decline. But one cannot solve those problems unless they are fully understood; nor is it possible to apply remedies without an accurate diagnosis. Part of the marketing approach seeks that diagnosis and prescription of solution; it goes beyond merely surviving today and takes a long view of organizational and institutional well-being. Too often the actions taken are short term, expedient, and designed to alleviate, not necessarily solve, an immediate problem. Marketing stresses a well-researched, carefully thought-out course of action that will give more permanent solutions.

In the profit and consumer goods area, marketing actively solicits the needs and wants of the consumer; in the arts it is critical to understand those wants and needs . . . but not merely to cater to them. Marketing in the arts involves not only what the customer wants but making decisions about what *ought* to be provided as well. Finding the balance between satisfying needs and leading arts tastes is a challenge.

Perhaps, first in the marketing plan comes a definition of the product, an understanding of what are later called the core product and the peripheral product. The appeal of the art, the artist, the institution, the event—all of these must be understood to capitalize fully on a consumer's desires. In other words, what is the product we offer? Is it only music, dance, sculpture—only the art itself? At what point do artistic personalities also influence the decision to participate? To what degree do other features identified with the art such as the hall, other people, dining, ease of access, self-image, and a host of other product attributes become important in customer perception and attraction? How can one fully and successfully utilize all of these stimuli in an appropriate mix to better market the product? Product mix is equally important. The variety of a season's playbill, an orchestra's season, a performance series' artists and forms—all must be considered.

The competition for an audience's time, as well as dollars, is becoming increasingly intense. Few arts events are the "only show in town," and it becomes more important than ever to determine what marketers call the "propitious niche," that point in the continuum of pleasant cultural and

leisure activities where the arts achieve maximum recognition and support. What is the competition and how does one confront it?

While it is desirable to think of an entirely open market or an entire population as potential users of our offerings, it is unrealistic. The experimental theater, the chamber music sponsor, the avant-garde gallery, the symphony, the ballet company, the local sponsor of touring programs— while there is undoubtedly some overlap of audience, each has a segment of the population for whom there is special appeal. Who are those people? What distinguishes them from others? How can they be reached most effectively? How can one ensure that full penetration of that market segment takes place? It is felt that prices, especially high prices and regular increases, are barriers to attendance, but can evidence be found to support or disprove the belief that there is strong resistance to price increases? These are some of the characteristic approaches of marketing research. It goes beyond analysis of the current audience; it also seeks an understanding of why people have not renewed memberships or subscriptions, and why others are disinterested in the arts. It can identify those people not yet reached and most amenable to becoming participants.

To conduct the research is one thing, but what uses are to be made of it? Certainly, its results may predict needed changes in product understanding and management; it can indicate directions for immediate improvements, and it will assist in planning for the future. The research process does not dictate what must be done nor how it is to be done; it provides information upon which decisions can be made.

The following chapters deal with marketing aspects that include the elements mentioned here and go beyond them to discuss consumer behavior, promotional policy and practice, pricing, and the need for evaluation and control.

Is there a need for improving marketing of the arts? Yes, if one is concerned with increasing revenues, enlarging audiences, and narrowing deficits. Yes, if one wants continued growth of the arts market to ensure the health of the arts and opportunities for artists. Yes, if one wants to help secure sufficient resources to afford both stability for the arts and efforts to share them with continually widening numbers of people.

More than anything else, the seminar participants and writers have stressed that marketing is common sense and involves an understanding of people on their own terms. One should know that marketing in the arts will not tolerate superficial, cosmetic efforts. It may necessitate starting over or revamping current approaches. Investments of time and money will be required. Resistance to change among staff may have to be overcome. But, can arts administrators afford not to make all of those investments and efforts—now?

2

MARKETING MANAGEMENT
AND THE ARTS

Michael P. Mokwa, Kent Nakamoto, and Ben M. Enis

The arts administrator faces serious challenges guiding an arts organization between the Scylla of increasing pressure and growing competition for more expansive audience support and the Charybdis of rising costs and diminishing growth in philanthropic giving (compare Netzer 1978). Balancing resources and demands looms as a constant threat to the vitality, independence, and ultimate survival of most arts organizations.

One approach to this paradoxical problem has been to contain administrative and production costs through budget trimming or increasing efficiency. However, costs can be cut and efficiency can be generated only so far before quality and artistic integrity begin to suffer. As a more viable approach, we advocate that arts administrators direct their attention to the strategic issues of achieving organizational responsiveness and effectiveness—an important province of marketing management.

Arts administrators are increasingly confronting the issue of marketing. For many, the term still conjures images of pitchmen and high-pressure selling gimmicks; for others, marketing means an expensive audience survey that confirmed the obvious, or an outreach program that sent the chamber ensemble to a local factory without generating one new subscription. Marketing really should not be considered in terms of simple or naive stereotypes. Conscious and precise marketing approaches are being successfully adopted by a growing number of highly regarded arts organizations.

We would like to acknowledge the support of the Center for Arts Administration, University of Wisconsin—Madison, and, in particular, its director, E. Arthur Prieve, for his continuous encouragement and dedication to the field.

The experiences of these organizations confirm that marketing can play a critical supporting role for the arts, but the arts must play the lead:

The mission and goals of the artist and arts organization are basic to the formulation of marketing strategy. Artists and arts administrators who fear that the introduction of marketing into the arts will lead inevitably to degradation of the artist to mechanic doomed to perform or create an endless succession of sellable *William Tell* Overtures, reproductions of *American Gothic* and readings of *Jonathan Livingston Seagull* are incorrect. Marketing does not tell an artist how to create a work of art; rather, the role of marketing is to match the artist's creations and interpretations with an appropriate audience.

Marketing is an investment—a necessary and inevitable aspect of arts administration. The issue is not whether an arts administrator will use marketing, but whether marketing will be used well or poorly, or effectively or wastefully (compare Kotler and Levy 1969).

Marketing can be performed with grace and sophistication. Marketing approaches need not be loud, aggressive, crass, or intrusive. The practice of marketing is itself a sophisticated art.

Marketing can persuade, it can encourage, and it can lead; but it cannot compel people to buy. Many of marketing's most severe critics give it more credit than it deserves. Marketing is not manipulation; it cannot make people buy things they do not desire. No doubt some marketers wish fervently for such power, but they do not have it. As the legendary impresario, Sol Hurok, is reputed to have said, "If the people do not want to come, there is nothing you can do to stop them."

Building on this background, we will discuss the fundamental nature of marketing and marketing management, focusing on its role in the arts.

THE NATURE OF MARKETING

Marketing is the voluntary and purposive process of developing, facilitating, and executing exchanges to satisfy human wants and desires. Figure 2.1 presents the marketing exchange process as it is depicted in elementary texts. (compare Enis 1977) Individual A has a product, an offering of value, which is conveyed to individual B in return for payment. The marketing exchange presupposes the following conditions:

1. Each individual has an unsatisfied want or wants;
2. Each has a surplus of some product that the other believes will satisfy the want (in modern society, the second product is usually money, the medium of exchange);

FIGURE 2.1

An Elementary Concept of Exchange

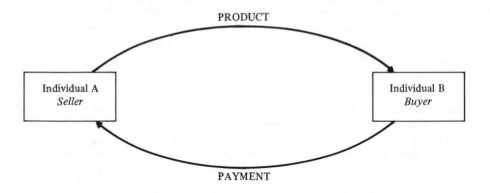

Source: Constructed by the authors.

FIGURE 2.2

Marketing Exchange Functions

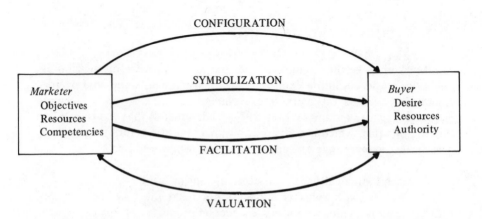

Source: Constructed by the authors.

3. The individuals have a method of communicating with each other; and

4. A medium or channel exists through which communications, products, and payments flow.

The two individuals will engage in the exchange, if each believes that he or she will be better off after the exchange than before. More precisely, marketing is exchange expected to result in mutual satisfaction. Marketing exchange thus rests upon two very important foundations: rationality and sovereignty. First, each party in the exchange is presumed to be capable of determining whether completing a given exchange will increase net satisfaction; this is the individual's "utility function." Second, each individual is assumed to have the right to voluntarily participate in the exchange transaction, as his or her calculations of utility dictate. Given these foundations, the study of marketing focuses on the nature of these exchanges—how they are created, stimulated, facilitated, and valued (Kotler 1972).

Figure 2.2 illustrates the marketing exchange process in more detail. As before, the process begins with two parties—the marketer (seller) and the buyer. According to norms of exchange specialization, the marketer, guided by a set of objectives, develops his/her competencies and available resources into an offering with potential value for the buyer. The exchange is developed and enhanced through conscious product configuration, symbolization, facilitation, and valuation.

Product configuration relates to the nature of the product and the design and arrangement of its attributes—the type of performance or exhibition, the featured artist and works, the season of performances, and the organization itself. In the arts the fundamental task of product configuration rests with the artists and artistic director; however, there is more to the product than the artistic expression. The total aesthetic and social experience requires careful consideration and configuration.

Symbolization involves the communication of information, which enhances the significance of the product in the eyes of the potential buyer. Product benefits and utilities are the focus of symbolization—the arts are entertaining, educational, refined, make great gifts, get you away from the children, and so on. The marketer facilitates the exchange by improving the buyer's access to the product or delivering the product to the buyer. The arts administrator can provide free parking, sell tickets through multiple outlets, accept credit cards, and develop an outreach program in the schools.

Finally, valuation involves the culminating agreement between the buyer and marketer concerning the worth or utility of the exchange in relationship to its costs. The buyer's decision will be based upon the level of desire for the product, the resources available to him/her, competitive products, and perceptions of the risk of not being satisfied upon completion of the exchange.

Thus, through the creation of products valued by a substantial group of

buyers (the market), marketers attempt to achieve their objectives. These could be profits or sales for the commercial organization or audience support, donor contributions, and artistic freedom for the arts organization. It is critical to realize that the marketer and the buyer generate a common interest—the desire for mutual satisfaction. The manner in which exchange processes are developed, programmed, and operationalized—the management of marketing—forms the core of this chapter. Before proceeding to describe and analyze the tasks and technologies of marketing management, it is important to understand the basic philosophies that guide marketing decisions and efforts. In the arts, as in any other field, marketing exchange is shaped by the basic philosophy espoused by the organizational decision makers.

MARKETING MANAGEMENT PHILOSOPHIES

The "product concept" is the first of these philosophies. Organizations adopting the product concept concentrate on the configuration task in developing an exchange. This philosophy is widely prevalent in arts organizations. Artists and artistic directors are often concerned exclusively with the problem of producing the ultimate—the best painting, sculpture, piece of music, dance, play, poem, and building. The premise on which the product concept is based is that consumers will seek out and react to good products that are reasonably priced. The problem is that consumers do not act in accordance with this premise; thus, marketing activities guided by a product philosophy are incomplete, ignoring (or underplaying) the symbolization and facilitation tasks.

The second marketing philosophy is called the "selling concept." The selling concept proposes that the basic function of the organization is to convince people to purchase its products. Perhaps the best-known practitioner of the selling concept in the arts is Danny Newman (1977), who advocates reliance on subscription sales as the means of ensuring survival. His approach relies on sales-stimulating devices such as discounting and advertising. With regard to promotion, Newman suggests the importance of "floridity of statement and showmanship. . . . We should fill our brochures with readable, entertaining, bright material. Above all, they must be invested with selling thrust."

The problem with this approach is that it assumes that, for any product, a market can be generated through promotional and pricing manipulations. This assumption, especially in the arts, may not be warranted. Furthermore, the strategy that accompanies the selling concept is often undirected and unfocused in an effort to create mass appeal. This can result in an ineffective promotional campaign and ultimately can disillusion customers whose expectations are inflated and then not realized.

The alternative to the preceding philosophies is the "marketing con-

cept." It is based upon three simple principles: (1) specifying clear organizational goals and objectives; (2) understanding the buyer's (the market) needs, desires, and capabilities; and (3) formulating integrated strategic marketing programs that effectively match the organization and its market. As we suggested earlier, the aims and goals of the artist and arts organization are the foundation for strategy formulation. They provide guidelines and standards for generating the exchange strategy. However, exchange means mutual satisfaction, and, therefore, the astute arts administrator realizes that an understanding of the consumers' needs, desires, and capabilities provides insight into the nature, behavior, and size of the audience for any performance, painting, or poem.

Guided by their goals and knowledge of the market, arts administrators attempt to reach those goals by formulating an integrated exchange offering for an appropriate audience. To generate and execute the exchange, the arts administrator combines configuration, symbolization, facilitation, and valuation in an effective, directed approach. The strategic process of marketing management encompasses these exchange tasks.

MARKETING MANAGEMENT

We identify five invariant functions of marketing management that indicate and describe the decisions and decision technology of strategic marketing. We call these functions seeking, matching, programming, consummating, and auditing (Enis and Mokwa 1979). Each of the functions is defined in Table 2.1.

Seeking

Marketing management begins by "seeking" buyers. Emphasis upon this point seems trivial; obviously, exchange requires a buyer as well as a marketer. But, the fundamental point is more subtle. The marketer must understand what the buyer wants—in terms of the buyer's desires, expectations, and capabilities rather than his/her own. This point is demonstrated in such homilies as "people do not buy drills, they buy holes," "you may not like worms, but fish do," or "beauty is in the eye of the beholder."

For arts administration, the seeking concept suggests that the administrator try to see the art experience, not only as the artist views the creation but also as the potential patron views it. One may go to a play or symphony not only to enjoy the performance but also to interact with friends, be known as a patron of the arts, get out of the house and away from the day-to-day cares of living, show off new clothes and jewelry, or learn more about the subject matter of the performance. The subtle but important point is that the patron of the arts may not be "buying" only what the arts administrator believes the artist is selling.

TABLE 2.1

Marketing Management Functions

Function	Description
Seeking (Market Analysis)	The definition and characterization of a market and its environment and the identification of market potential.
Matching (Strategic Positioning)	The analysis of market response potential in relation to organizational goals, competencies, resources, and environmental constraints. And, the designation of a desired strategic market position.
Programming (Market-Mix Decisions)	The design and valuation (pricing) of specific offerings (product/services) and of communications (promotion) and delivery systems.
Consummating (Transaction Behavior)	The implementation of market programs and the execution of exchange (transaction) episodes.
Auditing (Control)	The evaluation and monitoring of marketing decisions and actions and of market outcomes and impacts. And, the development of corrective decisions and actions.

Source: Enis and Mokwa (1979).

The focus of the seeking function is analysis of potential consumers and the market environment. The arts administrator must determine what potential customers desire to buy and how they will behave in the buying process. This determination may be very formal and elaborate, using sophisticated techniques of marketing research. Often, however, it is rapid, informal, and intuitive. Regardless, market analysis requires systematic contact and thoughtful communication with present and potential patrons.

No matter how well artists or art administrators believe that they know what the audience wants, they should appraise their judgment periodically and objectively.

Matching

Arts patrons, like all consumers, have a wide variety of desires, interests, and capabilities. No work of art satisfies everyone. Furthermore, each arts organization has distinctive goals and competencies as well as finite resources. No arts organization can be all things to all people. Recognizing these facts, the second function of marketing management is to develop a selective product/market strategy that matches the objectives and competencies of the organization, expressed in produce mixes, with appropriate market segments.

The matching function is performed as follows. Initially, the arts administrator analyzes the results of the seeking function in which groups or segments of potential patrons are identified. The segments are examined to determine which consumer groups: (1) have an interest or desire to experience an artistic product that the organization can or has developed, (2) can be communicated with by the organization (3) are willing to expend the time and effort to experience the arts product; and (4) can provide sufficient support for the presenters to realize their objectives. Support will include both tangible and intangible resources. In most circumstances it should include a substantial amount of earned income. But support should also contribute to the achievement of other goals, such as the artist's personal satisfaction, the audience's increased aesthetic awareness and comprehension, and the enhancement of the general cultural level of the community.

The next stage of matching involves the formation of a strategic product/market premise, which includes the selection of a product mix, the specification of target markets, and definition of a competitive stance, which provides the organization with a differential advantage within its market. The process of matching is an operationalization of the marketing concept and it includes: first, a clear understanding of the arts organization's mission and goals; second, analysis of consumer, market, and environmental dynamics, particularly competitive behaviors—not only of other presenters but of other forms of entertainment and leisure activities; third, careful and objective assessment of organizational resources and capabilities; fourth, identification of the current match between the organization and its market potential, especially any "gap" between market performance and market potential; and, fifth, the selection of an integrated marketing program to maintain or enhance the current market position or reduce a market performance/potential "gap." The important concept in the matching function is the definition and assessment of the opportunity costs and benefits of reaching alternative organizational goals and/or satisfying various market segments.

For the arts, this means that the administrator must carefully consider alternative strategies in terms of specific benefits, revenues, and other organization support and the costs, both monetary and nonmonetary. This suggests that the presenter does not necessarily have to develop mass market strategies, expand into new markets (such as the culturally disenfranchised), nor present or display radically different performances or collections to generate sufficient support and revenue. The arts administrator should first consider the development of the total product configuration and the comprehensive penetration of the current market before exploring other strategies. There are marketers who successfully design mass market strategies—for example, the Smithsonian with its wide variety of collections or major civic centers that present performances ranging from rock to chamber music or from Sophocles to Samuel Beckett to children's theater. But there are also successful arts organizations that operate in very specialized product/market domains—for example, the Center Theater Group in Los Angeles specializes in contemporary drama. The critical management decision is to develop and match realistic organizational objectives and competencies with dynamic market realities—the essence of responsive strategy formulation.

Programming

Market programming is the formulation of a marketing-mix strategy targeted for a particular segment. It involves the conception, development, integration, and "test marketing" of combinations or "mixes" of the various exchange elements to concomitantly satisfy the desires and interests of the target market and the objectives of the organization. The important concept in the programming function is operationalization—determination and integration of the optimum combination and substance of exchange elements. Of course, the optimum is seldom attained but does provide a standard to guide programming decisions.

Market programming involves a wide variety of decisions that vary in complexity. For example, a common product configuration strategy in symphony programming is to present the new and innovative selections before the intermission so that patrons will not be tempted to come to the first part of the program to hear their old favorites and then leave before experiencing the new compositions. A more complex strategy is the product-mix program of a repertory theater, which attempts to balance its season by including contemporary productions as well as classics and comedy as well as tragedy.

Beyond these simple examples, market programming strategies become quite elaborate as programming decisions are expanded beyond product configuration to include the other exchange elements—symbolization, facilitation, and valuation. These elements of the exchange process are the

controllable variables of managerial marketing strategies and represent the basic tools of marketing managers. As such, marketers have developed a shorthand, calling the controllable program elements "the 4 p's"—product, promotion, place, and price. Table 2.2 provides an extensive, but not exhaustive, list of exemplary marketing program decisions for an arts administrator.

TABLE 2.2

Selected Marketing-Mix Decisions for a Theater

	Marketing-Mix Decision
Market/Product	
Attenders/performance	Variety of types
	Number of each type
	Quality
	Consistency
	Fad, classic, avant-garde
	Subject matter
	Educational value
	Controversiality
	Date/time
Attenders/personalities	Performers
	Authors
	Producers
	Directors
Attenders/organization image	Elite versus "down home"
	Names on board
	Stability (longevity)
	Involvement in civic affairs
Attenders/facility	Neighborhood
	Ambiance
	Decor
	Seat comfort
	Acoustics
Attenders/added services	Parking
	Cloakroom
	Bar
	Restaurant
Attenders/added performance activities	Receptions
	Banquets
	Galas
Attenders/supplementary products	Programs
	T-shirts
	Records
	Commemorative

TABLE 2.2 (cont.)

	Marketing-Mix Decision
Subscribers/season series composition	Consistent with past
	Number of performances
	Number of different series
Subscribers/season series options	Seating preference
	Added "special" performances
	Opening night
New audiences/outreach programs	Artist in schools
	Residencies
Donors/benefits	Memberships
	Prestige
	Special events and services
Donors/volunteer work	—
Place	
Facility	Centrality to attenders
	Accessibility to patrons (handicapped, aged, children)
Ticketing outlets	Number
	Locations
	Milieu (department store)
	Hours/days open
Ticketing type	Hard tickets
	Computerized
Ticketing—other methods	Mail order
	Phone order
	Reservation
Ticketing—payment	Check
	Credit card
Transportation	—
Tours	—
Runouts	—
Outreach	—
Promotion	
Advertising	Paid
	Public service announcement
	Professional quality
Media mix	Television
	Radio
	Newspaper
	Magazines
	Billboards
	Direct mail

TABLE 2.2 (cont.)

	Marketing-Mix Decision
Budget	Allocation to media
	Relative effectiveness (attenders/ ad dollar)
Special promotion	Displays at ticket counters
	Previews
Public relations	News, feature converage
	Events
	Staff activities
	Board activities
Special sales efforts	—
Personal sales efforts	—
Price	
Pricing basis	Cost (break-even)
	Demand
	Audience sensitivity
	Competition
Scaling of the house	—
Subsidy	Grant support
	Restricted donations
	Organizational budget
Donations	Levels
	In-kind
	Services
Discounting	Series/season
	Student rush
	Senior citizens
Nonmonetary cost concerns	Convenience
	Security
	Reputation

Source: Compiled by the authors.

Consummating

The fourth marketing function involves transaction behavior, the actual interaction between marketer and buyer. The guiding concepts are implementation of the total marketing program and its execution in specific transactions. This includes agreement on the conditions of exchange—acknowledging that both parties expect net satisfaction to increase as a result of this transaction. In practice, consummating involves adjustments to correct deficiencies or errors in the performance of the other marketing management functions so that a transaction can be completed.

Consummating, for arts administration, means directing attention to all the transaction details, large and small. What discount or premium is appropriate? Should the opening be black tie? Are the ticket outlets functioning adequately? Are facility arrangements complete? Are preparations made in case of bad weather? Is everyone seated before the curtain is raised?

Auditing

Ideally, the completion of a given transaction establishes the foundation for a continuing exchange relationship. Thus, the marketer must monitor and evaluate the exchange dynamics. The critical issues are satisfaction of both the marketer's objectives and the buyer's desires and effectiveness of the marketer's analyses, decisions, and actions. The ideal toward which marketing management strives is that both parties increase their net satisfaction as a result of participating in the exchange transaction; therefore, they will develop an exchange relationship that becomes reinforcing for the consumer and increases efficiency in the future execution of the marketing management functions for the administrator.

For arts administration, this means that the artist, the administrator, and the patron should consider that the time and effort expended on a particular artistic experience were worthwhile. The strategic arts administrator becomes involved in consumer and organizational analysis again. Was the patron satisfied or not? And probing more deeply, what aspects of the presentation contributed to satisfaction? Which did not? Was the market program implemented correctly? Was it efficient? Was it effective? Why? Answers to these questions and others provide guidelines for improving future decisions and programs. Thus, the conclusion of the auditing function marks the beginning of the seeking and matching functions for the next exchange transaction. A comprehensive approach to auditing provides information to guide the integrated management of all the exchange processes.

In summary, marketing in the arts involves the specific application of general marketing management functions. The arts administrator, in effect, "orchestrates" the elements of exchange, the marketing mix, by performing the functions of seeking, matching, programming, consummating, and auditing in such a way that the desires of both artists and patrons as well as organizational objectives are satisfied and resources are efficiently utilized and developed.

MARKETING THE ARTS

We have presented an overview of the marketing exchange process and marketing management philosophy and methods. It is our conviction that the arts can benefit from greater marketing consciousness and precision.

Marketing strategies and principles can be used by arts organizations, but for many organizations it will not be a simple or easy task. The following considerations must be stressed:

1. The arts are not soap. We realize that arts cannot be marketed in precisely the same way that Procter & Gamble sells laundry detergent. The content or substance of marketing differs with each product, including each different art product. The problems, the ideas, the techniques, and the program mixes differ.

But, the marketing process does not. The arts administrator must perform the functions of seeking, matching, programming, consummating, and auditing just as the consumer product brand manager does. The customers and market dynamics differ; the strategies, resources, and goals of the organizations differ; the research capabilities may be different; the marketing mix will be unique to a given presentation or season; and satisfaction will be measured in different units. But all of these things will occur. A systematic approach to performing the marketing management functions provides a useful, strategic framework for arts administration.

2. Arts administrators should learn more about the marketing management process. We feel confident predicting that more and more art administrators will be interested in marketing concepts and techniques. Marketing is very successful and very visible in the commercial sector, and its continued expansion into the arts is inevitable. An arts administrator will find it necessary to learn more about marketing, just as he/she must know more about planning, budgeting, union procedures, and copyright laws.

Learning will require investment of time and effort as well as money. It involves reading, attending seminars, workshops, and conferences, but, above all, it means experimenting—learning by doing. It will require more interaction between arts administrators and marketing professionals and among arts administrators who can share openly their successes and failures with one another. And, learning requires that arts administrators carefully consider and study their own successes and failures.

3. Arts administrators should learn more about their organizations and environment, the problems they confront, and choices they face. Marketing management can supplement—but it cannot supplant—the informed, mature judgment of arts administrators. An objective, realistic understanding of the arts, the arts organization, and the cultural, economic, and political environments contributes to mature judgment.

The arts play multiple, complicated roles within society. The institutions that facilitate the creation and delivery of artistic experiences shape and execute those roles, and, as such, the management of those roles is a vital domain of arts administration. Therefore, arts administrators face difficult choices, such as enhancing artistic freedom, quality, and leadership, yet balancing audience elitism and populism, the aesthetic and entertainment value of a presentation, the presentation content and its educational support, and the level of artistic production and creation versus artistic

interpretation and delivery. Arts administrators can skirt these challenging decisions by reacting to the pressures of their environment, market, and organization. Or, they can lead and actively shape the environment, the market, and the arts organization. To do this, there is a need for confident comprehension of the issues, problems, and decisions faced by the arts administrator and also for a strategic technology such as marketing to facilitate understanding and decision making.

4. Marketing principles and management processes can be developed and applied to all types of arts organizations and to many problems. Within this text, there is a definite (but not exclusive) focus on the application of marketing to "presenting and distributing" arts organizations and the problems inherent in presenting the arts. This is not to suggest that marketing is limited to application only in these organizations or only to these problems. Perhaps, it indicates that we are only at the frontier where the two important fields meet. The constructive development of marketing principles for community arts organizations arts councils, the individual artist, or even the National Endowment or for generating donor revenue, educating the culturally neglected, and stimulating new works are all challenging extensions, which can be constructed on the foundations that are established within this text.

Our message, then, is that marketing is neither a saviour for the arts nor is it something to fear or condemn. Marketing is a fundamental human process that we can study; then, we can formulate a set of general principles that may be useful in managing an arts organization. Properly adopted and implemented, a strategic marketing approach will direct attention to some of the critical problems and challenges facing the arts organization, and it may suggest some answers.

REFERENCES

Baumol, William, and William Bowen. 1966. *Performing Arts: The Economic Dilemma*. New York: Twentieth Century Fund.

Enis, Ben M. 1977. *Marketing Principles: The Management Process*. 2d ed. Santa Monica, Calif.: Goodyear.

Enis, Ben M., and Michael P. Mokwa. 1979. "The Marketing Management Matrix: A Taxonomy for Strategy Comprehension." In *Conceptual and Theoretical Developments in Marketing*, edited by. Chicago: American Marketing Association.

Kotler, Philip. 1972. "A Generic Concept of Marketing." *Journal of Marketing*, April, pp. 46–54.

Kotler, Philip, and Sidney J. Levy. 1969. "Broadening the Concept of Marketing." *Journal of Marketing*, January, pp. 10–15.

National Endowment for the Arts. 1976. *Annual Report*. Washington, D.C.: National Endowment for the Arts.

Netzer, Dick. 1978. *The Subsidized Muse*. New York: Cambridge University Press.

Newman, Danny. 1977. *Subscribe Now!* New York: Theater Communications Group.

3

ARTS CONSUMERS AND AESTHETIC ATTRIBUTES

Sidney J. Levy

Between the crowd and ourselves no bond exists. Alas for the crowd; alas for us, especially.

Gustave Flaubert, 1852

Where there is no bond between the crowd and the artist, marketing has failed. Such an assertion may arouse feelings of indignation, because the ideas customarily associated with the word *marketing* imply that artists who succeed in marketing their work are corrupt and meretricious. These ideas are based on defining marketing as the willingness to do anything to make a sale. Some people are, of course, willing to do that. However, more fundamentally, marketing is essential to everyone, including all artists. It is not just the promotions used to sell tickets. Marketing points to the fact that almost all artists want an audience, very few being willing to blush unseen and waste their sweetness on the desert air. And, wanting an audience, whatever they do about it is marketing, good or bad.

Marketing refers to the complex of exchanges in which the aesthetic product of painting, song, story, and performance is offered to the audience for a price—a price of attention, emotion, and action. In a primitive sense this exchange is enough, the performance in exchange for the astonishment, applause, laughter, pity, and fear. In a complex modern world the audience also has to be informed that the event will occur somewhere; and having many choices of things to laugh at and admire, they may have to be wooed and persuaded to attend. Also, like providers of anything, the artist who does not want to starve in a garret (should a free one be available) needs to be paid, as Mozart's begging letters testify.

Special acknowledgment is due for contributions to this project by Shirley Greene of Social Research, Inc., and John A. Czepiel of New York University

Given the above situation, all the conditions for marketing exist—sellers, buyers, products and services, outlets, communications, and prices. All that remains is to decide such things as what the offerings will be, where they will be made available, what prices will be charged, and what kind and size of audience are desired; then, what means will be used to accomplish these goals. These decisions point to the marketing necessities that face all individuals and organizations, whether artists or others. The objectives of the artist and the arts organization need to be formulated, and then means need to be searched out to achieve them. One of the main means that assists in marketing is studying the audience, to understand them better and better. Again, the purpose is not merely to "give them what they want" but to so comprehend their personalities, situations, attitudes, and aspirations that the arts administrator might better see how to forge the bond between them and the aesthetic offering.

Surveys of consumers usually show that Gustáve Flaubert was right—only small proportions of the public are active in supporting the arts. Some comfort is taken in the growth of attendance at museums and various kinds of performances. There are notable surges of interest in archeological artifacts (King Tut and Pompeii), and an occasional retrospective exhibition (for example, Monet, unexpectedly, catches on), and, some communities develop unusual devotions to orchestra, opera, or dramatic repertory groups. It is interesting to speculate on the causes for such surges and the likelihood of their enduring (Goethe complained of the restlessness of the modern audience). One would like to believe that consumers' appreciation of the arts is a stable outgrowth of affluence, leisure, and education and that, as families cultivate this appreciation in their children, it will take root and continue to develop. Historically, such a pattern is evident, at least as the size of the elite has grown.

But more particular understanding seems needed to gain insight into why so many children do not pursue the cultural opportunities afforded them. The dreary findings of the Lincoln Center High School Program and Lincoln Center Elementary Program (*Arts Reporting Service* 1972) that showed that exposing children to a few live performances had little impact hint at the magnitude of the problem of cultivating the young audience outside the home. Similarly, the optimistic report published in *Arts and the People* by the National Research Center for the Arts (1973) probably reveals again that adults often give lip service to the value of high culture but fail to attend it seriously.

Explanations do not come easily as the many forces at work in society are complexly interwoven, so that there are regional differences, social class differences, age differences, and various social and psychological bases for diverse aesthetic responses. These can all be studied, broadly and in detail, in attempts to explain the arts consumers' behavior. For example, Smith (1974) offers the hypothesis that decrystallization or decay of social structures is related to an emphasis on deference given to style, such as dandyism in

clothing, and the models of taste and demeanor provided by celebrities. In a rapidly changing society, geographic and social mobility make demands on citizens to find cultural entrepreneurs, individuals who offer their images to serve as reference points for orienting to modes of expression. In various arenas, these individuals become stars by which cultural voyagers may orient themselves and give legitimacy to the activity. It is hard for the audience to separate out the sheer artistry of Baryshnikov, Sills, Picasso, Solti, or Fellini from the appeal of their personal styles and personal celebrity, if such a separation is conceivable. The tolerance for anonymous art always exists— just as anyone can appreciate the beauty of nature or a strikingly adorned passerby—but the contemporary Western world seems far from appreciating relative impersonality in creativity as in medieval religious art or the mass-produced look of the recently exhibited modern Chinese peasant art. Modern values highlight individual public figures as stylish creators and want to know about their private lives as well. While this was no doubt true for da Vinci and his sodomy suit, and Cellini's escapades, the contemporary mass media and the urge for candor carry celebrityship to new heights, as part of aesthetic appreciation, broadly conceived.

Turning from explanations pitched at this broader cultural level, it is possible to study market segments among consumers of aesthetic experience—to ask what distinguishes significant segments. Findings from such a study will be reported here, with the ultimate goal of suggesting some implications for marketing of the arts. (This chapter builds on an earlier study by Levy and Czepiel [1974].)

The study examines some of the motives people have for consuming activities commonly regarded as cultural or aesthetic. These are distinguished from work activities by being part of leisure; they are voluntary choice activities that fall on a continuum of social value or prestige at a level regarded as peculiarly meritorious or qualified. They include symphonic music, ballet, modern dance, opera, painting, sculpture, legitimate theater, et cetera. The inquiry is exploratory and interpretive in nature. It is not a large sample survey of attendance and audience demographics. Rather, it seeks to learn about people's feelings, reasonings, and perceptions—to see the place that high and popular arts have in their lives and values and what meaning aesthetic objects and activities have for them. The research consists of the analysis of lengthy conversational interviews with married people (individually, with each spouse) about the kinds of people in the family and their attitudes toward various forms of aesthetic experience. This method is a holistic one, moving freely among the qualities of the people, their personalities, social positions, and experiences; their attitudes toward aesthetics; and their perceptions of aesthetic attributes. In addition to the freer-style interviews, larger samples were questioned in a more systematic way. These people were tested for scores on a scale measuring "Attitude toward the Aesthetic Value." They were also administered a semantic differential concerning the attributes they wanted for the objects in their lives

and an indicator of how they would like to apportion their time, ideally, among numerous cultural alternatives.

The data are still being analyzed, but some findings can be informally reported here. These will be discussed as follows: Obstacles to aesthetic appreciation and consumption of the arts, avenues to such participation, and preferred factors among aesthetic attributes.

OBSTACLES TO APPRECIATING THE ARTS

When people are asked why they do not attend cultural events more than they do, or at all, they usually say they would rather do other things, that they do not have enough time, cannot afford it, do not find them interesting or relevant, et cetera (Nielsen and McQueen 1974). These are real obstacles, which mainly suggest that there is insufficient motivation; many who do attend have no more money or time but would rather not do other things and do find the arts interesting and relevant. As people talk more fully about their feelings and opinions, a richer sense of the obstacles emerges, showing that responses reflect the complex social and psychological symbolisms that define the arts.

Elitism seems an ineluctable aspect of the arts. They are deemed to require a refinement or elevation of taste, a capacity to understand and appreciate (appraise, evaluate, enjoy) in a sensitive manner. Those who have these qualities, aspire to them, or are willing to mimic them are proud and feel superior to those who do not. The latter may recognize this situation, as sharply stated by these working-class men:

> No art interests me. I bet you are interested in art because you are so reserved and I bet you even went to college, grew up in a better neighborhood. This is a rough neighborhood and I think people who consider art around here would be considered oddball. What I am saying is that you are cultured, I am not. We are from two different worlds.

> Those things are too rich for my blood. I don't think it's any fun. I'd be bored. That's for uppercrust people, the ones that have their noses in the air.

Closely linked to the lower-status perception of the arts as overly refined is their relative femininity. Despite the unisex movement, equal rights for women, and the consequent liberation of males to wear longer hair and colorful clothing, there remains the idea that the arts are for women:

> I think basically we are a sports-oriented society. We stand in line for baseball and football games but not for theater or concerts. I think for the middle class society, artistic endeavor has an effeminate connotation.

The actual statistics for games and concerts are probably irrelevant to this opinion. Even a high-status man can entirely disclaim the local aesthetic realm as woman's work: "Our house is very modern. I had nothing to do with it. My wife did it, I just gave her the money."

The arts are intimidating. Because special sensitivity or cultivation is thought to be required, the arts make people uneasy and defensive. Access to the pleasures of sports and entertainment and to understanding of the utilitarian, functional character of nonart seems routinely easy. By comparison, the arts demand mysterious insights and judgments, arrogantly exercised by those who have the nerve to make them. Relatively few people feel competent to cope with art for art's sake. They lack confidence in their own aesthetic reactions, looking dependently to experts or avoiding the problem. When an "artistic temperament" appears, it seems deviant and uncomfortable:

> If I wanted to buy art I could only do so if I got an art expert. I would be afraid to buy just on the basis of what I liked.
>
> Our Susan is a much more cautious child, more artistically turned, a fine-tuned child. Our Joan is typical, attractive, secure; Joan is a joy.

This uneasiness can extend itself to all the awkward social requirements of dress and behavior in alien environments. At one end is the rare famous devotee of Chicago Opera House events who turns up in the audience dressed as Giselle or the Black Swan; more common is this woman's thought: "I wouldn't know how to dress or act to go to a theater or concert."

Why do people think that artistic personnel have "feminine" interests and that the arts are the preserve of an elite, and why do they feel intimidated by them? These are not simple or isolated obstacles; they are the consequence of the entire sociopsychological situation that taught them what kinds of people to be. To comprehend the spectrum of outlooks at issue here, it is perhaps usefully shocking to realize how remote is the distance felt by extreme members of the nonaudience for the arts. To lack aesthetic appetite is a form of starvation, afflicting personalities whose lives are generally ungratifying, whose family relationships are strained or hateful, or whose emotional tone is desperate, depressed, and deprived. They feel finished (despite, like the following two men, being still under 30 years of age), although their lively fluency sometimes hints at their potential vitality and deeper hungers:

> What am I? It's hard to describe myself. I am hardly worth describing. I'm a factory worker, married, got three kids. It's the same old grind everyday, nothing to look forward to. I work my ass off. I am not going anywhere in life. Well, I watch baseball, that's about all I like. My wife is stupid, can't even carry out an order or keep the house clean. She is really a stupid idiot. The kids are always dirty, I don't know anything about my kids, that is my

wife's business to watch out for them. I don't want to talk about them. I have never traveled. Theater is trash. Never seen a stage show. Music I can leave alone. I don't read trash like magazines.

I feel inadequate. I have been married four years now. I feel so bottled up, I want to get free. Even my wife isn't happy, certainly I'm not, not sure I can survive this marriage. I feel so let down and nobody cares. I want to reach out for some of these art things we've been talking about, but I don't know how. I wish some miracle could happen to make us grow. Jill, my wife, don't have much brains. She drives people away, sits like a log, doesn't like to do anything. My daughter is sneaky like her mother.

In another instance, a woman is thwarted in her simplest aesthetic yearnings, as both husband and wife attest.

HE: I like to sit and relax, get waited on, watch sports on television. I don't care what my home looks like. I want my wife to wait on me hand and foot. No long-haired stuff for me, puts me to sleep. No one plays an instrument, and I have never heard anyone in this house sing.

SHE: I can't live up to his demands. I am mixed up, upset. If I try to pick out a throw rug, he gets mad. He says I don't have enough horse sense to pick out anything. He tells me how dumb I am. I cut his nails, run his bath, even take his socks off. He wants me to be joyous when I see him at the door. I would like my furnishings improved, buy pretty throw rugs and curtains. I'd like beautiful pictures to hang on the wall, simple furniture, delicate lamps. I'd like a soft look, frilly white curtains.

It is tempting to dismiss such cases as too far from the norm and, perhaps, more the province of psychology and social work than arts administration. But, it is also worth noting that such people represent a substantial portion of the population. The Attitude toward the Aesthetic Value scale was administered to a sample of 342 people (of varying social class, age, location in the country, et cetera). The instrument calls for agreement or disagreement with statements asserting positive and negative positions about aesthetic activities, their value, support, importance to society, et cetera. Despite the general tendency to express virtuous thoughts about such things, about 35 percent of the sample scored low on the aesthetic value, and only about 40 percent scored high.

The pathological extremes often reveal dynamics at work in more moderate instances. Here they suggest that obstacles to aesthetic appreciation are an interaction between the negative self-concepts of people who feel unequipped and hostile and their perceptions of the arts as hopelessly beyond them. These views are expressed most vehemently by those of lower social class positions. Middle- and upper-class people who have alienated attitudes toward the arts usually express flat disinterest, a lack of experience, or ignorance. They may emphasize the esoteric nature of the arts. And there

still are those who regard the arts as immoral in language, exhibitionistic in displays of the body, or reflective of the free behavior of artists:

> I rarely buy art work. I don't know enough about it, so I don't enjoy it.

> No art museum for me. All you see is a blue border inside a red border, inside a black border, and it sells for $38,000. I just can't see anything there.

> I don't know anything about art. The kids have dragged me. I don't understand it.

> I'm not really interested in those crazy nuts making fools of themselves. I don't like to see people jumping around or throwing themselves around in dancing.

Higher-status people may use subtler ways of disclaiming involvement, perhaps by showing themselves superior to the old-fashioned values represented:

> Nowadays I feel the theater is too limiting a medium. My wife has a more traditional view of theater, she still goes. I find theater a bore.

The reality of the obstacles to aesthetic appreciation is great. Some high art simply cannot be understood by that half of the population that has below average intelligence—an intellectual basis for elitism that may never disappear. Various appreciations require more than exposure; if cultivation is lacking, it is hard to catch up, to gain that accumulation of subtleties that fills the interstices of experience with richness of reference and association. It is also hard to catch up because it is in the nature of certain elites to keep moving toward novel grounds of distinction and rarity, so that by definition the mass is kept at a distance. Also, insofar as some high art is defined by its iconoclasm and criticism of conventions, people who live by those conventions will refuse to attend to it. This segmenting process occurs within the high arts realm as well, where avant-garde taste for modern literature, dance, painting, and theater looks down on those who stick with a steady diet of Beethoven, Tchaikovsky, and traditional representational art.

AVENUES TO PARTICIPATION

It seems evident that many people will never be awakened to the pleasures of high culture, their distance and antagonism being so great. But some lower-class and lower-middle-class people do find their way to this enjoyment—the arts may be the province of an elite, but it is not solely an upper-class one. Following are some of the elements that foster consumption of the arts.

The virtuous, uplifting aspects of the arts, their refinement of sensibility, and nonmaterialism make them suitable for children. Therefore, the presence of children can bring aesthetics and the arts to the home, beginning with finger painting and working up.

> The children don't watch too much TV. I prefer to get them coloring books, clay, cutout dolls.

> I like to buy jewelry for gifts, that is my point of view. But my son is not very materialistic, he would rather I give him money to invest in music. We are buying them some art now.

When motivation is not strong, the lack of accessibility makes the situation worse, justifying complaints about time and money as problems. Some decentralization of opportunities helps. The contribution to high culture is often slight, given the theatrical fare at some summer and dinner theaters, serving as a deceptive source of self-congratualtion. Bookmobiles carry literature to poor neighborhoods, art fairs are ubiquitous, the suburban theaters remove the excuses for not going downtown—and the atmosphere is elevating.

> I have never been to an art gallery. I could never afford an original painting. But I could see something I liked and maybe buy it if I saw it at the art fair.

> I had never seen a stage play. We just don't have much interest in stage shows. But six months ago we did go to the Drury Lane Theater on 95th Street. We have some friends at our church who arranged this outing so we decided to attend with them.

> I saw Pat O'Brien at the local theater near here. We got a free ticket through our organization. I could never go downtown, too far to go and too expensive.

Similarly, recordings and electronic presentations of art (records, Clark's "Civilisation" series, public television's "Great Performances," et cetera) provide enriching experiences and awareness, although not always the willingness to attend live performances: "We used to go, but now see them on TV."

Mobility of various kinds is of special value in fostering knowledge about the arts. In general, the arts are phenomena of the city—and of the great city; it is natural that rural residents show least interest (National Research Center for the Arts 1973). People who travel to the city and the downtown area are more likely to have exposure and opportunity. Generally, mobility brings with it contacts with new people, new visual environments, and the chance for new enthusiasms and ways of using time. New

playmates, new teachers, and new office settings are spurs to new aspirations and kinds of attendance:

> A group at the office decided to see *Hello Dolly*, so we organized to go one evening. First real theater I ever saw.

> I have a boss interested in art, I see some in his office. I would like a nice picture some day.

It is a truism that visitors to a city do more museum and theater going than many residents. Many places are filled with tourists. People who never attend theater in Chicago may see several shows in New York or London on a visit, or even go for that purpose. It is as if the arts are not part of daily life or are something reserved for vacations, part of escape from the total home environment:

> I haven't seen any plays lately. It's the kind of thing we feel we have an obligation to support but can't make time for it. In London we really do a lot. Last time we were there, we saw 14 or 15 plays in a period of a week or ten days. But that is different.

> I travel for the same reason I read, to escape. When I travel I'm interested in the cultural aspects of my destination, museums, galleries, antique stores, plays.

Social mobility is one of the outstanding incentives for involvement with the arts. Taking part in a high status activity confers on the participant a certain cachet (literally stamped on the hand at the Old Town Art Fair in Chicago to indicate a paid admission). It means one has arrived at the higher levels of the cultural life of the community, mingles with the right people, and knows what is going on in the arts world—or in an important segment of it:

> We go on Members' Night whenever they have a new exhibit. I enjoy using the Members' Lounge and other special privileges. When we went to the Rauschenberg show, Vincent Price was there.

Through whatever means—status strivings, family tradition, tutelage of friends, teachers, the leisure of travel, et cetera—the aesthetic motivation takes root in certain personalities. Some experience this as natural for humans or as a growth process; others as an illumination or conversion. Then, looking, studying, buying, attending, and planning become part of one's life:

> We are planning on buying more when we see something we both like and can afford. He dreams of owning a Giacometti. I'd be satisfied with a more

modest work by Moore or Picasso, or some marvelous ceramics by Edna Arnow.

The full commitment to a way of life that includes the arts is a far cry from the complaints of too little time or money. Examples are these working-class women who do not allow their modest circumstances to deter them:

> I saw *King Lear* at Goodman Theater, it made Shakespeare very real to me. I don't think many people realize how exciting it is to see people perform live. . . . When I get a chance to go to art exhibits I enjoy it, I like the exposure. . . . When I go to the Art Museum I like many contemporary artists and I get much pleasure looking at the old masters. We have one sculptured metal flower. We have one print of a still life by Cézanne.

> I feel I am growing personally. Now that my children are growing I visit art museums more, I check out everything. I find I especially love sculpture and photography. These are new interests, food for my aesthetic appetites. I love the arts, marvel at artists' creativity and facility. I now use pictures as an integral part of my decorating. I buy what I like.

The attitude of commitment to the arts is most vivid among those of higher status. Aesthetic interest seems pervasive, shared in the family, and finds expression in numerous directions; it is varied, subtle, inquiring, subjective, direct, and hedonic. It may be both traditional and trendy:

> Happiness comes in finding what makes you feel good. My wife is a good woman, bright, perceptive. She reads everything, does needlepoint. In art sometimes we have quite different tastes. She plays the trombone. We go to the movies and enjoy them. Even a film like *The Wild Bunch* has a macabre sort of beauty. My home is full of things I love either aesthetically or sentimentally. Bentwood rockers, an oriental rug, art work by Strobel, Dahlstrom, King, a Tiffany lamp, a four poster bed. I like variety. In my room I use an American flag graphic paper, in my bathroom St. Laurent towels and shower curtain. We like to go to museums, one man shows."

> We want to create a continual stretch atmosphere in our home, pushing farther towards goals beyond our reach in terms of books, literature, social activities, and relationships. We go to art fairs, we love to take rides to antique shows, and to explore.

> My baby is extremely musical and he sings whole songs or he goes and brings the guitar for us to play for him. We like movies, have seen several done beautifully. Financially, we manage the money for those shows we want to see, and I am usually dying to see them. We collect antiques and objects of fine art. When we were first married we had more paintings than furniture. We like painting, sculpture, ceramics. A home isn't a home without books and musical instruments. We can always find some extra money to buy a painting that appeals to us. We put some money in a

painting fund weekly for a long time. We never pass up something we really like even if we can't afford it. Aside from being an exceptionally good husband and father, my husband complements my personality because he is even, I am not. He is gentle, artistic, creative. He can sit at home and make wire sculptures for hours.

This qualitative analysis sketches in motives and feeling tones along a continuum of arts consumption, reflecting low, moderate, and high aesthetic attitudes. It highlights the complex of cultural-social-psychological situations characterizing varying degrees and styles of affiliation with the arts.

AESTHETIC ATTRIBUTES

Another way of approaching people's perceptions consisted of execution of semantic differential scales. Respondents were asked to judge the idea "The Objects in My Life Should Be. . . .," as shown in the Appendix to Chapter 3. The purpose was to observe the choices made between each pair of words describing basic qualities of experience or aesthetic attributes. These terms are taken as building blocks that make up larger concepts. In choosing between them, respondents may show underlying consistencies through the clustering of their choices. This clustering was observed by means of factor analysis and will be summarily reported here.

The words that tend to go together are inferred to have some common element in people's minds, one that guides the preferences they are expressing. The specific aesthetic attributes may thus be taken to represent more fundamental aesthetic dimensions. Factoring gives only the relative strength of the clusterings. The fundamental aesthetic dimension that the clusters represent are matters for speculation and interpretation, and anyone may play. Six main factors are described here, the first three being the most clear:

Factor I—bold, exciting, thrilling, crowded, active. (retiring, peaceful, soothing, alone, leisurely)

Factor II—familiar, real, symmetrical, matching (strange, fanciful, asymmetrical, contrasting)

Factor III—hard, sturdy, practical, technical, powerful, profitable (soft, delicate, decorative, emotional, graceful, social)

Factor IV—stage plays, curved, painting, (movies, angular, photograph)

Factor V—sophisticated, outstanding, luxurious (sentimental, customary, comfortable)

Factor VI—dramas, serious, dramatic, alone, (musicals, funny, pretty, crowded)

Some factors seem more evident than others, being mainly a matter of redundancy in the list. In other instances the words seem to be different facets of a broader principle. Factor I stands out because of its focus on

vigor. It might be called the activity or excitement factor. It suggests that people in general want stimulation, a feeling of liveliness; activity, movement, and excitement are important. The majority tended to select all five stimulation words, and almost three-fourths of the sample chose "bold" and "active." This factor was especially pronounced among younger people; men went for "thrilling" and "crowded" somewhat more than women did, and the factor was more important to middle-class people than to lower-class people.

Factor II is the realism factor, and it reflects the fundamentally conservative or conventional orientation of the population away from the unusual. Eighty-six percent (greatest consensus shown) chose "real," and 79 percent, "familiar"; there was some greater tolerance for "contrasting." The realism factor is greatest among the lower class, but interest in the "strange" and the "fanciful" is not great, even among upper-middle-class people. More young people can accept the strange.

Factor III suggests a conventional sex-typing sex identity dimension, with traditional masculine elements opposed to traditional feminine elements. As a result choices are more evenly divided in the sample, despite some general tendency toward preferring the "sturdy" and "practical." Sex differences are most pronounced here, with choices by males and females going in the expected directions, modified somewhat by the greater interest in "feminine" attributes among the upper middle class compared to the lower class.

Factor IV is less clear in its significance. There is a strong general preference for the "curved" rather than the "angular". And, it is something suited to the three-dimensional rounded character of theater or the flowing character of painting, versus the film. The results reflect the greater choices of the movies by men, lower-class people, and young people, and the greater acceptance of the legitimate theater by higher-status people, women, and mature people. Perhaps this factor refers to the Arts, per se, and their open-life human quality, compared with the stiffer, impersonal, canned character of photography.

Factor V seems to be oriented toward social status. Most people (82 percent) claim to prefer "comfortable" to "luxurious," perhaps being sensible about it; generally, they would like things to be "outstanding." The main differences are between the higher and lower social classes, the latter being especially oriented toward the "sentimental" and the "customary."

Factor VI seems to be a heavy-versus-frivolous or seriousness factor. It carries with it a tone of introspection and withdrawal, against the light-hearted crowd at the musical comedy. Choices tend to be divided, despite the usual appeal of the easy and popular. Women and young people are more inclined to prefer the "funny," the "pretty," the "crowded," and "musicals," and the "soft." Men, older, and upper-status people incline in the opposite

TABLE 3.1

Factor Analysis of Aesthetic Attributes

Factor I: excitement	
Bold/retiring	.633
Exciting/peaceful	.613
Thrilling/soothing	.597
Crowded/alone	.450
Active/leisurely	.359
Factor II: realism	
Familiar/strange	.644
Real/fanciful	.585
Symmetrical/asymmetrical	.584
Matching/contrasting	.509
Factor III: sex identity	
Hard/soft	.449
Sturdy/delicate	.542
Practical/decorative	.445
Technical/emotional	.447
Powerful/graceful	.548
Profitable/social	.486
Factor IV: the arts	
Stage plays/movies	.684
Curved/angular	.343
Painting/photograph	.455
Factor V: social status	
Sophisticated/sentimental	.613
Outstanding/customary	.381
Luxurious/comfortable	.333
Factor VI: seriousness	
Dramas/musicals	.442
Serious/funny	.378
Dramatic/pretty	.376
Alone/crowded	.353

direction. Perhaps it is a maturity factor. The six factors are summed up in Table 3.1.

These results are a kind of oversimplification, and they repeat that commonly observed motives and behaviors toward the arts are derived from the factors here identified as excitement, realism, sex identity, the arts, social status, and seriousness. But, they remind one that preferences for aesthetic attributes are blended to express the self-definitions and aspirations of the audience. The factors imply that there are powerful consistencies at work, dictating the felt appropriateness of given forms of experience for major segments of the population who act out these feelings.

MARKETING OF THE ARTS

Modern thought regards marketing as a process of exchange between individuals and groups, each of whom wants something and offers something. The study of marketing is the study of the participants and their aims and conditions of exchange and the complexity of events, situations, locales, and relationships arising from the mutual attempts to accomplish their purposes. The present material has examined some aspects of this exchange by focusing on the consumers and how they perceive the arts, rather generally conceived, and on the nature of their aesthetic aspirations.

This information does not in itself tell artists and arts administrators what to do to market the arts. That, fundamentally, rests in their objectives and the means they are willing to undertake. Marketing the arts does not necessarily mean increasing the size of the audience, but it may. It does not mean persuading people to spend more money for the arts, but it may. It does not mean using advertising or hiring marketing personnel, but it may. It does not mean changing the offerings to cater to the masses, though it may.

Marketing management seeks to implement the goals of the organization (and the individual) through helping to define and clarify those goals and by taking actions that will successfully contribute to the required exchange relationships. What might the above findings imply for making such plans and efforts? A few general suggestions are offered.

1. Some problems of personnel and management attitude-may require attention. Museum administrators have been found to vary significantly in their orientations toward the institutional mission. The client, inner, and professional orientations were identified and shown to be in conflict at times. For example, highly client-oriented administrators wanted a large future attendance increase, regarded the museum's services as particularly valuable to visitors' lives, attributed to visitors a high capability in judging the quality of the museum services they receive, and favored intimate staff-customer interaction in preference to detached dealings. The highly inner-oriented administrator did not think that the museum's clients were especially capable of differentiating degrees of quality in museum services to them (Thrasher 1973).

2. It is likely that the audience for the high arts will continue to remain quite limited. Substantial portions of the population do not believe these are necessary to their lives and will resist all blandishments and opportunities. Many objections made by consumers are rationalizations of lack of interest, so extreme efforts by arts administrators, except for the most missionary, are probably not warranted.

3. Enlarging the audience for the arts requires taking account of the perceptions of the potential audience. The rates of nonparticipation are so high that it might be supposed that almost any reasonable effort could bring

in some of those who express willingness. In the New York State study, *Arts and the People*, nonattendance within the past 12 months (prior to the study in 1973) was as follows:

	Percent
Ballet or modern dance	83
Concert or opera	65
Theater performance	58
Science museum	44
History museum, site	43
Art museum	41

Nonparticipants harbor many inhibiting images of the arts as relatively austere and effete, effeminate, esoteric, inaccessible, too demanding of study and concentration, arrogant, et cetera. Coping with these attitudes is not easy, but progress is made when experience shows the contrary or reorients the negative value. To bring about the experience, marketing usually recommends incentives, free samples, easy trial, and starting with examples that most contradict the opposed imagery. Personalities help in this endeavor—men ballet dancers who are masculine, such as Edward Villella, and opera singers who are not foreign divas, such as Leontyne Price. English translations help, as in the television broadcast of Verdi's *Otello*.

The growth of informality is an asset to the more common consumption of the arts. Assuming that high culture needs special dress or manner is an obstacle, analogous to the ceremonial approach to wine drinking. Then, again, one might believe that something important in the total aesthetic experience is lost when certain standards or protocols are compromised or that the high culture has descended from the lofty level that was part of its ambience and charm.

4. However, Municipal Park concerts, Free Street Theater, and Barefoot Beach Walk art exhibits point to the segmentation among arts consumers and do not prevent elite groups from dressing for first nights. Taking account of market segmentation, addressing it, and increasing it are important ways of marketing to the diversity in the population. This is not a new idea, as witness the levels of donor, patron, sustaining member, contributing member, and the like at some museums. But, many arts institutions have little information and rather vague ideas about the segments they serve and could serve. Categorizing segments and defining them by demographic characteristics, interests, needs, and levels point to different sets of actions that might be taken (Ryans and Weinberg 1978).

An important segment to search out are the people who truly feel frustrated yearnings, whose deeper hungers for aesthetic gratification are in need of feeding, but who are thwarted by circumstances, ignorance, location, family, or money. These include women still locked at home, young people with promising sensibilities, and upwardly mobile people who would like to find their way to elite experiences.

5. There is too little study of the obstacles to learning and enjoyment as these appear to the consumer—not of the usual litany of time, money, and distance but of the closer-in deterrents. Despite Ticketron, there are common problems with box offices and getting tickets; there are the erratic and often peculiar refreshment arrangements, the paucity of knowledgeable or helpful personnel, and the dearth of information. Most museums display and explain in the archaic and restrained fashion that encourages fast walking through static rooms with suspicious or indifferent guards and no place to sit.

6. If the plain fact is that most people want stimulation and excitement, they do not usually see it in the arts but go, rather, to sports, picture shows, and so on. This may not be the fault of the arts themselves, as their fans do find them stimulating. What makes enjoyment possible at the high level is the enthusiast's ability to echo to the fabulous perfection of Bach, grasp the architecture and flow of Schubert's A-Major Quintet, or recognize the daring of Rodin's *Balzac*, the point to Mondrian, or the organic insight of the Pilobolus dance group.

Hopefully, that will come eventually. In childhood there is fantasy and constant newness, supplanted by the safety of realism and familiarity, to be overcome by creativity and imagination. Indirection is needed as well as appeals to lesser motives, status striving, the excitement of glamorous people, the value of a good investment in a work of art or the bargain in a membership, the promise of a richer life for one's children, the social pressure of everyone is doing it, and the changing roles in sex identities of young moderns. Like the churches and charitable fund-raising organizations, the arts institutions need sisterhoods, young couple clubs, Saturday Night Mixers, Golden Age Festivals, and Kiddie Kontests. Sometimes there are spiritual results, too.

7. The arts administrators are trying collectively to change the society. They face a great deal of competition and must promote their products and services in the marketplace of aesthetics. Like all organizations they must study audience needs in order to interact in a desirable way with that audience. Then they can survive and grow. With enough government money and leadership, anything can happen. In the meantime it will be one person at a time, one family at a time, one community at a time, lured by bargains, social competition, carnivals, charismatic figures, and changing images, through activity and excitement, to the sublime.

REFERENCES

Arts Reporting Service. April 3, 1972, p. 1.

National Research Center For the Arts. 1973. *Arts and the People*. New York: National Research Center of the Arts.

Levy, Sidney J., and John A. Czepiel. 1974. "Marketing and Aesthetics." *Proceedings*, American Marketing Association, pp. 386–91.

National Research Center for the Arts. 1973. *Arts and the People.* New York: Publishing Center for Cultural Resources.

Nielsen, Richard P., and Charles McQueen. 1974. "Performing Arts Consumer Behavior: An Exploratory Study. *Proceedings*, American Marketing Association, pp. 392–95.

Ryans, Adrian B., and Charles B. Weinberg. 1978. "Consumer Dynamics in Nonprofit Organizations." *The Journal of Consumer Research*, September, pp. 89–95.

Smith, Thomas Spence. 1974. "Aestheticism and Social Structure: Style and Social Network in the Dandy Life." *American Sociological Review*, October, pp. 725–43.

Thrasher, Steven D. 1973. "The Marketing Concept in Museums: A Study of Administrative Orientations in Cultural Institutions." Ph.D. dissertation, Northwestern University.

APPENDIX TO CHAPTER 3

Semantic Differential

CIRCLE: 0 — when you feel *very* much this way
 o — when you feel *rather* much this way
 . — when you feel *slightly* this way

The objects in my life should be. . . .

comfortable	0	o	.	.	o	0	luxurious
leisurely	0	o	.	.	o	0	active
customary	0	o	.	.	o	0	outstanding
decorative	0	o	.	.	o	0	practical
stage plays	0	o	.	.	o	0	movies
curved	0	o	.	.	o	0	angular
crowded	0	o	.	.	o	0	alone
serious	0	o	.	.	o	0	funny
smooth	0	o	.	.	o	0	textured
real	0	o	.	.	o	0	fanciful
dramatic	0	o	.	.	o	0	pretty
plain	0	o	.	.	o	0	ornate
exciting	0	o	.	.	o	0	peaceful
technical	0	o	.	.	o	0	emotional
graceful	0	o	.	.	o	0	powerful
dramas	0	o	.	.	o	0	musicals
social	0	o	.	.	o	0	profitable
sturdy	0	o	.	.	o	0	delicate
photograph	0	o	.	.	o	0	painting
sophisticated	0	o	.	.	o	0	sentimental
traditional	0	o	.	.	o	0	futuristic
bold	0	o	.	.	o	0	retiring
symmetrical	0	o	.	.	o	0	asymmetrical
familar	0	o	.	.	o	0	strange
hard	0	o	.	.	o	0	soft
seen	0	o	.	.	o	0	heard
matching	0	o	.	.	o	0	contrasting
words	0	o	.	.	o	0	pictures
thrilling	0	o	.	.	o	0	soothing

4

A SURVEY OF MARKETING PERSPECTIVES OF PERFORMING ARTS ADMINISTRATORS

Steven E. Permut

INTRODUCTION

During the last ten years, as the number of performing arts organizations multiplied and attendance figures broke new ground (*Cultural Post* 1976; National Committee for Cultural Resources 1975), one might have assumed that marketing of the arts was unnecessary. Indeed, some might have argued that the idea of marketing in the context of high culture is antithetical at best and destructive at worst. Such perceptions, at least in part, are based on aesthetic considerations and rather traditional views of the purpose and mission of cultural production and distribution (Toffler 1967; Taper 1970; Gans 1974).

However, financial exigencies and increasing public sector involvement in the arts have focused attention on some very fundamental questions, including the nature of the arts product, its general availability, and the composition of the arts public. In addition, as economic pressures increase the need to focus on building a full house and maintaining donor involvement and support (compare Baumol and Bowen 1966), arts administrators are looking hard at traditional management concepts and techniques as a means of increasing organizational viability. Marketing, as one of the disciplines of general management, appears to hold considerable potential

The support of the Program on Non-Profit Organizations, Yale University Institution for Social and Policy Studies, is gratefully acknowledged.

in helping organizations toward this goal (Kotler and Levy 1969; Levy and Czepiel 1974; Kotler 1975).

Throughout the present volume, marketing scholars have attempted to demonstrate the need for, and applications of, a marketing orientation in performing arts organizations. However, given the history of these organizations, one might naturally wonder to what extent marketing concepts and approaches have been applied by performing arts administrators—if they have been applied at all.

This study was undertaken to learn more about the marketing perceptions of arts administrators and look more closely at the current state of adoption of marketing ideas. Numerous authors have called for a marketing orientation in the performing arts sector (Weinberg 1977; Reiss 1974; Raymond and Greyser 1978), yet no study has yet focused on the perceptions and experiences of those arts administrators involved with marketing responsibilities.

METHOD

The Respondent Sample

In order to identify those individuals within a performing arts organization likely to be knowledgeable about marketing activities, a mailing list was used to define the universe of arts administration. The list, numbering 5,140 individuals, was reduced by drawing every third name and subsequently checked to eliminate titles such as "artistic director"—individuals who would not be expected to be involved meaningfully in the marketing activities of their organization. The reduction process yielded a final list of 1,237 individuals representing four types of performing arts organizations: symphony, opera, dance, and choral.

Once the universe of performing arts administration had been suitably reduced to 1,237 individuals, a letter was sent requesting the name and title of the individual(s) within the organization most likely to be involved with general marketing activities and responsibilities. A definition of what was meant by the term marketing was omitted since this was one of the research topics to be explored by the study. A total of 383 names was thus obtained, each identifying the individual most likely to be appropriate for the present study. A questionnaire was then mailed directly to these 383 individuals, with 88 (23 percent) actually returning completed questionnaires, as shown in Table 4.1. As with all survey-based research studies, the usual caveats apply regarding possible nonrespondent bias, generalizability, and related concerns (Permut, Michel, and Joseph 1976).

TABLE 4.1

The Respondent Sample

Organization	Approximate Number Nationally	Sample
Symphony [a]	700	34
Dance company [b]	375	26
Opera company [c]	140	15
Choral group	110	13
Total		88

[a] Traditional groupings include major (34), regional (19), metropolitan (92), urban, and community. Community orchestras were not included, however, in the present study.
[b] Perhaps six major companies.
[c] Approximately 73 with budgets over $100,000.

Questionnaire

The survey instrument was constructed using the basic framework of Kotler's marketing audit (1975, pp. 55–75). While the audit is offered to organizations as a tool to assist managers in evaluating the specific and overall components of their marketing efforts, it is used here to assess the extent to which performing arts organizations recognize, understand, and apply basic ideas inherent in a marketing-oriented enterprise. Since some authors have argued that all organizations engage in marketing, whether they realize it as such, the audit provides a broad instrument for indexing this hypothesis within a national sample of performing arts organizations.

FINDINGS

Definition and Role of Marketing

Arts administrators responding to the full questionnaire were asked to describe briefly the meaning of the term *marketing* as used within their own organization. Based on a straight content analysis of 85 of the 88 responses, the following predominant views emerged: marketing was seen as primarily sales promotion, heavily tied to advertising and selling activities (particularly for special programs or unusual events); and marketing's main contribution to the organization was one of increasing season and individual performance ticket sales, increasing the absolute number of season ticket subscribers, and enhancing the awareness and image of the organization and its individual performances (including guest artists and conductors) among those who patronize the organization. The concept of marketing was

fundamentally viewed as a selling technique or orientation normally identi-
fied with profit-motivated business.

The *role* of marketing within the organization was also viewed as
potentially conflicting with artistic considerations. For example, one busi-
ness manager with a major opera company noted the apparent distrust of
marketing by those charged with artistic and programmatic responsibilities:
"Marketing is inappropriate from an artistic point of view, since it is viewed
as a constraint on artistic freedom; it is therefore viewed with great hostility
by some [within the organization]." In essence, marketing's role was
primarily to help communicate and sell the artistic offerings to those
supporters (subscribers and donors) for whom the organization wished to
perform.

While distrust and misperception of the role of marketing can be
explained, in part, by unfamiliarity with the concept itself, only nine
respondents claimed that marketing played a major (positive) role within
their organization. Of these nine organizations, five were from symphony
orchestras, two from the world of opera, and one each from dance and
choral. However, none of these respondents offered an explanation of how
this was accomplished or what exactly was meant by a major role. Interest-
ingly, an almost equal number of respondents (seven) stated flatly that
marketing had no role to play in their organization (three from symphony
orchestras, three from opera, and one from a choral group). One orchestra
business manager felt compelled to add that marketing could not play a
role in his organization "because no one had bothered to write a part for it!"

Perceived Importance of Marketing

Each respondent was also asked about the perceived importance of the
four primary marketing variables—namely, promotion, pricing, distribu-
tion, and product considerations. These four elements comprise the "mar-
keting mix" and represent the most important controllable factors under
marketing management's control (see Kotler 1976, as well as other papers in
this book for further elaboration). Across all respondents, the following
perceptions were found:

1. Promotion was clearly viewed as the preeminent marketing variable,
with 72 administrators (82 percent) rating it "most important." Included
within this general category of activities were mass media advertising
(engaged in by 95 percent of those organizations represented), sales promo-
tion (for example, two-for-one ticket specials or cooperative tie-ins with a
nearby restaurant, engaged in by 88 percent), public relations (including
news releases and other goodwill efforts, engaged in by 88 percent), and,
finally, personal selling (defined as those activities other than box office
selling, engaged in by 72 percent). Direct mail promotional activities were

engaged in by 91 percent of all organizations responding, while outdoor poster advertising was used by 79 percent.

2. Pricing was viewed as second most important of the available marketing variables by 67 respondents (76 percent). Pricing of tickets was viewed as relatively inflexible by 70 percent of those responding, arguing that prices were relatively fixed due to past and projected costs of operating at acceptable levels, as well as by the competitive environment (that is, other organizations with similar offerings). Formalized cost-plus-pricing for season subscription tickets was claimed by 71 (81 percent) of all respondents, although written comments suggest that there is a wide difference of opinion about what cost-plus-pricing means. Sixty-one percent agreed that pricing decisions were largely intuitive, while 72 percent felt that prices were sometimes set in an arbitrary manner. Seventy-four percent claimed that prices were set with full recognition of some specified break-even point or profit target. Whether such goals were reached or, for that matter, really considered, was not explored. Interestingly, only one organization reported a formalized experiment to assist management in determining an optimal pricing strategy.

3. Distribution was a concept of apparent irrelevance to respondents, with only 14 (16 percent) indicating this general area to be of any importance at all. The term itself was most often related to having tickets sold by various outlets, such as retail stores, located away from the central performance location. Several respondents mentioned the need for "getting the performance out to the people" by simply expanding the number of performance sites to maximize audience exposure. The concept of channels of distribution as used by traditional private sector organizations is apparently seen as having some limited relevance as a marketing variable within the performing arts context. However, as demonstrated in a subsequent section of the present volume, the potential contribution of distribution considerations may be far greater than is presently recognized.

4. Product considerations yielded perhaps the most interesting responses, with two out of four respondents agreeing with the statement that "our primary product is the performance of [symphonic music/opera/dance/choral] *music*." Only a handful of administrators mentioned that they viewed the product of their organization in terms of "social/aesthetic experiences," "enhanced leisure time pursuits," "cultural development," or other, more broadly defined conceptualizations. This is indeed unfortunate, one might argue, since product intangibles abound in the performing arts context. Paralleling the arguments of Shapiro (1973, p. 131) one might view the product as comprising personal satisfaction, pride, a feeling of belonging, and a warm feeling inside.

In sum, marketing was viewed far more narrowly than is traditionally the case within private sector organizations. Further, marketing was characterized as being of rather limited value outside of promotional and ticket-selling considerations. At least three-fourths of all respondents agreed that

marketing methods are viewed with skepticism by their respective organizations, and six individuals emphasized the "deceptive potential" or "ethical void" associated with the concepts of marketing.

Thus, against this backdrop, it was not surprising to find that 42 percent of those responding agreed with the statement that "truly professional performing arts organizations do not need to be marketed." In fact, there appeared to be serious reservations about the appropriateness of marketing concepts in the world of artistic endeavor. Perhaps the most striking area of controversy that emerged from the present study involved the role of audience versus artistic considerations, as discussed in the following section.

The Role of Audience Research

For most private sector organizations consumer research plays a major role in the development of products or services. By learning about consumer needs, wants, and desires, for-profit organizations have maximized the likelihood that products and services will indeed be well received in the marketplace. In fact, successful marketing-oriented firms start with the consumer side of the equation before new products/services are created or before existing ones are modified (for example, see Levitt 1975).

Artistic products, however, are not necessarily so easily created or tailored to meet the needs and wants of an audience. Clearly, performing arts organizations have also to satisfy the needs and desires of the artists themselves, and thus a potential conflict of opinion arises over the need for, and value of, audience-based research in artistic organizations.

Of the 88 arts administrators participating in the present study, only one out of four claimed that at least one audience research study had been conducted during the past 12 months within their respective organizations. Table 4.2 provides an overview of the nature of these studies.

As one can see from Table 4.2, audience-based research was most often used by symphony orchestras to learn about audience preferences for specific artists, followed by audience preference for specific program selections. Audience preferences for locations, dates, or times of performances were least frequently researched. Since only one organization accounted for three or more of the studies listed, these figures essentially represent research efforts of different organizations rather than only a few, very active organizations. At the same time, one must recall that these efforts collectively represent only 25 percent of all respondents in the present study, which, in turn, represents only about one-fourth (88 out of 383) of arts administrators with marketing responsibilities who chose to respond to the study or questionnaire.

Another index of research activity performed by these organizations is provided by the annual relative allocations of audience research budgets. For the past fiscal year, figures ranged from a low of zero dollars (no

TABLE 4.2

Audience Research Studies of Performing Arts Organizations Conducted During the Past Year

Research Studies	Number of Studies Conducted[a]			
	Symphony Orchestra (32)[b]	Dance Company (23)[b]	Opera Company (13)[b]	Choral Group (13)[b]
Audience preference for specific program selection(s)	4	0	2	2
Audience preference for specific artist(s)	7	2	2	0
Audience preference for *special* events or programs (not regularly scheduled)	1	1	0	3
Audience preference for locations/dates/times of performances	0	1	0	2
Audience preference for different ticket price(s) (individual or season)	3	1	2	0

[a]Figures given are for number of *studies* conducted, not number of organizations.
[b]Indicates number of organizations responding to question.

research undertaken by 58 organizations), to a modest $170 for only one research project, to a maximum of $5,800 for more extensive audience research. When viewed against a hypothetical operating budget of, say, $100,000 for a regional orchestra, the top research allocation reported here represents only 5.8 percent of available funds. Even without comparison with other kinds of organizations, it appears that such meager expenditures serve to highlight the lack of importance generally attached to audience-based research among performing arts organizations.

Perhaps one of the most controversial questions regarding the appropriate role of consumer research emerges in the form of a perceived conflict between the whimsical expectations of the performing arts consumer and the artistic prerogatives of the performing arts organization. Indeed, several administrators felt compelled to point out that consumer (or audience) research was, for all intents and purposes, inappropriate since "artistic expression should not be bound by audience expectations or preferences." In fact, only three respondents (3.4 percent) agreed that "consumer preference should effectively dictate performance selections," while ten administrators felt that consumer research "should be a major factor" in performance selection decisions. Consumer satisfaction, however defined, was not viewed as a significant factor in program decision making by any of the administra-

tors responding. Quite clearly, product decisions, to use the marketing phrase, are viewed as independent from audience preferences, and, thus, knowing more about the audience side of the house appears to add little information of value to programming decisions for most performing arts organizations. However, some notable exceptions can be found (Weinberg and Shachmut 1978). Audience-based research appears to be viewed more often as a (feared) *substitute* than as a mere *supplement* to artistic decision making (DiMaggio and Useem 1978).

Beyond the questions raised about audience preference are questions about audience behavior—for example, knowing more about why some people attend a given performance, or buy a weekday ticket, or fail to renew their season subscription. Only 4 out of 85 actual respondents (5 percent) in the present study claimed to have asked members of their respective audiences specific questions concerning reasons for attending a given performance or regarding some other behavior of potential interest to the organization (such as the reasons for continous support, or "brand loyalty," over several years). All four respondents reported asking such "why" questions of current subscribers; no mention was made, however, of exploring underlying behavioral questions with former subscribers (those who no longer attend performances), nor was mention made of research addressed to other relevant publics (for example, private donors or corporate/government sponsors). While research, either implicit or explicit, may well be conducted by some organizations, the real underlying basis for the behavior (or lack of behavior) of relevant publics receives extraordinarily limited attention.

Understanding the Marketing Environment

Performing arts organizations, like other ongoing enterprises, operate within a larger environment that influences the viability and ultimate success of the organization. Factors that comprise the marketing environment include changes and trends with respect to demography, economy, technology, government, and culture. In addition, the nature of competition for the organization's products/services/ideas as well as its customers/audience/supporters can be expected to play a major role in the viability of an organization (Rockefeller Panel Report 1965).

Among the 88 performing arts administrators responding to the present study, only 6 (7 percent) reported "formal analysis each year or two" of demographic changes in their market area. Formal economic analysis was said to be conducted by 10 (11 percent) of those administrators responding, while 51 (60 percent) reported formal analysis of trends in the governmental sector (local, regional, and/or federal). As expected, all respondents claimed that cultural changes and trends were formally reviewed periodically.

Analyses of the marketing environment mentioned above were con-

ducted by the organization itself (92 percent), while seven organizations (8 percent) employed outside consultants or research services. There was no mention made of so-called multiclient (shared) research studies, nor did any organization indicate that a full-time researcher was employed on a regular basis to deal with these types of analyses. In fact, volunteer researchers were reportedly used by about one out of seven organizations.

In terms of formal analysis of competition, performing arts administrators seemed split on both the importance of such information and its relative influence on the artistic direction of their organization. First, with respect to "the competition, viewed in the broadest sense of the term," 62 (74 percent of 84) respondents reported conducting formal analysis at least annually or biannually. Of the 22 respondents not reporting formal analysis of the competition, all but two reported informal analysis of some type.

The definition of *competition* seemed to focus on other performing arts organizations within some reasonable proximity, together with some slightly enlarged view of related organizations. For instance, a symphony orchestra might tend to view competition as other orchestras competing for public support, as well as some of the other cultural offerings in the area, including opera, ballet, and professional dance or theater companies. In only four cases did respondents explicitly refer to such competitive factors as TV/radio broadcasts of performing arts, movie-going, live popular music concerts, and other forms of potentially important competitive events.

The perceived importance or impact of such analyses, however, on artistic decisions is another matter. Of those organizations that formally research the competitive environment, only two were viewed as being "influenced in a meaningful way" by the results of such analysis. For those organizations conducting informal competitive analyses, none was viewed as being meaningfully influenced in its artistic decision making. Thus, the nature of competitive analysis, while potentially enlightening, is not perceived as having any impact on the artistic prerogatives of the organization.

DISCUSSION AND CONCLUSION

Involvement—Administrator, Audience, Artist

One cannot help from being struck by what appears to be a relatively low level of involvement with marketing by performing arts administrators. Indeed, as two professional observers of management education have recently observed, "In no area of arts management has the absence of professionalism been more evident than in marketing" (Raymond and Greyser 1978, p. 130). The reasons for marketing's slow adoption seem tied to the enduring perception within many performing arts organizations that marketing is a tool of commercial enterprise and, therefore, can contribute little other than sales promotion to the cultural mission of the organization.

At the same time, of course, the cultural mission of many performing art groups is being challenged by the financial viability of the enterprise just to maintain itself on a month-to-month or season-to-season basis. Financial constraints press hard against traditional artistic views that the reason for cultural enterprise is to allow cultural expression to flourish regardless of the demand for, or appreciation of, the artistic offerings. Unfortunately, artistic prerogative is often cast in opposition to audience preference rather than simply being viewed as two parts of the same essential undertaking—namely, cultural exploration or exchange among interested parties.

Marketing cannot solve the conflict between audience preference, on the one hand, and artistic prerogative, on the other; in fact, it need not even address the question to make its contribution felt. Rather, marketing provides a systematic framework for understanding the elements or factors that individually and collectively influence the exchange process. That is, marketing offers a way of grasping the exchange of support, money, patronage, satisfaction, and other audience factors with the offerings, musical creations, expressions, and cultural demonstrations of the artist and the arts organization. It does so by focusing management's attention on the semicontrollable factors of the marketing mix (that is to say, on considerations related to the product, price, promotion, and distribution issues). Further, a marketing orientation argues that different audience groups or market segments behave in different ways toward the organization because of different preferences, attitudes, motivations, and experiences (for example, Ford Foundation 1974; Heitmann and Crocken 1976; Nielsen and Nielsen 1975–76). By examining such audience characteristics, one is able to learn a great deal about the effectiveness or lack of effectiveness of product/ price/promotion/distribution decisions. In this way, a marketing orientation provides information and understanding about the exchange process, but it does not automatically make decisions for the organization.

The Challenge Ahead

The present study provides some illumination about where we are at the present time in terms of marketing perspectives of performing arts administrators. In spite of the fact that approximately 20 universities offer master's degrees in arts management, and many notable special programs are oversubscribed, the adoption of marketing concepts and tools appears meager at best.

The next logical question one is tempted to ask is simply, How can the adoption of a marketing orientation be enhanced? Or, phrased in a different way, what are the constraints operating within a performing arts organization that impede the adoption of a marketing point of view?

When administrators included in the present study were asked to respond to the first of these questions, 36 out of 82 (44 percent) suggested the

need for greater exposure to marketing ideas by means of specialized workshops, conferences, seminars, and related programs. Hopefully, the occasion of the "Marketing the Arts" conference, from which the present book emerged, is the type of programmatic exposure being suggested by these administrators.

In addition, the importance of demonstrating the successful application of marketing thinking was raised by 18 of the respondents. If marketing really has a place in performing arts administration, these individuals might argue, then let it show what it can do. In this spirit one might argue for the creation of case studies of successful and not-so-successful marketing applications, similar to the well-known *Cases in Arts Administration* by Raymond, Greyser, and Schwalbe (1975). By documenting the context as well as specifics of a wide variety of administrative situations, the relationship of marketing to the total management process can be seen in bold relief.

With regard to the question raised about constraints operating within a performing arts organization, respondents in the present study offered the insights: first, historical or "traditional" constraints may limit the role of an administrator to implement newer ideas and concepts; second, only 14 out of 81 (17 percent) respondents claimed any formal exposure to marketing thinking, suggesting lack of training as another constraint; and, finally "administrative pressures" accounted for a variety of additional constraints, ranging from a lack of available staff and/or budget to mount a marketing effort to the inability to find the time to even think about marketing

The adoption of a marketing dimension as an integral part of the overall management process is difficult to achieve for all organizations, even those in the commercial sector. Yet, it would appear that the ultimate viability of any organization can only be enhanced by a continuing sensitivity to the people and groups it seeks to serve. In return those well-served people and groups should likely further support and encourage the organization and its mission.

Judging from the present study, a great deal more needs to be done to allow marketing to make its contribution to this process. For even at face value, such a contribution can only be in the best interests of all concerned with the future vitality of the performing arts.

REFERENCES

Baumol, William J., and William G. Bowen. 1966. *Performing Arts: The Economic Dilemma.* New York: Twentieth Century Fund.

DiMaggio, Paul, and Michael Useem. 1978. "Decentralized Policy Research: The Case of Arts Organizations." Unpublished manuscript, Center for the Study of Public Policy, Cambridge, Mass.

"Estimated Growth in Selected Cultural Field: 1965–1975." 1976. *Cultural Post,* May/June.

Ford Foundation. 1974. *The Finances of the Performing Arts.* New York: Ford Foundation.

Gans, Herbert J. 1974. *Popular Culture and High Culture: An Analysis and Evaluation of Taste.* New York: Basic Books.

Heitmann, George, and W. E. Crocken. 1976. "Theatre Audience Composition, Preferences, and Perceptions." *California Management Review*, Winter, pp. 85–90.

Kotler, Philip. 1976. *Marketing Management: Analysis, Planning, and Control.* 3d ed. Englewood Cliffs, N.J.: Prentice-Hall.

———. 1975. *Marketing for Nonprofit Organizations.* Englewood Cliffs, N.J.: Prentice-Hall.

Kotler, Philip, and Sidney J. Levy. 1969. "Broadening the Concept of Marketing." *Journal of Marketing*, January, pp. 10–15.

Levitt, Theodore. 1975. "Marketing Myopia." *Harvard Business Review*, September-October, pp. 26–44, 173–81.

Levy, Sidney J., and John A. Czepiel. 1974. "Marketing and Aesthetics." *1974 Combined Proceeding of the American Marketing Association.* Chicago: American Marketing Association, pp. 386–91.

National Committee for Cultural Resources. 1975. *National Report of the Arts.* New York: National Committee for Cultural Resources.

Nielsen, Richard P., and Angela B. Nielsen. 1975–76. "Performing Arts Audience Segments—A Case Study." *Performing Arts Review*, Winter, pp. 301–12.

Permut, Steven E.; Allen J. Michel; and Monica Joseph. 1976. "The Researcher's Sample: A Review of the Choice of Respondents in Marketing Research." *Journal of Marketing Research*, August, pp. 278–83.

Raymond, Thomas C., and Stephen A. Greyser. 1978. "The Business of Managing the Arts." *Harvard Business Review*, July-August, pp. 130.

Raymond, Thomas C.; Stephen A. Greyser; and Douglas Schwalbe. 1975. *Cases in Arts Administration.* rev. ed. Cambridge, Mass.: Arts Administration Research Institute, Harvard University.

Reiss, Alvin H. 1974. "A Marketing Challenge: Finding New Audiences for the Arts." *American Way*, February, pp. 25–29.

Rockefeller Panel Report. 1965. *The Performing Arts: Problems and Prospects.* New York: McGraw-Hill.

Shapiro, Benson P. 1973. "Marketing for Nonprofit Organizations." *Harvard Business Review*, September-October, pp. 123–32.

Taper, Bernard. 1970. *The Arts in Boston.* Cambridge, Mass.

Toffler, Alvin. 1970. "The Art of Measuring the Arts." *Journal of Aesthetic Education*, January, pp. 53–72.

Weinberg, Charles B. 1977. "Building a Marketing Plan for the Performing Arts." *Association of College, University and Community Arts Administrators Bulletin.* supp. no. 58. Madison, Wis. Association of College, University and Community Arts Administrators.

Weinberg, Charles B., and Kenneth M. Shachmut. 1978. "Arts Plan: A Model Based System for Use in Planning a Performing Arts Series." *Management Science*, February, pp. 654–64.

5

ARE ARTS ADMINISTRATORS REALLY SERIOUS ABOUT MARKETING?

Paul M. Hirsch and Harry L. Davis

The Seattle Museum staged its Tut exhibit at the Seattle 1962 World's Fair grounds. . . . Many spectators rode the [amusement park's] bumper cars while they waited for their crack at ancient Egyptian culture. . . . New York's Metropolitan. . . , with the September line stretching 12 hours at one point, hired musicians, clowns and jugglers for entertainment.
Roger Ricklefs, *Wall Street Journal*, December 15, 1978

INTRODUCTION

The term *arts administrator* brings to mind the president, general manager, or executive director of a major symphony, museum, ballet, theater, or comparable aesthetic enterprise. As arts organizations come to place increasing authority in the hands of professional administrators, rather than artistic directors or head curators, they are racked by internal conflict and power struggles over goals, mission, staffing, and operations. Some of the characteristic concerns that arts organizations share include serving both local and national audiences—for example, the New York Philharmonic; the showcasing or production of new works, in addition to presenting better-known and more popular "classics"; a need to narrow deficits and break

We are grateful to the Center for the Management of Public and Nonprofit Enterprise, Graduate School of Business, University of Chicago, for generously supporting the research on which this paper is based.

even rather than an orientation toward making a profit; an emphasis on artistic standards rather than simply seeking to satisfy popular taste; and an identification with "high culture" and elite audiences.

A broader definition of arts organizations might be expanded to include those that "retail" productions and performances, once they are established and go on tour. Here, while the local "sponsor" (for example, a college's office of public events, a civic theater, or a commercial theater) may or may not remain nonprofit, the booking agencies and artist management organizations with which they deal are clearly profit-oriented (see Chapter 14). Together, their business is largely to distribute to their audiences brand-name productions and performers, whose national reputations and professional experience were developed elsewhere. They are generally more box office-oriented than arts organizations that develop new talent and productions. Relatively speaking, these "distributor" arts organizations share most of the same concerns as the "producer" organizations but also experience less intense conflicts over their goals and strategies (for an expanded discussion, see Hirsch 1978).

Where marketing is concerned, we can distinguish distributor from producer arts organizations: for the distributor, our question becomes how strong their interest is in better marketing, while for the producer, it is whether they are serious about marketing at all. For many producer arts organizations, in particular, there is substantial reason to doubt whether they are, in fact, serious. In this overview, we shall review the evidence for this assertion, touch on our own research for most of the major arts organizations in Chicago, and set out conditions under which particular types of arts organizations are most and least likely to turn to the market expert for help, utilize the information developed, or, conversely, fail to act on or implement the information provided.

MARKETING AND "ELITE" ARTS ORGANIZATIONS

Over the last several years, there has been a growing social movement—spurred by private foundations and the National Endowment for the Arts (NEA)—to upgrade the overall quality of arts administration. The program for an NEA conference on research in the arts (December 1977), for example, included six papers on how to obtain better information about consumer wants, three econometric models for forecasting their aggregate demand, a discussion of arts organizations' accounting practices, a presentation by the management firm of Booz, Allen and Hamilton on options for collecting better economic information, and a report on the "need" for orchestra conductors and managers.

While most arts organizations welcome the infusion of government financial support, few of their representatives express enthusiasm for the idea that they become more businesslike in their management and adminis-

tration, even if the Office of Management and Budget expects this of all organizations and industries receiving federal aid. Upgrading in this context encompasses diverse areas, ranging from improved accounting methods and audits to better models of space utilization, analyses of food services' and gift shops' efficiency, to rethinking membership or subscription targets, prices, programs offered, and even the goals of the organization (compare Raymond, Greyser, and Schwalbe 1975).

As a body of theory, practice, and technique, marketing has the capacity to speak to many of these issues. It has been utilized, in varying degrees, by different arts organizations. The record so far, however, presents an interesting standoff. A substantial number of market research studies of arts audiences have been conducted, and an increasing amount of information is available about the arts consumer. Our experience in Chicago, confirmed nationally by a review of *Audience Studies of the Performing Arts and Museums* by DiMaggio, Useem, and Brown (1977), also has shown that these studies most often are initiated by or requested of friends and nonemployees of the organization, who expect the information will be found valuable. The research is then conducted at little or no cost to the arts organization and delivered to the marketing or development person(s) in the organization. Its technical quality ranges from excellent to poor. Yet, usage or nonusage by arts administrators was found to have no relation to the quality of reliability of the research conducted. In addition, we know that even where arts administrators responsible for marketing and promotion do take such studies seriously, there is a strong likelihood that they will not be able to convince others in the same organization to take actions based on the information. Studies are often conducted but not paid for, not understood, and, more frequently, "filed" rather than acted on. To be sure, arts organizations are not unique in so behaving. Quite often, research results are not accorded serious attention until an organization grows desperate.

In our research we have been struck with the great diversity encompassed by the simple term *arts organizations*. Certainly, not all are alike, and it is important to distinguish among them in order to point out where marketing concepts will most likely be employed and implemented, where they are appropriate, and where they do not belong. A major concern among arts administrators we have interviewed is to balance "art" and "entertainment." While these attributes may not be mutually exclusive, a conflict between them exists for both producer and distributor arts organizations. A community theater director, for example, knows that a Neil Simon play will outdraw Sophocles, and art museum curators are well aware that "blockbuster" exhibits like King Tut and Pompeii bring people to see "shows" rather than less well-publicized offerings and permanent collections. Artistic groups prefer to lead rather than follow the tastes of their audiences. They express a reasonable concern that to follow literally the results of market surveys would simultaneously make them more "responsive" and lower their artistic quality or integrity.

This raises issues of organizational mission, goals, and strategies that cannot be resolved simply by better knowledge of marketing skills. Marketing, in this context, is most appropriate in the implementation of strategic decisions. For some organizations, this makes marketing inherently suspect, equating the attraction of more people with the lowering of their standards. The dispute over "how far to go" is never far from the surface and seems basic. It divides people in arts organizations as much as those outside them; and the positions taken often correspond with each person's job responsibilities. Such conflicts are hardly due to the arts confronting a newly applied discipline. The arts have been rather successful for many years. What is more critical is that a new and different market environment has rapidly developed.

MARKETING, CONSTITUENCIES, AND INTRAORGANIZATIONAL POLITICS

Marketing concepts become important and visible when an arts organization decides to shift more of its financial costs onto the consumer. One of the historical sources of revenue for the nonprofit arts organizations, private donors, has not kept pace with rising costs. As this occurs, the consumer market—traditionally tolerated—takes on increasing significance, exemplified by expanded membership drives and subscription campaigns. Federal, state, and local government, as well as private foundations, also have become a more significant factor in the funding of the arts. Since donors, consumers, and government all represent markets with interests of their own, the traditional association of marketing with consumers needs to be broadened also to encompass development and education.

Each of these constituencies usually is represented in the arts organization by a corresponding function—for example "development" for donors, and "membership" and "subscription" for consumers. The degree to which any of these offices will be upgraded with professional managers usually varies inversely with how well the arts organization is doing financially. In other words, the better the organization's financial state, the less pressure it will feel to change its ways. Marketing concepts and tactics are most likely to be called on not only to obtain more support from consumers but also to attract more donor and government support. Therefore, the greatest opportunity for marketing experts to demonstrate their abilities is in times of crisis when resistance to change by traditional power holders generally decreases (Wilensky 1967). In times of greater comfort, it is more difficult to persuade successful executives they ought to change their ways.

Where the situation is not a crisis, three useful perspectives predicting the integration of the marketing function into the arts organization are marketing philosophy, organizational theory, and economics.

The first perspective is normative. Traditional marketing philosophy

(compare Kotler 1972) suggests that, where information is available to organizations about consumers' wants, needs, and characteristics, the information will or should be acted upon. Consequently, the failure of arts organizations to take these data seriously raises several problems. The main question is whether arts administrators are acting rationally by ignoring the available information. The normative presumption is that they are not and indicates the need to learn more about their reasoning by studying the individuals involved or the organizational logic for action.

The second perspective, incorporated in terms like *technical cores* versus *boundary units*, is drawn from organization theory (Thompson 1967). The technical core or power centers of arts organizations are built around putting together and mounting successful productions or exhibits (in either commercial or artistic terms). Marketing and development are both viewed as boundary or staff functions separated from the more central activities of the technical core. Their main purpose is to narrow deficits and "buffer" the organization from the potentiality of adverse financial conditions. The easier it is to raise funds, the lower the power and prestige of marketing. This perspective not only suggests the powerlessness of these functions within the organization, but it also poses the research question of whether the top administrators in these organizations' "dominant coalitions" may not actually be raising the bulk of the funds donated. If so, they would have even less reason to take the formal marketing departments' activities seriously.

The third disciplinary perspective is that of the economist. Economic models assert that virtually all men act rationally; the key is to locate the utility functions of the administrators. This perspective in conjunction with organization and marketing theory is valuable for interpreting the place and position of the marketing function in arts organizations. It suggests that more needs to be learned about the broader markets in which arts organizations operate, relations with donors, and how arts administrators assign priorities to different organizational functions within the wide variety of tasks in which they are engaged.

CONCLUSION

We suggest the following preliminary propositions that discriminate among the conditions and circumstances in which arts organizations will be receptive to marketing concepts and techniques.

First, marketing expertise will be brought in initially at the tactical level to aid in implementing established organizational goals and strategies. For most arts organizations there is room for substantial improvement in areas such as subscriptions and memberships, development, promotion, and pricing. Changing goal-related policies will likely cause more conflict and suspicion on the part of powerful members of the dominant coalition. Second, marketing strategies and tactics, like any policy innovation, will

have a far greater chance for success when they are supported by top management and other influential members of the organization. Within the arts this includes the "creative" people—directors, actors, curators. Marketing departments need to market their ideas to other groups inside their organization. (An excellent model for this is the way "Sesame Street" was produced by the Children's Television Workshop [Lesser 1974].) Third, arts organizations are more likely to try radical policy innovations when they are desperate. Finally, after some organizationwide credibility has been established, then an arts organization will try new ideas concerning its basic mission and strategies.

REFERENCES

DiMaggio, Paul; Michael Useem; and Paula Brown. 1977. *Audience Studies of the Performing Arts and Museums.* Research Report no. 9. Washington, D.C.: National Endowment for the Arts.

Hirsch, Paul. 1978. "Production and Distribution Roles among Cultural Organizations: On the Division of Labor across Intellectual Disciplines." *Social Research,* Summer, pp. 315–30.

Kotler, Philip. 1972. *Marketing Management.* 2d ed. Englewood Cliffs, N.J.: Prentice-Hall.

Lesser, Gerald. 1974. *Television and Children.* New York: Random House.

Raymond, Thomas C.; Stephen A. Greyser; and Douglas Schwalbe. 1975. *Cases in Arts Administration.* Cambridge, Mass.: Arts Administration Research Institute.

Thompson, James D. 1967. *Organizations in Action.* New York: McGraw-Hill.

Useem, Michael, and Paul DiMaggio. 1978. "An Example of Evaluation Research as a Cottage Industry: The Technical Quality and Impact of Arts Audience Studies." *Sociological Methods and Research,* August, pp. 55–84.

Wilensky, Harold. 1967. *Organizational Intelligence.* New York: Basic Books.

6

MARKETING PRINCIPLES AND THE ARTS

P. David Searles

The importance of sound marketing to the arts world is manifest all around us. Daily, we see the number of problems facing the arts growing with alarming speed. The skillful use of proved marketing techniques is one way to reduce some of them to manageable proportions.

In this chapter, seven fundamental principles of marketing will be presented and tested for suitability in the arts. Parenthetically, the reader need not accept or agree with these seven principles nor with how they apply to the arts. There is room for discussion, debate, and modification in all of this—especially because there has been so little formal attention paid to marketing the arts.

Of the seven principles of marketing, it is concluded here that five are perfectly appropriate and of genuine value to the arts. The other two may not only be inappropriate but could be potentially dangerous. First, let us examine the five that do indeed apply equally to the commercial world and the arts world.

APPROPRIATE PRINCIPLES

There is no single factor more important to the success or failure of a consumer product than its basic, intrinsic quality. Quality is far more important than "price" or "promotion." The manufacturer who sacrifices quality for the sake of price does so successfully only in the short run. One of the first lessons is the futility of spending advertising and promotion dollars on behalf of a product that is inferior to its competitors. The product that has a quality advantage, even a small one, is destined to capture its competitor's business and rule the market—that is, until another product is introduced that is even better.

Without any question, this same principle applies in the arts world. The arts organization that produces a quality product is the organization that will prosper. There is no substitute for it. Cutting corners in a way that adversely affects the artistic quality of an organization is the sure road to failure. The arts administrator, just as the corporate executive, must be concerned first and foremost with quality. The expenditure of effort and money on behalf of an inferior arts product inevitably leads to the same fate as that that befalls a shoddy commercial product. You may be able to fool some of the people for a short time, but sooner or later—opening night, probably—poor quality will receive its just reward.

A second principle that has stood the test of time is the importance of concentrating on one thing, doing that one thing well, and telling people effectively what it is that you do so well. This principle is equally true in the arts world. In fact, it seems so obvious that one wonders why the arts administrator so frequently ignores it. There are numerous examples of arts institutions that are intent on providing something for everydody, such as summer festivals that have a "smorgasbord" approach to the performing arts with no theme or sense of unity in the summer's season.

There is an illustration of this principle from the dance world. Several years ago one of the country's oldest dance festivals had fallen on hard times. New management arrived who had the courage to decide what it wanted to do and set about doing it. The festival's version of the smorgasbord approach was abandoned, and in its place a commitment was made to new works, the experimental, and the avant-garde. The single-mindedness of the execution of this "marketing strategy" has created a reputation and following that enabled the group to move 600 miles away from its original home and still be successful.

In the commercial sector managers talk about the need to tend to one's "basic business." Any activity lying outside of this limited arena merits attention only after the basic business is secure and prosperous. The same is true in the arts. Decide what one does best, and then do it.

The third principle that pertains to the arts world is the importance of knowing your consumer—in the arts world one would say "audience." Many stories abound about so-called mass marketing techniques and the pluses and minuses for society that come with them. However, the concept of mass marketing hides the fact that the most successful products are those that are directed not at the masses of people but at a separate, distinct, and reachable segment of the population. No knowledgeable businessperson would accept the proposition that everyone is a potential customer for his product. He must know the distinctive characteristics of his consumers or who he thinks will be his consumers, if he is to be successful.

This principle holds equally for the arts community. Given the very broad range of arts activities in the United States, it is obvious that certain segments of the population will be drawn more to some art forms than to

others, while other segments may have no interest in any of the arts. The arts organization needs to know its community, what that community likes and dislikes, and which segments of the community are most likely to be interested in its artistic product.

The larger arts organizations have the resources today to use sophisticated market research techniques to measure and define their actual and potential audiences. Unfortunately, at the other end of the economic spectrum—and that is where most arts organizations reside—the arts administrator needs this information just as badly as do his wealthy colleagues but cannot afford it. Even the smallest organizations with minimal resources can do something, even if it is fairly unsophisticated, once it understands the value of this knowledge. Whether an organization has the resources to do research in a fully professional sense or only at a bare minimum, the principle remains the same. Whether artistic or commercial, an organization must know its audience if it is to be successful.

It is a cliché in the commercial world—but true—that one must spend money to make money. This is the fourth principle. Two characteristics often distinguish the successful commercial firm from the unsuccessful. The first is the availability of sufficient capital to do a thorough marketing job. The second is the willingness to risk that capital. There is no question that it takes courage to commit tens of millions of dollars to support a marketing effort before the first sale is made outside of a test market. The same is true in the arts world. But, unfortunately, the majority of arts organizations lack both the resources and the courage to carry out an aggressive marketing program.

As an example, those who live in Washington, D.C. have an opportunity to experience aggressive marketing by arts organizations. Those who live in certain neighborhoods shop at certain kinds of stores, attend certain kinds of arts events, subscribe to certain kinds of magazines, or are known to work for organizations such as the Arts Endowment are the targets of very professional marketing activity. The Kennedy Center, the Washington Performing Arts Society, the Arena Stage, and the Folger Theatre are just a few of the organizations that have the resources and the skills to reach potential audiences through the mails, by newspaper, over the radio, and occasionally by phone. Their materials are of the highest quality and are delivered with great precision and skill. Without this strong marketing effort, it may be that attendance would be reduced significantly.

The fifth principle is that marketing effort should be concentrated on people who have characteristics similar to those who already are supporting the activity or buying the product. One of the greatest temptations the novice marketer must resist is directing major marketing efforts toward people who are different from current consumers. To the novice, the potential for improvement is overwhelming. Just think, 100 percent of the people who will receive the message are not currently consumers. Think of

the efficiency. Unfortunately, these efforts will be largely wasted. The experienced marketer knows that the greatest success will come from those people who are already loyal supporters and those like them.

There is no question—arts organizations will be more successful in increasing patronage from three times a month to four or five times a month than they will be in getting somebody who has never attended a performance to attend once a month. Politicians have learned this lesson well. The greatest efforts in any well-managed political campaign will be directed at those elements of the constituency that are already providing the candidate a large base of support. It is now time for the arts world to learn this lesson, too.

If indeed marketing wisdom tells us to concentrate effort on those groups that are already sympathetic to us, then what of the responsibility to ensure that the arts touch the lives of more than just a few of the people?

The National Endowment for the Arts is particularly conscious of this responsibility because the current chairman has made this a fundamental tenet of his administration. It is not known whether there is a solution to this dilemma, but sound marketing strategies for primary audiences should not be confused with appropriate social marketing strategies.

These are the five key principles that apply equally to both the commercial and the arts world. To summarize:

1. The quality of the product is of utmost importance and is the essential first step in the marketing process.

2. The arts administrator and the consumer goods marketer must concentrate on one thing and do that one thing well.

3. The characteristics of the consumer are as important to the arts administrator as are the characteristics of the consumer to the manufacturer.

4. Marketing success requires the wholehearted commitment of funds and personnel.

5. The greatest success comes to those who target marketing efforts to segments of the population that are already sympathetic.

QUESTIONABLE PRINCIPLES

There are two other principles that seem inappropriate for the arts world. In fact, they could do far more harm than good if followed strictly by the arts world.

The first of these is the prevailing belief in the commercial world that consumer preference dictates product development and design. If the consumer prefers pink soap to blue soap, then the manufacturer sells pink soap. If people like whiskey that is light in color, then the manufacturer makes light-colored whiskey. Tens of millions of dollars are spent each year on research designed to determine consumer preferences for a wide variety

of products. No responsible marketer tries to sell something in the absence of evidence indicating that people prefer a product to available alternatives.

However, this author is convinced that the artist should design the core arts product, not the consumer or the audience. The artist speaks to all through his special insight into the human condition. The message comes whether or not we want it, whether or not we are receptive to it, and whether or not we even understand it. The individual arts consumer would undoubtedly select those artistic expressions that reflect his or her own taste, aspirations, and view of the world. If the audience were to decide, our arts world would become narrower and narrower and increasingly sterile. All of us need to be pulled, pushed, even thrown into new artistic experiences. This part of life—the content and makeup of the U.S. arts world—is simply too important to be entrusted to the nonartist.

The belief that the consumer is "king" may be correct for the commercial world. It is not appropriate and, indeed, would be harmful if applied to the arts world. The artist, not the consumer, should have the final and deciding vote on what the U.S. arts product is.

The second principle that is appropriate to the commercial world and not to the arts world is the feeling that the chief executive officer of a commercial firm should come up through the marketing ranks, not finance, production, research, or public relations. If the truth be known, most marketers consider themselves the elite in business. No one disagrees that the other business disciplines are important. It is simply that they are there to support the marketing function.

This principle would be most inappropriate if applied to an arts organization. The basic business of an arts organization is art, and it should be directed by an artist. Artistic considerations should always be paramount. Obviously, marketing should have a voice in decision making within an arts institution. But, as opposed to the commercial world where marketing considerations are of the utmost importance, in the arts world they are, and should be, supportive.

CONCLUSION

This then is the author's view of how the world of marketing fits into the world of the arts. If this chapter and the others in this book could result in nothing more than a broader understanding of the value of sound marketing to an arts group, it would be a great contribution. Not all of what is appropriate to the consumer goods marketer is appropriate to the arts administrator. But, the most basic marketing principles make eminent sense for the arts world. It is a challenge to combine the world of art and the world of marketing.

II

STRATEGIC ARTS MARKETING: PLANNING AND PRODUCT POLICIES

INTRODUCTION TO PART II

Strategic marketing involves systematic decisions and actions that attempt to position effectively an organization within its market context. Lack of explicit strategic thinking characterizes most arts organizations. This is a fundamental managerial weakness in the arts. It is manifest in reactive policy making and the erosion of many arts organizations' autonomy.

Strategic arts marketing focuses on matching an arts organizations' desires and competencies with those of a significant audience segment of the market. To make effective strategic choices, an arts organization must understand its basic character and capabilities as well as its market context, which includes consumers, competition, and other relevant constituencies.

Marketing planning is the focal policy process for developing strategic decisions. Good planning requires a careful blend of analysis and creativity. Product policies are at the core of the marketing plan. In the arts the product is a complex bundle of social, cultural, and aesthetic benefits experienced and shared by the artist and audience. Management of the arts product is indeed a delicate task. In this section the nature of strategic arts marketing will be discussed, emphasizing the role of marketing planning and product policy making.

Phillip Hyde and Christopher Lovelock observe in Chapter 7 that too much research and theorizing about the arts has focused on a "world view" of the field or on individual organizations. Their chapter, "Organizational Size and Its Implications for Marketing Strategy in the Arts," is based upon an intensive, exploratory study of Boston arts organizations. The authors propose that the size of an arts organization can be used to distinguish among strategic contexts. Large arts organizations face different market

problems and dynamics than smaller organizations. The authors skillfully describe the characteristics of the strategic market context for both small and large organizations, and they offer prescriptive strategies and marketing programs for each.

Whether an arts organization is large or small, market planning should be undertaken to formulate and communicate strategic programs. In Chapter 8, "Marketing Planning for the Arts Organization," Charles B. Weinberg provides a comprehensive discussion of the nature, scope, and utility of strategic market planning. A marketing plan is a systematic way of organizing analysis and programming, according to the author. He outlines a step-by-step format for planning. It begins with a situational analysis and culminates with a monitoring system. Each step is elaborated. The entire presentation is anchored in the author's relatively extensive research with the American Conservatory Theater.

Product policies are fundamental to marketing planning. In the arts product policies have been traditionally the province of the artist and artistic director. Thus, discussions of marketing approaches to arts product management are often received suspiciously and cautiously. This need not be the case as the next two chapters demonstrate.

In Chapter 9, "Product Management and the Performing Arts," Gene R. Laczniak carefully describes the performing arts as a very special type of product representing an aesthetic entertainment experience. The arts product representing an aesthetic entertainment experience. The arts product can be characterized by its intangible and ephemeral attributes and its cultural significance. The author explores the traditional concepts of product management as they relate to arts policy. A basic theme of this chapter is that an arts product has many dimensions. The formal product is primarily artist controlled, but the augmented (peripheral) dimensions of the product affect both artist and consumer behaviors and satisfaction.

This theme is developed more extensively by Eric Langeard and Pierre Eiglier in Chapter 10. They characterize arts organizations as services and focus their analysis on the "Interactive Behaviors of Arts Consumers and Arts Organizations." Interactive behaviors produce shared experiences between the artist and consumer, between the arts organization and consumer, and among consumers. Management of these multiple experiences requires the integration of operations and marketing decisions. According to the authors, the marketing process can be decomposed into two distinct functions: mass marketing and interactive marketing. An appropriate mix of the two functions is advocated. A fundamental goal of the mix is to develop arts consumers' participation into organizational "membership." This presentation is a provocative discussion highlighting the complexity of product/market interaction in the arts and the need for innovative theories and perspectives to manage arts products effectively.

7

ORGANIZATIONAL SIZE AND ITS IMPLICATIONS FOR MARKETING STRATEGY IN THE ARTS

Phillip Hyde and
Christopher Lovelock

Grace is given of God, but knowledge is bought in the market.
Arthur Hugh Clough

FRAGMENTATION AND DIVERSITY IN THE ARTS

One of the problems that arts researchers face is coming to grips with the tremendous product diversity of the arts market. Everything from a performance by a community theater to a display of eighteenth century artifacts in a restored house is in competition for the arts consumer's time and money. We believe that too much arts market research has focused on the problems of individual arts organizations or on a "world view" of the field itself. In particular, we are concerned lest researchers be overwhelmed by this diversity and so fail to see specific patterns and trends that are common to important subgroups within the whole.

Experience in the marketing of services has shown that different service industries have historically tended to think of themselves not only as very different from physical goods (such as grocery products and automobiles) but also as uniquely different from other service industries. Thus, airlines felt

The authors gratefully acknowledge the research assistance provided by the Massachusetts Council on the Arts and Humanities, Anne Hawley, Richard Fitzgerald, and Peter Jablow, who was formerly with the Metropolitan Cultural Alliance in Boston.

they had nothing in common with banks, which in turn felt they had nothing in common with hotels, which likewise saw themselves as facing totally different problems from fast food outlets, banks, and airlines.

In practice, at one level almost all organizations share certain marketing problems in common and can learn from one another. At a more specific level, all service organizations—including the arts—share some characteristics that have significant marketing implications. These include a perishable product that cannot be stockpiled, an emphasis on experiential factors rather than tangible attributes, production and consumption that take place simultaneously, conflicts between operating efficiency and consumer satisfaction, a high labor and personal service component, and a continuing need to "smooth" demand levels to fit available capacity at any given time.

HOW SHOULD ARTS ORGANIZATIONS BE CATEGORIZED?

In our experience most arts organizations like to think of themselves as, if not unique, at least distinctively different. If any aggregation is done, it is usually on the basis of artistic form—ballet, opera, art museums, symphonies, theater, et cetera.

As a result of the discipline-oriented bias of much arts thinking, there is a risk that the manager of a small symphony will look for advice from another, larger symphony orchestra in another city when its real problems may be more like those of the neighboring small theater company. It is our belief that an organization's marketing problems and prospects are influenced more by common institutional characteristics than common product considerations. (We should stress at the outset that we are concerned here primarily with arts-producing organizations, as opposed to presenters and educational centers in the arts.)

Accordingly, we propose a more functional approach to looking at arts institutions, involving a search for explanatory variables other than art form that might have an impact on the organization's marketing strategy.

AN EXPLORATORY STUDY

In an effort to understand what organization variables might transcend artistic form, we undertook an objective evaluation of 49 Boston area arts organizations (Appendix A to Chapter 7). The organizations in our sample were all members of the Metropolitan Cultural Alliance, a trade association of just about every arts organization in Boston, plus some educational/recreational organizations such as the New England Aquarium. The sample is slightly weighted toward the performing arts, since that reflects the Boston situation. However, the diversity of offerings is tremendous—everything from the Cambridge Society for Early Music to the Museum of Fine Arts and from the Pocket Mime Theatre to the Museum of Transportation. We

looked at four broad variables: institutional characteristics, funding situation, product offering, and target market. Within each category, we developed from five to ten specific characteristics, which were incorporated into a series of three-point scales (Appendix B to Chapter 7).

Next, each of the 49 arts organizations in our sample was rated by someone familiar with that organization and with the Boston arts scene in general. A second informed judge then checked each of these ratings. Relatively few differences of opinion were encountered and consensus was soon reached where these did occur (in a few instances, a third opinion was sought). The results were then analyzed to see what institutional patterns might emerge. The object of the exercise was to identify the extent to which "different" arts organizations shared the same characteristics and then explore the marketing implications of any relationships of interest.

Several caveats need to be raised concerning this methodology. First, many of the characteristics rated are somewhat judgmental; second, a three-point scale provides a rather coarse measure; and third, there is a risk of "halo effects"—that is, a rating on one attribute may bias a subsequent rating on another attribute for the same organization. While the use of a second (and occasionally a third) judge on each rating provided a certain degree of control, it would be unrealistic to claim a high degree of precision for the results, and we advise readers to interpret them cautiously.

The Boston Arts Environment

Our study is, of course, limited to Boston, which is in some ways unique. So, it is a logical question to wonder whether what we found here would hold true for other areas of the country. Boston, along with some other cities, has a long tradition of artistic life—traditionally supported by private and corporate philanthropy—and there is a similar tradition in small arts organizations.

Although Boston may be able to support more arts organizations than other cities of comparable size, we tend to believe that the organizational types represented in this research do exist in other places (although not necessarily in the same proportions). The marketing implications we draw may need to be modified to correspond to local conditions in other cities, but we believe that the organizational variables used in this study are representative and may be generalized.

The key variable in which we were interested was the size of the organization, as measured by its annual operating budget. What constitutes a "large" arts organization? Frankly, it's hard to know exactly where to draw the line. Of the 49 organizations we studied, eight had budgets in excess of $1 million and would probably be classified by most people as major organizations.

After some thought we decided to abandon the three-way grouping

adopted for budget size on the rating scale in Appendix B to Chapter 7 and split our sample approximately down the middle. As a result we ended up with 26 arts organizations with budgets of $200,000 and over and 23 with budgets below this figure. For simplicity, we will refer to these as "larger" and "smaller" organizations, respectively.

After the ratings had been completed, cross-tabulations were run to determine the relative degree of association between organization size and each of the other 29 characteristics. Two measures of association were used: tau, which measures strength of association, and chi-square, which measures statistical significance. The results of the analysis are shown in Table 7.1.

Findings

An analysis of Table 7.1 shows that, relative to smaller organizations, larger arts organizations *tend* in general to:

Have an institutionalized organization ethos rather than one tied to a single individual,
Be highly visible in the community,
Have a high fixed cost structure,
Be fairly highly unionized,
Obtain the bulk of the dollar value of total giving from a relatively small number of donors,
Receive gifts from both within and outside greater Boston and the Northeast,
Obtain a majority of their income from gifts, grants, and nonaudience sources,
Maintain a reasonable continuity of funding sources from year to year,
Have significant labor costs that account for a high proportion of total expenses,
Provide more frequent opportunities for patrons to enjoy their offerings,
Offer a wide range of different offerings,
Actively reach out to both local and national audiences (through broadcasting, records/reproductions, and/or tours), and
Be patronized by people who return several times a year.

Smaller organizations, by contrast, tend to be mirror images of the larger ones on each of these characteristics. We do want to warn, however, that these are simply generalizations that tended to hold true for the 26 larger organizations when compared with the 23 smaller ones in our sample. It would be simple enough to find an exception to the rule on any given characteristic, but that exception would probably not alter the value of each generalization.

TABLE 7.1

Relationship between Organizational Size and Other Variables

	Tau Value
Institutional characteristics	
Organizational ethos	.60[a]
Prestige in artistic circles	-.30
Visible in community	-.67[a]
Cost structure	-.71
Location	.09
Age of organization	-.39
Current financial situation	.33
Primary objective	-.29
Extent of unionization	.30[b]
Funding situation	
Donor concentration (dollar-size)	-.56[a]
Donor location	.45[c]
Income source	.36[b]
Funding sources	.23
Continuity of funding	-.40[b]
Product offering	
Labor intensity	-.58[a]
Scheduling	.36[b]
Distribution location	-.24
Product line	.53[c]
Level of repetition	-.22
Product source	.01
Ethos	-.15
Accessibility (time and location)	-.23
Programming focus	.08[b]
Target Market	
Specification	.59[a]
Audience size	.77[a]
Audience fees	.19
Repeat purchase	.43[b]
Admission restrictions	.01
Prior expertise	-.04

[a] Denotes significance at p < .001 level.
[b] Denotes significance at p < .05 level.
[c] Denotes significance at p < .01 level.

Notes: Strength of association: A tau value of less than .30 denotes a relatively weak relationship. Direction of association: Use of a minus sign denotes an inverse relationship between the independent and dependent variables as defined by the scales in Appendix B to Chapter 7 (for example, a "1" rating on one variable tends to be correlated with a "3" rating on another—see this appendix for clarification in any given instance).

MARKETING IMPLICATIONS FOR LARGER ORGANIZATIONS

In total, we identified five clusters of characteristics that are common to large arts organizations. Let us look at their implications for development of marketing strategy.

First, the management structure of larger arts organizations is much more institutionalized, and the organizations themselves are much less personally run than are the smaller organizations. A change in a director or board chairman is likely to have less effect on the organization's long-term direction or fund-raising ability than a comparable change in the smaller organization. The large organization is capable of making long-term commitments and plans and of engaging in well-planned development efforts. Its board of trustees operates in the traditional manner—setting policy, raising funds, and hiring executive staff.

Second, larger organizations are not necessarily in a stronger financial situation than smaller ones. But, they are more likely to obtain a majority of their income from grants, gifts, and nonaudience sources. They also seem to be assured of some continuity of funding, although often a high proportion of the dollar total comes from a relatively small number of donor sources. They are more visible in the community, more established, and, in most cases, have built up a habit of attendance among many patrons.

Third, larger institutions, as might be expected, have a large audience that is more likely to make repeat purchases. They often reach out to a much broader public than do smaller organizations and make an attempt to capture the casual viewer and tourist. Their offerings are scheduled more often, which makes for flexibility in attendance by patrons. This larger and broader market is less prone to sudden shifts in taste, fashion, or the economic situation.

Fourth, there is a strong tendency toward unionization in big arts organizations (to a lesser extent, they are also more likely to own and maintain their facilities). These factors contribute to a high ratio of fixed-to-variable costs. The large organizations all have large professional staffs that have long-term commitments. The small organizations tend to operate with volunteers or, at best, with token wages. This absence of paid employees can lead to higher turnover, resulting in sudden shifts in both quality and artistic focus.

And, fifth, because they have heavy fixed costs to meet (including the payroll for many full-time employees), larger organizations make maximum use of their resources in an effort to recover as much as possible of these costs. One strategy is to develop a broad product line that appeals to a much broader public than is true for most smaller arts organizations. The Boston Symphony probably provides a good example. During a typical year the symphony operates a summer musical program at Tanglewood with outdoor concerts and an advanced music school. During the winter it operates its

usual subscription series. In the spring there is a Pops season with members of the symphony and specially contracted players; meantime the Boston Symphony Orchestra's first chair players combine to form the Boston Symphony Chamber Players. For the symphony each activity is seen in different terms with a different marketing focus for each. Another example is the Museum of Fine Arts, which is now constructing a separate building for "blockbuster" shows (such as *Pompeii AD79* and *Treasures of Tutankhamen*) that will enable the museum to house these shows completely separate from the rest of the museum's offerings.

The size of the audience sought by some of the larger arts organizations is such that they have to position themselves in a much broader context than the smaller organizations. Either they must draw from a very wide geographic base or go after a share of the total leisure market, which includes seeing a movie, going to a baseball game, et cetera. The competition facing large organizations is thus often far more diverse than for smaller ones.

MARKETING IMPLICATIONS FOR SMALLER ORGANIZATIONS

The results of our study yielded a variety of insights concerning smaller arts organizations. First, the management ethos in smaller organizations tends to be much more personal. They are often organized around a charismatic artistic figure (or circle), whose personalized management style results in a more passive board of trustees (if the organization even has one). The principal artistic figure sets the policy, style, and tone of the organization. This individual may or may not have a strong marketing orientation. There are some exceptions to this generalization, but they are relatively rare. There are also, of course, a few larger organizations centered around a guiding genius—such as the Joffrey Ballet or Sarah Caldwell's Opera Company of Boston—but they are relatively uncommon.

Second, the financial base of many of these smaller organizations is, predictably, shaky. They tend to be newer and less well established. This illustrates something common to many arts organizations—the ease of entry into the market. It does not take a great deal of capital to start a small performing arts organization. A number of volunteers can get together, rent a space, and put on a performance—all at very little cost. To a large extent many small organizations are outside the market economy. This means that they are run by what are effectively "volunteers." These organizations are unable to pay a living wage to the majority of their employees, who get by either by taking a very low salary or doing some part-time work in a related or unrelated field. Because these organizations are not committed to paying salaries, their wage costs are, of course, quite low.

Third, there is a great deal of what might be called "cloning" in the arts market. In looking at the individual results of our evaluations, we were

struck by the similarity of the ratings for a number of small musical organizations. They may have diverse perceived stylistic differences—some do early instrumental music, others do early choral music. But, when looked at objectively and collectively, these organizations are very similar in structure and operation. The question is, Does the average consumer perceive any stylistic differentiation? Is there a discernible artistic vision or purpose? If not, it becomes that much harder to carve out a distinctive market niche and develop both a reputation and a broad following.

Fourth, many smaller organizations exist specifically for the creation of new or innovative products. They are what Hirsch (1978) calls "creator organizations." By contrast, larger arts institutions are more concerned with distributing a performance or production, building new audiences, et cetera. The smaller organization's primary commitment is generally to its artistic product, not to the audience. But overlooking the audience may lead to no audience at all.

Fifth, the marketing focus for smaller organizations is toward critics or other influential, artistic people. Their primary means of communication is through word of mouth or reviews in the daily press (or, more likely in Boston, the alternative weeklies). In all cases word of mouth is critical. An interesting study would be to work out the diffusion patterns operating among the audience for a small performing arts organization. Critics in some communities, as in Boston, are usually positive influences. In other communities they can be very hostile. An organization's relationship to a critic is usually complex and often has a love-hate quality. Few small organizations are able to dissipate the effects of several bad reviews. But, as one museum director expressed to us, a rave review is not necessarily a guarantee of a large audience. Yet, good critical reception is very helpful and perhaps necessary to obtain funding from local foundations and arts councils.

Sixth, smaller organizations tend to draw their audiences from a relatively narrow segment. Studies in Boston have shown that the audience for experimental and innovative programming is fairly homogeneous: the same types of people go to experimental dance, music, and theater. For promotional purposes this segment is reached fairly easily through the newspapers, which is probably one of the reasons why more aggressive or alternative marketing strategies are not undertaken. The net effect of maintaining the basic strategy, however, is likely to be failure to build a larger audience.

And, finally, the product line of the small organization is fairly narrow, and only a few organizations make an attempt to broaden their range of offerings. They create a "style" and stick to it. This commitment to a style is probably what brought its initiators together in the first place. But the resistance to new works by the broader arts audience is hard to underestimate, and any arts organization seeking to appeal to that audience has to take this into account in its programming. Smaller arts organizations that

produce revivals or retrospectives or program music by well-known composers tend to do better financially because their appeal is broader.

The key marketing implication to be drawn from this evaluation is that the smaller organization may have to expand its audience from those already predisposed to attend if it wishes to survive and flourish. In short, its efforts should be to stimulate primary demand. The addition of more arts activity has not been shown to hurt—the market is not saturated. Yet, traditionally, small arts organizations have not positioned themselves in the larger leisure market but in the smaller market that exists for the repeat consumer of experimental activity.

Because of their small size and the difficulty of achieving real financial growth, it is very difficult for small arts organizations to maintain themselves. After a certain period of time, the founders of such organizations tend to want some kind of personal security. At this point they may decide to pay themselves a "reasonable" salary, and that becomes a commitment. Or the founder may decide to leave and work for a larger, established organization (or, perhaps, leave the field altogether). When the founder leaves, the small organization is faced with the problem faced by many small businesses: that of becoming institutionalized.

In the arts, unlike business, there is no pattern of merger or consolidation. When an arts organization fails, it simply goes under (sometimes reemerging later in similar form). This points out again the ease of entry into the market and the fact that arts organizations see themselves as unique and very special.

In Boston the last decade has seen a tremendous growth in the number and variety of small arts groups. Whether the arts sector is actually growing in terms of audience is hard to know. However, when a small organization is artistically successful, there can be irresistible pressures to expand, both from the funding sources and the artistically involved; but there are tremendous risks involved in expansion. In the process it is not difficult to lose much of the original vitality that is so necessary for an arts organization's continued success. Parenthetically, it is very rare for an arts organization to start small and grow to major status over time. Most of today's large organizations that were started during the past 30 years actually began life as large organizations.

THE ROLE OF MARKETING FOR LARGER ARTS ORGANIZATIONS

Because of these different organizational characteristics, the marketing strategies that are appropriate for larger and smaller organizations also tend to be different. In the balance of this chapter, we will look separately at the role of marketing first, in larger arts organizations and, then, in smaller ones. We will focus primarily on the performing arts.

For the "majors" in the performing arts, the most significant development of the 1970s has been the increase in output. The major orchestras now have annual labor contracts and almost yearlong seasons. Ballet and theater organizations, too, have steadily lengthened their seasons and salaries. This vast expansion in output, in part due to labor demands for longer seasons and higher salaries, has meant higher deficits and an acute need for more income (Schwarz and Greenfield 1977). The first response of these organizations has been to look for more income from nonaudience sources.

Development offices have been opened and traditional appeals broadened to include more of the audience—not just the traditional donors. Urgent appeals have been made to government for support at all levels—local, state, and federal. Fund-raising appeals to individual, corporate, and foundation donors have also been stepped up. To a large extent these efforts have been successful. For instance, in the period 1972–75 the art's share of private charitable giving grew from around 4 percent to about 7 percent (American Association of Fund-Raising Counsel 1972–75). These figures and the actual numbers are not very reliable, but the trend is clear. The rapid growth of public money at the state and federal level is also well documented.

At the same time that both costs and output were increasing for performing arts organizations, costs were also rising for all organizations. For museums already operating on an annual basis, these increased costs—as well as the rise in art prices—caused a similar need for more income. Development offices were strengthened and admission fees charged in many museums for the first time.

There are, however, obvious limitations to the market for donations and grants. These limitations have become increasingly obvious in the 1970s. The prospect for additional dramatic increases—like the Ford Foundation's orchestra program and the National Endowment Challenge Grant program—appears somewhat dim. Major foundations are moving away from support of the arts. Although, to a certain extent, they are being replaced by local foundations, there has still been a significant lowering of the amount of money available for the arts. Compounding this problem is the fact that there are fewer individuals of great wealth willing to take on the role of patrons responsible for absorbing any operating deficits.

The next area of growth, then, is obviously income from user sources. This has recently become the primary focus of marketing efforts among the major institutions, paralleling the effort to market the increased output.

A Changing Product Offering

In product terms larger organizations have the visibility and resources to bring their products to a comparatively broad public. In general their product line has been broadened. We have already seen how the Boston

Symphony Orchestra has done this. Other organizations are sponsoring classes, offering educational activities, et cetera. Performing arts companies are now breaking down their ensembles into units, so that the company can give two performances at the same time. The orchestras have been particularly adept at this. We are seeing performances in new sites such as schools and parks. This has given rise to a whole new class of sponsoring organizations, including schools and park districts. Some organizations are renting out their facilities in an effort to squeeze out more income.

The successful dinner theater movement, with its emphasis on dinner plus a play, foreshadows another trend. That is, instead of marketing just the event itself, the institution can market a whole evening, including dinner, parking, et cetera. This is consistent with the idea of demonstrating that going to the arts is not just a single-minded event of listening to music or watching a play but rather a whole experience. It could also help some small theater groups to break out of their "poverty" cycle, but only if they are willing to tailor their offerings to meet the preferences of dinner theater patrons.

Ancillary income, particularly in museums, has become increasingly important. By ancillary income, we mean museum stores, licensing arrangements for designs in the collection, et cetera. The foremost exponent of this approach has been the Metropolitan Museum, which had $13.4 million in revenues from ancillary activities in 1977 and generated a profit of about $1.4 million. Restaurants, bars, and other visitor services—some of which have hitherto been poorly operated, money-losing ventures—are now being reorganized on a profit-making basis, in many cases. For instance, *Smithsonian* magazine has become an important money-maker for the Smithsonian Institution. As a result other organizations are now looking toward an expanded line of books and arts-related publishing, recordings, slides, gifts, art reproductions, and souvenirs.

Even among smaller institutions, there is no reason why ancillary activities should not generate a positive cash flow. Many museums have historically looked upon activities such as restaurants and museum stores as a "service" to patrons; not surprisingly, these operations have often shown a net loss.

Museums—and, to a certain extent, performing arts organizations—have taken other steps to broaden their product line and audience. "Blockbuster" exhibits like *Treasures of Tutankhamen*, the Chinese archeological relics show, and *Pompeii AD79* are familiar examples. These shows are often organized by foreign governments for exhibition in the United States. They are marketed as much as media events as art exhibits. Their impact has been tremendous. The "King Tut" exhibit was sold out by advance ticket in New York City, while in Washington people stood in line for eight hours. The impact was dramatic on most sponsoring museums: a whole new audience was gained. Products with the King Tut motif created a miniindustry. But the long-term effect of this is unknown. Although visitor attendance

and media coverage have been dramatic, it is open to question whether these new audience members will become regular visitors or contributors. Once the novelty wears off, can the museums maintain the impact these shows have made?

Delivering the Product of Large Arts Organizations

The major institutions tend to be located in downtown areas in fixed facilities. In the older cities the traditional audience of these institutions has moved out of town, and going to the arts is now a major event; it involves not only a ticket purchase but travel and parking, plus often a meal at a restaurant and a babysitter. There have been a few major institutions located in the suburbs, but in general they have not been successful.

Customer convenience has not always been foremost in management's mind. Until recently, museums were not open in the evening, and theater ticket purchases had to be made at the theater. To some degree this has now changed. Museums, often with public support, now usually remain open one or two evenings a week and on weekends. It is during these times that the majority of nonschool visitors attend. In the performing arts it is now possible to purchase tickets for most commercial events by telephone. These purchases are charged to credit cards with confirmed payment to the theater. Presently about 25 percent of Broadway theater ticket sales are transacted by this method (Hummler 1978).

But this practice does not seem to have caught on strongly outside the realm of commercial theater. Tickets for most other events continue to be sold at the main box office, although they can sometimes be purchased (with payment of a supplementary fee) through theater ticket agencies.

As far as taking the product to the people is concerned, touring the performing arts is very expensive and time-consuming. For most organizations it generally requires a heavy subsidy. It is for these reasons that activity will probably now grow. Museums, secure in one location, will have to make continuous efforts to attract people, although modest outreach efforts to schools may be made by "Museummobiles" containing selected exhibits on a specific theme and accompanied by a lecturer, audiovisual materials, and supporting text and display matter. A large part of museum audiences consists of school children who can be bused into town for the occasion. Meantime, the recent back-to-the-city movement could help urban cultural organizations.

Communications and Promotional Efforts

The major institutions, with their need to raise more earned income and market new output, have often looked to "promotion" as their salvation. To many arts managers (as with most other lay people) promotion *is* marketing.

There was virtually no marketing communication effort 10 to 15 years ago, other than just announcing schedules. But we now see the Boston Symphony engaging a highly respected advertising agency that has built a campaign around the symphony's conductor, Seiji Ozawa. Mass media advertising is expensive and can only be afforded by larger, financially stable arts organizations. Unless carefully targeted, it may be wasted, reaching large numbers of people with minimal interest in the arts. Most promotion (as distinct from informational effort) takes the form of public relations, which seeks to get features and news stories on radio and television and in the printed media. But this is not "free." Success in public relations requires professional expertise in the subject and in the public relations (PR) discipline. Only larger organizations can afford a full-time publicity/PR director.

Pricing Strategy

Price is a key element in the marketing mix for larger institutions. Performing arts organizations, in our opinion, often tend to underprice their offerings relative to competing attractions. Competing events that come to mind are sports events, movies, and popular concerts. The last mentioned are consistently priced higher than cultural events, especially for the less expensive seats. Yet, the evidence is overwhelming that the average arts consumer has a higher income than the population at large.

Arts organizations' pricing strategies are often kept artificially low because of a desire not to "keep out" the poorer audience member. We believe that the financial burden of subsidizing these potential lower-income attenders should be handled by subsidizing them directly through specific programs aimed at these target audiences or by restricted discounting strategies—but not by a blanket subsidy to keep all prices low. The public (and the arts-going public, in particular) has to be made aware of the cost of staging a performance or exhibit. The myth is that the arts break even or make a profit. (*Americans and the Arts* 1975). It is our belief that people can be educated to pay more once these costs are better understood.

Some larger organizations have recently raised prices significantly. For instance, the Metropolitan Opera went from $22 for its top price seats in 1974 to a $35 top in 1978. Similarly, the New York City Ballet now has a $17 top price versus a $10 top in 1974. In general, these increases have met only limited resistance. Predictably, that resistance has come from the lower end of the price scale, where increases have been more modest. But outside of New York City, most performing arts organizations have been reluctant to raise prices significantly.

In short, we contend that for the major institutions offering a well-recognized, quality product, it is possible to raise more earned revenue through an aggressive pricing strategy. But, the need and rationale for this strategy must be well explained to the public.

Positioning Arts Organizations

There has been little discussion devoted to how the major institutions fare against the panoply of other events competing for our leisure time. Here the difference between the larger and smaller institutions is most clear. Larger organizations have to attract an expanding share of the leisure dollar. The question, What is the competition? has not really been answered. Is the ballet company in competition with the symphony? We do not know. Or, is the real competition for arts attractions provided by professional sports teams, movies, television, and restaurants? If so, in what way? This question is wide open, and little research has been done on it. Because the arts market is so small, it does not seem unreasonable to hypothesize that the competition comes less from among similar organizations than from the leisure field in general. There is practically no research to support or reject this hypothesis.

In sum, the aim of all marketing programs for the "majors" is a traditional one: bring in more income and bring more people to the attractions. These organizations, as we have shown, are not ephemeral. They have significant long-term commitments—in some cases, to buildings and, in all cases, to their staffs. To meet these commitments and improve their financial situations, they are going to have to adopt the orientation, analytical tools, and strategies of marketing.

Weinberg (1977) suggests a systematic approach to the problem of formulating a marketing plan for performing arts organizations of all sizes, beginning with a situation analysis (where are we now?) and moving through goals definition (where do we want to go?) and evaluation of alternative marketing strategies (how are we going to get there?) to formulation of a specific marketing action plan.

THE ROLE OF MARKETING FOR SMALLER ARTS ORGANIZATIONS

For the smaller arts organization the aim of marketing is to achieve more stability, ensuring these groups the "right to fail." If an organization is strapped financially, then it cannot afford to fail. In the long run it probably cannot be successful artistically either. Larger organizations, by contrast, have achieved a level of stability, so their marketing problem is different.

In smaller organizations, money is nearly always tight. The prospect of a living wage for the participants is probably unrealistic, given present economic realities. This is an endemic problem for all of these organizations. People can only afford psychic income for so long. In contrast with the majors, there has not been a dramatic rise in output from smaller organizations. However, because of increased public funding, there has been a tremendous growth in the number of small organizations, giving rise to the

"cloning" effect mentioned earlier. The product of these small organizations is very specialized and appeals to a very definite market segment. To a certain extent it is presold. Yet, these organizations need to concern themselves more with the audience attending an arts event. Going to a performance is not a single item purchase: it is a night out, which often implies a restaurant and parking. Cooperative arrangements can be used much more aggressively by smaller organizations. In many of these organizations, however, we perceive an almost ideological bias against caring about the audience.

The Marketing Mix for Smaller Organizations

As with larger arts organizations small ones promote very little, using mostly print advertising. There is also surprisingly little experimentation in communications efforts; given the creativity so often evident in their productions, one might have anticipated more creativity in trying to reach and stimulate prospective audiences. Tod (1978) suggests some approaches. Of course, the small budget size of these organizations limits any large-scale promotional effort. But it is important to realize that these organizations do not need thousands of new bodies—even drawing a couple of hundred more patrons over a three-week run can make a major difference financially. The marketing problem of bringing in an additional 200 people calls for simple, cheap, creative ideas—not a major marketing program.

The central problem for the small company lies not in expanding the audience for a particular theater or arts organization but in expanding the total market for experimental theater, dance, music, et cetera. These organizations must learn to expand their market reach. They presently market mostly to critics and other artistically influential people by relying largely on word of mouth. Ways have to be found to reach further.

Unlike larger arts organizations, smaller ones have more flexibility in locating themselves. The question is, Should these arts organizations be spread around the city, or should most of the activity be concentrated in one location? One of the apparent strengths of the commercial theater is that its offerings are generally presented in a central "theater district." This tends to attract complementary services, such as restaurants. Additionally, a person going to one event may become aware of other shows in nearby theaters and be stimulated to patronize these at a later date. The success of the off-Broadway movement in New York City bears this out. If there is a choice—and there is not always—perhaps an argument can be made for having these small arts activities concentrated in one area, or at least clustered in two or three "nodes" of activity.

The purchase of tickets can also be made easier. As noted earlier, commercial theater has been able to implement a telephone system for charging tickets to credit cards, but for a number of reasons small arts

organizations have been unable or unwilling to do this. Many of them do not even have the resources to maintain extended box office hours, but this may be an argument for selling tickets on commission through conveniently located retail outlets, such as bookstores and music stores.

Most small organizations have no price policy and, in many instances, may be underpricing themselves. They tend to follow each other and, to a certain degree, the policies of the movie theaters. There is no evidence that a person who goes to these small organizations is less well off than those who go to the major institutions. The best entertainment buy that we know of is probably provided by small arts organizations. It sometimes appears that these organizations are very reluctant to charge higher admission fees. Sometimes this reflects the fact that they perceive themselves as appealing to students and other people on fixed incomes. Audience research may help determine whether this reluctance is based upon a sound appraisal of people's ability and willingness to pay more. A policy of selective discounting may be one way to handle the problem of ability to pay.

Since it is our belief that market reach has to expand, joint subscription schemes or sampler series may be very effective. Ryans's and Weinberg's (1978) research suggests strongly that subscriptions should not automatically be discounted in every situation.

Strategies for Smaller Organizations

Our conclusions regarding smaller arts organizations are several. First, their administrators should begin to think in marketing terms. They have to be concerned about why people come, who they are, what they experience when they get there, whether they return again, and if not, why not, et cetera. But, the managers of smaller organizations (and also some larger ones) tend to be much more concerned with product. As Raymond and Greyser (1978) note, "Most people in the arts are oriented more to the art itself than to the audience for it" (p. 130). Perhaps an example from the profit world will explain this dilemma. Arts administrators seem to reflect the orientation often found in engineers and operations people. They are highly concerned with the quality of the product and strive to explain the distinctive and unique properties of the product, often much more than the consumer finds necessary. Consumer needs receive secondary attention, by contrast. This holds true for many small museums and galleries as well as for the performing arts.

Second, the potential for a successful season of experimental and unique work is limited. The conservatism of the audience is hard to underestimate. People seem to want to go to something they already know or with which they have had experience. In the performing arts revivals usually do best. Unfortunately, good reviews are not sufficient to bring out

an audience. It takes a long time to build institutional loyalty in the nonprofit world, as it does in the profit world. Because of the economic conditions, it may be difficult for smaller organizations to remain in operation long enough to build this institutional loyalty.

Third, and perhaps most important, cooperative efforts should be expanded. There are real economies in cooperative effort, such as joint promotion, sharing of mailing lists, and cooperative use of the same offices and performance location or display space. All of these can be very effective. The limited budgets of arts organizations seem to demand it.

These are not new ideas. The Metropolitan Cultural Alliance in Boston was set up to do this. However, the institutional barriers to increased cooperation are several. Arts administrators, particularly those heading up small organizations, tend to be—if not artists themselves—at least very sensitive to artistic concerns. There is a high commitment to the artistic product and the integrity of the organization, as well as a strong sense of turf. Cooperative arrangements are often seen as a waste of time, while giving a helping hand to "inferior" organizations may be viewed as a squandering of precious resources. These are hard barriers to overcome, because there is no quick payoff. It takes time to find the right mix and build institutional loyalty.

Financial considerations are also a barrier, since the budgets of these organizations are so small and getting into the market is easy. Nevertheless, more cooperative efforts seem to us to offer the best hope of providing some stability and guaranteeing the right to fail.

FUTURE CONSIDERATIONS

It is important to realize that when we speak of an "arts public," we are only speaking of a small segment of the population. The audience for small arts organizations is an even more limited subset of this population. We know from research that the demographic profile of the arts audience in the United States is essentially stable over time. (DiMaggio, Useem, and Brown 1977.) Pricing discounts and a wide spread between the top and bottom admission prices have not changed the fundamental character of this audience, which possesses proportionally very high income, high education, and high social class. Indeed, education seems to be the best predictor of arts consumption.

In attempting to develop marketing programs for the arts, we believe that it is important for different arts organizations to be viewed in context. In this chapter, we have illustrated two different types of arts organizations, whose size differences mean that they are facing somewhat different marketing problems. We have tried to show that the solutions that they adopt may need to be somewhat different, too. Of course, there are other organizational

types in the arts, such as schools and presenting organizations, which are not a part of our sample; we suspect that they may face a somewhat different set of problems. This chapter is really only a start on what needs to be done to develop a better classification of all arts organizations and link this to development of appropriate marketing strategies.

APPENDIX A TO CHAPTER 7

List of Organizations Rated*

	Estimated Budget Fiscal Year 1979 thousands of dollars
Berklee College of Music Performance Series	75
Boston Athenaeum	150
Boston Ballet	2,246
Boston Musica Viva	40
Boston Repertory Theatre	453
Boston Shakespeare Company	206
Boston Symphony Orchestra	11,197
Brockton Art Center	277
Brookline Arts Center	223
Cambridge Ensemble	85
Cambridge Society for Early Music	60
Cantata Singers	44
Caravan Theatre	55
Cecilia Society of Boston	59
Children's Museum	810
Chorus pro Musica	53
Concert Dance Company	153
Cultural Education Collaborative	275
Dance Circle of Boston	45
DeCordova Museum	850
Ford Hall Forum	75
French Library	110
Heritage Plantation of Sandwich	300
Institute for Contemporary Dance	30
Institute of Contemporary Art	400
Isabella Stewart Gardner Museum	950
Loeb Drama Center Performing Series	55
Lyric Stage	40
Mandala Folk Dance Ensemble	35
Masterworks Chorale	35
Museum of the Fine Arts, Boston	10,000
Museum of Our National Heritage	375
Museum of the American China Trade	190

*There are 30 performing arts organizations in this sample. The budgets listed for the Berklee College of Music Performance Series, the Loeb Drama Center Performing Series, and the New England Conservatory of Music Performance Series are confined to the expenses incurred by the specific program series. Since many other costs associated with the series are believed to be absorbed by the sponsoring organization, they have been classified as having annual budgets in excess of $200,000 for the purposes of this study.

	Estimated Budget Fiscal Year 1979 thousands of dollars
Museum of Science	3,500
Museum of Transportation	201
New England Aquarium	1,000
New England Conservatory of Music Performance Series	45
New England Dinosaur	170
Next Move Theatre Company	300
Old Schwamb Mill	110
Opera Company of Boston	2,994
Peabody Museum of Salem	700
People's Theatre	25
Playwright's Platform	58
Pocket Mime Theatre	80
Shakespeare and Company	45
Society for the Preservation of New England Antiquities	1,203
Stage One	60
WGBH Educational Foundation	22,000

APPENDIX B TO CHAPTER 7

Arts Organization Rating Sheet*

Name of organization rated _____

Rater _____ Date _____

1. Institutional Characteristics

 a. Organizational ethos individual 1 2 3 institutionalized
 b. Prestige in artistic circles high 1 2 3 low
 c. Visibility in community high 1 2 3 low
 d. Cost structure high fixed 1 2 3 high variable
 e. Location city 1 2 3 suburban
 f. Age of organization old 1 2 3 new
 g. Budget size small 1 2 3 large
 h. Current financial situation shaky 1 2 3 solid
 i. Primary objective educational 1 2 3 recreational
 j. Extent of unionization low 1 2 3 high

2. Funding situation

 a. Donor concentration
 (dollar-size) high 1 2 3 low
 b. Donor location local 1 2 3 national
 c. Income source earned 1 2 3 unearned
 d. Funding sources private 1 2 3 public
 e. Continuity of funding stable 1 2 3 unstable

3. Product Offering

 a. Labor intensity high 1 2 3 low
 b. Scheduling fixed 1 2 3 continuous
 c. Distribution location single-site 1 2 3 multi-site
 d. Product line narrow 1 2 3 broad
 e. Level of repetition low 1 2 3 high
 f. Product source internal 1 2 3 external
 g. Ethos mass 1 2 3 elite
 h. Accessibility (time and
 location) easy 1 2 3 difficult
 i. Programming focus preservationist 1 2 3 innovative

4. Target Market

 a. Specification local 1 2 3 national

*The "Users Guide to Questionnaire" should be consulted for an explanation of the scales. For each scale please circle the number that best describes the organization in question.

b. Audience size	small	1 2 3 large
c. Audience fees	free	1 2 3 high
d. Repeat purchase	minimal	1 2 3 frequent
e. Admission	restricted	1 2 3 unrestricted
f. Prior expertise	none	1 2 3 much

Users Guide to Questionnaire

1. Institutional Characteristics

 a. *Organizational ethos: individual—institutionalized*
 To what extent does the organization presently reflect the values and driving force of a single individual, such that if that person left, the organization would either change its thrust radically or else fold?
 (1) Tied to a single individual
 (2) A few people dominate the organization
 (3) Many people involved—the institution is king

 b. *Prestige in artistic circles: high—low*
 How much prestige does the organization have in informed artistic circles? Note: this is not necessarily related to general visibility in the community.
 (1) High prestige
 (2) Medium prestige
 (3) Low prestige

 c. *Visibility in community: high—low*
 How well known is the organization to users and nonusers alike? Note: visibility need not imply a *good* reputation—the organization could be notorious or simply appeal to "popular" tastes.
 (1) Very well known
 (2) Somewhat known
 (3) Not well known at all

 d. *Cost structure: high fixed—high variable*
 Does the organization have heavy, ongoing costs to meet that are unrelated to the costs of putting on a specific performance? An example would be large, full-time payroll or payments for own building versus limited ongoing costs and most expenses associated with putting on a given performance (for example, payment of performers, rental of hall).
 (1) Most costs are fixed
 (2) A mix of fixed and variable costs
 (3) Most costs are variable

 e. *Location: city—suburban*
 Where is the organization based, and where do the great majority of its performance/exhibitions take place?
 (1) Boston/Cambridge
 (2) Inner suburbs
 (3) Outside Route 128

f. *Age of organization: old—new*
Does the founding of the organization date from
 (1) 50 or more years ago
 (2) 6 to 49 years ago
 (3) 5 or less years ago

g. *Budget size: small—large*
Is the budget
 (1) Five figures or less
 (2) Six figures
 (3) Seven figures or more

h. *Current financial situation: shaky—solid*
Is the organization
 (1) Continually living close to bankruptcy
 (2) Worried enough about money that some programs are at risk
 (3) Facing no threats for the near future

i. *Primary objective: educational—recreational*
Does the organization exist primarily to
 (1) Educate and instruct
 (2) Combine education with entertainment, relaxation
 (3) Divert and entertain

j. *Extent of unionization: low—high*
What proportion of the organization's paid employees are union members?
 (1) Less than 10 percent
 (2) 10 to 60 percent
 (3) Over 60 percent

2. Funding Situation

a. *Donor concentration: high—low*
 (1) Relies for bulk of gifts on just a few donors
 (2) Somewhere in between (1) and (3)
 (3) A high percentage of total dollars raised come from many relatively small gifts

b. *Donor location: local—national*
 (1) Almost all gifts come from Greater Boston area
 (2) Gifts come from Boston and Northeast
 (3) Gifts come from all over

c. *Income source: earned—unearned*
The organization's source of funds is
 (1) Mostly from paid attendances
 (2) A mix of paid attendance and gifts/grants
 (3) Mostly from gifts and grants

d. *Funding sources: private—public*
Gifts and grants come from
(1) Nearly all private sources
(2) A mix of private and public sources
(3) Nearly all public (city, state, federal) sources

e. *Continuity of funding: stable—unstable*
The organization's source of funds of all types (earned and unearned)
(1) Remains much the same from year to year
(2) Midway between (1) and (3)
(3) Changes almost completely from one year to another

3. Product Offering

a. *Labor intensity: high—low*
As a proportion of the organization's total expenditures
(1) Labor costs are very high
(2) Midway between (1) and (3)
(3) Labor costs are relatively low

b. *Scheduling: fixed—continuous*
Does the organization offer
(1) Clearly defined performances with fixed starting times where most people expect to come at the beginning and leave at the end
(2) Performances/showings somewhere between (1) and (3)
(3) Showings that are open for many hours at a time, where a visitor can expect to come when she/he likes and (within the constraints of closing time) stay as little or as long as she/he likes and leave whenever she/he likes.

c. *Distribution location: single-site—multi-site*
Does the organization, over a 12-month period, make its offerings available at
(1) Only one fixed location
(2) Two or three different locations
(3) Four or more different locations

d. *Product line: narrow—broad*
Does the organization provide
(1) A single, unchanging offering
(2) Some variations on a restricted theme
(3) A wide range of different offerings

e. *Level of repetition: low—high*
Does the organization
(1) Retain the same basic offering for extended periods
(2) Repeat a performance/display several times over a period of a month or less
(3) Not repeat the same performance more than a few times and confines it to a period of a week or less

f. *Product source: internal—external*
Does the organization generally
 (1) Create its own material (for example, compose its own music, write its own plays, show its own collection)
 (2) Combine its own creations with the work of others (for example, mount an exhibition of borrowed works in a highly innovative way; present Shakespeare in modern dress with special effects; or emphasize premiering new works)
 (3) Tend to confine itself to re-creating the work of others

g. *Ethos: mass—elite*
Does the organization seek to appeal to
 (1) Popular tastes
 (2) Both highbrow and lowbrow tastes
 (3) An educated elite

h. *Accessibility: easy—difficult*
Are the organization's offerings made available at times and locations that are
 (1) Convenient on both counts for large numbers of people
 (2) Not as convenient as they might be on one or both counts but could be worse
 (3) Inconvenient on both counts for many people

i. *Programming focus: preservationist—innovative*
Does the programming of the organization
 (1) Confine itself to preserving classical art forms
 (2) Combine preservation of classical items with new interpretations of the classics and introduction of innovative forms
 (3) Emphasize innovation

4. Target Market

a. *Specification: local—national*
Does the organization seek to
 (1) Attract only local residents
 (2) Appeal to both residents and visitors
 (3) Actively reach out (through broadcasting, records/reproductions, and/or tours) to a national audience as well as a local one

b. *Audience size: small—large*
Over the course of a year, is audience attendance likely to be counted in
 (1) The hundreds
 (2) The thousands
 (3) The tens of thousands (or more)

c. *Audience fees: free—high*
Is the required cost of participating in the organization's offering
 (1) Generally free
 (2) $5 or less (for a middle-range ticket price if such prices vary)
 (3) Over $5 for a middle-range ticket price

d. *Repeat purchase: minimal—frequent*
Do those who have participated in the organization's offering on one occasion (think of the "average" patron)
 (1) Rarely, if ever, return again that year
 (2) Occasionally (for example, once or twice) return that year
 (3) Return three or more times in a year

e. *Admission: restricted—unrestricted*
Does the organization
 (1) Restrict admission only to members (or other designated individuals)
 (2) Give priority (and/or reduced rates) to members/subscribers, et cetera, but still admit the general public
 (3) Appeal to the public in general

f. *Prior expertise: high—low*
Enjoyment of the organization's offering typically
 (1) Requires a high degree of prior knowledge and expertise on the part of the audience
 (2) Is enhanced by prior knowledge/expertise but is not dependent on it
 (3) Requires little or no prior knowledge/expertise for the "average" person

REFERENCES

National Research Center for the Arts, 1975. *Americans and the Arts: A Survey of Public Opinion.* New York: Associated Councils of the Arts.

DiMaggio, Paul; Michael Ussem; and Paula Brown. 1977. *Audience Studies of the Performing Arts and Museums: A Critical Review.* Washington, D.C.: National Endowment for the Arts.

American Association of Fund-Raising Counsel. *Giving USA, 1972-75.* Annual Reports. New York: American Association of Fund-Raising Counsel.

Hirsch, Paul. 1978. "Production and Distribution Roles among Cultural Organizations: On the Division of Labor across Intellectual Disciplines." *Social Research*, Summer, pp. 315-31.

Hummler, Richard. 1978. "Credit Cards Spark Broadway B.O. Boom." *Variety*, October 4, pp. 99, 103.

Lowry, W. McNeil, ed. 1978. *The Performing Arts and American Society.* Englewood Cliffs, N.J.: Prentice-Hall.

Raymond, Thomas, and Stephen Greyser. 1978. "The Business of Managing the Arts." *Harvard Business Review*, September-October, pp. 123-33.

Ryans, Adrian B., and Charles B. Weinberg. 1978. "Consumer Dynamics in Nonprofit Organizations." *Journal of Consumer Research*, September, pp. 89-95.

Schwartz, Samuel, and Harry I. Greenfield. 1977. "A Model for the Analysis of the Performing Arts: A Case Study of the Major Orchestras." Research Project for the National Endowment for the Arts, Washington, D.C.

Tod, Peter. 1978. "Attracting New Audiences." In *The C.O.R.T. Marketing Manual*, edited by G. V. Robbins and P. Verwey. vol. 3. London: Council on Regional Theater.

Weinberg, Charles B. 1977. "Building a Marketing Plan for the Performing Arts." *ACUCAA Bulletin*, May, pp. 1-7.

8

MARKETING PLANNING FOR THE ARTS ORGANIZATION

Charles B. Weinberg

The complexity of the modern arts organization and its interactions with the environment make planning a vital management function. Planning is essential if the organization is to integrate its many activities, use its resources, and serve its present and future markets effectively and efficiently.

Planning can help an organization by providing a means for the organization to deploy and develop its resources so as to reach its goals. However, planning also helps an organization by showing what is feasible for an organization of a given size and scope. Underutilized cultural centers and unfilled seats in auditoriums are often symptoms of organizations that have failed to plan adequately and to realize both the potentials and limitations that they face.

More fundamentally, planning provides direction to an organization and its members. As someone once said, "If you don't know where you are going, all roads lead there." Numerous arts organizations are carrying out a broad range of activities without any real focus. Other organizations find themselves running programs for no reason other than that somebody once agreed to do them, and nobody has since asked why the organization does the program and whether it should continue to do so.

In this chapter we shall explore the nature and role of marketing planning. Planning systems to be useful must be of a size and formality that are appropriate to an organization. Smaller organizations, in particular, will have neither the need nor the resources to carry out a planning effort that is as extensive or as formal as the one outlined in this chapter. This is because the smaller organization usually faces a narrower range of decisions than do larger organizations and encounters fewer communication difficulties among its staff. For example, a small theater group may present only one type of drama in a single location and have to answer only limited questions about the mix of activities it will undertake. In contrast, a large company's repertory may often be much broader, and it may not only perform in

multiple sites but also use its home base to host performances by other performing arts organizations. In brief, planning is not an "all or nothing" activity. Rather, each organization must determine the scope, detail level, and process of planning that is best suited for it. However, failure to plan at all often results in an organization's losing control of its own destiny.

THE NATURE OF PLANNING

Just what do we mean by *planning*? Although there appear to be almost as many definitions of planning as there are authors, most definitions are essentially similar. Drucker (1959) captures both the long-term orientation and the management implications of planning when he defines planning as "the continuous process of making present *entrepreneurial* (*risk taking*) *decisions* systematically and with the best possible knowledge of their futurity, organizing systematically *the efforts* needed to carry out these decisions, and measuring the results of these decisions against the expectations through *organized, systematic feed-back*."

Planning requires that management make a number of decisions—all interrelated—having to do with what to do to attain certain objectives or goals, how to do it, when to do it, and who is to do it (compare Boyd and Massy 1972, pp. 23–49). By its very nature, planning is a continuous process that necessitates control and reappraisal. The difficulty of making marketing decisions is well known, for marketing is a function that acts as an interface between an organization and its environment. It is even more difficult to develop a meaningful marketing plan, because of the futurity ("when") aspect and because of the necessity of dealing with an immense set of interrelated problems having to do with what, how, and who. Since almost all these problems involve a consideration of factors external to the firm, those over which literally no control can be exercised, the task of planning at first glance seems overwhelming. Yet the day-to-day pressures are so intense that management must have a framework, a plan, to guide its everyday decision making.

Benefits of Planning

Among the benefits that an organization can derive from developing and implementing a marketing plan are the following:

1. Coordination of the activities of many individuals whose actions are interrelated over time. Some decisions must be made before others or simultaneously with others. For example, the subscription ticket campaigns are dependent upon the variety, type, and number of performances that the organization is to present.

2. Better communication. Because of the inevitable compartmentaliza-

tion of management, it is essential that there be some integrating form of communication so that each executive will know, at least generally, what others are trying to achieve and how they are likely to proceed to accomplish their tasks. Many argue that the communication aspect of marketing plans is among its primary functions. This may be particularly true in arts organizations where both artistic and managerial activities are interrelated.

3. Identification of expected developments. Many administrators perceive rather well the nature of future developments if they make a disciplined effort to look ahead. By forcing themselves to plan, they often can locate such events fairly accurately in time and can better understand the interrelation and serial nature of these events.

4. Preparedness to meet changes when they occur. Through planning, executives are forced to think through what actions or counteractions they would take if certain events occur. Furthermore, the planning systems can help to reduce nonrational responses to the unexpected by placing obstacles in the way of those executives who would respond hastily and emotionally to an unexpected event.

5. Focusing of efforts. Managers generally have more problems and opportunities than they have resources available to devote to them. Successful planning systems provide a means for the organization to choose the problems and opportunities it wishes to devote its scarce resources to. In addition, a well-designed planning process should result in a systematic procedure for generating and evaluating alternatives. Too often, administrators consider only one course of action.

6. Maintenance of artistic integrity. A marketing plan, by specifying clearly the alternatives the organization will pursue and rooting that choice in a thorough understanding of the organization's artistic goals, helps prevent an organization from making a series of ad hoc decisions that carry it further and further away from its true concerns. Without a planning process that defines what the organization will do, whatever the organization does can become the definition of what it is.

Planning Levels

Planning can be carried out at many different levels of aggregation. There can be a plan for the organization as a whole, a plan for the different types of offerings of the organization, and a plan for individual market elements. For example, a symphony orchestra might have one marketing plan for its regular season in its main hall, another plan for a tour over a wide geographic area, and a third plan for a summer season. The marketing strategy for each alternative might be radically different—for example, the regular season may appeal primarily to upper-income subscribers who have a strong interest in the arts, and the summer season to those new to the arts who are willing to spend very little on the arts but are looking for an

enjoyable experience (which indicates why distinctive marketing plans are needed). Yet, these activities must be coordinated as well. Thus, the organization's overall plan is an integrated set of subplans.

Effective planning requires active interaction among organizational members. Senior officers of the organization need to set meaningful objectives for the organization. But, objectives to be meaningful must be within the realm of possibility for the organization. Thus, objectives can be moderated by analysis at parallel and lower levels. Furthermore, as noted above, subunits of the organization may develop sound marketing plans in isolation, but the need for coordination or the scarcity of resources may result in the modification of plans. The planning process, therefore, should be viewed not as a sequential procedure but as a cyclic process, with ever tighter circles being drawn on the organization's targets.

Formal Planning Systems in Arts Organizations

Although no survey has been carried out, it appears that few arts organizations have plans that actually impact on resource allocation and managerial decision making. One noteworthy example of an organization with an extensive planning system is the Boston Ballet Company, which has developed both long-term (five-year) and short-term (annual) plans in which it identifies strategic options and selects courses of action (compare Raymond and Greyser 1978). In North Carolina a number of state-supported performing arts organizations have developed annual marketing plans in recent years. In general, however, few arts organizations develop and utilize marketing plans.

Of course, the presence of formal written plans is not sufficient. Some organizations develop formal plans to meet the requests of funding organizations or board members, but these plans have no impact on management decisions. For example, Montgomery and Weinberg (1978) cite the following corporate example of the evolution of planning in one setting:

> In the company's early days of planning, divisions were mainly required to submit numerical estimates of profits, growth rates, sales, etc. over a five year horizon. Naturally the division managers provided numbers which were set at levels which would justify their desired resource allocation or gain the approval they were seeking. The company now requires statements of the actions necessary to achieve results and assumptions about the external environment upon which the projections are based. That is, the logic necessary to achieve a numerical goal is given. Consequently, corporate officers can challenge a division's plan.

The length, detail level, and format of the marketing plan can vary considerably according to the needs and capabilities of the organization. A

useful set of standards for judging the adequacy of a plan is provided by a United States Army staff manual (see Appendix A to Chapter 8). As can be seen, these criteria are based on the utility of the plan to the organization.

A frequently discussed issue is the question of how much flexibility an individual manager is to be allowed in developing a plan. A Conference Board study (Hopkins 1972) cites four arguments for a prescribed format and coverage: ensures completeness of plan's coverage of important factors, helps novice planners to build initial plans, facilitates review and control, and upgrades the quality of the average plan to "textbook" levels of competence. However, some managers feel that in making planning formats fit a textbook model, the manager loses the flexibility required to reflect adequately the critical factors in his or her market. In addition, there is the time and cost involved in reorganizing information from one form to another.

How long should a plan be? "Short enough to be actionable, long enough to be meaningful" is probably as specific as one can be. Organizations will vary in their ability to digest plans of various lengths.

In general, planning systems should be matched to the organization's individual style and capabilities. Planning systems, to be effective, require substantial involvement by key personnel in the organization and should result in pragmatic, results-oriented plans. As discussed at the outset of this chapter, smaller organizations will tend to have plans of narrower scope and possibly less formality than those of larger organizations.

PRODUCT-MARKET STRATEGIES

A fundamental step for an organization is the identification of the current product markets (that is, what products are offered to which markets) that it participates in and those that it might consider entering or leaving in the future. A dramatic way to characterize different product-market strategies is a four-way matrix (see Figure 8.1) consisting of increased penetration of current markets (1) with offerings similar to the present ones or (2) with new and different types of offerings and the development of new markets either (3) with the present offerings or (4) with new offerings. These four cells are extreme points and the degree of modification from current products and markets to completely new ones is obviously a more continuous process than that portrayed in Figure 8.1. Nevertheless, a product-market matrix is often a useful format for identifying and summarizing strategic choices.

As should be readily apparent, an arts organization—be it an opera company, a symphony orchestra, a museum, or a performing arts center booking touring groups—has a broad range of product markets in which it may wish to participate. Further, as Raymond and Greyser (1978) point out:

There are different ways of developing and offering [an orchestra's] "product" in order to maximize audience size (and increase audience enjoyment). For example, a symphony orchestra may play a wide variety of music via heterogeneous programming in a single set of concerts or via specialty programs, devoted to a single kind of music (for example, romantic or avant garde).

Furthermore, it can try to accomplish its audience education mission both by inclusion of new music in existing series (usually scheduling it before intermission!) and by presentation of "pops" concerts. The mixes of programming and series should reflect the orchestra's view of its most effective product marketing strategy.

At a broad overview level, it is useful to examine an organization's planning process as being concerned with the choice of the product markets in which the organization will participate. In addition to strategies involving increased penetration of current markets, arts organizations need to con-

FIGURE 8.1

Product-Market Scope and Growth Vector Alternatives

		Products	
		Present offerings	New offerings
Markets	Current markets	(1) Market penetration	(2) Product development
	New markets	(3) Market development	(4) Diversification

sider other alternatives as well. For example, many museums have success-fully developed on-premises shops for museum goers, which can be charac-terized as a product development strategy of new offerings for existing markets. Performing arts organizations have yet to develop similar product markets to any great extent, and even the ability of many to provide refreshments at intermission is questionable. It is worth noting, in passing, that some movie theater owners claim to make a higher profit from refreshment operations than from cinema operations.

Some arts organizations have successfully developed new markets for existing products by providing in-school programs at the elementary and high school levels. Often, such programs may also increase attendance at the organization's main performances as well. Touring companies are, perhaps, the classic way of reaching new audiences with present products—an approach that appears to be increasingly popular in both the performing and visual arts.

The final element of the product-market matrix, diversification, is the most difficult to accomplish successfully. Before taking such a step, an arts organization should ascertain whether it has the skills to enter new markets with new products. In private industry many firms have failed with diversifi-cation strategies that did not draw on existing strengths of the company. On the other hand, success can follow well-conceived diversification strategies. For example, some arts organizations have successfully developed schools for training young professionals. The underlying artistic skills possessed by people in the organization have, at least for some institutions, been success-fully transferred to educational programs.

In choosing product markets to participate in, the arts manager should know that modern approaches to marketing strategy require that the organization identify and utilize its key resources, especially those that set the organization apart from others that serve similar markets. These key resources, or distinctive competencies, are one of the fundamental building blocks for the formation of a marketing strategy. These competencies should include the artistic resources of the organization, for successful marketing strategies are based on each organization's own strengths. Although a marketing approach will hopefully serve to make an organization sensitive and responsive to both the current and long-term needs of its markets, a marketing approach does not imply that the organization lose its distinctive-ness and try to serve all markets. Indeed, that path usually leads to disaster. The failure of several colleges in the 1970s illustrates the danger of trying to meet the needs of the entire market by losing sight of unique capabilities. Religious schools that became nondenominational and all-male or all-female colleges that went coeducational found that success does not lie in serving everyone indifferently—rather, it lies in serving selected market segments extremely well. One of the major challenges facing any organiza-tion is the selection of markets to serve.

PLANNING AIDS

Computer Utilization—the ARTS PLAN Model

Many arts organizations use computers in some phase of their operations, such as subscription processing, payroll, fund drives, and mailing list maintenance. However, these applications, while important, are largely clerical in nature. Another significant application has been in ticketing, in which computers are employed to establish a geographically dispersed retailing system for the reservation and purchase of tickets. Only limited evidence, unfortunately, of computer systems that actually help arts managers make decisions is available.

Recently, however, two implemented applications of interactive computer systems as an aid to planning have been published. Leise and Holstein (1978) developed a financial planning model that has been used by the Albany Symphony Orchestra. The computer system allows the manager to assess readily the effect on the budget of changes in such items as the following: number of concerts, number of subscriptions, subscription discount percentage off the single ticket price, percentage of renewals from the previous season, number of rehearsals per concert, musician's pay scale, number of single tickets sold per concert, and the ticket price scale.

The second computer model, Weinberg and Shachmut's (1978) ARTS PLAN system, is more marketing oriented. This interactive computer system has been used for three seasons by the Lively Arts at Stanford program as an aid in product line planning and has recently been utilized and extended at the University of California—Los Angeles by Cooper (1978). The model consists of three major components: a forecasting system to predict attendance at an event, an interactive planning model by which the manager can test the impact of different choices of performing arts events on total attendance for the year, and a routine for assessing the impact of extensive promotion on different events. The following paragraph briefly summarizes the forecasting procedure of the ARTS PLAN model and Appendix B to Chapter 8 presents a demonstration of the use of the ARTS PLAN model. The number of options considered in the example problem is relatively small because of space limitations but in actual application can be considerably increased.

In developing a forecasting procedure, data were available for 93 performances over a three-year period ending in spring 1976. Upon examination of these data by the statistical technique of multiple linear regression, it was found that 80 percent of the variation in attendance around the average attendance level could be explained by knowing the type of performing arts event (for example, dance, jazz, chamber music), the quarter in which it was presented (fall, winter, spring), and other factors. Most important, it was found that the name of the individual performer was not needed, in general, to explain this 80 percent of the variation. This meant

that a forecasting system could be built for performers who had not previously been on campus and that seasonal effects could be segregated from others. As an example of the system's accuracy, the total ARTS PLAN system predicted attendance of 20,875 for 1976–77, which was virtually identical to the 20,882 actual.

Market Research and the Marketing Plan

As will be discussed in the next section, a critical portion of the marketing plan is an analysis of the external environments that have impact or may impact on the organization.The most important of these, of course, is the past, present, and potential future audience. Successful marketing planning must be based on a comprehensive understanding of customers— market research is the starting point for this understanding. Ryans's and Weinberg's (1978) article on a market research study conducted by the American Conservatory Theatre (ACT) in San Francisco illustrates the links between research, the marketing plan, and marketing decisions. In spring 1976, a questionnaire was mailed to ACT subscribers and a 45 percent response rate was obtained. Only a few of the results from the questionnaire will be discussed here.

The issue of why people subscribe to ACT was addressed through a question about benefits people might obtain from subscribing. One possible benefit is the subscribers' price discount of seven plays for the price of six. Other reasons include priority seating and a guarantee of obtaining a ticket. Surprisingly, the most frequently cited reason for buying a subscription was "makes me more certain to attend each play." This finding not only provides an interesting perspective on human behavior but also suggests possible strategies to use in subscription campaigns.

One of the interesting findings is that price discount was not one of the major benefits that people sought. As a result of preliminary findings from this survey, which supported management's prior beliefs and a number of other factors as well, ACT decided to no longer offer subscribers the "seven for six" price discount. The renewal rate remained within the usual bounds.

Care needs to be taken in generalizing from this result to other pricing strategies. ACT distributed to its audience a glossy, lavish program that described the play and current cultural events in San Francisco. The printing costs of this brochure were increasing, and ACT found that the only way it could afford to continue the brochure (even with advertising) would be to charge 25¢ a copy. ACT asked its subscribers whether they wanted to pay 25¢ a copy, or whether they preferred a less elaborate brochure. Despite the $50–plus cost per subscription ticket and the price discount results, 80 percent of the respondents said "no" to the 25¢ charge. Maybe the audience was saying "charge what you want for the subscription, but I want to enjoy my night out, and I don't want to be bothered searching for a quarter when I

get to the theater." ACT, consequently, still distributes programs free and canceled a contract with the printer of the 25¢ brochure, which many San Francisco theaters continued to use.

Another finding in this research questions some prior conceptions about subscription audiences. It is generally believed that virtually all subscribers go through a "trial" process of gradually increasing the number of individual events attended before becoming subscribers. However, the study found that more than one-fourth of the new subscribers had previously attended a performance at ACT—and this "sudden subscriber" segment was not particularly sensitive to the subscription price discount either.

Marketing plans based on knowledge of people's preferences and behavior are invariably more successful than those that are not. Many arts organizations carry out market research projects. For example, Useem and DiMaggio (1977) compiled a list of 270 audience studies conducted by visual and performing arts organizations. Unfortunately, they found that only a minority of the organizations actually used the marketing research studies in making management decisions.

A MARKETING PLAN FORMAT

The marketing plan is a systematic way of organizing an analysis of a market, an organization's position in that market, and a program for future marketing activities. Marketing strategies should be contingent upon the information learned by analyzing the organization's present situation and future goals. The elements of a marketing plan are not discrete components; they are interrelated, so that development of a marketing plan may involve cycling through the elements several times before a satisfactory plan is achieved.

In Appendix C to Chapter 8 a format for a marketing plan is presented. The purpose of presenting this format is to provide a starting point from which organizations can build their own marketing plan format and offer a checklist of important issues that should be included in a marketing plan (for example, Hopkins 1972). The following discussion amplifies portions of the format for a marketing plan. However, since other sections of the book will discuss the individual components in depth, these comments will be brief.

Situational Analysis

Situational analysis, the first component in a marketing plan, examines the organization in terms of its external and internal environments. An in-depth procedure for conducting a situational analysis is a "marketing audit"—that includes an historical summary, the present situation, and an assessment of future trends. The situational analysis covers a number of areas both internal and external to the organization.

Environment

For purposes of analysis, the external environment can be usefully subdivided into the political and regulatory, economic, social, and technical environments. How does the external environment affect the marketing operation? For example, WNET (a public television station) in New York has developed a video technology that allows events at Lincoln Center to be videotaped in an unobtrusive manner. What are the implications for the Metropolitan Opera or for a theater outside one of the big cities? How do these implications change when the possibility of home video cassettes is factored in as well? Turning to the social environment, the increasing number of women in the work force and the decline in numbers of women willing to work as unpaid volunteers may change the viability of certain marketing strategies. Working women may also be a segment that provides new opportunities for the organization.

Audience

Earlier, this chapter discussed market research to understand the potential audience—to understand how people become an audience, understand the current audience, and even understand the former audience. What marketing problems and opportunities does the sudden subscriber segment offer to ACT? Do people who do not come back represent normal "churn" or a signal about the service being offered? Of course, one wants to know the size of the current and potential audience and possible segmentation bases and have awareness of and attitudes toward the organization and its offerings. The information gathered here is one of the key components in the choice of product markets in which to participate.

Artists

Artists, here, include performers, directors, designers, et cetera. Artists and unions are a part of the environment and have a significant impact on marketing programs. Indeed, the quality and reliability of the product depend fundamentally on the artists, particularly those artists who are performing in the event being presented.

Funders

Just as consumers need to be understood, so do funding sources. Familiar marketing concepts involved in understanding users often can be applied to the funders as well. For example, university fund raisers claim that a trial-and-repeat pattern exists—that donors of small amounts after graduation are a likely source of substantial donations at a later date. The existence of brand loyalty is suggested by the success of the March of Dimes (the National Foundation) and the American Lung Association (formerly concerned primarily with tuberculosis) who hold the third and fourth

leading positions, respectively, in fund raising for national health organizations—even after changing their original focuses.

Competition

There are usually many and varied competitors for a person's time. For people who are frequent attenders of arts events, the competition is probably going to be the other cultural activities in the area. For people who infrequently attend arts events (for example, sudden subscribers), the competition is probably TV or inertia. They are two very different types of competitors, probably posing different types of problems and opportunities and requiring different marketing programs.

Internal

Analysis of the internal environment is critical as well. What are the objectives? What does the organization want to achieve? The artistic principles on which the organization is based should appear in this section. Overall, what are the strengths and weaknesses, honestly appraised? What key factors are there that distinguish this organization from others that will allow it to succeed in the face of competition and a possibly hostile environment?

Problems and Opportunities

This analysis of the external and internal environments should lead to the specification of a set of problems and opportunities. It has been said that, "We are all continually faced with a series of great opportunities brilliantly disguised as insolvable problems."

A momentum forecast of year-end position can be constructed, based on an analysis of the external and internal environments, assuming that the organization is operated as usual. The momentum forecast is then compared with the organization's desired year-end position, wherein the gaps between the momentum forecast and the desired position are identified. This so-called "gap analysis" helps to stimulate the creation of marketing program goals and strategies and motivate the people in the organizations. The critical environmental assumptions on which the marketing plan is based should be made explicit.

Marketing Program Goals

The goals should meet a set of guidelines. First, the goals should be specific and quantifiable. It is very hard to use a goal such as increasing the audience as a motivating device, because it is not known when it has been achieved. A goal expressed as "to increase awareness of the programs

offered in the community" raises a number of questions. Is it to increase the awareness of students, senior citizens, or new residents, and by how much? A more meaningful goal is that 40 percent of the new residents know that the program exists. The goals should be realistic, challenging, and tailored to the situation. On the other hand, the goals should not be set so high that they cannot be achieved. There should be a few, select "prioritized" goals that are important to the organization. If the goals are achieved, the organization can have a sense of accomplishment; if they are not achieved, then, at least, there should be a way of determining why, which should be useful in determining goals and setting plans for the next year.

Marketing Strategy

Marketing strategy is the means by which the organization achieves its marketing goals. Of course, in building a marketing plan, several different strategies usually must be constructed before the best one is chosen. Indeed, one of the key benefits of an effective planning system is to force decision makers to generate and evaluate multiple alternative courses of action. These alternatives must be tested against the conclusions drawn in the situational analysis section of the marketing plan.

Because arts organizations often need to raise money from people and organizations who do not use the service, two distinct but interrelated marketing strategies may be needed—one for fund raising and one for user services.

Positioning

Positioning, the fundamental statement of what the organization and its services represent and what they provide to whom, involves three factors. First, who the target segments are; that is, to which groups is the organization striving to appeal? The organization may try to appeal to more than one group at a time. ACT, for example, might try to develop one program for people who attend but do not subscribe, another for current subscribers, and a third one for lost subscribers—although problems of coordinating the efforts to reach each group need to be considered as well. Second, in each of the target segments, the manager needs to set the organization's competitive stance. Depending on the segment, the competition can vary considerably, as was discussed earlier. The next step in positioning is to establish the usage incentive. What are the primary benefits that the organization is going to offer its current and potential users in each segment? The positioning strategy is vital not only in terms of the consumers but also for the organization's management; it provides a focus for management efforts and is a key element, therefore, in channeling the efforts of the organization.

Marketing Mix

The marketing mix (product, price, distribution, and communication) is a convenient way of summarizing a set of marketing activities. These marketing activities support the marketing goals of the organization; the execution of these activities is just one part of marketing. Those new to marketing often consider these activities, especially advertising, to be all of marketing.

Product

Product, a generic term that includes both goods and services, is one element of the marketing mix. The product must be considered from the audience's point of view and is best conceptualized as a collection of attributes that provide a set of tangible and intangible benefits. In the performing arts the product can be categorized in at least four ways. One is the year-after-year product that the organization is providing to its community. A second is a particular year or season; the set of performances being offered—the variety, the quality level, the timing, et cetera. With the large number of alternatives available, the problem of which performances to book can be a very complex one. The ARTS PLAN model, discussed earlier, can be a useful aid to managers making such decisions. A third level is the series of plays packaged together such as a "choose your own series," a set of soloists, or a mix of types of performers. A fourth level of product classification is the individual performance itself. In most cases the individual offering needs to fit the perception of a day or evening out. In terms of ACT, for example, the market research indicated that there are very few people who just go to ACT—that is, leave their house to go to ACT and come back home immediately afterward. Many obtain the benefits of an evening out or a social experience—they may have dinner before, go out afterward, and drive to and from the theater with friends.

Price

Pricing is obviously a very important factor, even in deficit operations, such as is the case for most performing arts organizations, where box office revenues do not cover the full operating costs. In most cases price sensitivity is conditioned on a number of factors, including the overall marketing strategy. Even the offering of free tickets does not ensure that the hall will be filled to capacity. There is also a set of pricing issues with regard to series versus individual tickets (as in the earlier discussion of the "seven for six" price discount), student "rush" or last-minute discount tickets versus general student discounts, charge card versus cash or check only, weekday and weekend prices, seat location, price variation, as well as setting the overall price for performances.

Pricing is particularly difficult because the bulk of the costs generally do not vary on a per-audience-member basis. However, use of complex pricing and discount structures, in order to ensure that those willing to pay high prices do so, may cause consumer confusion and dissatisfaction, as the airline industry has found.

Another problem arises because of deficit operation. One method of reducing losses is to raise prices. But if the price is raised, fewer people attend the organization's events; therefore, the organization reduces the number of performances. This sets up a cyclic procedure for which the conclusion is unfortunately obvious. The marketing-mix framework suggests that an organization does not automatically need to resort to a strategy that appeals to increasingly narrower segments of either the wealthy or others who are highly price insensitive. Rather, a marketing approach suggests that an organization examine the various types of audiences that may attend and try to develop and implement appropriate multidimensional marketing plans.

Distribution

Distribution is of critical importance, especially if most audience members come from locations that are not near the auditorium. This suggests the need for considering branching strategies, if such an alternative is feasible. If it is not feasible for the performance to be offered at more than one location, at least the ticket information and reservation process can be dispersed geographically. An interesting marketing technique is to distribute a branch ticket (or voucher) that specifies a seat location that will be perceived as being the same as a box office ticket.

Marketing Communication

Marketing communication has been frequently discussed and will be mentioned here only briefly. Communication includes a whole range of activities such as advertising, personal selling (by volunteers or paid staff), publicity, word-of-mouth conveyance, and the performance itself. Communication programs need to be aimed at specific target audiences, with clear objectives set with regard to what informational, persuasive, attitudinal, and behavioral goals are to be reached in conjunction with other elements of the marketing strategy.

Contingency Strategies

A marketing plan should include contingency strategies. Because it is difficult to predict the future precisely, the manager should anticipate what the major surprises might be and, consequently, be prepared beforehand, in case such contingencies occur. One theater group has three plans for the

second half of the year, the critical factor being attendance revenues in the first half of the year. A major company has a policy that says that it does not accept unanticipated surprises as an excuse by a manager for annual plan goals that are missed. The plan can include contingencies, but if a manager says, "I never expected that to happen and as a result my sales are down by 20 percent," senior management replies that "If you are a good manager you should at least know what the possible surprises are going to be." Knowing the possible surprises provides a big advantage, because well-thought-out and timely alternative strategies can be available beforehand.

Marketing Budget

The next step in the marketing plan is the marketing budget. There are three critical resources in running an organization: money, people, and time. The budgeting question is usually how to utilize or allocate these resources, because most arts organizations do not have enough money, people, or time. These resources can be increased by a contribution program—a contribution not only of money but also of volunteer time. However, many diverse organizations are increasing their fund-raising efforts so that the market is extremely competitive. Fund raising is a difficult process and can divert key organizational members from other activities without commensurate return. In allocating resources it is critical to consider the interrelationships among marketing elements and have a clear notion of effectiveness and efficiency.

Marketing Action Plan

The marketing action plan is a detailed breakdown of the activities that achieve each of the goals and strategies and an assignment of responsibilities by name of individual or office. The activity schedule should be in milestone form. For example, if the goal is to increase the attendance from 60 percent of capacity to 75 percent of capacity by the end of the year, then attendance should be 65 percent of capacity at the end of two months. Or, if a new fund-raising program is to be developed a year from now, it means that three months from now some specified activities should be completed.

The following advice on implementation, given by Rothschild (1976) in his excellent book on strategy, should be kept in mind:

> *The next step.* The best strategy in the world may be close to worthless if it isn't implemented adroitly. This seems so obvious; yet in case after case, leaders in all walks of life who do have carefully prepared strategies fail to make them operational. As a closing, I would like to specify some important aspects of the move toward implementing plans that will increase the probability of successful execution.

1. *Proper organization.* Look at the type of roganization you have now and determine whether it fits the strategy you have adopted. An inappropriate organization structure is likely to cause failure.

2. *Measurement.* Do the current measurement systems encourage personnel to execute the strategy, or will they actually work against implementation?

3. *Rewards.* How do the rewards received for performance relate to the strategy? As is true of organization form and the measurement system, they can either support or distract.

4. *Understanding.* Do the key operating managers and professionals understand what has changed and why? Do they agree with the change, or will they only give it lip service? Do they know what is expected of them to make it work?

Monitoring System

The monitoring system is concerned with whether assumptions about the external environment are valid, whether the organization is implementing the plan in the desired manner, and whether the specified milestones and goals are being achieved. The critical elements are to discover and act on, if necessary, deviations from anticipated happenings and recognize unanticipated new opportunities and problems. Depending upon the findings, the organization should be prepared to make readjustments in the decided plan, implement a contingency strategy, or, in rare cases, develop a new plan.

SUMMARY

Most performing arts organizations carry out some of the elements of a marketing plan. However, there is a distinct advantage to conducting a thorough and systematic analysis of the organization's marketing situation and using that analysis as the basis for establishing a coherent marketing strategy. Building a marketing plan can take a considerable amount of effort, and each organization must decide how detailed and complex its plan should be and how many resources to devote to the research foundation on which the plan is built, the creation and evaluation of strategies, and the construction of the final plan. An organization's first attempt at building a marketing plan is going to be more costly than when the process is repeated. As discussed at the outset, however, the benefits of building a marketing plan are not limited to those connected with developing an approach to the market. They also include the use of the plan as a form of communication within the organization and a means to coordinate and focus efforts.

APPENDIX A TO CHAPTER 8

Characteristics of a Plan

The essential element of a plan is that it offers a definite course of action and a method for execution. A good plan—

a. *Provides for accomplishing the mission.* (Does it accomplish the objective of the planning?)

b. *Is based on facts and valid assumptions.* (Have all pertinent data been considered? Are the data accurate? Have assumptions been reduced to a minimum?)

c. *Provides for the use of existing resources.* (Is the plan workable? Are there any resources organic to the organization that are not being fully utilized? Are there any resources available from higher headquarters that should be used?)

d. *Provides the necessary organization.* (Does the plan clearly establish relationships and fix responsibilities?)

e. *Provides continuity.* (Does the plan provide the organization, personnel, materiel, and arrangements for the full period of the contemplated operation?)

f. *Provides decentralization.* (Does the plan delegate authority to the maximum extent consistent with the necessary control?)

g. *Provides direct contact.* (Does the plan permit coordination during execution by direct contact between coequals and counterparts on all levels?)

h. *Is simple.* (Have all elements been eliminated that are not essential to successful action? Have all elements been reduced to their simplest forms? Have all possibilities for misunderstanding been eliminated?)

i. *Is flexible.* (Does the plan leave room for adjustment to change in operating conditions? Where necessary, are alternate courses of action stipulated?)

j. *Provides control.* (Do adequate means exist, or have they been provided, to ensure that the plan is carried out in accordance with the commander's intent?)

k. *Is coordinated.* (Is the plan fully coordinated? When appropriate, has the commander been informed of nonconcurrence or noncoordination?)

APPENDIX B TO CHAPTER 8

Excerpts from a Sample Run*

Arts Planning Model.
Do you wish to investigate an entire season, or a single quarter? (*S* = Season; *Q* = Quarter)? \boxed{Q}
Which quarter do you wish to investigate
(Fall = 1, Winter = 2, Spring = 3)? $\boxed{3}$
Will data come from keyboard (K) or file (F)? \boxed{K}
No. of performances planned for quarter (Max = 17)? $\boxed{4}$
The following table presents the base-case attendance percentages which will be used in generating the first-round attendance projection.

Estimated Attendance Percentages (Historical)

*	Fall	Winter	Spring
(1) Chamb Mus	87	87	70
(2) Dance	52	52	44
(3) Guitar	104	104	92
(4) Jazz	81	81	74
(5) YCA	71	71	34
(6) Other—(700)	90	90	72
(7) Other—(1700)	38	38	31

*In addition the following supplementary effects have been observed:
(*G*) Gala Quartet 25
(*P*) Popular Dance Group 47

At this step you are asked to provide specific information on the program you are planning.

Performance Number 1
Enter Performance Name (Maximum 12 characters)? \boxed{Beth}
Enter Performance Type (use code number:)

1 = Chamber Music	3 = Guitar	5 = Young Concert Artists (YCA)
2 = Dance	4 = Jazz	6 = Other—(700)
7 = Other—(1700)		

? $\boxed{2}$
Enter Capacity of Hall? $\boxed{1700}$
Popular Dance Group (Y = Yes, N = No)? \boxed{Y}

(Remainder of initial input deleted.)

Attendance Predictions for Spring Quarter				
Performance Number	Performance Name	Percentage Attendance	Capacity of Hall	Attendance
1	Beth	P 91	1700	1547
2	Sari	74	1700	1258
3	Amy	34	350	119
4	Michelle	45	1300	585
Totals	*	69	5050	3509

Do you want to save Table on a file (Y or N)? [N]
Do you wish to make any changes? (Y = Yes, N = No)? [Y]
Enter number of performance you wish to change? [2]
Current status of performance number 2

Name	Sari
Type	(4) Jazz
% Attend	74
Capacity	1700
Attendance	1258

Indicate by code number the parameter you wish to change
Enter one only 1 = Performance Name 3 = Percentage Attendance

2 = Performance Type 4 = Capacity of Hall
? [3]

Old percentage attendance is: 74
New percentage attendance expected? [85]
Any other changes to this performance (Y = Yes, N = No)? [N]

Attendance Predictions for Spring Quarter				
Performance Number	Performance Name	Percentage Attendance	Capacity of Hall	Attendance
1	Beth	P 91	1700	1547
2	Sari	RV 85	1700	1445
3	Amy	34	350	119
4	Michelle	45	1300	585
Totals	*	73	5050	3696

Do you wish to make any modifications to the planned season? (Y = Yes, N = No)? [Y]

*User answers are in the boxes. For a more complete description of this model see Weinberg and Shachmut (1978).

Input type of change desired. (One only)
 1—Add a new performance
 2—Delete an old performance
 3—Replace an existing performance with another
 4—Make changes to an existing performance
? 2
Which performance do you wish to delete?
 (Enter performance number)? 2

Do you wish to examine promotional impact (Y = Yes, N = No)? Y
At this stage you are asked to estimate the impact of devoting considerable promotional effort to a particular performance.

Performance Name	Projected % Attendance	Estimated % Attendance with Promotion
Beth	P 91	? 95
Amy	34	? 34
Michelle	45	? 75

The following table lists performance by order of increase in attendance due to promotion:

Performance Number	Performance Name	Projected Attendance	Increase from Promotion	Attendance with Promotion
3	Michelle	585	390	975
1	Beth	P 1547	68	1615
2	Amy	119	0	119

Which performance, if any, do you want to promote. Indicate by performance number. If none, enter zero . . . ? 3
Performance number or zero if no more . . . ? 0
Attendance with Promotions chosen is now estimated

Attendance Predictions for Spring Quarter				
Performance Number	Performance Name	Percentage Attendance	Capacity of Hall	Attendance
1	Beth	P 91	1700	1547
2	Amy	34	350	119
3	Michelle **	75	1300	75
ʸTotals	*	79	3350	2641

APPENDIX C TO CHAPTER 8

Marketing Plan Format

Situational Analysis (Where are we now?)
External
 Environment (political, regulatory, economic, social, technical, et cetera)
 Audience
 Funders
 Artists (performers, directors, designers, et cetera)
 Competition
Internal
 Objectives
 Strengths and weaknesses
Problems and Opportunities
Momentum forecast
Identify gaps
Marketing Program Goals (Where do we want to go?)
Specific (quantifiable)
Realistic (attainable)
Important
Prioritized
Marketing Strategies (How are we going to get there?)*
Positioning
 Target segments
 Competitive stance
 Usage incentive
Marketing mix
 Product
 Price
 Distribution
 Marketing communication
Contingency strategies
Marketing Budget (How much and where?)*
Resources
 Money
 People
 Time
Amount and allocation
*Marketing Action Plan**
Detailed breakdown of activities for each goal/strategy
Responsibility by name
Activity schedule in milestone format
Tangible and intangible results expected from each activity
Monitoring System

*Separate but interrelated strategies may be needed for consumers and funding sources.

REFERENCES

Boyd, Harper W., Jr., and William F. Massy. 1972. *Marketing Management.* New York: Harcourt Brace Jovanovich.

Cooper, Lee G. 1978. "Forecasting Ticket Sales and Revenue for a Performing Arts Concert Series." Paper published by the Study Center for Cultural Policy and Management in the Arts, Los Angeles, Calif.

Drucker, Peter F. 1959. "Long-Range Planning." *Management Science*, April, pp. 238–49.

Hopkins, Davis S. 1972. *The Short-Term Marketing Plan.* New York: Conference Board.

Leise, Fred, and William K. Holstein. 1978. "The Computer: A New Member for Your Symphony Planning Committee." *Symphony News*, February, pp. 9–11.

Montgomery, David B., and Charles B. Weinberg. 1978. "Strategic Intelligence Systems." In *Analytic Approaches to Product and Marketing Planning*, edited by Allan D. Shocker. Cambridge, Mass. Marketing Science Institute.

Raymond, Thomas J. C., and Stephen A. Greyser. 1978. "The Business of Managing the Arts." *Harvard Business Review*, July-August, pp. 123–232.

Rothschild, William E. 1976. *Putting It all Together.* New York: American Management Association.

Ryans, Adrian B., and Charles B. Weinberg. 1978. "Consumer Dynamics in Nonprofit Organizations." *Journal of Consumer Research*, September, pp. 89–95.

Useem, Michael, and Paul DiMaggio. 1977. "A Critical Review of the Content, Quality, and Use of Audience Studies." In *Research in the Arts*, edited by David Cwi, pp. 30–32. Baltimore, Md.: Walters Art Gallery.

Weinberg, Charles B., and Kenneth M. Shachmut. 1978. "ARTS PLAN: A Model Based System for Use in Planning a Performing Arts Series." *Management Science*, February, pp. 654–64.

9

PRODUCT MANAGEMENT AND THE PERFORMING ARTS

Gene R. Laczniak

The purpose of this chapter is to explore the applicability of product management perspectives to the performing arts. *Product management* can be defined as the planning, organization, implementation, and control of products made available to consumers. More specifically, it involves activities such as setting product goals and objectives, determining the benefits (or utility) that product users derive, evaluating product performance, modifying existing products, and developing new product offerings. Broadly conceived, a product is anything that provides satisfaction or utility to the consumer. Therefore, a service such as an artistic performance (or a series of arts performances) can be viewed within the domain of a *product*.

The performing arts are a very special kind of product. They represent an aesthetic entertainment experience made available to the public. These artistic events are performed in a finite and fleeting time period rather than concretely manufactured like most products. Thus, the performing arts from a product strategy viewpoint are intangible and ephemeral as well as culturally important. In many respects this makes the performing arts product more difficult to analyze than a typical commodity or service.

In this regard, it is important to distinguish between the formal or core arts product and the augmented or peripheral arts product (Kotler 1976). The formal arts product is the artistic performance itself—the ballet, opera, symphony, play, et cetera, which is being presented. Related to the formal product is the core product in that the term *core product* embodies the consumer utility received from the formal product. It is the formal product from the consumer's standpoint. It represents the level of satisfaction or enjoyment that patrons receive from a particular artistic performance. On the other hand, it is also meaningful to delineate the augmented product— the total package of product features made available to the customer. For example, the augmented product might include the comfort of the seats in

the concert hall, the level of information contained in the playbill, the ease of parking for arts patrons, the courtesy of ushers, et cetera. The amount of utility received by customers from the augmented product can also be evaluated and is sometimes referred to as the peripheral product. A summary of this typology is presented in Table 9.1. If a particular organization offers a variety of artistic events—various formal products—this assembly of product offerings is called the product mix.

The formal arts product is typically controlled by the artistic director and the performers, not by the arts administrator nor by the audience. This is because an integral part of the creative, artistic process requires that the artist have control over the aesthetic product in order to inspire his audience and provide them with unique experiences. In contrast, in the realm of consumer goods, the marketing concept suggests that management should listen carefully to the expressed product attribute preferences of its customers as well as its distributors. This is less true in the performing arts, because one role of the artist is that of leading the audience, rather than reacting to its preconceptions. Thus, the essential artistic product (the formal product) is not determined primarily by the management of an arts organization.

It should be added, however, that control over the access of the formal product to the market can often be exercised. For example, within the arts delivery system (what marketers call the channel of distribution) presenters function as retailers by booking a series of arts performances that they feel will be attractive to their potential audience. In this role of retailer, the presenter or producer has nearly ultimate control over the artistic product in

TABLE 9.1

A Typology of the Arts Product

	A Narrow Conception of the Arts Product	A Broad Conception of the Arts Product
From the seller's standpoint	The formal product —the artistic performance itself (that is, the play, ballet, symphony, et cetera)	The augmented product —all the attributes connected with the artistic performance (for example, parking, the playbill, seating comfort, et cetera)
From the buyer's standpoint	The core product —the satisfaction consumers experience from the formal product	The peripheral product —the satisfaction consumers experience from the augmented product

Source: Compiled by the author.

that he or she can determine whether the product is offered in a particular market. In the arts organization itself the arts administrator has considerably less control over the formal arts product. Presumably, however, if the administrator and artistic director have a good working relationship, the artistic director will be open to market-oriented suggestions. Plus, the arts administrator is able to execute numerous adjustments to the augmented product that could make the total arts product much more palatable to a sought-after market segment. The importance of adjusting such "atmospherics" will be discussed later.

Most performing arts organizations operate in what is referred to as the "not-for-profit" sector. Since one major purpose of the arts is to enhance aesthetic sensitivity and refine cultural appreciation, the social value of such a mission cannot be translated easily into financial or economic terms. Nor is an accurate translation likely. As a result phrases like "efficiency," "optimize," and "maximize" have less importance in the lexicon of the performing arts than in the commercial sector.

Although profit is not and should never be the bottom line in a performing arts organization, there is a well-documented financial crisis facing the arts (Ford Foundation 1974). Inflation, the labor intensity of the arts, and other structured obstacles to increasing productivity seem likely to destine the arts to a long-term plight where production costs will exceed ticket revenues. Therefore, performing arts organizations will be pressured to generate a constant or improved level of aesthetic experience at a reduced cost. Product management can help achieve this goal. For this reason, this chapter espouses the viewpoint that an arts administrator can and should work in conjunction with the artistic director of a performing arts company for the long-run well-being of that organization (compare Raymond and Greyser 1978).

In summary, the performing arts are an intangible service instrumental in the development of our culture. The formal product is basically artist inspired and controlled, but major aspects of the augmented product can be managerially adjusted and improved. In addition, retailers of arts performances, such as presenters, can determine the product mix available in a particular market. The performing arts (for the most part) are subsidized by public and private donations because of their value to society and are properly part of the not-for-profit sector. However, because financial realities could cause a drastic reduction in the performing arts available to society, management perspectives that do not compromise artistic excellence have a definite place in arts organizations.

Finally, many of the principles and perspectives mentioned in this chapter are being used implicitly by some of the managers of U.S. arts organizations. The purpose here is to clarify the rationale for these practices, root them in marketing theory, and qualify their viability. In the discussion that follows, some ideas drawn from product management that have applicability in arts organizations are presented.

PRODUCT OBJECTIVES

An organization should have an overall direction or mission to which it aspires. Product objectives help refine what that mission should be (Hise 1977). For example, most arts organizations have goals that involve striving for artistic excellence and providing an aesthetic experience. Also, almost all performing arts organizations have a specified set of profit goals or target deficits. For some successful arts companies financial goals may or may not be the most critical criteria, although for every arts organization they are always important indicators of economic self-sufficiency. The financial goals that are set should be broken down into specific goals to be attained by each performance or performance series. In order to achieve such specificity, budgets should be consistently constructed, cash flows projected throughout the season, cost overruns investigated, et cetera. In addition to the obvious financial goals, a multiplicity of other arts product goals can help give direction to the organization. While few, if any, arts organizations operate without reference to some specific product goals, it is very useful if these goals are clearly stated and their realization is formally monitored.

Such product goals might include how the company is perceived by the arts community, the satisfaction levels of the audience, or the amount of publicity generated. Whatever the goals chosen, they should be realistic, explicit, and quantitatively stated, if possible. For example, a specific ballet troupe may have the goal of becoming "a first-rate dance company." While such a product goal is admirable, it is too vague to have tactical meaning. Instead, the following delineation of a goal might be more managerially useful:

Goal statement—We would like to be perceived as one of the three leading dance ensembles in the Southeastern United States by artistic directors of other ballet companies.

Goal measurement—Goal attainment will be measured each season by surveying a national sample of ballet company directors and asking them to rank order the dance companies in the Southeast on the basis of overall artistic excellence.

It should be noted that this hypothetical goal, selected only for purposes of illustration, could have been measured in other ways. The number of performances given or the amount of grant money received could have been used as surrogate measures of quality. Perhaps all of the measures mentioned could be taken and then weighted in a preagreed manner. The example was chosen only to illustrate how much more meaning a goal has when it is explicit and quantitatively measured. If the stated goal is achieved or nearly achieved, the company knows it is moving in the desired direction. Arts management has a concrete way of judging that the organization is attaining what it set out to do.

PRODUCT UTILITY

Traditional management theory stresses that products usually embody form utility. That is, a product has a combination of physical characteristics of value to the consumer. For example, when steel, rubber, glass, and other raw materials undergo multiple processing and culminate in an automobile, form utility has been created. Furthermore, various special product attributes in an automobile, such as air conditioning or a sun roof, have form utility for a certain consumer segment. In the case of the performing arts, form utility is replaced by a performance utility. Performance utility may be high or low, depending upon the artistic skill of the performers, the nature of the performance, and the "matching" of the program to the aesthetic preferences of the audience. Quite important, the concept of performance utility suggests that some measure of audience satisfaction should be developed for the performing arts product to have achieved its purpose.

The concept of performance utility also highlights the intrinsic nature of what the audience seeks in the performing arts. From the consumer's perspective, one is not "buying" a concert or a play or an opera; rather, one is paying for a satisfying aesthetic experience—enjoyment, the feeling of time well spent. This is the essence of the core product concept introduced earlier. In this sense the performing arts product and economic commodities have a great deal in common; neither will survive a prolonged time in the marketplace unless they provide utility to a critical mass of customers. This proposition holds even though the arts may be subsidized financially and executed brilliantly in the artistic director's opinion.

It should be added that the performing arts can also be analyzed with respect to other types of utility related to the product peripherals. Specifically, the arts administrator must ask how well the total arts product provides time, place, and possession utility. In other words, is the scheduling of performances convenient (time utility)? Are the benefits of attendance properly communicated (possession utility)? Is the location of the performances satisfactory (place utility)? For example, one theater company increased its Friday evening attendance substantially by changing its curtain time from 8:00 to 8:30, thereby permitting many potential customers time to enjoy a leisurely meal and still attend the performance.

Several organizations have experimented with locating a restaurant on the premises of the performance center. This tactic was based upon the accurate supposition that the arts customer viewed the evening as a "night out on the town" rather than just attendance at an arts performance. The location of a restaurant on the premises made planning the logistics of the evening easier, which seemed to contribute to improved performance attendance. Dinner theaters are the ultimate manifestation of this concept.

PRODUCT EVALUATION

Both the discussion of product objectives and product utility imply that good product management requires the continual monitoring of product performance (Rothberg 1976). In the realm of the performing arts, the evaluation criteria may be very different from those used in the profit sector. Specific evaluation criteria should stem from product objectives and the interpretation of performance utility that the arts organization believes to be most appropriate. For example, a particular symphony orchestra may conduct multiple evaluative measurements that are derived from its organizational goals. Among the evaluations conducted might be a survey of season ticket holders regarding their satisfaction with concert selections, a demographic and psychographic (or life-style) analysis of current patrons, a continual monitoring of unutilized seating capacity as well as current and projected profit/deficit, an analysis of all publicity achieved by the organization in the local and national press, and a systematic comparison of the orchestra with comparable symphonies (in terms of reputation, publicity generated, percentage of house capacity, musician salaries, et cetera).

Ideally, specific measurable benchmarks for each of these evaluations would be based upon set performance goals and stipulated in advance. Even if some of the goals prove unrealistic, the goal-setting and evaluation process force management to recognize some of the concrete indicators of the arts organization's success. It also formalizes an ongoing dialogue between the arts administrator and the artistic director.

PRODUCT SYMBOLISM

Products, including those generated by the performing arts, have an image or potential symbolism that is associated with their use and potentially contributes to their utility (Levy 1977). For example, the image one conjures of a man who drives a Porsche, smokes Havana cigars, and drinks Chivas Regal scotch is very different from that called to mind by the person who drives a Dodge Charger, smokes Camel regulars, and drinks Schlitz. The performing arts have an image—in fact, a spectrum of images—that can be slightly varied to enhance their viability and affect their demand.

The most typical image generated by the performing arts is that they are for "the cultured." Some analyses of the market for the performing arts have concluded that basically the arts appeal to the upper-middle class and upper classes and attempts to expand beyond this domain would be difficult and perhaps unrealistic (DiMaggio and Useem 1976). In other words, there is an elitism, distinguished partly by social class, associated with the performing arts.

Depending upon the type of symbolism with which a particular arts company wishes to be associated, the image of the arts as "elitist" can be nurtured or diluted. That is, for the purposes of audience development, a particular arts organization may want to communicate that attending the arts is the fashionable activity. On the other hand, in another community and situation, the concept that "the arts are for everyone" may aid performance attendance. This should not be interpreted to mean that arts companies should emulate the evasive chameleon and color themselves solely to inflate their audiences. Rather, an arts company, like a myriad of other products and services, has a distinct image in the mind of its audience and community. The astute arts manager will seek to determine what that image is and decide whether it is beneficial to maintain it. Otherwise, management can strive to change it by using various promotional tools. Survey research can be used to determine the image that an arts organization has in its area of operation.

ARTS PRODUCT DEVELOPMENT

All products can be improved so that they provide more satisfaction to greater numbers of people. The process of overseeing such adjustments is called product development. For example, even if one assumes the view that the ultimate arts market is constrained by factors such as education, social class, cultural openmindedness, willingness to experience new things, et cetera, seldom is every potential arts patron an actual arts goer. Thus, there usually exists a latent demand for arts performances that can be tapped. Product management theory suggests that managers who wish to expand demand or reverse declining demand have at least three product strategies to choose from: advocating new uses or applications for existing arts products, finding new markets for existing arts products, and creating entirely new arts products for new or existing markets. Each of these options is briefly discussed.

New Product Uses

In an arts perspective the introduction of new product uses requires illustrating benefits gained from attending the arts that the market may have not perceived. Market research can help establish what the current audience believes the existing benefits of attendance to be. Then the strategy of the administrative and artistic directors is to point out how presently planned arts performances can provide additional and perhaps previously unrealized benefits.

For example, market analysis for a repertory theater company may reveal that on a relative basis local university students are consistent attendees. The data may also suggest the performances are greatly enjoyed.

This does not mean, however, that this particular market is saturated or that benefits have been exhausted. The theater company might attempt, for instance, to work out an arrangement with the university's English department whereby performances would be provided as part of the requirements for certain college courses. Such a scenario increases the attendance of this particular market and also creates a rare situation where everyone gains. The theater company benefits by expanding its audience without incurring significant expense. The English department benefits by utilizing the actual performance of a drama presently being studied. Students benefit by having their studies "come alive" on stage. Many arts companies today ignore ready opportunities that are present in existing markets. These opportunities can translate into increased patronage by current arts goers simply by making additional benefits of attendance a bit more concrete. Parenthetically, the economic realities of some arts companies indicate that an incremental performance may result in the loss of more money.

New Markets

Finding new markets for the performing arts is the traditional strategy recommended for coping with the financial crisis facing the arts. This strategy is consistent with the posture taken by the National Endowment for the Arts that holds that "the arts are for everyone." Many arts organizations are currently using multiple new market strategies in an attempt to expand their appeal. The Milwaukee Symphony Orchestra has, for example, concert programming targeted at high school students; a Popular Artist Series, which combines the symphony with rock or folk musicians; a series of morning coffee concerts aimed at women's groups; and a limited number of noontime park concerts for passersby; special programming for primary schoolchildren and senior citizens. Efforts along these lines not only help mitigate financial exigencies but also contribute to the social goal that cultural exhibitions should be broadly diffused to the community. Marketing research can help specify what markets can most easily be tapped by varying the performing arts offering.

It is also important to recognize that some members of the arts community look at such efforts as a dilution of performing arts quality (Fromm 1978). They argue that while an adolescent might attend a concert held in conjunction with a rock star, that individual is unlikely to attend a season's regular performance. These critics further contend that such activities place the arts on a level with TV soap operas, because they try to "peg" the arts at the lowest common denominator of taste in the society. They feel that ultimately such activity will compromise artistic excellence. Alternatively, lack of systematic effort to expand interest in the arts could doom the arts to the projected financial crisis. Moreover, widespread cultural education would be stifled.

New Products

In the realm of the performing arts, new product strategy translates into initiating some substantially different programming in the case of a specific arts market. For example, a repertory theater company in the Plains states—doing mostly traditional and classical theater—was suffering from a lack of patronage. One summer the company decided to go on tour in the region with a series of one-act plays, including some comic adaptations with characters identifiable with the life-style of the local area. The programming also included traditional fare. The effort generated substantial publicity, was very successfully received, and provided the basis for both expanded audiences in the forthcoming season as well as the infusion of some foundation money to further upgrade the company.

From a community standpoint, new products can also be developed to replace currently unsuccessful efforts. For instance, a community may not be supporting the local opera company. Market research may indicate that the situation is unsalvageable. Specifically, the market for opera is limited, audience satisfaction is low, operating costs are skyrocketing, available grant money has been tapped, et cetera. However, research may also indicate that there is a market for a choral group, especially one capable of modern and seasonal renditions in addition to traditional choral arrangements. Such information can provide a foundation for launching a new arts product in the community, thereby filling some of the void left by the likely demise of the opera group. Some persons would argue that the replacement of an opera product with a choral product is a step down the cultural ladder for the community of concern. Leaving this philosophical question aside, the example suggests that at the community level, an arts organization providing subsidies can oversee the development of the performing arts in an area by monitoring the composition of the product mix (that is, the performing arts available as a service to the community).

THE PRODUCT LIFE CYCLE AND THE PERFORMING ARTS

All products—including the performing arts—have a time dimension that can be associated with their acceptance into the marketplace. Marketers call this relationship the product life cycle (PLC) (Wasson 1978). Essentially, the PLC charts the sales volume of a product over time. In the case of the performing arts, attained audience capacity might be substituted for sales. Marketing consultants who have studied the successes and failures of many products have found a typical S-shaped curve, which seems to emerge for many products. That is, during the introduction stage of a new product, sales occur rather slowly; next, they increase at a more rapid rate—the growth stage; eventually they stabilize—a period termed maturity; finally, the product outgrows its usefulness and sales decline. The typical product life cycle along with some possible objectives is illustrated in Figure 9.1. To

FIGURE 9.1

The Typical Product Life Cycle and Some Possible Arts Organization Goals

Sales

Introduction

Growth

Maturity

Decline

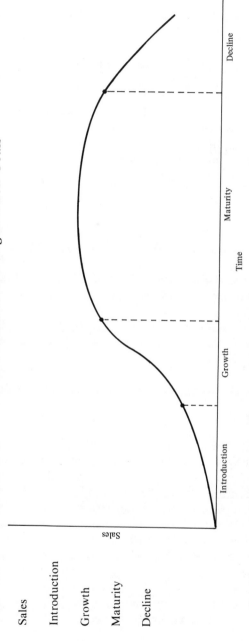

Possible arts organization goals at each stage of the PLC: Build *awareness* of arts company or availability of the art form. Develop in the potential audience the arts attendance habit; seek season ticket buyers. Modify arts product offering; maintain audience interest and loyalty through special promotions; experiment with new forms of programming. Withdraw the arts product from the market before unacceptable financial deficits are reached.

recapitulate in less abbreviated form, the product life cycle measures the sales or market acceptance of a product or service over time. The "stages" often associated with the PLC are discussed in the next five sections.

Introduction

For an arts product the introduction period most often would translate into the period of time when a company or art form is new to the community. Strategy during the introduction period involves making the potential audience aware that a particular arts performance will occur. Practically speaking, building awareness will require the formulation of an initial promotional campaign. In addition, this is a shake-down period for management during which ticket distribution policy must be established, advance publicity generated, and ticket prices set.

Growth

For a performing arts organization, growth is the period of time when the company or art form has met with initial favorable response (good reviews) and encouraging audience attendance (increased ticket sales). Strategically speaking, this is the point during which the arts manager would like to develop "loyalty" among patrons in order to capitalize on the currently favorable response. For example, strategies to convert single ticket buyers into season ticket holders would be undertaken. Efforts to sell blocks of tickets to corporations and social organizations would also be explored.

Maturity

During the maturity period, audience levels for available performances have stabilized. This may have occurred for various reasons: the available market has been developed, the novelty of the arts company has worn off, competition for the arts dollar has increased, et cetera. In any event the maturity stage may prevail for an extended period of time, with the company attaining artistic and occasionally audience/donor success (for example, the Metropolitan Opera). In general, arts managers must strive at this time to keep the company out of the decline stage. For example, specially priced performances might be offered, the benefits of continued attendance could be reiterated, new markets could be developed, and so on. Because a company at the maturity stage is particularly vulnerable to reduced sales (that is, audience attendance), the activities of competitors must be carefully monitored.

Competition should be broadly defined; it is not only composed of other resident and touring companies but of all organizations that strive for the consumers' recreational dollars. In this sense, sporting events, the state fair, the local zoo, the cinema, and many others should rightfully be viewed as the competition. Often, one of these competitors may initiate a marketing program, such as a promotion, which can be borrowed and adapted successfully by the arts organization. Ticket discounts for senior citizens is a concept borrowed by many arts organizations from their broader competition.

Product Modification

One major way of extending the maturity stage of a product is through product modification. In an ideal world the success of a performing arts company would be determined solely by how competently they executed their artistic function. At times a company that performs well simply has an inappropriate image in its market area. Such a situation can sometimes be rectified by changing that image, thereby leading to audience development and financial stability. The area of "image" management relates to our earlier discussion of symbolism. It is a combination of product and promotions management, because an effective change in image often requires some slight product modifications in addition to promotional changes. Thus, a dance company may be equally adept in performing classical and contemporary dance. Until now it may have relied more upon classical performances. This may have also been communicated in their promotional pieces (posters, brochures, newpaper ads, et cetera), thereby contributing to a conservative and traditionalist image. Suppose research indicates that a definite market segment exists for contemporary choreography. By changing the season slightly, perhaps doing three contemporary and two classical ballets instead of just the opposite, and stressing the modern dimensions of the company's programming in its promotions, the company can attract the modern dance enthusiasts without losing those with a preference for more traditional fare.

A symphony orchestra recently executed a similar strategy. Facing a 40 percent turnover of season ticket holders, a survey of patrons was launched to determine the problem. Research suggested that a significant number of patrons disliked the inclusion of many pieces by new and unproved composers. The survey also gathered data on audience preference. Using this information, the orchestra modified the mix of its selections for the coming season modestly. Mainly their promotions stressed the compositions and guest artists with documented audience appeal that would be appearing. The promotional campaign theme "Have We Got a Season for You" spoke directly to this point.

Decline

At some point many products, including organizations, outlive their usefulness. An astute arts manager should be able to recognize when such a situation is developing and extricate the product from the marketplace in the least painful way both financially and socially. This is not to argue that an arts organization facing declining attendance should automatically cease functioning. Previously, various strategies (developing new markets, new products, et cetera) were discussed that can be used to bolster an insufficient audience demand situation. On the other hand, certain circumstances can make the withdrawal of an arts product from the market a logical conclusion. For example, one regional dance company operated for several years with the minimum acceptable level of audience support—a "shaky" maturity stage. Two things happened; a dance company in a neighboring city grew quite strong, attracting superior dancers, and occasionally performed in the first dance company's home city. Second, national dance companies began to tour the area more frequently, siphoning off dance enthusiasts. Attendance sagged and evidence suggested that most of the potential dance market had already been tapped. The company disbanded. The decision as to whether an arts product should be eliminated is never easy, but it is less painful if a decision-making process has been specified in advance. For instance, a specific company facing an uncertain upcoming season may specify the following sequential plan: (1) if audience levels fall below 40 percent of capacity for the season *and* the financial deficit exceeds $40,000, execute option (2); (2) exhaust all possible sources of subsidy and seek merger with another regional company; if (2) fails to improve this situation, execute (3); (3) dissolve the company.

The process of managing an arts organization during its decline is not pleasant. From the standpoint of the individual arts company, the decline stage of the PLC may be the most difficult. Few arts companies will calmly help manage their final "goodnight." Their commitment to their artistic function prohibits the surrender to economic realities. More often financial considerations will force them out of operation but only after considerable "kicking and screaming." This resistance is understandable because of the dedication most artists have to their area of endeavor. However, a preplanned withdrawal should be preferred to the demise of a company brought on by shortsighted financial management. In conclusion the PLC can serve as a useful organizing framework for arts management decisions. While the examples above have focused primarily upon the life cycle of an arts company, the life cycle of a particular art form or production could also be usefully charted.

NEEDED RESEARCH IN ARTS PRODUCT MANAGEMENT

Two areas of performing arts management that seem particularly fruitful for the application of marketing research and analysis in the near

future stem from the topic of competition. First, arts organizations need to acquire a better understanding of their competition. As mentioned earlier competition consists of more than other arts organizations. Disposable income allocated to sporting events, individual recreation, festivals and fairs, et cetera, take away consumer funds otherwise available to be spent on the performing arts. An analysis of the life-styles of current and potential arts patrons, based upon market research, can help the arts manager establish precisely what organizations and events should be viewed as the competition in his/her particular market area.

Second, arts organizations should attempt to establish a systematic marketing information system (MIS), which will monitor the kind of programming and promotion that other arts organizations around the country, as well as the broader competition, are utilizing. Imitation of the successful strategies of other organizations should not be overlooked or viewed as unoriginal. IBM did not invent the computer, nor did Texas Instruments invent integrated circuitry; yet both firms dominate their industry because of their creative imitation. An eye to the strategies of similar organizations can frequently yield a plethora of product management experiments that can be applied to the manager's own organization.

CONCLUSION

Because the formal product aspect of the arts is primarily artist controlled, traditional product management strategy requires more adaptation to the performing arts than other areas of marketing, such as promotion and pricing. However, the domain of the augmented product provides considerable opportunity for the arts administrator to exercise control over the arts product. In addition, further down the channel of distribution, the arts presenters or retailers exercise maximum choice over the arts product in their series. In the near future it is hoped that arts organization managers and arts programmers will attempt to utilize, to a greater degree, some of the insights provided by product management.

REFERENCES

DiMaggio, Paul, and Michael Useem. 1976. "Social Class and Arts Consumption: The Origins and Consequences of Class Differences in Exposure to the Arts in America." *Theory and Society*, March, pp. 141–62.

Ford Foundation. 1974. *The Finances of the Performing Arts.* New York: Ford Foundation.

Fromm, Paul. 1978. "The Cultural Retreat of the Seventies." New York *Times*, July 23, pp. D1, 24.

Hise, Richard T. 1977. *Product/Service Strategy.* New York: Petrocelli Charter.

Kotler, Philip. 1976. *Marketing Management: Analysis, Planning and Control.* 3d ed. Englewood Cliffs, N.J.: Prentice-Hall,

Levy, Sidney J. 1977. "Symbols by Which We Buy." In *Classics in Consumer Behavior,* edited by L. E. Boone. Tulsa, Okla. PPC Books.

Raymond, Thomas J. C., and Stephen A. Greyser. 1978. "The Business of Managing the Arts." *Harvard Business Review,* July-August, p. 124.

Rothberg, Robert R. 1976. *Corporate Strategy and Product Innovation.* New York: Free Press.

Wasson, Chester R. 1978. *Dynamic Competitive Strategy and Product Life Cycles.* Austin, Tex. Austin Press.

10

INTERACTIVE BEHAVIORS OF ARTS CONSUMERS AND ARTS ORGANIZATIONS

Eric Langeard and Pierre Eiglier

The emergence and development of an art is by definition strongly related to a specific value system. It is also related to an economic system of production, distribution, and consumption. More and more, economic and art historians are developing insight into the complex interactions existing between art producers or organizations and consumers. (compare Attali 1977; Duby 1976). In this section we intend to analyze those interactions and explore the implications for action.

We shall endorse a definition of art given in a recent paper (DiMaggio and Hirsch 1976): "We will define 'art' to include not only the so-called fine arts, but also popular culture, design, and the institutional networks which produce art and connect publics to producers." Two reasons for the choice of such a broad definition are: first, this definition makes it possible to take into account the diversity of cultural needs of a given population; second, it provides an opportunity for analyzing both the output of arts organizations totally or partially dependent upon a public cultural policy and the output of the culture industry (in which are included amusement parks, discotheques, films, and the like). Specifically, we shall address the problems of those organizations that have direct contact with consumers on a regular basis. Painting, sculpture, the composition of a new symphony, or the writing of a new play are outside the focus of this chapter, which deals with the display of paintings and sculpture, the acting of plays, and symphony performances.

As marketing scholars we would like to emphasize the arts organizations' characteristics as service organizations. While their nonprofit dimension distinguishes them from profit organizations and may require specific treatment of the motivations of various suppliers of resources, the salient problem, from a marketing management point of view is the interactive process between consumers and art organizations, a problem shared by most other service organizations.

INTERACTIONS BETWEEN CONSUMERS AND ART ORGANIZATIONS

There are three main areas that will be explored here relating to the interactions between consumers and arts organizations. Why is the interaction with their clients central to the marketing management of arts organizations? Could the interactive paradigm be more helpful than the unit paradigm for understanding art consumer behavior? Can we describe the production, distribution, and consumption of art and culture as an interactive system?

The Centrality of the Interactive Process

Like most other service organizations, arts organizations have direct contact with consumers, even though in many cases they ask intermediaries to fulfill a specific task (for instance, selling tickets through branch outlets). It is not necessary to dwell on the intangibility of arts products, although in this area many ramifications are felt in consumer behavior (for example, the impact of word of mouth, the active search process, or the difficulties in creating customer confidence and building a good image).

Due to the intangibility of their services, arts organizations have to manage simultaneously production and consumption, which involve direct interface with clients. Consumers have to rely upon surrogate attributes, such as the quality and nature of the interaction with the organization, in order to measure their satisfaction. These interactions (or the lack of them) with professional people in a controlled environment are frequently the basis for good or bad aesthetic experiences. That experience, among individuals and for the same individual, may vary according to differences in their own behavior and differences in the effectiveness of organizational inputs, which are far from being standardized or subject to strict quality controls.

Many service organizations have difficulty recognizing the effect on their operations of simultaneous production, consumption, and direct interface with clients; yet, consumers do participate in these organizational operations, usually in a passive manner but at times quite actively. When administrators design procedural norms, they unconsciously expect—based on past experience—some kind of client participation. Arts organizations have long recognized the clients' participation; thus, the performing arts need an audience to reach high artistic levels. As part of that participation a symphony audience is supposed to comply to unwritten norms: silence and immobility. Museum visitors are supposed to walk slowly and talk quietly. If one customer behaves unexpectedly, the behavior is usually easily halted with the disapproval of the audience. However, if a significant group of customers do not apply the common rules any more, the overall procedures have to be changed or the quality of the consumer's experience is going to be

drastically reduced. Without a common "feeling" shared by all those concerned, no improvement can be expected.

Another kind of participation is possible—participation in the improvement of the overall efficiency of an artistic or cultural presentation. Arts administrators should be encouraged to look for the active help of consumers, because productivity gains are very often dependent on drastic changes in consumer behavior, which can be precipitated, for instance, by the implementation of self-service in a library or self-guided tours in a museum, at a simple level. It is interesting to note that at least in Europe many people advocate a minimization of the gap between professionals and consumers and between creative art producers and passive art patrons. We may reach a point where for cultural and economic reasons it is going to be necessary to increase the active physical and/or intellectual participation of consumers (in addition to the more passive spectator participation) in the production of arts.

These three characteristics—intangibility, direct contact, and consumer participation—explain the importance of the interactions between consumers and art organizations from a marketing management point of view. The appendix to Chapter 10 lists some of the main problems in these interactions for arts organizations and consumers.

Arts Consumer Behavior and the Interactive Paradigm

Marketing has many useful concepts to offer to arts administrators, but, unfortunately, the study of consumer's behavior has overemphasized their relationship with products before and after purchase and neglected consumer interface with the business organization. Both in the United States and Europe, scholars exploring the area of industrial and service marketing are convinced of the importance of what has been called the buyer-seller relationship. The richness of the observations has encouraged two authors (Bonoma and Bagozzi 1977) "to recognize the basically social character of the (marketing) activity." If this can be said of marketing, the social character of cultural activities is even more obvious. The combination of the two—marketing and the arts—is a good base in need of "a new perspective and different set of assumptions from marketing," which has been called the interactive paradigm. If substituted for the traditional unit paradigm, the interactive paradigm would improve the usefulness of marketing analysis. Marketing deals with exchange; therefore, a transactional viewpoint should lead the study of any particular situation.

According to the unit paradigm, each consumer is affected by stimuli that, in contact with processes internal to the consumer, yield a probability of purchase response. Such a model takes an atomistic and mechanistic view of human behavior. It may be useful for explaining the buying and consumption of basic, simple consumer goods. "Marketers, advertisers, and

sales staff have consistently treated consumers as stimulus-response systems, as entities to be acted upon rather than entities to be interacted with. The latter, but not the former, implies a mutual or joint adjustment of needs, outcomes and actions" (Bonoma and Bagozzi 1977, p. 12).

However, most marketing behaviors—and the marketing of arts belongs to this group—"occur as they are embedded in a social setting of encounters with others. The basic and most prominent variables in such interactions are not necessarily the stimuli to which the organism is exposed, but rather the character of interdependence relationally shared with the other parties to consumption" (Bonoma and Bagozzi 1977, p. 10).

This interactive view of marketing is most appropriate for the study of the diffusion and acceptance of arts and culture. The consumption process is much better explained as the result of reciprocal influences between the "provider" (for example, the museum, the opera) and "the recipient." Many arts organizations have a "natural" segmentation of their clientele without much help from a marketing expert. This segmentation is the outcome of the mechanism of interdependence, and any new season's program can be viewed as a negotiated settlement. Sometimes two segments of clientele are literally fighting against each other. In the southern part of France, operas have an influential clientele, who do not tolerate anything but *bel canto*. Any attempt to play modern opera and to please another, more eclectic clientele results in a fight. We have not only a bargaining process between arts consumers and arts organizations but also a very complex system of power and influence.

The development of the new museum, Centre Pompidou, in Paris is an interesting case. From the very beginning the well-stated goal was to bring an interdisciplinary-based modern art to a popular audience (a mass market) with a maximum freedom of choice and action. Based on the results of the first year, this objective seems to have been reached: 6 million visitors, with a rapidly growing segment of repetitive users. However, it is a real challenge both for the professionals and for the consumers to integrate the interdisciplinary dimension and manage these encounters with modern creation. A segment—a huge one—of the population is self-eliminating. Traditional, well-taught, rather passive amateurs are excluding themselves from the center as well as many average customers who have not had enough education, motivation, and independence to cope with this self-service, dynamic, and exciting arts center.

For most arts organizations market segmentation is not the result of a sophisticated marketing approach. Recently, many attempts have been made to attract new segments and enlarge the audience; very few have been successful. The interactive paradigm helps us understand that this is so because transactional interdependence is not easily organized between a "provider" and different segments of "recipients."

Arts consumer behavior would be better understood in relation to the performing arts, the museums, and the like if we look at these encounters as

a process of reciprocal influence, as a bargaining process. From a marketing theory point of view, the substitution of the interactive paradigm for the unit paradigm helps to take into account the centrality of the interactive process.

The Production and Consumption of the Arts as an Interactive System

In direct relation to the interactive paradigm, we would like to answer the third question raised in the chapter's introductory paragraph and try to describe the production, distribution, and consumption of arts and culture as an interactive system. In a paper published earlier we analyzed, in general terms, the service organization as a system (Eiglier and Langeard 1977b). Borrowing the concepts from this previous paper, we shall focus on arts organizations, describing the basic elements of the system and the relationships between these elements.

The system is based on the interrelation of three elements: physical support, contact personnel, and consumers. The combination of these three elements is necessary for the production of the service, and the quality of the relations that are established will contribute to the quality of the resulting service.

The Consumer

The concept of consumer does not require much explanation. Intellectual or spiritual involvement is a key ingredient to artistic success, not so much on an individual basis but as an audience. Physical participation is also required in many aspects of art and culture, and sometimes this participation is very active. Summer festivals are interesting cases in point. Concentrated along the Rhone River, in different cities, they attract a segment of the population, eclectic in their artistic tastes and willing to spend a lot of time in preparation for their summer vacation comprised of modern ballet, Italian opera, avant-garde films, and traveling back and forth from one place to another. Usually passive physical participation is also required (such as audience silence or formal dress).

Physical Support.

Physical support is the tangible support that is necessary for arts production. In cases such as museums or libraries, art objects and books are directly at the disposal of consumers, which entails planning, preparation, and management. In other cases, contact personnel coach the audience on how to use the materials, as for example with a variety of crafts.

For the production and consumption of arts the physical environment is a decisive, enhancing factor. The architecture of the Centre Pompidou has been a controversial issue. from a marketing point of view it could be said

that this provocative architecture was needed in order to raise the awareness of a rather conservative community. Sometimes a closed environment appears restrictive and patrons go elsewhere. Therefore, the festival of Aix-en-Provence, for example, has presented a program of classical music in the streets during the evening hours.

The Contact Personnel.

The contact personnel include both the sales staff and all other individuals in contact with the public. This means that professionals such as artists, technicians, and administrators share the collective responsibility of maintaining pleasant contact with the public. This is best exemplified in the "smiling" tradition of the circus. Assuming all technical or artistic expertise as being equal, the impact of an employee who meets customers' expectations means a great deal from a marketing point of view.

The production of the arts rests fundamentally on the various interactions of these elements. However, to obtain a more complete view of the system, it is necessary to add two more elements: the internal organizational system and the other clients of the arts organization.

The Internal Organization and Consumers.

If the physical support and the contact personnel are highly visible to the consumers, those personnel are conditioned by the internal organization, which sets objectives and controls the operations performed. These include all classical functions such as accounting and personnel management and also certain functions more specific to arts organizations. All of these have a direct influence on the visible elements.

Art is usually not offered to a single person at a time—there are usually several people or even a crowd in a museum, a theater, or at a festival. Consider two people, A and B. Both may or may not have the same type of relationship with the physical support and the contact personnel. Since A and B are in physical proximity, contact between them may be established; each may influence the quality of the show as it is perceived by the other and the satisfaction that is derived from it. For example, the mixed audience of a huge and lively festival located in an historic, medium-sized city (namely, Avignon, France) has a negative impact on the overall satisfaction derived by many people. Some resent the traffic jams and the invasion of cars; others blame the dirty streets and parks on young travelers camping all around. The management and control of crowds is not an easy process; many amusement parks have been hurt by an "overdose" of waiting lines.

What we call "ambiance" is based on the relationship between consumers, between consumers and the contact personnel, and between the physical support and the consumers. All are important elements of efficiency and marketing success.

The Relationships between the Elements.

One can break down the relationships into three subgroups: primary relations—some of them are isolated and individualized and others are duplicated; internal relations—these link the visible part of the art organization to the invisible part; and concomitant relations—attributable to the presence at the same time of different consumers. From a marketing point of view, we believe that these relationships have to be taken into consideration in order to recognize the basically social character of cultural activities. It is possible to apply the interactive paradigm to the production and consumption of art and culture and examine the implications.

IMPLICATIONS FOR ACTION

The implications for action are threefold. First, it is essential to understand some of the most important dimensions of the marketing complexity of arts organizations and how to reduce them. Second, to take into account the interactions between consumers and arts organizations, one has to assign two distinct functions to the marketing management of these organizations. Third, instead of unsuccessfully enlarging their audience, arts organizations should concentrate on the development of consumer membership.

Dimensions of Marketing Complexity

The marketing complexity of arts organizations is derived primarily from the social character of cultural and artistic activities. It is unlikely that the marketing complexity will be eliminated; however, to reduce this complexity it is necessary to define the elements of the arts system and understand the nature, degree, and objectives of the relationships among them. Some of the dimensions to be considered are the following:

1. Arts organizations offer a multiplicity of services. Even though an organization is designed to provide a single service, in fact, it offers several. There is a core service as well as a group of peripheral services that influence the quality of the core service. If one of the peripheral services is not up to standards or if an inappropriate set is offered, it can affect the consumer's satisfaction with the service as a whole.

2. Arts organizations are highly visible and invisible at the same time. It is the physical environment of the arts organization and the services it provides that are visible to the consumer. Though, unaware of it, the consumer has limited contact with the important internal organization. It is only when the system fails, for reasons due to an internal problem, that management becomes visible to the consumer.

3. Organizational size must be considered in location and distribution decisions. The scope and depth of the professional staff will be reflected in the marketing plan.

4. Marketing strategy must be "sold" to those staff members who are to implement it before any persuasive effort is made toward the consumer.

5. In arts organizations marketing is intimately linked with the production process. Therefore, operations personnel will have considerable power and influence in marketing management, which may cause conflict and marketing problems.

The Two Functions of Marketing Management

Marketing and operations management are so integrated that the basic approach of marketing management, as it has been developed in the consumer goods area, does not entirely fit the needs of service organizations and, more specifically, ths needs of arts organizations. To improve efficiency it is necessary to identify two distinct functions: mass marketing functions and interactive marketing functions (Gronroos 1978). Mass marketing functions have to be performed because "a single service consumer is rather unimportant to the total demand, which is built up by a large number of these relatively small buyers." To a large extent, a systematic survey of the behavior and attitudes of consumers may guide the marketing planning; advertising and pricing may be handled as traditional mass marketing activities, but they are secondary to the interactive marketing functions.

The crucial part of arts marketing is the management of the interactions between the audience and the arts organization. Most efficiency improvements imply a redistribution of roles, the audience role included. It is a marketing responsibility to communicate with the audience, to explain why an improvement is needed and why it cannot be done without full cooperation from consumers. This communication might be supported by mass media; however, most of it is effectively done on a small group basis, even on an individual basis. Facilitated by direct contacts between organizations' members and clients, communication is not the exclusive territory of so-called marketers. Everybody may have a positive or negative impact, not only through what is said but also through nonverbal behavior and even more through performance. Thus, the interactive marketing functions are heavily dependent on the quality of the management of human resources of the overall organization.

As we have said before, adding interactive marketing functions to the mass marketing functions is a recognition of the extreme functional interdependence that exists in arts activities. The two groups of functions should be kept apart. Within the structure it has to be decided who is going to manage the interactive marketing function—the marketing department or someone in charge of operations? It is certainly wise to delegate such a responsibility to someone who has easy access to or contact with the other functions, and a marketing background is not the most important criterion.

The Development of Client Membership

If an arts organization wants to implement interactive marketing functions and be successful, one has to understand the behavior of individual customers and groups of customers in the domain of arts and culture. Marketing research has to be solicited to participate in the reformulation of the system to provide a better understanding of the kinds of interaction consumers want to have with a specific arts organization.

From a managerial point of view, as has been stated earlier, the development of many new processes should involve consumers' participation. Several questions need to be answered such as, How do consumers behave as producers or deliverers of arts services? Why do some consumers willingly and actively participate in the service process and others do not? Are such differences related to situational variables or based on individual predispositions or a combination of both? Does active physical participation in the process imply a kind of psychological commitment to the arts organization? This last question is related to the issue of customer membership, which has been researched in the areas of education and health.

It is worthwhile to develop consumer membership—that is to say, to develop a desire for close association with the organization or even a willingness to be part of it? It is a useful policy that many small arts organizations have had for a long time.

A policy of membership becomes problematic in large-scale or multisite arts organizations because of the plurality of people and the division of labor. One of these problems is the presumption of more or less formal membership. Another problem is related to the existence of highly asymmetrical reciprocal relationships between the organization and the people. The sources of asymmetry are twofold: one is the concentration of competence and authority on the nonconsumer side; the second is the limited consumer's membership role as opposed to full-time purveyors of art or cultural services. The main consequence of such an asymmetry is alienation of the members and the development of mistrust, which result in a loss of their participation with the professionals. A cooperative attitude and an alienated attitude cannot be reconciled. The former is derived from the development of the consumers' membership.

The membership concept may also help some basic strategic choices. According to two authors (Lefton and Rosengren 1966), service organizations may vary in their concern for consumers along two major dimensions. The first one, longitudinality, refers to the service organization's interest in the future biographical career of the person. It may range from a highly truncated span of time to an almost indeterminate one. The emergency unit of a general hospital, any first-class gastronomy restaurant or the Louvre museum do not expect to serve the same person again and again. They are committed to instant success. The chronic-illness hospital or the local symphony orchestra serve a stable group of consumers for an indeterminate

period of time. They are committed to adjust their offerings to the consumers' life cycles.

Laterality, as a second dimension, refers to the extent to which an organization is responsive to the reaction potential of its users. Plus-laterality indicates a high degree of organizational responsiveness, while minus-lateral organizations make little or no effort to permit user reactions to influence formal operations. Lateral and longitudinal interests in consumers may vary independently of one another; therefore, four different categories of arrangements are possible. The best arrangement made by an arts organization is the one that fits the expectations of its consumers. These expectations vary according to the service situation and consumers' characteristics. The theaters that have redesigned their buildings and modified their operations in order to serve a dinner before the play are by all means plus-lateral organizations, allowing consumers' needs to influence formal operations. Expressing plus-laterality, they extend the scope of interest to their users' contemporary needs and desires. The museums that take care of the "frequent visitor" are trying to be plus-longitudinal organizations.

The search for an optimal arrangement raises the following issues: the plus-lateral-plus-longitudinal arrangement is not the optimal one in most circumstances, and from an organizational point of view it is the most complex kind of arrangement. What combinations become important in relation to the organization's life cycle? Why do arts organizations active in the same domain differ in responsiveness to the customer?

In order to operate smoothly service organizations have to obtain from their customers a variable amount of compliance based either on conformity or commitment or on both at the same time. A plus-lateral-plus-longitudinal arts organization has to obtain both conformity and commitment. A minus-lateral-minus-longitudinal arts organization has almost no conformity problem and no commitment is expected.

A typology of the nature of the relationships existing between consumers and organizations would be very helpful. Such a typology could be divided into three main categories: activity passivity, guidance cooperation, and mutual participation relationships. The real choice is between the last two, which are mostly different in terms of the amount of time, energy, and skills the consumer can and will invest in order to obtain a satisfactory service.

Finally, it has to be decided which one of the three kinds of consumer participation is the most appropriate: exchange of information, action, or accountability. In many European countries the budget for culture and arts is not going to be increased, and the experts suggest an increased mobilization of arts consumers at the local and regional levels. This may be temporary and very limited, such as volunteered help; others may wish to develop a stable plan for action based on the creative capacity of local resources. Also, from that point of view the concept of consumer membership might offer useful opportunities for managerial action. All of these

organizations, and more specifically those with multisite operations, have to link local customer feedback with local action. Besides tracking the delivery of current services, it involves customers in the process of improvement. If the investigation is well personalized, it contributes to the strengthening of the relationship between organizations and their customers. "A new kind of motivated customer can result: one who is not just satisfied but who also actively encourages others to patronize." (Daltas 1977).

CONCLUSION

Arts organizations have to face the marketing complexity of their operations. Instead of overestimating the potential benefits of mass marketing, the best allocation of resources is a long-term investment in an interactive marketing function well integrated to the rest of the organization. Finally, very few arts groups can successfully reach different customer segments at the same time, and they have to expect a much better payoff through the development of audience participation and membership.

APPENDIX TO CHAPTER 10

Organization and Client Problems of Interaction

Problems for the organization:
1. Arts organizations cannot maintain inventories.
2. Communication with the public is difficult.
3. Pricing is a complex policy.
4. There is no patent protection (except on names) for arts organizations.
5. The employee/consumer interface is uneasy.
6. Physical setting and environment are important to the quality of the service delivered by arts organizations.
7. The growth in size of the audience is highly dependent on the development of a network facilitating the selling of tickets, the selection of seats, transportation, and so on.
8. The process of artistic or cultural innovation requires a careful assessment of consumer reactions.
9. The standardization of arts operations has to be pursued, carefully avoiding any negative impact on the artistic work.

Problems for the client:
1. Confidence in the organization has to be permanently sustained.
2. His search process is usually difficult and has to be facilitated.
3. Word of mouth is the leading channel of communication.
4. Arts consumers have a tendency to be very emotionally involved with arts organizations or some parts of them.

REFERENCES

Attali, Jacques. 1977. "Bruits-essai sur l'économie politique de la musique." Presses Universitaires de France.

Bonoma, Thomas, and Richard P. Bagozzi. 1977. "The Dyadic Paradigm: The Second Plateau." Working paper, University of Pittsburgh.

DiMaggio, Paul, and Paul M. Hirsch. 1976. "Production Organizations in the Arts." *American Behavioral Scientist*, July-August, p. 736.

Duby, Georges. 1976. "Saint Bernard-L'art cistercien," Annales du Musée Guimet-Paris

Eiglier, Pierre, and Eric Langeard. 1977a. "A New Approach to Service Marketing." In *Marketing Consumer Services: New Insights*. Cambridge, Mass.: Marketing Science Institute.

————. 1977b. "Services as Systems: Marketing Implications." In *Marketing Consumer Services: New Insights*. Cambridge, Mass.: Marketing Science Institute.

Gronroos, Christian. 1978. "The Nature of Service Marketing." Working paper, Helsinki.

Lefton, M., and W. R. Rosengren. 1966. "Organizations and Clients: Lateral and Longitudinal Dimensions." *American Sociological Review*, December, pp 802–10.

III

MARKETING RESEARCH AND ARTS MARKET ANALYSIS

INTRODUCTION TO PART III

Good information is vital for effective decision making. Marketing decisions require a clear and valid understanding of market structure and dynamics. The methods and techniques of marketing research provide a systematic approach for gathering, generating, processing, and facilitating the use of market information.

In the arts, audience research has become relatively widespread and synonymous with the concept of market research for many administrators. Yet, most arts administrators have not found research results particularly helpful or insightful. Ambivalence among administrators abounds. Pressure for research studies continues to come from many directions, particularly boards and funding organizations; managerial norms emphasize research activities; and most arts administrators are truly uncertain of market characteristics. Why, then, has research had such meager impact on the decisions of arts administrators? This is a fundamental concern of this section.

Three issues provide the basis for the discussions in this section: technical quality has often been suspect in arts marketing research, the substantive problems addressed in arts market research often have been trivial and marginally relevant to the information needs of administrators, many arts administrators do not have the skills to guide or interpret marketing research. The basic purposes of this section are to enhance the arts administrator's understanding of the market research process and to demonstrate the broad scope of substantive problems requiring marketing research.

In chapter 11, "Toward Bridging the Utility Gap in Marketing Research for the Arts," Stephen A. Greyser explores the context and content of

the marketing research process in the arts. He sees the quantity of research growing but is disturbed at its uneven quality and, above all, its weak utility for arts management. Greyser's prescription for reducing the utility gap is to anchor marketing research in the decision problems faced by arts administrators—an accepted premise of the traditional business framework for marketing research. The author provides substantive examples for developing his prescription.

Extending the theme of Chapter 11, Patrick E. Murphy in Chapter 12 discusses marketing research as a decision-making tool that aids policy development for arts administrators but does not supplant it. In "Marketing Research for the Arts" the author outlines the fundamental procedure for systematically conducting decision-oriented marketing research in the arts context. Critical attention is directed to the definition of arts marketing problems and the step-by-step process of linking research to the problem-solving process.

The problem of consumer market analysis and its relationship to arts marketing strategies is the topic of Robert A. Peterson's chapter, "Market Analysis, Segmentation, and Targeting in the Performing Arts." Chapter 13 demonstrates the use of marketing research for substantive strategic problem solving. The decomposition of the market into meaningful segments is a fundamental analytical task of marketing management. The selection of a significant segment and the targeting of marketing efforts are basic to the effective positioning of an arts organization. Peterson uses information generated in a community arts market study to illustrate the principles of market analysis, segmentation, and targeting.

In the final chapter of Part III, "An Empirical Analysis of the Marketing Channels for the Performing Arts," John R. Nevin discusses the composition and dynamics of marketing channels in the performing arts. In Chapter 14 he investigates alternative channel structures and the relationships between channel members. Fundamental issues include: the definition of responsibilities in the channel, the distinctive execution of market functions by different channel members, and the process of negotiating and bargaining among channel participants. Better understanding of these issues could ultimately lead to a more effective delivery system for the arts.

11

TOWARD BRIDGING THE UTILITY GAP IN MARKETING RESEARCH FOR THE ARTS

Stephen A. Greyser

The purpose of this chapter is to examine the current state of marketing research for the arts. As the title suggests there is a utility gap in marketing research for the arts—the gap between what we know about marketing research and how well we have been able to apply that knowledge for management in the arts administration field. The goal here is to offer suggestions for narrowing, even bridging, the utility gap—or (stated another way) to try to decrease the futility factor in applying marketing research for arts administration.

By way of preview, initial comments will try to describe what the utility gap is—what the author sees as the gap between the promise and the failure of marketing research in the arts. This will be done in the broader context of changing attitudes toward marketing in the arts field. The next major section treats specific approaches to improving the state of the art—incorporating ideas regarding both technical quality and managerial application. Following this, some observations are offered on past marketing research, concentrating on experimental research approaches (including two case examples). In the final section some suggestions are made for bridging the utility gap.

Let me express my appreciation to Steven L. Diamond of Management Analysis Center for his insights and ideas that have been incorporated into this chapter. Let me also thank some 600 arts administrators in the Harvard Institute in Arts Administration over the past decade for their comments on this subject—especially those with firsthand experience with marketing research studies for the arts.

MISE AND FAILURE

What is the current state of marketing research in the arts? This can be addressed in terms of quantity, quality, and utility for management. Briefly, the quantity of marketing research in the arts is modest but growing. The quality is uneven, and the utility for management is weak.

The promise and the failure of marketing research in the arts is illuminated by these two contrasting quotes that reflect the views of a large number of people working in arts organizations:

> If only we knew more about our consumers, we could do a more effective job of building our audience.

> We did an audience survey, but if you ask me what we are doing differently as a result, I couldn't tell you.

Reinforcing the author's perspective is the following quote from the workshop on "Improving Audience Studies" at the recent conference on Policy Related Studies of the National Endowment for the Arts (Cwi 1978):

> While participants indicated that audience studies are becoming a standard practice, many seemed unsure as to whether the information gathered was worth the effort, time, and other resources expended. . . . In particular, participants were concerned with the role of audience studies in the development of the institution's marketing plan.

CHANGING ATTITUDES TOWARD MARKETING

Obviously, marketing research is only one element within the broader marketing field. There are some rapidly changing attitudes toward marketing—and a greater appreciation of marketing—on the part of people in the arts. Traditionally, one can characterize the attitudes of those in the arts toward marketing as consisting of ignorance, apathy, and suspicion.

The traditional ignorance (or neglect) of marketing in the arts can be attributed to the principal focus on the part of those in the field on the art itself rather than on the audience or market for it. This is analogous to the "product orientation" versus "consumer orientation" that long characterized many business organizations. Apathy grows from what may be called the "zealot syndrome." By this is meant the view held by so many in the arts (and other nonprofit fields) that their activities are so worthwhile that the public of its own volition will patronize the arts with little if any marketing effort—that is, "We don't need marketing." The suspicion comes from the view that marketing somehow is too slick and promotional for those who are involved with higher values such as are represented by the arts. This

characterization—obviously succinct and somewhat stereotyped—has been amplified elsewhere (Raymond and Greyser 1978).

Irrespective of one's view as to the breadth of applicability of this view of the traditional attitude in the arts toward marketing, one can clearly see a rapid change in recent years. The first stimulus to such change has been growing interest from the academic community, consultants, and arts professionals themselves. The academics and consultants have found a new field in which to practice. Those managing the arts have become painfully aware of the financial implications of partially empty houses.

More specifically, when one sees empty seats in theaters and halls in a time of particularly pressing financial needs, one begins to recognize the "opportunity loss" represented by those empty seats—even when one is achieving a 60 to 70 percent capacity attendance, which is generally considered good in many arts fields. Moreover, the foregone revenues can become important at the time when organizations seek grants from public agencies, which often employ a criterion of the percentage of revenues achieved through operations.

A final element of the changing view toward marketing is the rise of attention to "art as entertainment." This is reflected, for example, in the museum field by the emphasis on "big shows" such as the Pompeii exhibit and the King Tut exhibit. A further example in the commercial field is the increasing use of big television advertising budgets by Broadway shows.

Even in the commercial arts world, however, modern marketing is not always seen as fitting with artistic tradition. This is reflected in the following two quotes from letters to the editor (*Boston Globe* 1978) on the aggressive television campaign on behalf of *Man of La Mancha* in Boston:

> Like many people I have overdosed on "Man of La Mancha," having been bombarded with commercials showing Richard Kiley wailing away. What might have been a good play has been sold to me like toothpaste and toilet paper and my interest has been correspondingly lowered. This kind of advertising demeans the theatre. Can't a fine tradition like theatre in Boston retain its level of quality without being peddled over the airways like soap powder and Spam?

> To the man who marketed "La Mancha" I say "bravo!" For too long theatre has been under the ironclad hold of a few critics catering to an elitist audience. What "La Mancha's" successful TV advertising campaign has done is to circumvent the critics and broaden the audience.

APPRAISING AND APPLYING MARKETING RESEARCH

To return to marketing research specifically, let me try briefly to characterize the current state of that art in the arts field and then offer some specific suggestions for trying to improve the state of the art.

Relatively speaking, there is a lack of research sophistication in the arts field. This relates to both the appraisal of marketing research from a technical point of view and also the application of marketing research from a managerial point of view. This relative lack of research sophistication stems from two reasons. First, few arts organizations have managers with professional training in understanding (let alone conducting) marketing research or its application to management problems. This in turn reflects a further problem in that there are very few managers in arts organizations with professional management training in any area; in the past few years a steady trickle of people with formal management training has begun to flow into the field. A second problem is that most arts organizations have low (or no) budgets with which to conduct marketing research studies. Consequently, there is little opportunity for people in the arts to have contact with professionals in the marketing research field.

What is the net effect of these two factors—few people with professional training and low or no research budgets? The result is that many marketing research studies in the arts tend to be conducted semiprofessionally. For example, consider studies carried out by university students under the direction of faculty who have some research experience but typically not in the arts. In light of the modest conversance with arts institutions, despite some research expertise on the part of those carrying out such studies, it is not surprising that there tends to be little linkage of marketing research in the arts to specific management issues or problems. Both the relative inexperience with audience research on the part of most arts managers and the constraint of low-budget research are likely to remain realities affecting marketing research in the arts in the near future. Therefore, there are some real challenges for those who seek to help improve the state of the art in marketing research for arts organizations.

IMPROVING THE STATE OF THE ART

Efforts to improve the practice and application of marketing research in the arts must concern themselves with two areas. The first of these is to upgrade the technical quality of marketing research in the arts. Here one can use the experiences, standards, and criteria adaptable from commerical marketing research. The second area—and the one that has been most often overlooked—is the need to emphasize the utility of the research for policy making.

By this is meant direct links between the research that is conducted and the managerial decisions on which the research information can be brought to bear. The linking is especially important with respect to a priori rationales for the research and the kinds of applications envisioned for it.

Neither poor technical research nor technically good research inappropriately addressed to management issues represents desirable practice. The

ideal is to have meaningful and understandable guidelines that can be applied by nonresearch-trained arts managers in commissioning, appraising, and employing marketing research. Note that arts managers' being able to conduct such research themselves is not at issue here. But, nonresearch-trained arts managers should have tools available to facilitate their ability to talk knowledgeably—from a management point of view—about the goals for specific research projects and their prospective application.

Technical Quality

Technical quality concerns the effectiveness in professional terms with which the research or information gathering is planned and executed. Included are such elements as the sampling plan, questionnaire design, question wording, questionnaire collection procedures, analysis procedures, and report conclusions and recommendations. Because more detailed attention to these issues is given elsewhere in this volume (see particularly Chapter 12) and in a recent publication addressed to arts managers (Nevin 1978), included in Table 11.1 are illustrative questions within each of the six component areas mentioned above.

The sixth of these areas is one that is not always included in many lists of technical marketing research procedures. Given the basic theme that has been espoused, it should not be surprising when the importance of the conclusions and recommendations is underscored—particularly in terms of how they grow from the data in the study itself. Concern for this aspect of the technical quality of a marketing research study relates very closely to concern for the utility of marketing research for arts managers. In this regard a comprehensible summary is also desirable.

In focusing on technical quality the author is conscious of an academic's (and a professional marketing researcher's) predilection for professional competence. Such competence is clearly important. However, one should be careful not to overemphasize technical quality—because the real leverage in improving the state of the art in marketing research for the arts does not lie in the technical quality area. Rather, it rests in improving the utility of marketing research for the arts management community. Indeed, based on their NEA-sponsored study of audience research in the arts, Useem and DiMaggio (1978) report, "Technical quality and utility are largely uncorrelated."

Managerial Application

The management applications of marketing research in the arts can be viewed at two levels. The first concerns individual arts organizations. Here, a variety of issues and problems can be addressed by marketing research—for

TABLE 11.1

Sample Questions Concerned with Technical Quality

	Question
Sampling plan	Were relevant universes for the study properly defined?
	Did sample selection criteria include any significant undesired biases?
	Was the sample size adequate to draw generalizable conclusions?
Questionnaire design	Did questionnaire instructions clearly establish the intent/ purpose/objectives of the study?
	Did the questionnaire clearly and succinctly focus on the critical issues?
	Was the questionnaire unnecessarily lengthy or repetitive?
	Were the groups of questions organized so as potentially to bias other groups of questions followed?
Question wording/phrasing	Were the questions phrased so as to avoid any confusion or misunderstanding (that is, did respondents appear to be answering the same question that researchers intended to ask)?
	Was question phrasing biased so as to skew answers inappropriately toward positive or negative responses?
	Did question wording adequately take into account the interviewing mode (that is, personal, telephone, or mail survey)?
Questionnaire collection	What procedures were employed to collect completed questionnaires (for example, pre- or follow-up post cards, phone calls, or call-backs on personal and telephone interviews)?
	What response rate was achieved?

	Question
	Was this a respectable rate of return given survey mode, content, sample, length of questionnaire (that is, recognizing the trade-off of information value and the cost of obtaining that information)?
Analysis procedures	Was the analysis as reported appropriate to the data collected?
	Were appropriate statistical methodologies used for analysis?
	Were opportunities for meaningful analysis overlooked?
	Are data presented in a manner that is easily understandable to those not familiar with research and statistical procedures?
Report conclusions and recommendations	Do the data support the interpretations and recommendations offered in the report?
	Do the conclusions and recommendations logically follow from the stated purposes of the study?
	Do recommendations appear sufficiently actionable from an administrative point of view?
	Are results consistent with other known data from comparable audience studies and related sources?

example, audience profile information per se, information to help in promotion decisions, information to assist in pricing policies, and information that can bear on programming decisions. Illustrative questions and types of decisions in each of these four territories are given in Table 11.2.

In the programming area it should be noted that this is a zone in which virtually all arts people believe that they have the most solid information, without the benefit (or interference) of marketing research. Most effective arts administrations certainly know their audiences. Consequently, much research with existing audiences will tend not to focus on core programming matters. Nonetheless, there are opportunities even for those arts administrators who believe that they do know their audiences well to learn about some

TABLE 11.2

Questions Aimed at Individual Arts Organizations

	Question
Audience profiles	What kinds of people are strongly/moderately/not attracted to our offerings—in terms of demographic and attitudinal characteristics?
	Why are they attracted or not attracted?
	How do these characteristics differ for members/season ticket holders, versus box office (individual event) purchasers, versus former attendees, versus nonattendees?
	How do these different audiences view the community roles and quality of organizations?
	To what extent does attendance have a family versus an individual character?
Promotion	How were attendees informed about the organization and/or event? How does direct mail versus mass media affect the size and nature of audiences?
	To what extent are business or school tie-in programs associated with attendance?
	How do broader distribution methods for tickets affect audience size and nature?
Pricing	To what extent is low price an attraction?
	Is high price a barrier, or an attraction, to certain audiences?
	Does a discount for multiple attendance opportunities (for example, subscription, membership) enhance support?
	How does fund-raising solicitation affect attendance/involvement?
Programming	What current/new areas of programs/exhibits should be emphasized/deemphasized in terms of audience appeal?
	What days/times should performances/exhibits be available?

of the secondary program interests of their current audiences—all arts administrators can benefit from studies of the programming interests of those who are in the occasional (as distinct from the regular) audience.

Not all arts organizations have the capacity to do major pieces of marketing research. Nonetheless, there should be more awareness on the part of small organizations, particularly, regarding ways of conducting inexpensive yet useful marketing research. This is far more likely to result from a concern with management issues and their convenient researchability than it is with research techniques and their potential (but not carefully defined in the specific situation) applicability to the organization's situation.

The above considerations have focused on the interests of individual arts organizations. There is a set of broader-level considerations—pertinent either to consortium arts organizations (such as community arts groups) and even broader arts entities with statewide, regional, or national purviews. From this broader perspective a variety of issues beyond those treated above can be illuminated by marketing research. Three specific examples will be offered. The first is the extent to which there is general interest in a number of art forms on the part of arts audiences. More specifically, to what extent are audiences for the arts audiences across several art forms versus audiences that are singularly interested in one particular kind of arts activity? Studies that would shed light on this have some usefulness for individual arts organizations in planning their target marketing efforts for audience building. However, a broader use of this information would be for consortium organizations with an interest in sensing the "profile" of arts interest in a community or region.

A second territory concerns price thresholds and price barriers for different kinds of arts activities. Here, marketing research might shed some light on the shibboleth in most arts fields that there must be a number of very low-priced tickets available. (It has always interested the author that two kinds of events where tickets were very high-priced were opera and rock concerts!) Research across a variety of art forms could indicate the extent to which certain audiences have "expectations" of price levels for particular kinds of arts activities.

A third area focuses explicitly on a public policy dimension. That is the use of "market potential" as a basis for subsidy decisions by public agencies supporting arts organizations. Here we are talking more about cultural policy decisions than we are about arts administration per se; but the applicability of marketing research information remains. Efforts of this sort have already been undertaken overseas. Illustratively, in his insightful book *Cultural Development: Experience and Policies*, Augustin Girard (1972) of the French Ministry of Cultural Affairs has described a planning system for resource allocation in stimulating cultural development. In one chapter he addresses himself to "instruments of analysis" that permit planning in a conscious manner rather than via "superficial impressions and ad hoc

improvisations." Facilities and resources can be quantified through the Girard approach and statistics gathered on the activities of these units, the public they serve, and their costs. To quote Girard: "These data can then be used as a basis for determining norms and yardsticks of efficiency—even economic efficiency—and so, eventually, for laying down criteria by which the public authorities can act." In turn, based on careful analysis of such data, it is possible to make judgments as to how large a town/city should be before certain government-subsidized cultural entities should be established there. For example, based on subsidy costs for different art forms and different levels of public interest in them, different "threshold levels" of community size can be posited for the support of different art forms.

OBSERVATIONS ON PAST MARKETING RESEARCH IN THE ARTS

Some further observations on past marketing research in the arts field will be presented here. The sources of information for the kinds of research described above will be commented on. In addition, some comments will be offered on surveys and experiments in marketing research—and more attention urged to the potential benefits of the experimental approach in marketing research in the arts.

Sources of Information

The concern above was principally with what should be researched. Here, the different kinds of people who represent sources of information will be treated. For most marketing research in the arts, one can array the prospective respondents along a spectrum that defines a degree of involvement and support for the organization or the art form. These are arrayed as follows: current subscribers, current attendees, former subscribers, rarely attend, and never attend. In thinking about this spectrum one can ask questions about the ease of access to the different groups, as well as the value of information from the different groups.

Current subscribers (or members, et cetera) represent a group that is readily accessible (typically in terms of lists) and of relatively high value because of their knowledge of and involvement with the organization. Current attendees (but not subscribers) are relatively accessible—at least in terms of the opportunity to administer a questionnaire in the program, et cetera. However, at any given time one has only a subset of different kinds of current attendees, whereas for subscribers one can carefully select a sample or even gather information from the entire list. Current attendees represent a valuable source of information—particularly in terms of insights that may be derived that could convert these people into subscribers.

Former subscribers represent a very useful information source. These people once were involved with the organizations but no longer are. If the organization maintains good records (and the people have neither died nor moved away—two reasons for "dropping out"), the group is relatively accessible. The value of information can be very high in terms of understanding why some people "left the flock."

Those who rarely attend are relatively difficult to reach—since only a very small fraction of them will be in any group of current attendees who can be reached at a given event itself. To the extent that one is able to learn more about the profile of this group—for example, geographic, demographic, psychographic information—it may be possible to identify prospective target audiences for special attention by the organization. Occasional attendees represent a far greater potential for conversion to frequent attendees and/or subscriber status than do nonattendees.

The never-attend group is one to which a lot of arts organizations give undue attention. To bring a person across the barrier of interest in an art form or an arts organization in the absence of prior indications of such interest—and this is the characterization of the vast majority of the never-attend group—is a very difficult, albeit a very seductive, task. The seduction stems from the very large number of nonusers and the prospect that a conversion of only a modest percentage of them would have high potential benefits for the organization. While it would be highly beneficial if the conversion process could be accomplished, that task itself is so difficult that efforts addressed to those who never attend should not represent meaningful resource allocations to arts organizations individually. From a research point of view, this group is the least accessible, since one has to take almost a cross section of the general population in order to find them, and this is very expensive. Communitywide studies in behalf of all of the arts organizations in an area, a sensible use of resources, could well tap these people in a reasonably efficient manner. Research on never-attend people is best carried out in this broad-gauged fashion.

Some Experiences with Experiments

Most marketing research in the arts is typically of a survey research character. However difficult it may be to convince an arts organization that marketing research can be helpful, it is all the more difficult to "sell in" an experimental research approach. The typical arts administrator would view this as "tampering with my policies and programs." Experiments do call for "going public" (with at least part of the public) with a change or prospective change in policies and programs. This is a basic premise of varying one component of marketing policy in order to learn about the sensitivity/reaction of the public to it. Yet I think that there is some real learning potential from the greater use of experimental marketing research. Below two

somewhat disguised experimental research experiences are summarized. One is a study of differential fund-raising appeals. The other is a study of price sensitivity.

In the study of fund-raising appeals, the focus was on the differential "pull" of five different appeals in behalf of the specific organization. These appeals included some that could be viewed as rational, emotional, self-oriented, socially oriented, et cetera. The study was done in two different cities with the cooperation of an analogous institution in each. In addition, for reasons of comparative analysis and competitive "pull," standardized appeals for a number of other cultural/charitable organizations in each city were incorporated into the study design.

Briefly, the design and the controls on this experiment were well done. There were two different cities, a number of different organizations, and five different appeals for the institution in question. Two samples of a comparable character were drawn in each of the two cities. The measures employed to assess the relative pull of the appeals were behavioral in nature—a system of allocated votes to the different institutions. Also, there was the promise (and the reality) of actual money to be given to the organization that got the most votes in the study.

In short, this was a very well-designed—indeed an elegant—piece of marketing research. Unfortunately, the principal conclusion to be drawn from the resulting data was that no meaningful difference could be discerned among the major appeals in terms of their pulling power. Hence, in terms of the action that might be taken on the basis of the experiment, no clearcut direction was implied by the results.

In the study of price sensitivity, the focus was on subscriber reactions to different price levels for the performances of the arts organization. The study design incorporated a behavioral measure of allocating entertainment money among entertainment alternatives. These alternatives were represented by ads in behalf of each. The advertisement for the arts organization in question included different prices to different "treatment groups" of subscribers. The subscribers selected to be respondents were controlled on various characteristics.

The overall goal of the study was to develop a price-response curve. The data from this study suggested that prices could be raised substantially without significant subscriber loss; this could be done either by raising the prices across the board or by raising them somewhat more in the top-price categories. It also appeared that subscribers would not shift to lower-priced seats. Thus, in some contrast to the fund-raising study—where no meaningful difference emerged among the major appeals—here there was a conclusion that implied managerial action.

What did management do? Management proved to be very "risk-averse" with respect to actions. As in business there was worry over the extent to which "real world" subscriber behavior would be congruent with that shown in the experimental study. In addition, there was the concern—

one specific to subsidized organizations—that increased revenues from audiences would only lead to a proportionate decrease in outside subsidy. To some extent there was an attitude of "why bother with the risk?"

In reflecting on these experiences what can be said? First, experimental research tends to be expensive and, in the examples above, was subsidized by an external source. Second, the results can be inconclusive insofar as management action is concerned (for example, the promotional appeals study). Further, even where the data seem to be conclusive, management can be reluctant to act.

Despite some of the problems inherent in conceiving, conducting, and applying experimental research, it does have great potential in the arts field. This is principally because it usually represents a harder form of empirical evidence—especially if behavioral measures can be incorporated into the design—compared with the typical attitude survey research.

TOWARD CLOSING THE GAP

In offering suggestions for trying to close what was characterized as the "utility gap" in marketing research in the arts, again the author comes back to a focus on managerial decision making. As noted earlier when research grows from concern with a management issue or problem, the likelihood of using that research is all the higher. In essence, this is a restatement of the efficacy of the traditional business sequence or process of starting from a decision issue, moving to research, and examining/considering the research information in the context of actions that relate to the originally specified management decision or issue.

Based on their examination of audience research in 25 specific performing/exhibiting arts organizations DiMaggio and Useem (1978) stated:

> Not one of the 25 studies . . . was undertaken primarily to gather information necessary to influence a specific managerial decision. Instead they were instigated by . . . the need for political leverage (10 of 25), the appearance of an unexpected opportunity to have a cost-free study conducted (8 of 25), and a variety of diffuse concerns only indirectly related to specific decisions.

DiMaggio and Useem go on to summarize their view of the extent to which arts organizations employ the more traditional sequence/process described above. On this point they say: "The problem-solving model of research utilization proves of little value in describing the impact of actual research on organizational decisions."

In short, this author urges that more arts organizations follow the more traditional business model of why and when marketing research should be undertaken. What is missing from past studies of arts organizations' experiences with marketing research is a focus on managerial issues

and decisions. Not surprisingly, a clinical approach to examining a variety of managerial experiences with the commissioning and application of marketing research would be very helpful in this respect. These experiences could be organized along two dimensions. The first dimension is by kinds of marketing decisions—such as those touched on in comments about managerial applications earlier in this chapter. The second is by kinds of research—for example, surveys, experiments, et cetera.

This need not be a massive effort of "research on research." The DiMaggio and Useem study has provided us with a shape of the territory. What we need is further examination of specific managerial experiences. Of particular interest and import would be those that reflected the appropriate decision-process approach and employed research of good technical quality. From such prototypes can be stimulated a greater sense of not only what bridging the utility gap actually encompasses but how to do it better as well.

REFERENCES

Boston Globe. 1978. Letters Column, September 26.

Cwi, David, ed. 1978. *Research in the Arts.* Baltimore: Walters Art Gallery, p. 33.

DiMaggio, Paul, and Michael Useem. 1978. "Decentralized Policy Research: The Case of Arts Organizations." Unpublished manuscript, Center for the Study of Public Policy, Cambridge, Mass., pp. 8, 28.

Girard, Augustin. 1972. *Cultural Development: Experience and Policies.* Paris: United Nations Education, Science, and Cultural Organization, chap. 7.

Nevin, John. 1978. "Marketing Research and the Arts Administrator." *ACUCAA Bulletin*, April. Supplement.

Raymond, Thomas C., and Stephen A. Greyser. 1978. "The Business of Managing the Arts." *Harvard Business Review*, July-August, pp. 123–32.

Useem, Michael, and Paul DiMaggio. 1978. "An Example of Evaluation Research as a Cottage Industry." *Sociological Methods and Research*, August, pp. 55–84.

12

MARKETING RESEARCH FOR THE ARTS

Patrick E. Murphy

A dance company is making alterations in the content and style of their performances. It is felt that the company should change its name.

A theater group consistently performs before sell-out audiences. Management wonders how much ticket prices might be raised without reducing attendance.

The symphony orchestra plans to go on tour but is not certain where would be the best places for it to play to draw large audiences.

A new exhibit is being secured by the local museum. The director is concerned that the dollars spent to promote the exhibit be placed in local media to gain maximum impact.

The examples above contain a common element. That is, in each situation a need for marketing research exists. Decisions such as those listed above are often made by arts administrators without adequately researching the needs and desires of their market. The ultimate success of arts programs could be enhanced by a thorough understanding of the marketing research process. Thus, the purpose of this chapter is to outline this procedure and explain it using arts examples.

The kinds of marketing research may range from a study of general issues to particularistic ones. Although the majority of this chapter deals with an analysis of specific arts-related problems or opportunities, managers may want to conduct research on areas of general concern. For example, several arts companies may investigate the attitudes of individuals toward the arts in their local community.

Before discussing the steps of the marketing research procedure and how they relate to the arts, a few preliminary caveats are warranted. First, the ultimate objective for engaging in research is to assist managers in decision making by reducing uncertainty. For the arts this objective can

usually be attained if arts administrators and performers have information available for the type, timing, length, costuming, et cetera, of performances desired by arts customers. It is essential that these groups not be afraid of research and understand that it is a useful tool. Second, research needs to be viewed as an ongoing process of managing information rather than a one-shot project. Although a survey of this year's symphony subscribers will provide data to answer immediate questions, this undertaking ideally would be only part of a continuous effort to evaluate the symphony. Third, research should be built in as a line item in the budgeting process so that adequate funds are set aside for it.

A fourth initial area of concern is to define what is meant by marketing research. Specifically, *marketing research* is a systematic process of gathering, analyzing, and interpreting relevant information for decision making. Each of the elements of this definition requires a brief elaboration. A "systematic process" infers that the systems approach is utilized in the research procedure and that it consists of a series of steps. Initially, the information must be "gathered" by one or several techniques, then "analyzed," and finally "interpreted." Although much information is available, only that which is "relevant" to the problem at hand needs to be researched. The objective of improved decision making is also made explicit in the definition.

MARKETING RESEARCH PROCEDURE

The steps in the marketing research procedure are shown in the Appendix to Chapter 12. An understanding of this process is important for the arts managers, even though the research may be conducted by an independent research agency. Since the administrator will ultimately be charged with implementing the results of any research project, it is essential that this individual feel comfortable with all facets of the research process.

Problem Definition/Opportunity Identification

The first, and often most difficult, step in the marketing research procedure is to define the problem or identify the opportunity facing the organization. Although it is traditionally thought that research is necessary only when a problem exists, recognition of an opportunity in the marketplace is an equally valid reason for conducting research. A precise problem or opportunity statement in this stage will alleviate many unforeseen difficulties later in the process, because it allows the researchers to focus on one manageable issue. The development of this problem or opportunity statement is ideally a collective effort of the artistic director, administrators, and researcher. The best way to examine this step and its relation to the arts is to provide several illustrations.

For example, the declining subscriptions to a dance company or symphony or falling attendance at a museum are not problems. Rather, they should be viewed as symptoms of underlying problems. Specifically, declining attendance could be attributed to changing attitudes of the populace toward the arts' product. Possibly the symphony or art museums are only attracting a small group of people to their performances and exhibits. A reason for this problem could be lack of promotion (that is, people are not aware of the programs or they are promoted in inappropriate media). Finally, the drop in season ticket subscribers or overall attendance may be associated with the "price" of the arts product. Even though it is usually not possible to lower the price, it would be beneficial to single out price as the major contributor to a drop in attendance.

Opportunities are sometimes not easy to spot, but research offers a promising avenue for more thoroughly investigating them. Both the consumers and marketing mix (that is, product, price, promotion, and channel of distribution) variables represent potential opportunities to the arts marketer. As was recently stated elsewhere (Raymond and Greyser 1978), the search for market opportunities should follow the arts organization's statement of purpose. Maybe an arts group can reach a new segment of the market like high school students or senior citizens (Jacques 1977). The arts "product" may be altered to make it more attractive to patrons by changing performance aspects such as specific program selection and nonperformance features like ticket outlets and parking. These programs might necessitate new channels of distribution such as touring companies or exhibitions. Two recent examples are *The Wiz* and the King Tut exhibit. Finally, the advertising media mix might be changed (for example, more radio and less newspapers) to attract new customers, and innovative pricing schemes could be tested.

Exploratory Research

The second step in the marketing research procedure shown in the Appendix to Chapter 12 is exploratory research. After the problem or opportunity is defined, the researcher does not immediately begin to collect primary data. Rather, one usually takes a step back and studies the current situation. An informal search for information from internal, external, and secondary sources is undertaken.

There are several internal sources of information that should prove useful to the conducting of marketing research in the arts. Of course, the performers and artistic director may illuminate product-related problems (that is, performance) such as lighting, costumes, and choice of plays or musical scores. The financial officer for an arts company could pinpoint the areas that produce the greatest costs and revenues. Even ticket takers or museum guards may overhear things that patrons would not articulate to management.

Potential external sources of information for exploratory researching include a few subscribers, community leaders, and possibly the art critics from the local media. It should be mentioned that this effort would be an informal and unsystematic poll of these individuals. The purpose of this preliminary external investigation is to gain additional insight into the arts problem/opportunity.

Secondary sources consist of information gathered previously and for another reason but that may be applicable to the current context. For instance, census data for metropolitan areas can provide arts managers with a profile of the locations with a high percentage of potential patrons. Local firms such as banks and newspapers may have more current demographic information available that they will share with the arts researcher. Also, arts periodicals such as *Symphony News*, *Performing Arts Review*, and *Museum News* might contain information about how other arts companies solved similar problems or opportunities. A list of 270 audience studies recently compiled by DiMaggio, Useem, and Brown (1977) pertaining to the visual and performing arts may prove to be an invaluable source of secondary information.

Two final points regarding the exploratory research stage need to be stated. First, these sources should be evaluated on the dimensions of relevance, credibility, and accuracy (Enis 1977, p. 280). Second, if this information satisfies these criteria, the researcher may sometimes be able to solve the problem or identify the opportunity without further research. Thus, it would not be necessary to continue with the latter stages of the procedure, which are both expensive and time consuming.

Sampling Plan

Once it is determined that collection of primary data is necessary, a sampling plan must be devised. Unless an arts administrator plans to study only a small group such as large contributors to the opera, a sample rather than a census is dictated. According to the Appendix to Chapter 12 there are several specific steps in developing a sampling plan: specification of sampling unit, selection of sampling method, and determination of sample size.

The sampling unit refers to who is to be studied. Table 12.1 shows both consumer and external publics from which an arts organization may want to sample. The size of consumer publics in Table 12.1 would probably necessitate that only a small percentage of individuals from these groups be sampled. Furthermore, a subdivision of arts "consumer" publics into smaller entities such as opera or symphony season ticket holders may be beneficial.

A second facet of the sampling plan is to select the proper sampling method. The most important criterion in sampling that must be satisfied is that the sample be representative of the population. Two major types of sampling procedures may be utilized—probability and researcher-controlled

TABLE 12.1

Arts Publics (patrons)

	Potential Sample Group
Consumer publics	
Season ticket holders (subscribers)	
Other attendees	
Local community	
Students (high school and college)	
Senior citizens	
External publics	
Business community	
Local government	
State and federal agencies (NEA)	
Foundations	

sampling. Of course, probability sampling draws from the mathematical theory of probability. An example of a random probability sample would be to draw names from a list of season ticket holders or a museum membership roster. Stratified homogeneous groups and cluster geographic areas samples represent other probability sampling possibilities (Boyd, Westfall, and Stasch 1977, pp. 336–60).

If the probability assumptions cannot be met, researcher-controlled (nonprobability) sampling measures are employed. Convenience, judgment, or quota are the major subclassifications of this type (Tull and Hawkins 1976, pp. 158–62). For instance, a quota sample of high school students from various class levels may be drawn to determine their attitude toward various arts activities.

The final aspect of the sampling plan is to determine the desired sample size. Naturally, the larger the sample size, the more reliable it should be. However, trade offs between the time and money it takes to draw the larger number of respondents must be recognized. This is an especially significant limitation for most arts organizations who are often limited financially. Sophisticated statistical techniques can be employed to determine the optimal sample size, given certain confidence levels (Churchill 1976, pp. 302–15).

Questionnaire Design

While the sampling plan for a research project is being devised, a concurrent activity is questionnaire construction. The process of writing accurate questions that will elicit the needed response is a difficult process. Table 12.2 gives an explanation and a few tips on some of the important

TABLE 12.2

Questionnaire Construction Guidelines

Question Category	Explanation	Hints
Types		
Closed-end	Specific answer categories provided	Vary the types of questions to avoid monotony
Dichotomous	Yes/no questions	Include "don't know" category
Multiple choice	Several answers	Limit to four to eight choices
		Include "other" category
Rating or ranking	Scale questions	Explanation necessary
		Use relevant scales
Open-end	Nondirected response	Keep to minimum
		Provide adequate space
Sequence	Order of questions	Be logical
		Start with warm up or easy ones
		Embarrassing or threatening questions at end
Wording	Phrasing of questions	Simple, clear
		Don't lead respondent
		Don't use value-laden or ill-defined words such as "reasonable" or "regularly"
		List definite time period
Pretesting	Trial run	Always necessary
		Use same type of persons you expect to sample
		Pretest every time a question is changed
		Use same method of administration (for example, mail, telephone, or personal) as final questionnaire

aspects of questionnaire design. The methodology for measuring consumer needs, preferences, perceptions, and satisfaction is beyond the scope of this chapter but is discussed in depth elsewhere (Kotler 1975, pp. 123–57).

In addition, a few general comments about questionnaires that all managers should keep in mind are warranted. First, the questionnaire should be tailored to the public (Table 12.1) that is being studied. For instance, regular arts subscribers or those familiar with specific performances could be asked more in-depth questions than members of the community who are not intimately familiar with the arts. Second, the types of questions that will gather the desired information are naturally the ones to be used. The best questionnaires are often the most simple—questions do not have to be complicated to be considered good. Third, if empathy for the respondent is felt, he/she *will not be* overloaded with too many or irrelevant questions. Arts researchers should also be realistic in not expecting too much from a questionnaire, because their product is often ill defined, the price is high, and the channel of distribution limited. It is, therefore, difficult for respondents to evaluate arts issues in a concrete and objective manner.

Collecting Primary Data

As shown in the Appendix to Chapter 12, there are three major alternatives to collecting primary data—observation, survey, and experiments. Although it may be possible to learn something about an audience's reaction to an arts performance by observing its reaction to it, the observational method has limited applicability in this context. The other two data collection options, however, have much relevance to solving arts problems or opportunities.

The survey method (that is, questions are asked of predetermined respondents) has been utilized in most arts research to date (Mann 1967; Koali-Nagy and Garrison 1972; Nielson, Nielson, and McQueen 1975; Heitman and Crocken 1976; Ryans and Weinberg 1978). The types of surveys that are used are telephone, mail, and personal and group interviews. The telephone is appropriate for a brief questionnaire in a limited geographic area. For instance, a general study in an urban area of consumer awareness of arts companies and their performances could be gauged. Specifically, one might ask, "What play is currently being performed by the Milwaukee Repertory Theater? Have you seen it? Did you enjoy it? Why or why not?" This series of questions would provide a reading on the consumer awareness of and interest in the theater.

The mail survey has the advantages over the telephone of allowing more in-depth questions and the respondents' completing it at their leisure. Several arts companies could combine questions and be able to get a reaction to each of their specialties. Also, a mail questionnaire sent to subscribers can be tailored to their particular needs. If a museum or

performing group wanted to study a national sample of consumers or one of the external publics in Table 12.1, the mail survey is a particularly good vehicle because of its low cost. Finally, the low response rate (sometimes 10 to 20 percent) is the major limitation to widespread usage of the mail questionnaire.

The personal interview is much more flexible than the mail or telephone surveys, because the interviewer can ask respondents in-depth questions and probe to get an answer. If a symphony were losing a large number of subscribers, a personal interview would probably be necessary if a thorough list of reasons for the former consumers' actions were desired. The high cost of training and supporting personal interviewers must be recognized by arts organizations that are contemplating this survey option.

A final type of survey is called the group interview or "focus group" (Bellenger and Greenberg 1978, pp. 171–84). This interview consists of several (8 to 12) preselected individuals being asked a series of in-depth questions by a trained leader. The group dynamics may lead to responses that individuals would not advance independently. This technique is often useful in the exploratory research stage of the project to get a more thorough understanding of the problem/opportunity being studied. For instance, arts patrons of differing sections of the city or attendance frequency could be questioned about several facets of arts performances or museum exhibits.

Experiments represent the final data collection alternative. An experiment is distinctive because cause and effect relationships can be measured (Cox and Enis 1972, pp. 291–330). Although experimental efforts have been utilized rarely in arts settings, they appear to have widespread applicability in the promotion and price areas. If a choral group was contemplating advertising their upcoming performances, an experiment could be devised to test the effect of different mass media on ticket sales. Divergent pricing structures could also be set up and their effect on attendance measured. The use of control in an experiment must be handled carefully to ensure that the manipulated independent variable (that is, advertising or pricing) actually caused the change in the dependent variable (that is, sales, attendance, awareness, et cetera).

Data Analysis

Once the primary data collection is complete, the analysis can begin immediately. As shown in the Appendix to Chapter 12, this usually is a two-step process. First, "data reduction," which includes getting the data ready for analysis and calculation of descriptive statistics, is performed. Then, "statistical analysis," which encompasses a more thorough testing of relationships in the data, can be undertaken.

The arts researcher must make arrangements for editing, coding, and tabulating the questionnaire as part of the data reduction process (Tull and

Hawkins 1976, pp. 477–503). Editing refers to going through the completed questionnaires and making sure they are answered correctly. Coding requires establishing categories and assigning data to them. Since most studies with large sample sizes are tabulated by machine, code sheets are used for key-punching to IBM cards or optical scanning. It is essential that this step be taken into account during the questionnaire construction phase and that it be precoded for this purpose. Finally, from the tabulations a frequency count either in absolute or relative (percentage) terms can be generated. For certain types of surveys such as awareness of specific arts programs, this may be a sufficient analysis.

If a more complete analytical approach is desired, there are several statistical techniques available. To analyze the relationship between specific demographic variables and attitudes or behavior toward the symphony, theater performances, or museum exhibits, a chi-square analysis can be conducted. Ryans and Weinberg (1978) utilized a linear discernment analysis to compare three subscriber groups of the American Conservatory Theatre across fine demographic and behavioral characteristics. Other sophisticated multivariate techniques such as factor analysis, multiple correlation or regression analysis, and multiple classification analysis could be employed in certain types of arts research (Green and Tull 1978, secs. 3 and 4).

Interpretation and Implementation of the Findings

The final step in the marketing research procedure is the interpretation and implementation of the results. This usually requires the preparation of a final written report and often an oral presentation of it. Interpretation of the findings entails drawing conclusions that relate to the initial problem/opportunity and the researcher's making recommendations from these conclusions. For example, a possible conclusion from a telephone survey of potential arts goers may be that only a small number of people are aware of the local dance company and its performances. The recommendation would logically be to increase the promotion budget for the dance company.

The final aspect of the marketing research procedure is to implement the findings. This is the job of management, however, and not of the researcher. Sometimes it may not be possible for the administrator to implement the recommendations of the researcher because of budgetary or time constraints. Nonetheless, a concrete response to the research results is needed. If the promotion budget of the dance company in the aforementioned example cannot be increased for budgetary reasons, the administrator should relay this decision to the researcher and the performers and possibly seek alternative recommendations.

The importance of this implementation phase to the arts manager cannot be overstated. If the administrator and artistic director are involved

with the researcher in the early (problem formulation) stages of the research, they will likely be more apt to react favorably to changes that will be part of the implementation process. Research both begins and ends with management. Thus, the arts administrators who are committed to an ongoing evaluation of all facets of their programs can benefit greatly from the insights of the researcher.

CONCLUSION

In addition to understanding the marketing research process, several other research-related issues are of concern to the arts manager. First, a decision has to be reached on who will actually conduct the research project. Although it may be possible to utilize in-house staff or a service group like a university class to conduct a small study, often an independent marketing research agency may need to be hired. Familiarity with the criteria used in selecting and working with a research agency can assist the arts manager in this procedure (Blankenship and Barker 1973; Adler 1975a, 1975b).

A second consideration for arts administrators is the cost of marketing research. An important axiom within marketing is: good research is expensive. Therefore, arts managers who are often operating at a financial disadvantage should be realistic in their assessment of how much research they can afford. A comparison of the costs associated with different survey methods used for an audience profile study would be a valuable exercise for the manager or research consultant (Nevin 1978). In this manner it may be possible for the arts administrator to develop a cost/benefit analysis for any potential research endeavor.

Third, research should be viewed only as a tool to facilitate decision making. Research is an aid to management decisions, not a substitute for it. For example, a community arts council's study of a local opera company might indicate that the best strategy would be to disband the group because of low audience appeal and lack of revenue. However, the chief administrator may decide that opera performances are necessary to offer a complete performing arts program and continued subsidy is justified. Thus, the managerial decision may not always follow the results of the research project. It needs to be quickly added, however, that management in most instances should follow the research results.

FUTURE RESEARCH DIRECTIONS

Since most arts organizations conduct marketing research related to specific problems they are experiencing, it is difficult to propose many generalizable future research directions. The areas where it appears research should focus are on the type of research, sample, and the results.

The most prevalent research in the arts to date has been the one-shot

survey. It would seem that future efforts need to be directed toward more longitudinal studies. A yearly or semiannual survey of arts subscribers would provide the companies with a benchmark of the changes in audience attitudes and/or behavior over a period of time. This information would be valuable in devising long-term strategies to satisfy the arts goers and patrons.

The survey has possibly been an overused data collection tool in the arts setting. Asking questions of respondents about the arts in a survey setting may yield socially desirable rather than accurate replies. Therefore, experimental procedures using behavioral dependent variables (that is, attendance or monetary contribution) appear to offer arts researchers and managers an excellent opportunity to investigate problems or opportunities. As mentioned previously, promotion and pricing strategies are particularly well suited to this type of analysis.

The samples used for arts research have traditionally been limited to one geographic area and a narrowly defined group of consumers. The exceptions to this trend were the National Research Center for the Arts (1975) and Ford Foundation (1974) publications, which examined a national sample of arts consumers. In the future it seems that more regional and possibly national samples should be drawn where it is financially feasible. Also, more diverse groups of potential consumers within a specific geographic area (see Table 12.1) probably need to be studied. These larger sampling efforts would hopefully expand the information available about arts products and consumers.

Finally, the results of arts research projects should be disseminated as widely as possible. Since arts administrators are waging similar battles on funding and attracting audiences, a sharing of experiences and findings from research probably would be beneficial to arts managers in other geographic areas. Thus, it seems that publication either formally or informally of research results would be an objective worth pursuing by arts administrators. If individuals view their ultimate position as fostering the dissemination of the arts in society, then the information gathered from research efforts should be distributed to others in similar situations.

APPENDIX TO CHAPTER 12

The Marketing Research Procedure

1. Problem definition or opportunity identification

2. Exploratory research
 Internal sources
 External sources
 Secondary sources

3. Sampling plan
 Sampling unit specification
 Sampling method selection
 Sample size determination

4. Questionnaire design

5. Collecting primary data
 Observation
 Survey—telephone, mail, personal, group
 Experiments

6. Data analysis
 Data reduction
 Statistical analysis

7. Interpretation and implementation of findings

REFERENCES

Adler, Lee. 1975a. "How to Hire a Marketing Research Agency." *Sales Management*, November, pp. 105–7.
———. 1975b. "Working with Research Agencies. *Sales Management*, December, pp. 76–78.
Bellenger, Danny N., and Barnett A. Greenberg. 1978. *Marketing Research: A Management Information Approach*. Homewood, Ill.: Richard D. Irwin.
Blankenship, A. B., and Raymond F. Barker. 1973. "The Buyer's Side of Marketing Research." *Business Horizons*, August, pp. 73–80.
Boyd, Harper W., Jr.; Ralph Westfall; and Stanley F. Stasch. 1977. *Marketing Research: Text and Cases*. Homewood, Ill.: Richard D. Irwin.
Churchill, Gilbert A. 1976. *Marketing Research: Methodological Foundations*. Hinsdale, Ill.: Dryden Press.
Cox, Keith K., and Ben M. Enis. 1972. *The Marketing Research Process*. Santa Monica, Calif.: Goodyear.
DiMaggio, Paul; Michael Useem; and Paula Brown. 1977. "The American Arts Audience: Its Study and Its Character." Working paper, Center for the Study of Public Policy, Cambridge, Mass.
Enis, Ben M. 1977. *Marketing Principles: The Management Process*. 2d ed. Santa Monica, Calif.: Goodyear.

Ford Foundation. 1974. In *The Finances of the Performing Arts*. vol. 2. New York: Ford Foundation.

Green, Paul E., and Donald S. Tull. 1978. *Research For Marketing Discussion*. 4th ed. Englewood Cliffs, N.J.: Prentice-Hall.

Heitman, George, and W. E. Crocken. 1976. "Theatre Audience Composition, Preferences, and Perceptions." *California Management Review*, Winter, pp. 85–90.

Jacques, Damien. 1977. "The Rep Has Rapport with the Young Too." *Milwaukee Journal*, January 30, pt. 5, p. 5.

Koali-Nagy, Christina, and Lee C. Garrison. 1972. *California Management Review*. Winter, pp. 137–43.

Kotler, Philip. 1975. *Marketing For Nonprofit Organizations*. Englewood Cliffs, N.J.: Prentice-Hall.

Mann, Peter H. 1967. "Surveying a Theatre Audience: Results." *British Journal of Sociology*, January,

National Research Center for the Arts, Inc., and Associated Councils of the Arts. 1975. *Americans and the Arts: A Survey of Public Opinion*. New York: American Council for the Arts.

Nielson, Richard P.; Angela B. Nielson; and Charles McQueen. 1975. "Attendance Types of Performing Arts Events and Explanations for Attendance and Non-Attendance." *Performing Arts Review*, Spring, pp. 43–69.

Nevin, John R. 1978. "Marketing Research and the Arts Administrator," *ACUCAA Bulletin*, April supplement.

Raymond, Thomas J. C., and Stephen A. Greyser. 1978. "The Business of Managing the Arts." *Harvard Business Review*, July-August, pp. 123–32.

Ryans, Adrian B., and Charles B. Weinberg. 1978. "Consumer Dynamics in Nonprofit Organizations." *Journal of Consumer Research*, September, pp. 89–95.

Tull, Donald S., and Del I. Hawkins. 1976. *Marketing Research: Meaning Measurement and Method*. New York: Macmillan.

13

MARKETING ANALYSIS, SEGMENTATION, AND TARGETING IN THE PERFORMING ARTS

Robert A. Peterson

Performing arts organizations—especially not-for-profit organizations—face a distinctive set of marketing-related problems. Many of these problems derive from the nature of the performing arts "product offering"—the bundle of benefits offered by a performing arts organization. Because the performing arts offering is typically a service, rather than a physical product, it possesses such characteristics as abstractness (intangibility), individuality, and perishability. These characteristics imply the performing arts offering is different every time it is performed and that it be performed and consumed simultaneously. Such characteristics imply little opportunity for development of production economies or application of standard product marketing techniques.

Moreover, the marketing task of a performing arts organization is unique because one of its "missions" is to educate the public and develop appreciation of the cultural contributions of performing arts (compare, Raymond and Greyser 1978). As a result of this mission the performing arts product is often priced below the cost of producing it. More bluntly, the revenue from ticket sales is frequently not nearly enough to make the performing arts organization self-sufficient financially. Historically, the reason for such a pricing scheme was to encourage attendance; the effect of such a pricing scheme is to complicate the role of marketing by necessitating two constituencies—consumers and donors.

The traditional consitutency of a performing arts organization consists of those individuals (consumers) who personally attend or participate in a performance. Collectively these individuals are termed *an audience*, and the commonly stated goal of arts marketing is to "build" an audience. Addition-

Appreciation is expressed to W. D. Keeble for his assistance in preparing the empirical example and to S. A. Mitchell for her help in problem conceptualization.

ally, there is a second constituency. This constituency consists of donors—organizations and individuals who contribute resources, both of a financial and a time nature, to the performing arts organization. Illustrative financial donors would include government agencies (for example, the National Endowment for the Arts), business (for example, the Chrysler Corporation), private foundations (for example, the Ford Foundation), or individuals (for example, the Rockefeller family). Time donors are those individuals who volunteer their personal time and assist in the production of a performing arts event without financial recompense.

While there is some overlap between the constituencies, this overlap is typically minimal. Although some donors attend performing arts events, and some audience members are donors, the constituencies should be treated as distinct marketing entities. One must market them separately and with different marketing programs. Obviously, both constituencies are critical for the long-run success of any performing arts organization.

Still, in spite of such idiosyncracies and the broad and diverse nature of the performing arts, the not-for-profit performing arts organization shares similarities with for-profit and standard-product business organizations. Among these would be the desire to survive as a viable entity and the need to allocate and manage resources most effectively. Because of these shared similarities, it is often possible directly to apply some marketing or marketing-related approaches, concepts, and techniques employed in business organizations to performing arts organizations. Market analysis and the related activities of segmentation and targeting would appear to be likely candidates for such transfer. Indeed, the present discussion focuses on the application of these three activities in marketing the performing arts offering with regard to both constituencies of the performing arts organization.

MARKETING FUNDAMENTALS

Market analysis, segmentation, and targeting are essential marketing activities in that they need to be conducted prior to the development of any comprehensive marketing program. Beginning with market analysis, each builds upon the preceding activity(ies) in a stepwise fashion so that, collectively, they constitute a foundation for all marketing strategy. However, prior to discussing each in detail, it is necessary to reflect briefly on the fundamental task of marketing.

The fundamental task of marketing in an organization is to differentially attract and retain those consumers who best serve to meet the goals of the organization. In other words, with few exceptions, an organization can no longer expect to be "all things to all people." Rather, it must pursue a selective marketing strategy and employ those activities that concentrate upon customers most beneficial to the organization. An example would be the attempts of an arts administrator to attract and retain simultaneously the

"high volume" or "heavy users" for a particular art form, since these consumers would tend to be the most profitable customers for the arts organization.

Initially, attraction and retention could be viewed as extremes on a single continuum. However, this would probably be too narrow a view. While an organization might employ an attraction strategy to the complete exclusion of a retention strategy (and vice versa) in a short-run situation, this would probably occur only in an exceptional instance. Instead, it is more likely that an organization will employ a strategy containing elements of both attraction and retention. In such a strategy the relative emphasis given each element would differ, perhaps across groups of customers, but both would be present. Essentially, then, attraction and retention should be treated as complementary rather than substitutes, with primary attention given to their proper "mix" in strategy development and implementation.

Moreover, both activities are critical to the long-term success of an organization. Consumers must be first encouraged to "experience," try, or purchase an organization's offering. Then, having attended a performance, they must be encouraged to repurchase it on a continual basis so that they become product-loyal. For a typical performing arts organization, the retention function would involve more than obtaining mere "repurchases"; it would involve "trading up" a customer from casual attender to subscriber to contributor/donor.

To illustrate the concepts of attraction/retention, consider the case of a performing arts organization such as a theater. Such an organization will normally possess three distinct audiences or customer groups: subscribers (a loyal core of season ticket holders and perennial attenders), infrequent/occasional attenders (individuals attending less than half of the performances each season), and rare attenders (individuals attending a performance once or less than once per season). Given such an audience configuration, theater management might simultaneously implement three different marketing strategies—one emphasizing retention for subscribers, an attraction/retention mix for the infrequent/occasional attender group, and an aggressive attraction strategy for rare attenders. This strategy is presented schematically in Figure 13.1.

The attraction/retention task exists whether an organization is offering a product or a service. Moreover, it exists regardless of how an organization defines "customers" or "goals." For performing arts organizations customers can be viewed as either (or both) audiences or donors, while goals can range from dollar profits to number of individuals educated. Hence, given the attraction/retention perspective, it is apparent that the task of marketing is quite similar for performing arts and other (for-profit, not-for-profit) organizations.

It is important to keep the notions of attraction/retention continually in mind when considering either marketing strategy or tactics. Not only do they

FIGURE 13.1

Illustrative Marketing Strategy—Customer Group Mix

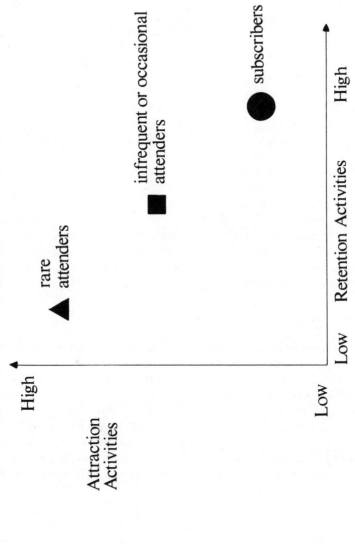

serve as the basis of marketing strategy, but they also guide the prestrategy activities of market analysis, segmentation, and targeting. As such, attraction and retention will be referred to throughout this discussion.

MARKET ANALYSIS

Within the framework of attraction/retention, a prerequisite for developing successful marketing strategies is market analysis. Traditionally, a market consists of consumers in an identifiable geographic location willing and able to adopt the existing or potential product offering of an organization (Kerin and Peterson 1978). With regard to a performing arts organization, a market would consist of present, past, and potential customers for its particular offering.

For numerous reasons, including increasing market sophistication and increasing competition for the performing arts dollar, it is imperative for a performing arts organization to have a "complete" understanding of its market. Unless the administrator possesses such an understanding, there is no way he or she can successfully market the performing arts.

The present discussion deals with market analysis—identifying customers and noncustomers for a performing arts product. As such, the emphasis will be upon audience analysis as opposed to donor analysis, even though many of the comments hold equally well for either constituency.

Essentially, market analysis consists of answering six customer (present customer, past customer, potential customer) and product offering (the performing arts organization's and competing organizations') questions. In summary form, these questions are (Peterson 1977): Who are they? What do they want? How do they want it? When do they want it? Where do they want it? and Why do they want it?

Taken as a group, these six questions serve as an analytical framework for market analysis. Systematically answering them permits market identification, forms the basis of a market opportunity analysis, and provides insights into market communication modes. Moreover, as will be discussed later, answering these questions gives a foundation for segmentation and targeting analyses. For ease, the "who" and "why" questions will be considered individually, while the remaining four will be discussed together.

Who Are They?

The starting point of a market analysis is the determination of who constitutes present/past/potential customers. Answering this question requires the use of three general categories of variables—psychographic, usage/behavior, and media variables.

Psychographic variables refer to an individual's general char-

acteristics—psychological ones such as personality, values, beliefs, attitudes, and life-style, and demographic ones such as sex, age, education, income, or occupation. (An additional variable, residence location, is often useful.) While these variables are useful in basic market definition, frequently they do not provide enough information to discriminate adequately between, say, present and past customers. Therefore, they are normally supplemented with a second category of variables.

Usage and behavior variables are those variables that relate more directly to the general performing arts area. They include variables to ascertain types of performing arts events attended, frequency of attendance, and attitudes relating to these behaviors.

The third category of variables consists of media exposure patterns and frequencies. These variables relate to what media customers are exposed to—favorite newspapers, magazines, radio stations, television programs, and the like—as well as where or when and how frequently they are exposed to these media. This latter category is important in developing communication strategies in addition to expanding a market profile.

Collectively, these three variable categories serve generally to define a market—who are the present, past, and potential customers of a performing arts organization. As a result of answering the "who" question, a performing arts organization should be able to determine attendance incidences and penetration rates for the organization and its competitors as well as the profiles of individuals who attend various performing arts events. As such, answering the "who" question provides a market background.

What, How, When, and Where

Questions relating to what, how, when, and where are situation-specific in that they relate directly and simultaneously to specific performing arts customers and product offerings. Responses to these questions form the basis of "marketing mix" decisions, those decisions relating to the nature and price of the product offering (the "what" question). Additionally, they provide insights into how, when, and where the product is to be distributed or made available to the market. They form the basis of a market opportunity analysis—an analysis of the wants and needs of the market as well as insights into how these can be fulfilled. In other words, these questions deal with how a performing arts organization can best attract and retain desired customers, be it through a pricing strategy, changing the location, hours, et cetera, of the organization, product offering, or the like.

These four questions should provide directly actionable marketing information as opposed to general knowledge or background. Unfortunately, obtaining meaningful, valid and reliable answers to these questions is more difficult than obtaining answers to the "who" question. Therefore, they require much more creative thought.

Why Do They Want It?

Probably the most difficult question to answer in market analysis is why consumers purchase/use a particular product. This is because answering the "why" question requires an understanding of an individual's motives or psychological states. Not only is it difficult to construct the correct question to determine motives, but often individuals will not or even cannot answer the "why" question. They may consider the question/answer too personal or embarrassing; even if they are willing to answer, they may be unable to verbalize their answers or perhaps even know why they did or did not perform a particular action.

Recently, a popular approach to answering the "why" question has been to investigate the benefits perceived to exist or relate to the purchase and usage of a particular product offering. For example, customers might be queried as to the benefits they received from attending a particular symphony performance, or what benefits they derived from making a financial donation to a local opera company. One study of donors reported that individuals who donate to charitable organizations often do so because of feelings ranging from guilt, to power, to altruism—all of which might be difficult to verbalize.

Still, of the six questions, the "why" question is the most critical in terms of developing marketing strategy. Answers to this question form the basis of the specific appeals to be employed when designing or marketing the performing arts product offering.

Market Analysis Research Strategies

Answering the six customer and product offering questions in a meaningful manner implies the use of marketing research. While this topic is extensively covered elsewhere in this book from a technical perspective (see Chapters 11 and 12), a few managerially oriented comments may prove beneficial at this juncture.

First, market analysis literally means market analysis. Merely studying present customers is not a market analysis. While many performing arts organizations conduct audience analyses, these are not market analyses. Not only do audience studies provide insufficient information for effective decision making, they may well provide misleading information. This is because a market analysis must be comparative in nature. Even though absolute customer characteristics are useful for decision making, it is far more valuable to be able to compare characteristics of present, past, and potential customers. While absolute customer characteristics are useful for descriptive purposes, for actionable decision making relative comparisons are more useful. For instance, the average age of a symphony audience might be 36.8 years. While this statistic is interesting it is more useful to

know that the average age of the population from which the audience is drawn is 22.3 years. The implications in this case are obvious.

Second, there are numerous potentially viable research strategies and tactics that could be pursued for any given market analysis. No single research strategy is equally valid for all market analyses. Generally, however, for an initial market analysis a relatively large sample (size being dependent upon the number of performing arts organizations being considered and the number of consumers in a market area) of consumers is required. This is because the performing arts "public" typically is at most 3 to 4 percent of a population; the audience of a specific performing arts organization is often miniscule. Thus, a large sample size is required to ensure inclusion of individuals who attend performing arts events. Moreover, special care should be taken to obtain a representative sample of consumers.

Since the initial market analysis often serves as a reference against which future analyses are compared, it is imperative that the research scheme incorporate a mechanism to ensure adequately that performing arts attenders are proportionally present to a degree permitting meaningful investigation.

Finally, even though the particular research approach may vary widely from study to study, two cautions need to be noted. One is that every element of the research process should be oriented toward providing useful findings—findings that can be implemented in a marketing program. Additionally, for findings to be useful it is necessary to deal with consumption units as discrete entities, not as the composite entity often portrayed when profiling market characteristics. The latter is an insidious habit that frequently leads to the characterization of an "average" or "typical" customer that is far from accurate. There is no "average" customer—each is a unique individual.

Market Analysis Results

At the conclusion of a market analysis, findings should include background profiles (for example, summary psychographics, usage patterns, and media exposure patterns) of present, past, and potential customers. Moreover, a market analysis should provide information as to the specific needs and desires of customers. These would be obtained from the "what", "how", "when", and "where" questions. Finally, a market analysis should lead to an understanding of and appreciation for the benefits desired from a performing arts event or organization—the "why" of attending a performing arts event.

Taken together, the information mosaic derived from a market analysis should permit insights into the structure of a market—how it is constituted, and most important, what needs and desires are being met and which are

not. Only through such a structuring will a true and complete understanding of a market be achieved, and only through such a structuring can an effective marketing program be developed.

Market Analysis Example

To illustrate certain market analysis concepts, a limited-scale market analysis conducted in Austin, Texas, will be briefly discussed. This analysis focused on four performing arts organizations:

Zachary Scott Theatre (ZS): A theater that provides productions of melodrama as well as more legitimate work.
Symphony Square (SS): A nonprofit performing arts center primarily oriented toward a wide variety of musical events.
Austin Civic Ballet (ACB): A professional ballet company performing dances in the classic and romantic traditions.
Symphony Orchestra (SO): A full symphony orchestra performing a broad range of classical music.

The market was defined as adults living in the metropolitan Austin area. To obtain a relatively inexpensive, representative sample from the market, a telephone survey was conducted using systematic random digit dialing of telephone numbers. This is a nondirectory approach that results in a representative sample of households with telephones (some 97 percent of the households in Austin).

Questions were asked that incorporated the six areas previously mentioned. However, because the purpose here is not to present substantive findings, but rather to suggest an approach or a framework, only selected results are discussed. Indeed, the uniqueness of Austin per se would probably prohibit generalization of study findings.

One of the objectives of a market analysis is to determine how many individuals attend various performing arts events. In other words, the purpose is to determine the attendance or penetration rates of various organizations. This permits estimates of audience potentials. For the four organizations considered here, the respective penetrations (defined as attendance in prior 12 months) were:

Organization	Percent Attending
Zachary Scott	8.0
Symphony Square	8.5
Austin Civic Ballet	5.8
Symphony Orchestra	8.6

Hence, 8 percent of the total market attended at least one performance at Zachary Scott Theatre in the preceding 12 months. These percentages can then be related to population numbers to estimate audience sizes. Interpretations of figures such as these must be moderated by knowledge of the number of events offered, ticket prices, and so forth.

Going one step further, it is necessary to determine the audience overlap—the extent to which individuals attend or participate in more than one organization's events or performances. This overlap is highlighted below for the Austin data:

Number of Organizations Attended	Percent Attending
0	75.1
1	16.9
2	4.6
3	2.2
4	1.2

From this it is apparent that less than one-fourth (24.9 percent) of the Austin market attended any of the four organizations in the past 12 months. It is also evident that a small, hard-core group of individuals—1.2 percent—attended all of the organizations at least once.

An analogous procedure can be followed for each organization independently. Attenders can be classified as to the number of times they attended the events of each organization and, then, categorized as to degree of attendance—light, medium, or heavy.

Once attenders have been identified, they then can be described in terms of their psychographic characteristics. The results of doing so for two demographic variables—education and occupation—are presented in Table 13.1.

As stated previously, in order to better interpret market analysis, it is necessary to provide comparative data. The comparative data serve as a yardstick and aid in customer evaluation. Thus, consider Zachary Scott attenders. Thirty-four percent of the individuals attending Zachary Scott Theatre were college graduates. This compares with 19.3 percent of the entire market, 29.6 percent of those attending any of the four (Zachary Scott included), 15.8 percent of nonattenders, and 26.3 percent of those attending Austin Civic Ballet. The appeal of Zachary Scott to the relatively more educated is readily apparent.

In a like manner, study respondents were asked the "what," "how", and "where" questions. Similarly, they were asked why they attended or did not attend each organization's performances. Of those who attended Zachary Scott Theatre, the primary reasons included: 11 percent do so to support the organization, 70 percent simply liked the play performed, 7 percent viewed

TABLE 13.1

Percentage Responses

	Total Market	Attenders	Non-attenders	ZS[a]	SS[b]	ACB[c]	SO[d]
Education							
Less than high school degree	8.4	2.5	10.4	0.0	2.6	0.0	3.6
High school degree	30.1	17.3	34.4	22.9	13.2	10.5	17.9
Some college, trade, or business school	35.1	37.0	34.4	31.4	42.1	21.1	25.0
College graduate	19.3	29.6	15.8	34.3	26.3	26.3	28.5
Postgraduate work	7.1	13.6	5.0	11.4	15.8	42.1	25.0
Total	100.0	100.0	100.0	100.0	100.0	100.0	100.0
Occupation							
White collar	17.6	24.7	15.3	25.7	23.7	15.8	14.3
Blue collar	17.3	4.9	21.5	2.9	5.3	0.0	7.1
Clerical/sales	16.4	17.3	16.1	17.1	18.4	15.8	21.4
Student	12.7	16.1	11.6	14.3	15.8	15.8	7.1
Retired	11.8	4.9	14.0	8.6	2.6	5.3	7.1
Professional	11.5	21.0	8.3	22.9	23.7	42.1	39.3
Other	12.7	11.1	13.2	8.5	10.5	5.2	3.7
Total	100.0	100.0	100.0	100.0	100.0	100.0	100.0

[a] Zachary Scott Theatre.
[b] Symphony Square.
[c] Austin Civic Ballet.
[d] Symphony Orchestra.

it as mainly a social event, and 12 percent gave miscellaneous responses. Of those who did not attend Zachary Scott, the major reasons given were: 46 percent stated "no interest," 27 percent did not "have the time," 4 percent said it was a bad location, 2 percent gave expense as a justification, and 21 percent stated either "no reason" or other reasons such as awareness. Several marketing strategies are immediately suggested by these responses.

Finally, respondents were queried about their favorite radio station. The results for four different (programming ranged from rock to country western to baroque) stations are provided in Table 13.2 as illustrative. While 25.7 percent of the total market listed station KLBJ as the favorite station, 28.4 percent of the attenders did so, and 55.6 percent of the Austin Civic Ballet attenders so indicated.

TABLE 13.2

Favorite Radio Station

	Total Market	Attenders	Non-Attenders	ZS[a]	SS[b]	ACB[c]	SO[d]
KLBJ	25.7	28.4	24.6	25.8	33.3	55.6	16.0
KOKE	13.4	5.4	16.6	6.5	5.6	—	4.0
KASE	6.9	9.4	5.9	—	11.1	11.1	20.0
KCSW	7.3	8.1	7.0	12.9	8.3	11.1	8.0

[a] Zachary Scott Theatre.
[b] Symphony Square.
[c] Austin Civic Ballet.
[d] Symphony Orchestra.

In brief, then, by means of marketing research it is possible to perform a market analysis. Merely by using the six fundamental questions—who, what, how, when, where, and why—as a framework, considerable insight into a market can be obtained, as well as background for developing marketing strategies and programs. As such, market analysis is a prerequisite for market segmentation.

MARKET SEGMENTATION

Once a market analysis has been conducted, it is then possible to systematically combine consumers into a number of groups called *market segments*. These segments can be formed on the basis of consumer similarity on a single or a multitude of variables, where the variables could range from general characteristics such as demographics to situation-specific variables.

The most important criteria are that segments be (Kerin and Peterson 1978) as homogeneous within and as heterogeneous among as possible, easily identifiable and uniquely measurable, and distinct as regards reactions to an organization's marketing effort.

The first criterion means that within a segment the consumers should be as similar as possible on as many attributes as possible. At the same time differences among the various segments should be as great as possible. An example of an elementary segmentation procedure would be to partition a market into males and females; with regard to sex, the homogeneity/heterogeneity criterion has been met perfectly. The second criterion relates to the costs of segmenting. If the costs of segmenting (identifying and measuring market segments) are greater than the benefits of segmenting (for example, greater revenues), then segmenting is not feasible. The final criterion is the most important. Unless the segments can be uniquely marketed to and react to marketing efforts differently or uniquely, segmentation is not a viable marketing strategy. Implicit in these criteria is that any segments employed are large enough to merit individual attention.

The idea underlying market segmentation is that it represents a middle ground between treating each consumer differently and treating each identically. Market segmentation is based upon the notion that while each consumer is somewhat different from other consumers they are relatively homogeneous subsets, who can be treated similarly as regards marketing efforts. As such, the three theater groups previously mentioned—subscribers, infrequent/occasional attenders, and rare attenders—may be considered typical market segments, since they easily meet the criteria set forth above.

Techniques and Bases of Segmentation

There are numerous approaches used to segment a market, and these range from the elementary to the esoteric. The former would include constructing two segments on the basis of a single variable (for example, buyers and nonbuyers). The latter would include some form of conjoint-cluster analysis, a statistical approach virtually requiring a large-scale computer and considerable statistical sophistication.

Likewise, there are many variable bases that can be employed when segmenting a market. These can vary from employing general characteristics like demographics, to product offering purchase or usage behaviors, to benefits desired in a product offering. Answers to any of the six market analysis questions constitute potential segmentation bases.

In general, approaches to market segmentation—in terms of variable bases and techniques—are nearly idiosyncratic to the individual performing the segmentation. Partially because of this, there has been some controversy

as to the "correct" approach. Arguments have ranged from the philosophical (should segmentation be aggregative or disaggregative) to the technical (should the approach employ a compensatory or noncompensatory statistical technique). In spite of such arguments, many of which tend to be academic, there is one conclusion that appears inescapable: there is no panacean approach to market segmentation. Each segmentation analysis must be considered as distinct; rather than attempting to force a segmentation approach, attempts should be made to apply the most appropriate variable bases and techniques, given the specific market and management demands at hand. Indeed, due to several factors, such as the relatively small number of homogeneous performing arts attenders and the uniqueness of the performing arts product offering, classical (that is, product-oriented) segmentation may not even be feasible. Instead, only an attender-nonattender dichotomy may be realistic for many performing arts organizations. Such a situation should become evident once a market analysis has been conducted. As a cautionary note a marketing manager should be aware that segmentation is not unequivocally required for successful marketing.

Use of Market Segments

Adopting the philosophy of market segmentation means adopting the segment as the basic marketing decision unit. As such, segmentation provides a systematic way to develop a viable strategy by focusing on the wants and desires of select groups of consumers instead of attempting to please all consumers, and to implement this strategy by using selective marketing appeals and specific media. In brief, it permits economical operationalization of the attraction and retention concepts. Moreover, segmentation provides a mechanism for controlling marketing efforts by tracing revenues to specific market segments and, coupling these with associated costs, permitting an evaluation procedure for establishing the performance effectiveness of a marketing/segmentation program. Obviously, as mentioned previously, if the costs of segmenting/marketing to a segment exceed the revenues from doing do, this would call for some type of corrective activity.

MARKET TARGETING

After a market has been segmented, it is then necessary to select the segment or segments upon which to concentrate marketing efforts. Market targeting is merely the selection of the segment(s) that the organization decides to focus on. Market targeting essentially consists of two stages, one quantitative and one qualitative.

Market and Sales Potentials

The quantitative stage in market targeting revolves about estimating the market and sales potentials of selected market segments. Once these potentials have been determined, it is then possible to evaluate the "worth" of the possible target segments.

Market potential determination involves the total unit or dollar sales volume associated with particular market segments. In general, calculation of market potentials involves multiplying three factors together for each segment for a given time period: segment size times average attendance times price. More specifically, market potential equals the product of segment size (measured by the number of consumers), the average number of times segment members purchase the performing arts offering (average number of times attend/expect to attend performing arts events), and the price charged or to be charged for the performance.

Sales potential estimates, on the other hand, represent estimates of the sales volume the organization can expect to garner for itself from the respective segments. While market potential determination is relatively straightforward, sales potential determination is inherently more difficult, for incorporated in it are implicit yet necessary assumptions concerning expected marketing programs, budgets, and other factors.

Finally, the value of a particular market segment can be estimated by subtracting its probable marketing costs associated with a given marketing program from its sales potential. In most instances, those market segments with the greatest potential value are most likely to be the target markets.

Targeting Example

To illustrate one approach to target market selection, albeit a somewhat oversimplified approach, the survey data previously discussed were analyzed. Consider the occupation question. Each specific occupational category listed can be thought of as a distinct market segment. Rather than profiling the attenders in terms of the various occupations and organizations, a different calculation can be performed.

Specifically, the probability of an individual from an occupational category attending any single organization can be calculated for each occupation and organization. The probability is termed a *conditional* probability and is expressed as the probability of an individual attending organization X given the individual is a member of occupational segment Y. This conditional probability can be loosely interpreted as a coefficient of segment responsiveness or likelihood of attending.

As can be seen in Table 13.3, given that an individual is a white-collar worker, the probability is .158 that the individual attended Zachary Scott Theatre in the past 12 months. The probability of attending ZS, given that

occupation is white collar, is determined by dividing the number of these individuals by the total number of individuals in the white-collar segment.

In a similar manner attendance probabilities—responsiveness coefficients—can be computed for other organizations and occupations. And, analogous to the previous profiling case, the probability of attending any of the four organizations can be calculated and used as a comparison or reference base.

TABLE 13.3

Attendance Probabilities

Occupation	Attenders	ZS[a]	SS[b]	ACB[c]	SO[d]
White-collar	.35	.158	.158	.053	.070
Blue-collar	.07	.018	.036	.000	.036
Clerical/sales	.26	.113	.132	.057	.113
Student	.32	.122	.146	.073	.049
Retired	.11	.079	.026	.026	.053
Professional	.46	.216	.243	.216	.297
Other	.33	.095	.143	.048	.048

[a]Zachary Scott Theatre.
[b]Symphony Square.
[c]Austin Civic Ballet.
[d]Symphony Orchestra.

Given the probability of attendance for various segments, the potential "value" of the segments can be determined from the following formula:

Value = segment size × probability of attending

where the size can be estimated from survey data or other (for example, census) data. Using the size percentages previously determined from the survey, the value of the respective occupational segments was calculated for the Zachary Scott Theatre and presented as Table 13.4. The white-collar segment possessed a value of 2.8 (17.6 × .158). This value should be treated as an index number (without units) and used in a relative fashion when making cross-segment comparisons. If the value indexes are relatively homogeneous for a particular variable, this would imply the variable is not a good candidate as a segmentation base.

In this targeting scheme it is apparent that value results from an interaction of segment size and attendance probability. Neither above is sufficient for a high value index, yet it is possible for a segment to possess a relatively high value by having either a large size or a high attendance probability. However, in applying the scheme some minimal segment

TABLE 13.4

Occupational Segment Values

Occupation	Size	×	P(ZS/Seg)	=	Value
White-collar	17.6		.158		2.8
Blue-collar	17.3		.018		0.3
Clerical/sales	16.4		.113		1.9
Student	12.7		.112		1.4
Retired	11.8		.079		0.9
Professional	11.5		.216		2.5
Other	12.7		.095		1.2

size/probability should probably be imposed so that a segment possesses some practical significance in terms of size or attendance probability. Finally, wherever possible some price/revenue component should be added to the approach before it is operationally finalized. This is illustrated in Table 13.5 for media targeting.

Although the targeting approach above was developed primarily for quantifying segment targeting activities, it can also be employed in selecting promotional media. In particular, by using the size of a media vehicle, treating the vehicle as a "segment" and calculating attendance probabilities as before, and determining the costs of comparable advertisements, the relative value of various vehicles can be computed. This has been done below for four radio stations. As before, this approach considers not only the sheer size of a vehicle but also its potential responsiveness; moreover, it explicitly takes into account advertisement cost. Here, station KLBJ possesses the highest relative value and perhaps should be considered the primary radio vehicle candidate. Cross-media evaluations would be more difficult to make due to lack of advertisement and cost comparability.

TABLE 13.5

Calculating Relative Values

Station	Size	×	Probability (ZS/ Audience)	×	$\frac{1}{\text{Cost of Spot}}$ (dollars)	=	Value
KLBJ	25.7		.119		$\frac{1}{21} = .0476$.1456
KOKE	13.4		.057		$\frac{1}{16} = .0625$.0477
KASE	6.9		.000		$\frac{1}{20} = .05$.000
KCSW	7.3		.211		$\frac{1}{20} = .05$.077

Through some relatively elementary calculations, it is possible quantitatively to evaluate market segments as to their viability as target markets. Moreover, by employing the scheme posed here, it is also possible to make selected media evaluations.

Positioning

The qualitative stage in market targeting consists of simultaneously positioning a performing arts organization and its products. In brief, positioning refers to searching for a distinctive product/market segment niche. Included in positioning are decisions concerning whether an arts organization should concentrate on attracting/retaining a single segment or should simultaneously and differentially attract/retain several segments. Needless to say, positioning requires considerable creativity on the part of management—creativity based upon a thorough knowledge of the answers to the six questions posed in the market analysis section. In fact, it is not inappropriate for performing arts management to consider positioning as answering six questions that parallel those previously posed. With regard to the performing arts product offering: Who do we *want* to serve? What do we want it to be? How do we want to offer it? When do we want to offer it? Where do we want to offer it? Why do we want to offer it?

CONCLUDING COMMENTS

Marketing the performing arts requires distinctive skills, skills that are difficult to develop through traditional means such as commerical product management experience or formal education. The former involves different, often conflicting skills, while the latter currently does not possess an adequate underlying body of knowledge. Indeed, little has been written about performing arts marketing; smaller still is the number of useful articles in the area of market analysis, segmentation, and targeting (for example, Kaali-Nagy and Garrison, 1972; Nielsen, McQueen, and Nielsen, 1974).

In several instances the concepts set forth in this chapter are intuitively self-evident. Still, in spite of such intuitively logical concepts, hopefully the present discussion contributes in some measure to the establishment of a performing arts marketing literature. By employing the concepts discussed, arts administrators may be able to guide more effectively their organizations in successfully achieving their respective missions. Ultimately, though, effective use of the concepts or activities rests upon the creativity of the arts administrator. For instance, an individual performing arts organization or administrator may not possess the expertise or financial capability to conduct a market analysis. However, a consortium of arts organizations may be able to conduct a common market analysis, sharing both the burden and the resulting information. Through such creativity all performing arts organizations, as well as their respective audiences, will benefit.

REFERENCES

Kaali-Nagy, Christina, and Lee C. Garrison. 1972. "Profiles of Users and Nonusers of the Los Angeles Music Center." *California Management Review*, Winter, pp. 133–43.

Kerin, Roger A., and Robert A. Peterson. 1978. *Strategic Marketing: Cases and Comments*. Boston: Allyn and Bacon.

Nielsen, Richard P.; Charles McQueen; and Angela B. Nielsen. 1974. "Performing Arts Audience Segments." *Journal of the Academy of Marketing Science*, Fall, pp. 602–09.

Peterson, Robert A. 1977. *Trends in Consumer Behavior Research*. no. 6. Chicago: American Marketing Association Monograph Series.

Raymond, Thomas J. C., and Stephen A. Greyser. 1978. "The Business of Managing the Arts." *Harvard Business Review*, July-August, pp. 123–30.

14

AN EMPIRICAL ANALYSIS OF THE MARKETING CHANNELS FOR THE PERFORMING ARTS

John R. Nevin

The concept of public and nonprofit marketing has come of age during the 1970s (Lovelock and Weinberg 1978). The initial article by Kotler and Levy in 1969, "Broadening the Concept of Marketing" stimulated a debate that continued for years in the marketing literature. Ten years later, most marketing scholars generally agree that public and nonprofit marketing has achieved adult status.

By the mid 1970s marketing tools and concepts were being actively employed in specific public and nonprofit areas such as health, energy, public transportation, politics, higher education, fund raising, and the performing arts. The initial applications focused primarily on health, public transportation, and political topics (Lovelock and Weinberg 1978). Only recently have the performing arts begun to emerge as a nonprofit application area.

Relatively few applications of marketing in the performing arts have appeared in the marketing literature (Levy and Czepiel 1974; Kirpalani 1974; Laczniak and Murphy 1977a, 1977b; Lovelock and Weinberg 1978; Ryans and Weinberg 1978). These publications are primarily "micromarketing" in perspective and conceptual as opposed to empirical in nature. The micromarketing perspective focuses on the management of single or individual arts organizations. The macromarketing perspective, in contrast, focuses on the marketing process in its entirety and the aggregate mechanism of institutions performing it (see Bartels and Jenkins 1977).

Very little empirical marketing research concerning the performing arts has been conducted (Nielsen and McQueen 1974). The two empirical

The author gratefully acknowledges the valuable assistance of William Payne in the design and data preparation stages of the research. He also thanks Pamela Gilmore for her computer programming assistance.

research studies that have been published in the marketing literature (Nielsen and McQueen 1974; Ryans and Weinberg 1978) focused on consumer research. In the future one can logically expect that the preponderance of empirical research concerning the performing arts will continue to focus on micromarketing consumer research issues, because it is the easiest kind of marketing research for an arts organization to conduct. According to Lovelock and Weinberg (1978), "Arts organizations have found it easy to undertake consumer research because it is relatively simple to identify a sample of users and to administer a questionnaire." Empirical research on macromarketing issues, such as efficiency, marketing processes and systems, and channels of distribution, will most likely continue to be a rare entity in the performing arts in the future.

This chapter assumes a macromarketing perspective by empirically investigating the channels of distribution for the performing arts, and provides an in-depth understanding of the nature of the marketing channels for the performing arts. Specifically, it examines composition and structure as well as the specific functions, flows, and interdependencies that are ongoing between the various participants in the performing arts channels. Hopefully, an understanding of the current structure and functioning of the marketing channels for the performing arts will lead to an improvement in the delivery of the performing arts through more effective interorganizational management. According to Stern and El-Ansary (1977):

> Interorganization management seeks to improve overall distribution system performance through more effective management of the relations among the organizations responsible for the delivery of a particular product or service to its predetermined points of consumption.

MARKETING CHANNELS FOR THE PERFORMING ARTS

Marketing or distribution channels for the delivery of such essentials as health services, governmental services, food, automobiles, as well as the performing arts are often managed ineffectively and inefficiently. This mismanagement results in an enormous loss of resources and a disgruntled consumer. The solution to this mismanagement lies, it appears, not only in adopting consumer-oriented objectives and programs but also in managing the systems responsible for the delivery of the objectives and programs in a more satisfactory manner.

The area of analysis that is most pertinent to finding solutions to these and other types of marketing channel problems is called the management of interorganizational relations in marketing channels. This area of study is basically concerned with the process of achieving availability for consumption rather than with merely the process of consumption. To understand the process for making the performing arts available for consumption, it is

essential to have an in-depth understanding of marketing channels for the performing arts. This in-depth understanding includes an analysis of the general purpose and composition as well as the specific functions, flows, and interdependencies that are ongoing between the various participants in the channels for the performing arts.

A marketing or distribution channel is an interorganizational system comprised of a set of independent institutions and agencies involved with the task of moving anything of value from its point of conception, extraction, or production to points of consumption (Stern and El-Ansary 1977). Some of the institutions and agencies involved in the distribution of the performing arts are portrayed in Figure 14.1. Included in figure are the organizations that are primarily responsible for the contractual arrangements and the flow of the performances from the performing artists to the consumer audiences. There are numerous agencies and institutions excluded from Figure 14.1 that facilitate the passage of title and the physical movement of the performances, such as transportation carriers, the National Endowment for the Arts, and foundation, business, and individual contributors. The interorganizational distribution system for the performing arts consists of both those organizations primarily responsible as portrayed in Figure 14.1 and those excluded agencies and institutions that facilitate the passage of title and the physical movement of the performances.

Even though it is incomplete, Figure 14.1 permits at least a beginning conceptualization of the various channels of distribution for the performing arts. Nine different channels of distribution for the performing arts are depicted. An example may help to clarify the nature of a channel of distribution. Let us consider the channel from performing artists through arts councils to performing arts audiences. During the summer 1978 the Wisconsin Arts Board hired a touring show of 12 actors, dancers, and musicians to bring a rare theatrical experience to state residents and visitors. They presented some 30 performances of a comedy entitled *Star Baby* in state parks and forests of Wisconsin during the summer. In addition, the Wisconsin Arts Board hired a tour coordinator to handle sponsoring and scheduling, a technical manager to assist with the sets, and a publicist who provided publicity for each stop on the tour. Since the sponsor or presenter was not included in this channel, the Wisconsin Arts Board had to assume the responsibility for performing the functions normally provided by a sponsor.

As a new institution or agency is added to or eliminated from a given channel, it is important to view the new configuration as a new and different entity, because the problems in managing relations within the channel become distinctly different. For example, when a dance company decides to employ a booking agency rather than relying solely on its own tour manager to book its event with sponsors, it is confronted with a new set of interorganizational relations that involve motivating, directing, and con-

FIGURE 14.1

The Marketing Channels for the Performing Arts

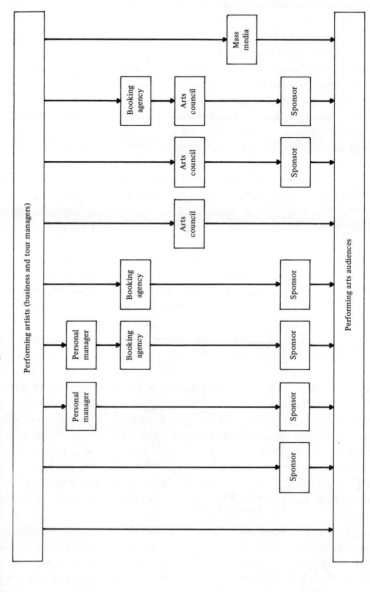

trolling an independent booking agency that divides its promotional efforts among performing artists.

An understanding that channels consist of interdependent institutions and agencies is essential to the implementation of interorganizational management. Within a channel of distribution for the performing arts, channel members should come to some agreement on the functions and activities to be performed by each channel member. In the absence of agreement on the role of each channel member, one can expect a good deal of conflict. The specification of role relationships or the rights and responsibilities of each channel member is a prerequisite to effective interorganizational management.

RESEARCH QUESTIONS AND METHODOLOGY

This study investigates empirically the following research questions about the channels of distribution for the performing arts:

1. How important are the alternative channels of distribution for the performing arts?
2. What are the role relationships (responsibilities, conflicts, cooperation, and satisfaction) among the alternative channel members for the performing arts?
3. What are considered to be the most important activities in organizing a successful performance?
4. What is the typical product mix or assortment of performances offered by sponsors and booking agencies?
5. What decision criteria and influences do sponsors and booking agencies consider to be the most important in choosing among alternative performances and deciding what price to charge for them?
6. What promotional devices do sponsors and booking agencies consider essential in order to promote a performance adequately?
7. What are the attitudes of sponsors and booking agencies on a variety of channel-related issues in the performing arts?

In order to examine these research questions, data were collected through a mail survey questionnaire mailed to a systematic sample of 300 college, university, and community administrators of performing arts centers or sponsors and 50 performing arts booking agencies. The sample of sponsors was selected from the 1978 membership roster of the Association of College, University, and Community Arts Administrators. The sample of booking agents was selected from the Official Talent and Booking Directory (Tolen 1975). Seventy-seven sponsors (26 percent response rate) and 16 booking agencies (30 percent response rate) completed and returned the questionnaire. Sponsors and booking agencies were selected as sample subjects because they are the two dominant marketing intermediaries in the

channel for the performing arts. The sponsors, in essence, function as retailers by offering an assortment of performances to the ultimate consuming public. Using the retailer as the primary information source has been the most commonly used approach in empirical investigations of the behavioral dimensions of channels of distribution. The booking agencies function as an agent wholesaler and were included because they play an extremely important role in the channel for the performing arts.

IMPORTANCE OF THE CHANNELS FOR THE PERFORMING ARTS

Tracing the negotiations within a channel of distribution sheds considerable light on the importance of the various marketing intermediaries. The negotiation patterns for the two dominant channel members (sponsors and booking agencies) in the performing arts are presented in Table 14.1. Three important findings seem to emerge from an examination of the data. First, sponsors depend very heavily on booking agencies, as 75 percent of all sponsors' bookings over the past two years were reportedly made through booking agencies. Second, booking agencies reported booking 60 percent of their performances through sponsors. Obviously, there is a substantial interdependence among sponsors and booking agencies. Finally, booking agencies reported booking one-fourth of their performances through other booking agencies. This dual booking agency pattern is a fairly common practice in the channel for performing arts.

The negotiation patterns in Table 14.1 can be used to estimate the relative proportion of performances or bookings flowing through the major channel alternatives. The estimated relative proportions of performances flowing through five major channel alternatives are shown in Figure 14.2. All

TABLE 14.1

Negotiation Patterns of the Two Dominant Channel Members in the Performing Arts (percent)

Bookings (performances) Negotiated over the Last Two Years Directly with	Proportion of	
	Sponsor Bookings	Booking Agency Bookings
Booking agency	75	32
Tour manager	4	0
Personal manager	6	2
Arts council	1	2
Artist	8	5
Sponsor	6	59
Total	100	100

FIGURE 14.2

Relative Proportion of Performances Flowing Through Major Channel Alternatives

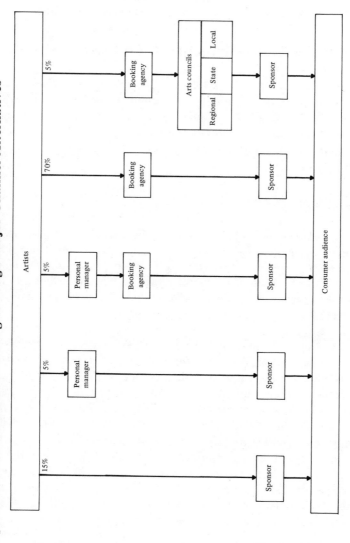

of these five channels utilize either a sponsor and/or a booking agency. Two channel alternatives account for 85 percent of the performances handled by these five separate channels. The artist booking agency/sponsor/audience channel accounts for 70 percent of the total performances booked through these channels. In addition, the artist/sponsor/audience channel accounts for 15 percent of the performances. These findings dramatize the importance of the booking agency in the channel for the performing arts.

ROLE RELATIONSHIPS AMONG CHANNEL MEMBERS

An investigation of the role relationships among channel members needs to consider the nature of responsibilities, conflicts, cooperation, and satisfaction among these members. An examination of these individual behavioral dimensions provides an opportunity for more effective management of the relations among members of the marketing channels for the performing arts.

Responsibility of Channel Members

The channel members who currently assume the most responsibility for a variety of marketing-related activities are shown in Table 14.2. The responses of sponsors and booking agencies are presented separately in this table in order to dramatize any differences in perception that may exist. As might be expected, the sponsors and booking agencies assume most of the responsibilities in the performing arts channel.

Sponsors and booking agencies both agree that sponsors assume most responsibility for organizing special services, paying for special services, placing of advertising, providing for and paying personnel not covered by a "yellow card," providing special security, and abiding by copyrights. Sponsors reported that booking agencies assume the most responsibility for providing promotional material and a detailed, specified program of the performance. Booking agencies, in contrast, were quite likely to claim that the most responsibility for providing promotional material and a program of the performance was the responsibility of the artist. Apparently, booking agencies are reluctant to assume this responsibility, even though a sponsor's only contact is likely to be with a booking agency and not an artist. These differences of opinion are most certainly a source of potential conflict among channel members.

Conflict among Channel Members

The degree of conflict among channel members over channel activities and functions is reported for both sponsors and booking agencies in Table

TABLE 14.2

Channel Members Currently Assuming the Most Responsibility for Various Marketing Activities (percent)

Marketing Activities	Sponsor		Art Council		Booking Agency		Personal Manager		Tour Manager		Artist	
	Sp.[a]	Bk.[b]	Sp.	Bk.	Sp.	Bk.	Sp.	Bk.	Sp.	Bk.	Sp.	Bk.
Souvenir sales	21	39	0	0	4	8	9	15	54	39	12	0
Providing a detailed, specified program of the performance	16	20	0	0	61	27	5	27	5	0	12	27
Editing/changing the program selection	59	27	0	0	8	13	7	13	1	7	25	40
Organizing special services	87	80	0	0	4	0	4	13	5	0	0	7
Paying for special services	90	75	3	6	4	0	0	6	3	0	0	13
Placing of advertising	100	94	0	6	0	0	0	0	0	0	0	0
Providing personnel not covered by a "yellow card"	96	77	0	8	1	0	1	0	1	8	0	8
Paying for personnel not covered by a "yellow card"	90	77	1	8	4	0	1	0	1	0	1	15
Providing special security	97	94	0	0	0	0	0	0	3	6	0	0
Abiding by copyrights	71	63	1	0	10	6	1	13	4	0	11	19
Paying of royalties	70	69	1	0	12	0	0	0	4	0	13	31
Providing promotional materials	10	19	0	0	77	38	4	6	7	6	3	31

[a] Sponsor responses.
[b] Booking agency responses.

Note: Responsibility was measured by asking the respondent the following question: "Who currently assumes the *most* responsibility?"

14.3. Overall, there were very low levels of conflict evident in the channel for performing arts. There were, nevertheless, a few interesting findings. Sponsors reported more than occasional disagreement or conflict with respect to providing promotional material. This is not surprising given that booking

TABLE 14.3

Degree of Conflict among Channel Members Over Channel Activities and Functions (Average Ratings)

Channel Activities and Functions	Degree of Conflict	
	Sponsor Mean Response	Booking Agency Mean Response
Perquisities (such as food, drinks, et cetera) in the dressing room	29	29
Souvenir sales	16	16
Provision of promotional material (posters, tear sheets, et cetera)	39	23
Usage of promotional material	15	31
Editing/changing the program selection	26	33
Exclusivity clause in the contract	23	31
Complimentary tickets to the artists	13	18
Complimentary tickets to others (for example, the press and distinguished guests)	22	22
Special services		
Lecture/demonstration	20	14
Miniconcerts	16	17
Master classes	19	19
Interviews	26	24
Receptions	19	19
Placing of advertising	17	15
Providing personnel not covered by the "yellow card"	19	23
Providing special security	18	23
Abiding by copyrights	12	16
Paying for royalties	9	17
Prevention of performance reproduction	14	31

Note: Degree of conflict was measured by using a four-point rating scale: very frequently = 100; somewhat frequently = 67; occasionally = 33; and never = 0. The question asked was as follows: "How frequently do you disagree with another party over each of the following items: . . .?"

TABLE 14.4

Degree of Cooperation among Channel Members in Booking Acts (average ratings)

	Degree of Cooperation	
	Sponsor Mean Response	Booking Agency Mean Response
Booking agency	88	86
Tour manager	78	75
Arts council	68	63
Personal manager	74	67
Artist	81	86
Sponsor	77	83

Note: Degree of cooperation was measured using a five-point scale: very cooperative = 100; somewhat cooperative = 75; neither cooperative nor uncooperative = 50; somewhat uncooperative = 25; and very uncooperative = 0.

agencies seem somewhat unwilling to assume responsibility for providing promotional material. Booking agencies differed substantially from sponsors in their perceived level of conflict with respect to usage of promotional material and the prevention of performance reproduction. Apparently, booking agencies perceive more frequent disagreement over these two activities than sponsors.

Cooperation among Channel Members

The reported degree of cooperation among channel members in booking acts is shown for both sponsors and booking agencies in Table 14.4. Sponsors and booking agencies both view most channel members as reasonably cooperative. Arts councils and personal managers are, however, perceived to be the least cooperative of the channel members. Apparently, booking agencies, sponsors, and artists all seem to get along with each other quite amicably.

Satisfaction with Channel Member Professionalism

The sponsors' and booking agencies' levels of satisfaction with the professionalism of the channel members are shown in Table 14.5. Booking agencies, artists, and sponsors are perceived to be reasonably professional by both sponsors and booking agencies. Arts councils, in contrast, are perceived to be somewhat less professional than other members by both sponsors and booking agencies.

TABLE 14.5

Level of Satisfaction with the Professionalism of the Channel Members (average ratings)

	Level of Satisfaction	
Channel Members	Sponsor Mean Response	Booking Agency Mean Response
Booking agency	77	75
Tour manager	71	69
Arts council	58	53
Personal manager	70	56
Artist	73	75
Sponsor	68	77

Note: Level of satisfaction was measured by using a five-point scale: very satisfied = 100; somewhat satisfied = 75; neither satisfied nor unsatisfied = 50; and somewhat dissatisfied = 25.

IMPORTANCE OF CHANNEL ACTIVITIES IN ORGANIZING A SUCCESSFUL PERFORMANCE

Sponsors and booking agencies were asked to indicate how important they believed a number of channel-related activities are in organizing a successful performance (see Table 14.6). Overall, the most important activities to the success of a performance seem to be promotional material, placing of advertising, interviews, detailed program of the performance, complimentary tickets to others, and prevention of performance reproduction. There were, however, some interesting differences in the perceptions of sponsors vis à vis booking agencies.

Sponsors placed considerably more importance on the availability of a detailed, specific program of the performance, being able to change the program selection, and giving a lecture/demonstration than did booking agencies. Booking agencies, in turn, ascribed considerably more importance to complimentary tickets to the artists and others, interviews, providing special security, and prevention of performance reproduction. The booking agencies, obviously, place more importance on activities of concern to their artist clients, while sponsors are placing greater importance on activities of immediate concern to their art audiences.

ASSORTMENT OF PERFORMING ARTS OFFERED

The typical or mean assortment of performing arts offered by sponsors and booking agencies is shown in Table 14.7. Booking agencies seem to handle primarily artists in theater, symphony, rock, instrumental and vocal

TABLE 14.6

Importance of Various Channel Activities in Organizing a Successful Performance (average ratings)

Channel Activities	Degree of Importance	
	Sponsor Mean Response	Booking Agency Mean Response
Perquisities, (such as food, drinks, et cetera) in the dressing room	57	59
Souvenir sales	31	41
Promotional material (posters, tear sheets, et cetera)	94	94
Detailed, specific program of the performance	94	80
Being able to edit/change the program selection	76	65
Exclusivity clause in the contract	73	70
Complimentary tickets to the artist	59	64
Complimentary tickets to others (for example, the press and distinguished guests)	83	92
Special services in general	86	80
Lecture/demonstration	77	70
Miniconcerts	69	67
Master classes	73	73
Interviews	81	93
Receptions	69	64
Placing of advertising	94	93
Abiding by the "yellow card"	70	83
Providing special security	63	77
Prevention of performance reproduction	74	83

Note: Importance was measured using a five-point scale: very important = 100; somewhat important = 75; neither important nor unimportant = 50; somewhat unimportant = 25; and very unimportant = 0.

recitals, and other types such as mime and middle-of-the-road music. Booking agencies do not seem to book substantial volumes of the other types of performing arts. Sponsors, in contrast, reported offering a much broader range of types of performing arts. Sponsors' assortments seem to consist primarily of artists in theater, instrumental recitals, chamber orchestra or ensemble, and contemporary dance. In addition, sponsors also

TABLE 14.7

Types of Performing Arts Offered by Sponsors and Booking Agencies (mean percents)

Types of Performing Arts	Sponsor Responses*	Booking Agency Responses*
Symphony	6	10
Chamber orchestra/ensemble	12	5
Recital—vocal	5	8
Recital—instrumental	12	8
Choral singers	4	3
Opera	4	3
Theater	14	30
Contemporary dance	10	3
Ballet	6	2
Jazz	6	2
Rock	4	10
Folk/country music	4	3
Ethnic music/dance/theater	5	5
Other (mime, and so on)	8	8
Total	100	100

Note: Respondents were asked to indicate "What proportion of your bookings or performances over the past two years were from each of the following types of performing arts?"

*These mean percents have been normalized to a base of 100 percent.

offer a reasonable assortment of symphony, vocal recital, opera, ballet, jazz, rock, folk and country music, and ethnic music, dance, or theater. The sponsors offered a broad assortment of performing arts to its audiences, while booking agencies tended to specialize in a few types of performing arts. Since booking agencies are primarily profit-oriented businesses, then logically it follows that they concentrate their efforts on the most potentially profitable performing arts bookings. The sponsors, being less profit-oriented, offer a wider assortment of performing arts events by using profitable bookings to subsidize the unprofitable ones.

DECISION CRITERIA AND INFLUENCES IN CHOOSING AND PRICING PERFORMANCES

What criteria or information do sponsors and booking agencies consider important in deciding which acts to book? The sponsors' and booking agencies' answers to this question are shown in Table 14.8. Surprisingly, sponsors and booking agencies gave almost identical importance ratings to each of the 12 criteria except one. In order of importance the most important

TABLE 14.8

Importance of Various Decision Criteria in Deciding to Book an Act (average ratings)

Decision Criteria	Degree of Importance	
	Sponsor Mean Response	Booking Agency Mean Response
Audience reception/appeal	98	96
Seating capacity	78	75
Promotional assistance provided/offered	74	83
Word of mouth	77	85
Recommendation by arts council	52	52
Fills an empty date	35	48
Good track record of sponsor/artist	87	95
Booking agency's suggestion	60	69
Good critical reviews	82	81
Facility quality/technical limitations	83	73
Part of a "package deal"	52	58
Recommendations by the board of directors	55	36

Note: Importance was measured using a five-point scale: very important = 100; somewhat important = 75; neither important nor unimportant = 50; somewhat unimportant = 25; and very unimportant = 0.

decision criteria were audience reception or appeal, good track record of artist, good critical reviews, word-of-mouth communication, and technical limitations of facility. The one exception was recommendations by the board of directors, which sponsors necessarily considered more important than booking agencies since performing arts administrators are directly governed by their boards.

The degree of influence that the various performing arts publics should have on which events to book and at which price are presented in Table 14.9. In deciding which events to book, both sponsors and booking agents indicated that sponsors should have much influence, while sponsor associations, booking agents, arts councils, individual contributors to the arts, and the National Endowment for the Arts should have some influence. With respect to the price of tickets, both channel members indicated that sponsors should have much influence and sponsor associations some influence. Booking agencies indicated that they should have substantial influence on the price of tickets, but sponsors drastically disagreed by indicating that

TABLE 14.9

Degree of Influence the Various Performing Arts Publics Should Have on Two Specific Decisions (average ratings)

Performing Arts Publics	Which Acts to Book		Price of Tickets	
	Sponsor Mean Response	Booking Agency Mean Response	Sponsor Mean Response	Booking Agency Mean Response
Arts councils	31	35	19	25
Sponsors	80	89	78	79
Labor unions	3	5	3	12
Artist's guilds	16	6	10	12
National Endowment for the Arts	37	17	18	15
City or state government	13	0	13	8
Private foundations	21	18	18	21
Individual contributors to the arts	35	21	24	23
Sponsor associations	52	58	42	46
Booking agents	35	62	20	63

Note: Influence was measured using a three-point scale: much influence = 100; some influence = 50; and no influence = 0.

booking agencies should have very little, if any, influence on ticket prices. This disagreement is obviously a source of potential conflict in the dominant channel for the performing arts.

PROMOTIONAL DEVICES ESSENTIAL TO PROMOTE A PERFORMANCE ADEQUATELY

Sponsors and booking agencies were asked to indicate which of nine different promotional devices they considered essential to promote a performance adequately (see Table 4.10). Although sponsors in general consider promotional devices more essential than booking agencies, they agree on the ordered importance of the different devices. Both channel members consider photographs of principals, fliers, and imprinted window cards to be the most essential promotional devices. Also considered essential by at least half the sponsors and booking agencies were text for television and radio spots and interviews. Artists and booking agencies should arrange for *at least* the promotional devices mentioned above to be made available to sponsors through booking agencies. In the future, artists, booking agencies, and sponsors alike will be under great pressure to make greater use of all these

TABLE 14.10

Promotional Devices Considered Essential to Promote a Performance Adequately (percent)

	Proportion Considering Device Essential	
Promotional Devices	Sponsors Responses	Booking Agents Responses
Imprinted window cards	78	69
Fliers	87	81
Picture mats	35	19
Ad mats	42	25
Tear sheets	47	25
Photographs of principals	95	94
Text for TV or radio spots	53	56
Outdoor advertising	12	25
Interviews	44	56

promotional devices because of the increasing competition posed by other forms of entertainment.

CHANNEL MEMBER ATTITUDES TOWARD THE PERFORMING ARTS

Both channel members were asked to express their attitudes on a broad range of issues concerning the performing arts. The specific attitude statements and their responses are presented in Table 14.11. Some of the stronger attitudes expressed by the channel members were as follows:

1. Sponsors and booking agencies do not generally agree that their responsibility is to fill the house.
2. Sponsors and booking agencies both feel strongly that the arts should broaden its audience base.
3. Sponsors and booking agencies feel the arts should have more outreach programs.
4. Sponsors and booking agencies both feel sponsors should move the arts to the people.
5. Sponsors, but not booking agencies, feel that high artists fees are the main reason for higher ticket prices.
6. Sponsors and booking agencies both feel that unions are making too many demands that raise prices.
7. Sponsors and booking agencies perceive arts councils' activities to be improving the reception of art by the public but not providing needed assistance to sponsors and booking agencies.

TABLE 14.11

Selected Attitudes of Sponsors and Booking Agencies Toward the Performing Arts (average ratings)

Selected Attitude Statement	Sponsor Mean Response	Booking Agency Mean Response
My primary responsibility is to fill the house	63	56
My primary responsibility is to be a custodian to the arts	71	63
The performing arts should be made to pay their way through astute sponsor management	51	52
The arts should broaden its audience base	95	80
The arts should focus on those who support the arts the most	46	40
The arts should have more outreach programs	85	82
The sponsors should move the arts to the people—that is, the suburbs and the country	73	70
High artists' fees are the main reason for higher ticket prices	74	63
Unions are making too many demands that raise prices	71	72
Better coordination among the intermediaries will improve performances and will lower costs	64	67
A major problem is finding out which acts are available	38	41
Arts councils are providing needed assistance for me	44	39
The activities of arts councils have improved the reception of art by the public	66	66
It is a problem to find acts to fit my audience	37	36
It is a problem to find audience support for my performances	55	55

Note: Respondents were asked to indicate how much they agreed or disagreed with each of the above statements using a five-point scale: strongly agree = 100; somewhat agree = 75; neither agree nor disagree = 50; somewhat disagree = 25; and strongly disagree = 0.

One of the more interesting attitudes expressed was the revelation that neither sponsors nor booking agencies consider it their responsibility to fill the house. Apparently they must consider it the artists' responsibility to fill the house, if anyone can be considered responsible. At the same time both sponsors and booking agencies feel very strongly that the performing arts should broaden its audience base. The interesting question that arises is, Who, if anyone, is going to assume the responsibility for either filling the house or broadening the audience base for the performing arts?

CONCLUSION

By providing an understanding of the current structure and functions of the marketing channels for the performing arts, this article will assist channel members in improving their performance through more effective management of the relations among the channel members. Channel members need to determine who is going to assume the responsibility for providing promotional materials and a program of the performance, since they are considered two of the most important activities for the success of a performance. The specific promotional materials considered most essential were photographs of principals, fliers, imprinted window cards, text for television, and radio spots and interviews. Knowledge of the most important decision criteria and influences in choosing performances should enable any of the channel members dealing with booking agencies or sponsors to develop more effective promotional material aimed at channel members.

It is also hoped that this exploratory study will create awareness for and stimulate additional empirical research on macromarketing issues in the performing arts.

REFERENCES

Bartels, Robert. 1974. "The Identity Crises in Marketing." *Journal of Marketing*, October, pp. 73–76.

Bartels, Robert, and Roger L. Jenkins. 1977. "Macromarketing." *Journal of Marketing*, October, pp. 17–20.

Baumol, William, and William Bowen. 1966. *Performing Arts: The Economic Dilemma*. New York: Twentieth Century Fund.

Hunt, Shelby D. 1976. "The Nature and Scope of Marketing." *Journal of Marketing*, July, pp. 17–28.

Kirpalani, V. H. 1974. "Marketing and the Arts: Discussion." In *1974 Combined Proceedings*, edited by Ronald C. Curhan, pp. 396–98. Chicago: American Marketing Association.

Kotler, Philip. 1972. "A Generic Concept of Marketing." *Journal of Marketing*, April, pp. 46–54.

Kotler, Philip, and Sidney J. Levy. 1969. "Broadening the Concept of Marketing." *Journal of Marketing*, January, pp. 10–15.

Laczniak, Gene R., and Patrick E. Murphy. 1977a. "Planning and Control for Performing Arts Marketing." In *1977 Educators' Proceedings*, edited by Barret E. Greenberg and Danny E. Bellenger. Chicago: American Marketing Association.

———. 1977b. "Marketing and the Performing Arts," *Atlanta Economic Review*, 27:4–9.

Levy, Sidney J., and John A. Czepiel. 1974. "Marketing and Aesthetics." In *1974 Combined Proceedings*, edited by Ronald C. Curhan, pp. 386–89. Chicago: American Marketing Association.

Lovelock, Christopher H., and Charles B. Weinberg. 1978. "Public and Nonprofit Marketing Comes of Age." In *Review of Marketing 1978*, edited by T. Bonona and G. Zaltman, pp. 413–52. Chicago: American Marketing Association.

Luck, David J. 1969. "Broadening the Concept of Marketing—Too Far." *Journal of Marketing*, July, pp. 53–55.

Nielson, Richard P., and Charles McQueen. 1974. "Performing Arts Consumer Behavior: An Exploratory Study." In *1974 Combined Proceedings*, edited by Ronald C. Curhan, pp. 392–95. Chicago: American Marketing Association.

Ryans, Adrian B., and Charles B. Weinberg. 1978. "Consumer Dynamics in Nonprofit Organizations." *Journal of Consumer Research*, September, pp. 89–95.

Stern, Louis W., and Adel I. El-Ansary. 1977. *Marketing Channels*. Englewood Cliffs, N.J.: Prentice-Hall.

IV

ELABORATING AND CONTROLLING THE ARTS MARKETING PROGRAM

INTRODUCTION TO PART IV

A marketing program is a bridge between the artist and the audience. It is built upon the elements of marketing exchange—configuration, symbolization, valuation, and facilitation. These exchange elements are manifest in a set of policy decisions, commonly referred to as the "marketing mix."

The marketing mix can be conceptualized as the basic tools for the arts marketing decision maker. The elements of the mix include: product, promotion, pricing, and delivery. An effective arts marketing program requires carefully defined and balanced decisions interrelating each element of the marketing mix. In earlier presentations arts product and delivery (distribution) policies were focal topics. In this section promotion and pricing are investigated and a policy-making framework for each is developed.

In Chapter 15, "Promotion Policy Making in the Arts: A Conceptual Framework," Roger A. Strang and Jonathan Gutman describe the multiple tools of promotion and discuss the utility of each. They build a framework for designing promotional strategy in the arts. The first stage of the model is segmentation of an audience according to different levels of involvement with the arts organization. Next, a specific objective and message premise for each segment is formulated. According to the authors, different promotional tools, then, should be used to accomplish distinctive objectives. The total promotional policy process requires careful coordination and integration with other marketing-mix elements.

Christopher Lovelock and Phillip Hyde in Chapter 16, "Pricing Policies for Arts Organizations: Issues and Inputs," describe pricing as probably the least interesting element of the arts marketing mix; however, they emphasize that the need for effective pricing policies in the arts is magnified by growing

costs and deficits, a less benevolent funding market, and pressures for increasing earned income. The authors argue that external influences have pressured arts prices downward and that conventional administrative wisdom has been an ineffective basis for pricing. Carefully, the authors delineate the nature, role, and elements of pricing in the arts. They demonstrate that pricing involves much more than a dollar value for tickets; that it requires a clear understanding of cost structures, organizational objectives, and consumer price sensitivity.

Implementation of integrated, thoughtful marketing programs should enhance the arts organization's ability to meet realistic goals and performance objectives. Constructive monitoring and evaluation of both decision processes and market performance are vital for effective arts administration. However, evaluation and control policies have not been well received in the arts environment. Control can be constraining; evaluation of arts policies can be very difficult to conceptualize and politically destructive. The final presentation explores the concept of managerial control and the role of marketing evaluation within the arts organization.

In Chapter 17, "Marketing Control and Evaluation: A Framework for Strategic Arts Administration," Michael P. Mokwa argues that the concepts of control and evaluation are poorly understood and practiced in most arts organizations. He outlines the benefits of explicit control policies for arts organizations and defines each process. A prescription advocating formative strategic evaluation policies for the arts is elaborated. A marketing audit framework and a set of orienting questions are outlined. In conclusion, the author raises the issue that the goal structures of arts organizations are tied to the sociocultural role of the arts. Until that role is better defined, arts organizations will continue to struggle in judging their effectiveness.

15

PROMOTION POLICY MAKING IN THE ARTS: A CONCEPTUAL FRAMEWORK

Roger A. Strang and Jonathan Gutman

An effective promotion program is a very important part of the marketing activities for most performing arts organizations. It is these persuasive communications that play a major role in attracting the audience required for both artistic success and financial survival. This chapter discusses the issues involved in the development of effective promotion programs, including the tools of promotion, determination of appropriate objectives, definition of target audiences, and decisions on the level, theme, and mix of activities that should be undertaken.

Shapiro (1972) and others have noted that promotion activities for arts and other nonprofit organizations may be directed to two audiences, potential sources of funds as well as prospective patrons of the services provided. This chapter emphasizes promotion activities directed toward the latter group, although the principles have general application in both areas. It begins by considering the role and objectives of promotion programs and then discusses how target audiences may be defined in terms of these objectives. It is suggested that this perspective provides a guide as to the budget level, promotional theme, and selection of appropriate promotion techniques. A presentation of a summary framework concludes this chapter.

TOOLS OF PROMOTION

Promotion has been defined as "all the tools in the marketing mix whose major role is persuasive communication" (Kotler, 1975, p. 201). The promotion policy maker in the arts has a wide variety of tools that may be employed. These may be classified into four groups:

1. Advertising—any paid form of nonpersonal presentation and promotion of ideas, goods, or services by an identified sponsor. These include

broadcast advertising, print, direct mail, outdoor posters (also boards and displays), transit, novelties (T-shirts, buttons, et cetera), programs, and flyers.

2. Publicity—nonpersonal stimulation of demand for a product, service, or organization by planting news about it in print or via broadcast media that is not paid for by the sponsor. This includes press releases, press conferences, staged events, reviews, broadcasts, and speeches.

3. Personal contact—Oral presentation in a conversation with one or more prospective purchasers for the purpose of making sales or building goodwill. This includes telephone selling, group sales, education programs, box office, ushers, refreshments, and the like.

4. Sales promotion—a temporary additional incentive to encourage purchase or sale of a product or service. These include premiums (gifts with purchase), price discounts, package offers (for example, two seats for the price of one), contests, and sweepstakes. They may be offered to the audience or to intermediaries (such as ticket agents or telephone sales people).

PROMOTION OBJECTIVES

Promotion activities are only one element of the marketing strategy that an arts organization can employ, and, therefore, promotion objectives must be established in light of the overall organizational goals. Earlier chapters have discussed the many goals that a performing arts organization may have, and it is these, together with the decision on the general strategy for achieving them, that determine the role and objectives for promotion. Promotion is only one technique for attracting an audience. Therefore, the role of promotion may vary widely among different arts organizations. It may be very important for a newly established community arts group that has a large potential audience that knows little about the organization or its program. On the other hand, promotion would play a small role for a well-established group such as a state-sponsored school touring company that relies on other elements of marketing strategy.

The specific objectives for promotion may vary widely, but no doubt the most common is to attract an audience. However, promotion is often limited in the extent to which it directly leads to attendance. Promotion activities provide persuasive communication, but the final decision to attend is usually a function of many other factors, including the nature of the event, quality of the performance, costs of attending, and convenience of the location. In fact, all the elements of marketing strategy are involved to some degree, and in many cases, especially with regard to advertising and publicity, it would be misleading to make promotion policy decisions on the assumption that they are directly related to sales. For this reason it is often more useful to focus on

the process by which persuasive communication leads to the decision to attend. Therefore, it is proposed that promotion objectives should be established in terms of three principal steps in this process:

1. Information. To Inform. In order to make their decision on whether to attend, a patron needs basic information on the event itself (what is it, who will be performing) as well as the date, location, time, cost of tickets, and how tickets may be obtained.

2. Persuasion. To Persuade. In addition to the above prospective patrons may need additional incentives to encourage them to attend. There are a wide variety of possible incentives including the quality of the performance, the presence of a recognized star, the unique nature of the event (for example, premiere), special price offers on tickets, convenience of location, pleasant atmosphere, opportunity for personal enrichment, social satisfaction, and the like. The importance of these will vary according to the type of event and the target audience.

3. Education. For most people an appreciation of the performing arts is learned or acquired over time. This means that the expansion of the audience for the arts requires the development of a level of understanding sufficient to arouse the desire to attend an arts event. This objective is distinguished from the preceding one because it requires education before prospective patrons can recognize the value of a particular incentive (a featured performer is of little interest to a prospective patron who has no way of evaluating the quality of his or her work). A second distinguishing feature is that education activities are often undertaken separately from promotion activities, which are directed to attracting patrons for specific performances.

TARGET AUDIENCE

Many arts organizations may be established to present a program of performances for the entire community. However, as was discussed in the chapter on market segmentation, it is usually not practical or efficient to direct promotion activities to the population as a whole. Typically organizations do not have the money to reach all community members, nor would it be efficient, given that the audience for most performing arts events is drawn from a limited group. Most studies show that the bulk of arts patrons are well educated and above average in income and are students or from households where the occupation of the head is professional, managerial, or technical. In fact, one expert has estimated that potential subscribers for a performing arts series comprise no more than 2 percent of the population of most cities (Newman 1977).

Even within this group various subsegments can be identified that,

because of differences in their decision-making process or other factors, can be selected as targets for unique promotion programs. In any community these can include groups distinguished on a number of demographic bases such as age, education, or membership in an affinity group. Promotion to students may involve extensive use of posters and the campus newspaper with some messages emphasizing associations with classroom studies. Senior citizens may be reached through direct contact with the organizers of social activities, and a similar strategy would be appropriate for employees of large companies or public servants. In some communities another significant group may be tourists or other visitors, where promotion may be supported by visitor development organizations. In addition to these groupings, promotion strategy decisions may be improved if two other breakdowns are used. These are artistic preference and level of involvement.

Artistic Preference

Several surveys including those of the Urbana-Champaign community (Nielsen 1975), the University of California—Los Angeles (UCLA) community (Scalberg 1977), and students at the University of Southern California (Gutman 1978) have shown that patrons do not attend all types of performing arts activities but have distinct preferences for certain related art forms. While each of the studies employed a different selection of arts events and arrived at slightly different classifications, there appear to be at least five major types of activities that appeal to particular market segments. These are theater, classical music, contemporary music, voice, and dance. A more comprehensive listing is given in Table 15.1. This is by no means an exclusive classification, since it may vary by community and there is considerable overlap (most classifications explain only 60 to 70 percent of the variations in attendance).

A major implication from these findings is that related events should be promoted together as a package. For example, the traditional mailing of a large, comprehensive booklet describing all the activities for the year may be replaced by smaller brochures that emphasize only those events in which the prospective patron has shown an interest. This is a step that has been taken by many state and regional travel organizations and has the effect of reducing costs (mailing and printing) as well as minimizing the opportunity for the recipient to overlook the series or program in which he or she is particularly interested. In his survey, Nielsen found some significant demographic and behavioral factors which could be used to identify potential audiences for particular types of events; but in any community, patrons' interests can be determined by previous requests or a survey. Since there is some overlap, each brochure or advertisement would need to indicate that information on other programs is available and how it could be obtained.

TABLE 15.1

Artistic Preference—Major Classifications

Type	Subgroup
Theater	Drama
	Comedy
	Experimental
	Musical
Classical music	Symphony
	Chamber music
	Instrumental recitals
Contemporary music	Jazz
	Folk
	Rock
	Band
Voice	Opera
	Choral
	Voice recitals
Dance	Ballet
	Modern dance
	Folk/ethnic dance

Level of Involvement

Another possible segmentation that has important implications for promotion strategy is the basis of the degree of involvement that potential patrons are likely to have toward a particular event. Three possible groups can be identified:

1. Enthusiasts—patrons with a strong interest in a particular art form who will seek out information on future performances. Weinberg and Shachmut (1978, p. 659) found that this group was the primary audience for the young concert artist series at Stanford and noted that they were "believed to seek information about performances without the benefit of extensive promotion." Members of this segment are likely to belong to support groups, subscribe to the season or series, and/or participate themselves in the activity on a nonprofessional basis.

2. Interested—potential patrons with a lesser degree of commitment who may be persuaded to attend a performance if given sufficient inducement. Despite the preferences mentioned above, there is a good deal of overlap, and this segment is likely to include people who may attend a variety of performing arts events.

3. Nonattenders—these are members of the community who do not know enough about an art form to consider attending but who may become patrons if they can learn enough to appreciate its merits. Nielsen (1973) has suggested that the emphasis on immediate benefits may also be helpful in converting nonattenders. The greatest potential for attracting patrons from this group is probably among those who belong to one of the demographic categories mentioned above, but the rest of the population should not be ignored.

This last categorization has particular relevance for promotion policy decisions because it divides the market in terms of the principal promotion objectives. Thus, the objective for promotion activities directed to each of the segments would be:

Target Audience	Promotion Objective
Enthusiasts	To inform
Interested	To persuade
Nonattenders	To educate

It should be noted that these are only the principal objectives and that there will be considerable overlap. The enthusiasts will still require some persuasive elements to encourage them to renew their subscriptions, and those who may be interested will certainly need the basic information about the performance and tickets. However, this perspective does provide an indication as to the nature and magnitude of the promotion task and is, therefore, useful in the development of effective strategies, as will be discussed further

PROMOTION STRATEGY

The development of promotion strategy requires decisions in a number of areas including the amount of resources that is to be committed, the promotional theme or appeal that is to be used, and the particular mix of techniques to be employed.

Promotion Budgets

The promotion budget depends on a number of factors. For most organizations in performing arts, the principal constraint is the amount of money, volunteer time, or other resources that are available. The theoretical approach to promotion budget setting calls for expenditures to the point where incremental revenues equal costs and where the return from additional investment in promotion activities is exactly equal to the return on

other marketing activities. Even if this level of expenditure is impossible in practice for arts organizations, it does not mean that the basic principles should be ignored.

What is the dollar value of unsold seats? Since the incremental costs of servicing each additional patron are very low, it may be worthwhile spending up to the total value of these unsold seats in order to fill the house. Earlier in the chapter it was noted that promotion was only one way to attract an audience and budgets should be set according to its role in the strategy for a particular organization. Unfortunately, there is usually little information to compare the drawing power of diverse elements such as the quality of the production, the price of the tickets, and the amount of advertising.

The existence of a resource constraint does, however, force a closer consideration of the relationship between the budget and the promotion objectives. It is clear that the amount of resources available limits the ability of a promotion program to achieve particular objectives. A $1,000 budget does not allow for much in the way of newspaper advertising in most metropolitan areas. Under these conditions the objectives may be viewed as a hierarchy involving increasing levels of resources. The greatest return undoubtedly comes from ensuring that all those who are the primary target for a particular event (the enthusiasts) have the necessary information to enable them to purchase tickets. A greater level of effort is required to persuade those who are potentially interested to attend, and the lowest return of all comes from educational efforts with their low response rate that may not be realized for several years. Similarly, the response rate for subscription renewals is many times higher than that for promotional activities designed to attract new subscribers. Under these conditions it has to be recognized that a limited budget may only permit the achievement of limited objectives, and expectations should be lowered accordingly.

There are many ways of getting the most out of limited budgets. The North Carolina Arts Council makes bulk media buys and then provides the space or time to arts organizations at a lower rate. It also works with the governor's office to solicit donations of billboards, newspaper space, and broadcast time. Most media will provide a certain amount of free advertising as part of their public service efforts, and in some cases this can be expanded through assistance with programming. An example of this is the daily "Luncheon at the Music Center" program over KFAC in Los Angeles, which features interviews and performances by resident or visiting artists. The arts organization may also have direct access to certain media such as community newsletters or state publications. Arizona State University has used this opportunity to make effective use of announcements over the public address system at football games.

Another factor that affects promotion budgets is the organization's stage in its life cycle and its reputation in the community. Many universities in college towns have performing arts programs that are well established and for which there is a sizable population in the enthusiast or interested

category. This may be thought of as a basic stock of goodwill, which can also be efficiently tapped through direct mail to past season patrons. On the other hand, a new organization has to devote substantial resources to education and persuasion in order to achieve the same results. The American Conservatory Theatre offered discounts of 50 percent to subscribers in its early years, but these have now been eliminated.

A final factor to be considered in budget setting is the event (or series) itself. It is quite clear that some art forms have a much greater audience than others. Several studies have found that patrons are most likely to attend live theater, followed by various musical events down in decreasing frequency to dance, which has a relatively small following. This suggests that, unless there are overriding objectives, the promotion budget should be varied from event to event. A similar situation may arise where events have differing drawing power because of the presence of a well-known performer or other strong appeal.

A major advance in the area of promotion budgeting has been the development of a model to aid promotion allocation decisions (Weinberg and Shachmut 1978). This model was developed for the performing arts program at Stanford and explicitly incorporated many of the factors noted above. It not only recognizes variations in response due to type of event, day of the week, and the like, but also allows the manager to include his or her estimated response to different levels of promotion. The model then calculates the optimal allocation of promotion dollars over the entire year. In a test it was found that some events should receive no individual promotion at all, while others benefited from substantial support. It was also possible to make adjustments during the year. The model has proved highly successful, and at the end of the 1976–77 year the actual attendance was 20,882, which was almost identical with the predicted attendance of 20,875.

Developing the Promotional Message

Promotional communications rely on a persuasive appeal or message to achieve their objectives. Developing an effective message is not an easy task, since it is often viewed as a subjective question about which many people, within and outside the organization, are likely to have an opinion. Therefore, there is a need to establish some greater objective basis for the selection of the promotional message.

One author has suggested that effective advertising needs to satisfy three criteria: desirability, exclusiveness, and believability (Twedt 1969). Thus, the promotional theme for a performing arts organization should describe a desirable feature of the event(s), emphasize the ways in which the event is distinctive from competing attractions (a major reason for nonattendance is involvement with other leisure activities), and present the message to the target audience in a believable form. Newman (1977) supports this in

recommending that mail brochures should be simple to understand, have clear printing (many potential subscribers are older), feature photographs that include the audience in order to emphasize the shared experience. The brochure should also feature the discount being offered (the immediate benefit noted earlier) and highlight star performers and whatever is new about the program from previous years.

The question of what desirable feature or features of an event should be presented can only be answered with basic research into the decision process of the different market segments. Why do people attend a particular event and not others? The reasons for patronizing a particular program appear to vary according to the type of event. One study of the audience at a city symphony concluded that the most important reason was the program itself (42 percent have it as first choice), followed by the entertainment value of the evening (31 percent), the conductor (14 percent), the soloists (10 percent), and the educational value (3 percent) (Raymond, Greyser, and Schwalbe 1975). On the other hand, the quality of the principal singers is apparently more important, along with the reputation of the composer, in the decision to attend an opera. In the case of the symphony the message could stress the program and the pleasures of a concert, while the opera could be promoted on the reputation of the performers.

These are findings and their importance may well vary among different market segments. Educational value is relatively unimportant to the general symphony audience but may be a significant factor in student group attendance. Similarly, there will be come patrons who will attend to see or hear the performance, while others may be more interested in the social satisfaction of a pleasant evening with friends.

The appropriate message for the enthusiast has been discussed earlier, and this section has been largely concerned with persuasion. If the target audience is the group that is unaware of the benefits associated with an arts event, then the message may need to be broader in terms of basic descriptive material about the art form. This might cover history, the various talents required for performance, the different ways in which the art may be presented, and some simple, entertaining examples.

The development of advertising or publicity materials may be greatly assisted by the use of freelance professionals or local agencies. In some agencies a certain amount of assistance may be provided free, but in any event an agency or freelancer could be retained for only a few hundred dollars per month. This may well be cheaper than hiring a full-time staff member. It may also pay off in terms of improved effectiveness, as the North Carolina Arts Council has found. They also report that the higher quality means that newspapers and other media are more willing to carry their messages in the public service programming. Many organizations are also tempted to use their own artistic staff, who may do beautiful work but whose efforts may be more expensive to produce and lack strong audience appeal.

Whatever the message, it is important that the performance justify the claims. Word of mouth is a strong influence in the performing arts, and a poor effort may alienate not only the audience but also those with whom they come in contact.

Selecting Promotion Techniques

For the message to have any effect it must be presented to the target audience in a form that maximizes its impact. As noted at the beginning of this chapter, there are many techniques available to present the message, and the policy maker is required to select the one, or more usually the combination, that will be most efficient. Again, this decision is best made on the basis of an understanding of the decision process employed by the target audience(s). Three items of information are particularly important: Who makes the decision to attend? What do they decide? What sources of information do they use?

Decision Makers

Identification of the decision maker can be made initially in the basic market analysis and segmentation procedure. In most families the wife is much more likely than her husband to make the decision to attend an event. However, it is important to recognize that attendance at most performing arts events is a group decision; only a small proportion of the audience attends alone (Langeard, Crousillat, and Weisz 1977). This means that promotion programs may have to provide different messages to the various parties involved and to utilize different techniques to reach them. Such a situation is most likely to occur with affinity groups, such as a bank social club where the decision to attend may be made by a small committee on the basis of personal contact by the arts organization. However, publicity or advertising (for example posters for bulletin boards) may be needed to ensure that they have the support of their members.

Decision Time

The time at which the decision to attend is made is a more critical question for performing arts than for typical product purchases. Most products can be purchased at any time, but a person may attend a play or concert only within the time span during which the performance is scheduled. Each performance is essentially a perishable product that is on sale for a limited time only. In order to reduce risk the audience must be "presold" as much as possible, and promotional resources have to be allocated over the decision period. The requires a knowledge of when the audience makes its decision. A study in New Orleans (Hanneman 1977) found that 34 percent of the audience had made their decision more than three months before (almost

half of these had received a series brochure), with 30 percent deciding to attend one to four weeks before the performance and another 30 percent making their decision during the preceding week. While this may reflect the actual promotion program employed, it does suggest that the audience can be sold well in advance and that there is a need to promote close to the actual event.

Most of the promotion budget should be allocated to advance slaes, not only to reduce risk but also, since most of these will be subscription sales, because these promotion efforts produce a higher return than later attempts to sell single tickets. Most of the early buyers are likely to be enthusiasts with later purchasers being less involved with the particular arts activity. This suggests that promotion messages should be different at various stages. The early deciders will need the full schedule from which to choose, while later groups may need more limited information. There may also be variations in the promotion techniques. Newman (1977, p. 33) recommends beginning subscription sales with publicity "artillery" and then attacking with the "infantry" of direct mail and personal selling. Media advertising would be more important closer to the events themselves.

Information Sources

Identification of the sources of information about arts events that decision makers use is clearly important for effective promotion planning. A survey of students at the University of Southern California asked respondents to recall the media in which they had seen advertising for performances. The two most frequently mentioned were the campus newspaper (88 percent recall) and on-campus posters (85 percent), with no other medium (flyers, city newspaper, brochures, or campus radio) scoring as much as 20 percent (Gutman 1978). There are variations among audiences, and the UCLA community survey found that newspapers were the most important source of information about entertainment events, followed by word of mouth, and then brochures, magazines, and radio/television (Scalberg 1977). Word of mouth was also reported as an important information source in a study of the audience at a musical event sponsored by a university performing arts organization in New Orleans (Hanneman 1977). This study found that newspapers were the most important source of general information about arts events (reported by 78 percent of respondents) with word of mouth mentioned by 32 percent. Information about that particular event had come from brochures (34 percent), followed by newspapers and word of mouth (both 24 percent). Another survey of audiences at different arts events in upstate New York found that, in fact, word of mouth was the most frequently mentioned of eight information sources (Tauber and Weissenberg 1971).

The importance of word of mouth indicates that the decision process for arts events is one in which information does not go directly to many

patrons but is passed on by their friends or relatives, who may be defined as "opinion leaders." This two-step flow of information has been identified in many decisions from voting to prescription drugs as well as the performing arts. A recent study of theater goers in France found that approximately one-fourth of them could be classified as cultural opinion leaders (Langeard, Crousillat, and Weisz 1977). As hypothesized, it was also found that the opinion leaders looked for more information in the mass media than did the nonleaders, while the influence of personal sources of information was significantly stronger on the decisions of nonleaders than on those of the leaders.

It is clear that opinion leaders are an important channel for promotional communications and should be utilized as fully as possible. The first step is to involve the right people. Tauber and Weissenberg (1971) suggest that this can be done by various research techniques or by identifying people who "match the characteristics of natural opinion leaders . . . [They] . . . should be mobile, have a large number of acquaintances and a high frequency of contacts. They should have an existing high status among their peers, be gregarious and have a positive attitude" toward the particular arts event. These people then need to be kept fully informed about current and future activities, perhaps by involving them in support groups. Since opinion leaders operate in all market segments and are probably different for different types of events, this may require establishing support groups to represent each target market as well as each major area of activity.

Opinion leaders are consulted because of their perceived expertise, so the provision of information will reinforce this perception as well as helping them to respond to questions. For many people there is a great deal of risk associated with attending an arts event, and they will actively seek both descriptive and evaluative information, which may not be available (or credible) through conventional channels. It may even be a more effective use of promotion funds to invest in personal contact (or at least a newsletter) with these support groups at the expense of advertising on a broad scale.

More active use of opinion leaders may include everything from urging support group members to "make up a party" or "bring a friend" to events to asking them to send out brochures to people on their Christmas card lists or to hold subscription sales parties in their homes. A representative from the arts organization can speak at these parties and considerable peer pressure can be discreetly exerted. These functions have apparently been very successful in increasing subscription sales for orchestras in both Louisville, Kentucky, and Buffalo, New York (Goodrich 1976).

Further guides to the selection of appropriate promotion techniques are provided by considering the characteristics of the target market. Newspapers are most likely to be read by older, well-educated groups, with television having a greater appeal to individuals with lower levels of education and income. Younger people are best reached via radio. A telephone contact program may miss many potential subscribers in upper-income groups

because their numbers are unlisted. Personal contact generally is likely to be cost-efficient only for group sales or subscriptions.

Classification by objectives and level of involvement is also useful since different techniques will vary in their effectiveness:

1. Informing—probably most efficiently achieved through advertising (newspaper or direct mail).

2. Persuading—utilize all promotion techniques insofar as they are cost effective. This probably limits the contribution of personal contact to affinity groups, although volunteers are often used in telephone calls to potential new subscribers. Advertising on a broad scale may reach a new audience (as Broadway has found by using television for some of its more popular productions) or may offer instant credibility (as the new Long Beach Entertainment Center sought to do by associating itself with a leading department store chain). Sales promotion offers may attract some new patrons, but one study concluded that most are likely to be accepted by people who would have come anyway (Scalberg 1977).

3. Educating—this is a difficult task since a great deal of information has to be conveyed. Personal contact is, therefore, likely to be the most efficient technique despite its high cost. Publicity, such as an "arts week," may be helpful in attracting attention and providing introductory information.

CONCLUSION

This has attempted to provide a broad framework to guide promotion policy decisions for the performing arts. The five major promotion decision areas (objectives, target market, budget, message, and mix of techniques) were examined and relevant research reviewed. There are many factors that need to be considered in each of these areas, but one approach was suggested that provides a consistent link among each of them. This approach is summarized in Table 15.2.

It is suggested that, in addition to segmentation on the basis of demographic factors and artistic preference, most arts organizations can divide their target audience into enthusiasts, interested, and nonattenders. The principal promotion objective with each of these groups, respectively, is to inform, to persuade, and to educate. The rate of response to promotional efforts is likely to be highest for the enthusiasts and least for the nonattenders, and this will affect budget decisions. Enthusiasts will probably need little persuasion to attend, but those who are merely interested will require considerable effort, including the provision of various incentives. The nonattenders need basic descriptive information to develop an understanding of the activity to be presented. In terms of techniques it is likely that direct mail advertising will be sufficient for most enthusiasts, with all

TABLE 15.2

A Framework for Promotion Strategy in the Performing Arts

	Target Audience		
	Enthusiasts	Interested	Nonattenders
Objective	To inform	To persuade	To educate
Response rate	High	Moderate	Low
Promotion message	Basic information	Incentives	Descriptive
Promotion technique	Advertising (direct mail) Personal contact (support groups)	Advertising (direct mail, newspapers) Sales promotion Publicity Personal contact (affinity groups, new subscribers)	Personal contact Publicity

techniques being used to encourage those who are interested. Personal contact is probably required to bring the nonattenders into the audience.

Although a number of studies have addressed the issues raised here, it is clear that a good many questions remain unanswered. From the promotion policy point of view, the decision process for the arts is clearly an area of concern, in particular, the factors that influence the decision and the role of opinion leaders. The effectiveness of different media and the scheduling of promotion activities are also issues of concern.

REFERENCES

Goodrich, Jonathan. 1976. "Fortissimo Marketing Effort Builds Audiences for Buffalo Philharmonic." *Marketing News*, December 3, p. 7.

Gutman, Jonathan. 1978. "The Performing Arts at U.S.C." Unpublished report, University of Southern California, June.

Hanneman, Patrick and Charles B. Weinberg. 1977. "University Arts Program." In *Cases in Public and Nonprofit Marketing*, edited by Christopher H. Lovelock and Charles B. Weinberg. Palo Atlo, Calif: Scientific Press.

Kotler, Philip. 1975. *Marketing for Nonprofit Organizations* Englewood Cliffs, N.J.: Prentice-Hall.

Langeard, E.; M. Crousillat; and R. Weisz. 1977. "Exposure to Cultural Activities and Opinion Leadership." *Proceedings*, Association for Consumer Research, pp. 606–10.

Newman, Danny. 1977. *Subscribe Now! Building Arts Audiences Through Dynamic Subscription Promotion*. New York: Theater Communications Group.

Nielsen, Richard. 1973. "Types of Theatre Information and Marketing-Audience Development among the Alienated." *Performing Arts Review*, Spring-Summer, pp. 44–57.

Nielsen, Richard; Angela B. Nielsen; and Charles McQueen. 1975. "Attendance Types of Performing Arts Events and Explanations for Attendance and Non-Attendance." *Performing Arts Review*, Spring, pp. 43–69.

Raymond, Thomas C.; Stephen A. Greyser; and Douglas Schwalbe. 1975. *Cases in Arts Administration*. rev. ed. Cambridge, Mass. Arts Administration Research Institute.

Scalberg, Ernest J. 1977. "Report on the Development of a Marketing Data Base: A Survey of U.C.L.A. Audiences and the Los Angeles Community." Unpublished report, University of California, Los Angeles, October.

Shapiro, Benson P. 1972. "Marketing in Nonprofit Organizations." Cambridge, Mass.: Marketing Science Institute.

Tauber, Edward, and P. Weissenberg. 1971. "Audience Development for Community Theater: Opinion Leaders and Word-of-Mouth Communication." *Performing Arts Review*, Fall, pp. 525–34.

Twedt, Dick W. 1969. "How to Plan New Products, Improve Old Ones and Create Better Advertising." *Journal of Marketing*, January, pp. 53–57.

Weinberg, Charles B., and Kenneth M. Shachmut. 1978. "Arts Plan: A Model-Based System for Use in Planning Performing Arts Series." *Management Science*, February, pp. 554–664.

16

PRICING POLICIES FOR ARTS ORGANIZATIONS: ISSUES AND INPUTS

Christopher Lovelock and Phillip Hyde

MR. GRAHAM: What is a cynic?
LORD DARLINGTON: A man who knows the price of everything and the
value of nothing.
Oscar Wilde, *Lady Windermere's Fan*

From the perspective of most arts administrators, pricing is probably the least interesting element in the marketing mix. The artistic product is, of course, at the center of creative activity and the raison d'être for the organization's existence. Mounting a performance or an exhibition in a particular location and bringing it to the audience at a particular point in time—the distribution element of the mix—is always a challenge and often a frustration, as directors and producers wrestle with noncustom-designed facilities or struggle to get everything together in time to reach the rapidly approaching deadline of opening night (or day). Meanwhile communicating artistic offerings to the prospective audience and trying to tempt, persuade, or otherwise encourage them to come provides opportunities to exercise creative skills in writing, graphic design, layout, and perhaps audiovisual elements, too.

But pricing brings economic reality home to roost with a jarring thump. Set prices too low and the organization will slip deeper into the red than ever. Set prices too high and this may deter potential patrons from coming. Set any price at all and it may represent (at least according to the conventional wisdom) a barrier that excludes children, students, the elderly, and the disadvantaged.

Yet, pricing is crucial to the success of arts organizations. And as other sources of funding level off and inflation increases, admission income becomes increasingly more significant. Since few institutions can afford the luxury of heavy subsidies, people attending shows and performances must

generally be charged admission prices that cover, or at least contribute to, the cost of staging them. Decisions on pricing go far beyond the basic question of how much to charge, since the real world is more complex than economic models of pricing generally assume.

It is our thesis that a marketing perspective—with its orientation toward how consumers make decisions, how they behave in a complex market environment, and how they learn about and choose from competing alternatives—can highlight key pricing issues facing arts administrators and also help them make appropriate decisions on prices.

DOWNWARD PRESSURES ON ARTS PRICING

Despite rapidly rising costs, two factors combine to exert downward pressure on arts pricing—a thrust that can only exacerbate existing economic woes. First, the principal product of arts organizations is a service that is basically experiential in nature.* Plays, films, concerts, and exhibitions may serve to entertain, stimulate, educate, and/or uplift, but there is nothing tangible to take away afterward. In a live performance the production and consumption of this experience take place simultaneously in real time. And they generally take place in a physical facility with a predefined capacity. This has some interesting marketing implications.

If seat M-32 in the balcony is unsold for tonight's performance of Beethoven's Ninth, then it cannot be stockpiled for resale tomorrow, because tomorrow's performance (even if a repeat) is another product.

Selling that seat and keeping it sold, along with all its sibling seats, thus incorporates a time dimension that is far more significant for services than it is for the sale of physical goods. In short, theater seats and short-term exhibition attendances are perishable products. Since the costs of selling an empty seat, for a performance that is about to start, are close to zero, there is a tendency to offer "rush seats" at minimal prices or even to give away blocks of seats free to enhance the artistic experience with the thrill of a full house. (A unique characteristic of live performances is that poor sales can diminish the quality of the experience for those who do attend—rows of empty seats are depressing for both audience and performers alike.)

If the show or performance is highly popular, rush tickets merely serve to fill up the few remaining seats. But, if prospective patrons know that the house is never full, there is little incentive to buy full-price tickets in advance.

*A number of arts organizations are adding retailing subsidiaries (for example, museum shops) to sell—at a profit—such tangible items as pictures, recordings, objets d'art, reproductions, and souvenirs. In addition, they may have catering services offering meals and refreshments. These goods and services also have to be priced, but, since they are supplementary to the main service, they will not be discussed in detail in this chapter.

Instead, many will seek to get cheap rush tickets, with disastrous economic consequences for the sponsoring arts organization.

A second factor is that many people expect the arts to be relatively inexpensive. Government and other funding agencies often preach the message of the arts' responsibility to reach out to all segments of society. Keeping prices low is seen as a way of lowering the barriers that discourage the great majority of the population from participating in the arts. Sometimes this philosophy ignores the distinction between ability to pay a given price and willingness to pay that price for attending a particular performance. Many students and blue-collar workers (to cite two groups often used as the rationale for low pricing strategies) will turn up their noses at the thought of paying $5 to attend a play or symphony concert but willingly spend double that to go to a rock concert or an ice-hockey game. Indeed, many nonarts goers at all levels of society would probably not choose to patronize an arts event even if they were paid to do so; there are other ways they prefer to spend another scarce currency—their time.

CONVENTIONAL WISDOM

Innovation or More of the Same?

No one has yet conducted a comprehensive study of pricing the arts from a marketing perspective across a wide range of different types of arts organizations. But, some experiments have been tried, surveys undertaken, and conclusions drawn. In several instances conventional wisdom reflects a simplistic view of the role of pricing and the failure to take other variables into account. Sometimes new research may give reason to question widely practiced but potentially suboptimal managerial strategies. Consider the following:

1. Danny Newman (1977) in *Subscribe Now!* strongly advocates discounts for subscription series. He cites enormous successes achieved by "five for the price of four" type promotional campaigns. But perhaps the operative word is *promotion*, not discounts. Price can often be used to capture attention, and Newman has clearly used it in this way. The question is, Which contributes most to increased sales: more promotion or lower price?

2. In *The Subsidized Muse*, Dick Netzer (1978) reports that from 1965/66 to 1973/74 average ticket income per attendee at major performing arts organizations in the United States increased by 45 percent, about 10 percent more than the overall rise in the consumer price index. Average attendance per performance declined slightly over this period. From this,

Netzer concludes that demand for arts attendance is somewhat price elastic.*
Yet, possible alternative hypotheses are: tastes changed, competition from
other alternatives became stronger, or the combination of recession and
scandal in high places made people more reluctant to leave their homes for
an evening of culture. Netzer's analysis is also a highly aggregative one,
failing to throw any light on the important issue of variations in behavior
among different market segments toward different types of arts offerings.

3. Ryans and Weinberg (1978) surveyed subscription series buyers for
the American Conservatory Theater (ACT) in San Francisco. Contrary to
popular belief, these people indicated that their major reason for buying
subscription series was not to save themselves money but to make sure they
went to the theater more often. Acting on this finding (and other informa-
tion), management abandoned the discount; but this action had no discern-
ible impact on subscription sales. Is this finding generalizable to other
audiences in different cities, attending other types of performances? New
research might provide revealing insights.

4. Many arts organizations—notably museums—use a voluntary dona-
tion approach instead of a fee, suggesting a specific amount as a suitable
donation. Experience across the country indicates that the average donation
is often only about half the suggested amount. The Metropolitan Museum in
New York fared slightly better, receiving an average of $0.82 per visitor
when it suggested a general admission fee of $1.25 and $0.50 for students.
What does this say about the attitudes of arts consumers toward payment? It
would certainly be useful to know how many people paid the suggested
amount (or more) and how many gave nothing at all.

The other side of the coin is that innovative pricing practices introduced
by management are not always popular with customers, as described by
Jules Boardman (1978), who is responsible for marketing at the National
Theatre (NT) in London.

When Britain's new National Theatre complex opened in 1976, an
unusual pricing strategy was adopted for the larger two of its three
auditoriums, the Olivier and Lyttelton Theatres. The design of these two
halls was such that, by comparison with conventional theaters, there were
literally no "bad" seats—all provided an exceptionally good view of the
stage. In the 894-seat Lyttelton Theatre, just under one-fourth of the seating
area was priced extremely low, £ 0.50 and £ 1.00, (£ 1 = approximately U.S.
$2) to attract students and others on fixed incomes. To bring lively young

*Price elasticity measures the extent to which a change in price has an impact on the
demand for a particular good or service. Demand is said to be highly price elastic when a small
price increase (decrease) results in a large fall (rise) in demand. But when changes in price have
little or no impact on demand, then demand is said to be price inelastic.

people into close contact with the actors, the front four rows of the "stalls" (orchestra seats) were furnished with smaller, narrower seats priced at £ 1.00. All other seats were priced at £ 2.35, with advance purchasers receiving a ticket voucher that could be exchanged for a numbered seat ticket two hours or less prior to the performance. Anyone wishing to reserve a specific numbered seat in advance could do so for a supplementary reservation fee of £ 2.00 (that is, £ 4.35 in total).

The voucher scheme ran for 20 months in the Lyttelton Theatre. Boardman states that it widened the audience and provided tremendous flexibility, with voucher seats automatically dressing the house from front to back and "hot ticket" shows generating substantially higher revenues from similar capacity houses due to the much higher proportion of reserved seat sales.

Eventually, several factors led to the replacement of the voucher scheme in favor of a more conventional approach. The scheme proved complex to describe and operate. Rising costs led to a situation where management felt that the basic ticket price, applicable to three-quarters of the house, would have to be raised to an unreasonably high level. The voucher scheme was also controversial among theater goers. Conditioned to expect wide variations in both prices and seating quality among existing London theaters, as well as to the tradition of theater tickets' guaranteeing a specific, numbered seat, many patrons felt obliged to arrive two hours before a performance so as to be sure of trading their vouchers for "good" seats. Others simply found the voucher/reservation scheme hard to understand.

The more conventional pricing policy in effect at the National Theatre's two larger halls in January 1979 involved six increments—£ 1.25, £ 2.00, £ 2.80, £ 3.70, £ 4.30, and £ 4.90—and it was cheaper for matinees. In the smallest hall, the Cottesloe Theatre, admission was £ 1.75, and all seats were unnumbered. In both instances the front rows of the stalls consisted of narrower seats without armrests, priced at £ 2.00 each. Yet, several noteworthy pricing strategies remained in the two larger halls, despite abandonment of the voucher scheme:

1. To attract younger audiences and others who did not plan their theater going far in advance, about 75 less expensive seats were held for sale at the box office on the day of the performance.

2. Any seats remaining unsold 30 minutes before curtain-up were made available at a flat "standby" rate of £ 2.25, unless normally priced lower. (In the Cottesloe Theatre standby seats cost £ 1.00 but were restricted to members of student organizations.)

3. Senior citizens could book any available seat at a midweek matinee for £ 2.00

4. Wheelchair spaces and seats for up to two escorts were provided at £ 1.75 each.

5. Holders of major credit cards could buy tickets by phone.

6. At selected performances in early January, adults buying in one of the three top prices could also buy tickets in the same price range at only £ 1.50 each for all accompanying youths and children (18 and under).

Although the NT's voucher scheme played to mixed reviews, Boardman believes it was responsive to market dynamics and helped to widen the audience for the NT (which has expanded very substantially since the move from the Old Vic Theatre to the new complex. The NT's past and present pricing strategies illustrate several themes that run throughout this chapter, including experimentation, the tailoring of prices to different market segments, striking a balance between audience maximization and revenue maximization (with an emphasis on the former) and facilitating the ticket buying process for patrons.

Establishing Objectives

Underlying any decisions on pricing strategy must be a clear understanding of the organization's objectives.

As shown in Table 16.1 there are three basic pricing objectives open to an arts organization—the first two are financially oriented, and the third is consumer oriented.

Commercial theaters and museums are profit-seeking organizations. Within certain limits they attempt to maximize the surplus of income over expenditures. Nonprofit arts organizations, by contrast, are more likely to be concerned with achieving break-even or with keeping the operating deficit

TABLE 16.1

Alternative Bases for Pricing

	Objective
Maximize profit	Make the largest possible surplus after covering fully allocated costs
Cover costs	Cover fully allocated costs (including institutional overhead)
	Cover costs of staging a show (after deducting any specific grants and excluding institutional overhead)
	Cover incremental costs of selling a seat
Fill to capacity	Accept any warm body
	Maximize attendance by specific market segments

within acceptable bounds. In Britain, for example, the Arts Council (which acts as a conduit for government funding of the arts) urges that subsidies to performing arts organizations should be matched on a one-to-one basis by self-earned income.

Determining the cost side of the equation can be difficult. As shown in Table 16.1 there are several different types of costs. Fixed costs are those that continue (at least in the short run) to be incurred even if no performances are held. This "institutional overhead" is likely to comprise such elements as building rent or depreciation, utilities, taxes, cleaning, insurance, salaries of administrators and artists under annual contract, repairs and maintenance, security, et cetera.

Then there are variable costs associated with staging each production, that is, expenses that would not be incurred if the performance was not staged. These may include production and transportation, stage operation, wages of part-time actors, musicians, and other temporary personnel, and royalties. Such costs tend to vary from show to show, depending on the number of people involved, the extent of special effects, et cetera. There is sometimes a gray area between fixed and variable costs, depending on one's time horizon. Thus, before a contract is signed with a soloist to appear at a concert, the soloist's fee and expenses are variable costs. Once the contract is signed, any cancellation fee payable becomes a fixed cost, but the balance remains a variable cost.

Finally, there are the incremental costs associated with selling an additional unit (for example, a seat). In the arts—as in many other services—such costs tend to be extremely low (unless the audience receives free drinks or souvenirs or is of the type that is particularly litter or vandalism prone). By contrast, the incremental costs associated with selling concession products (books, souvenirs, drinks, et cetera) may form a significant percentage of the final selling prices.

The difference between incremental costs and selling price is known as the *unit contribution margin* (not to be confused with a charitable gift). To determine the margin on a theater or museum ticket, one simply deducts from the total selling price any tax, commission, or other cost incurred solely as a consequence of selling that specific ticket. The balance remaining is the margin, and it typically represents a high proportion of the ticket price. But the margin on a commercially produced book or recording sold in the lobby bookstall may be only 30 to 40 percent of the selling price, because the item in question has usually been purchased for resale. The significance of this margin is that it represents a monetary surplus on each unit sale that goes to offset operating costs and overheads. By raising the selling price (assuming unit costs remain the same), the marketer can increase the unit margin. But if raising the price results in disproportionately lower sales, then the total surplus achieved will decline.

PRICING AND DEMAND LEVELS

Maximization—Price versus Attendance

As we have already noted, performing arts organizations are usually anxious to fill the house, since this tends to provide a more exciting and rewarding experience for both audience and performers. But setting prices to maximize attendance is not necessarily the same as pricing to maximize revenues. Weinberg (1978) shows how the difference in objectives between for-profit and nonprofit organizations results in a different role for pricing and communications in the marketing strategy adopted by nonprofits. Much depends on the price elasticity of demand—the extent to which a change in price has an impact on people's willingness to buy a ticket.

This can be illustrated with the economist's familiar demand curve, which in any given situation assumes knowledge of how prospective customers will respond to alternative prices. Figure 16.1 shows how the demand schedule might look for a certain type of performance at a particular auditorium (based, perhaps, on past experience and experimentation and/or on surveys among target consumers). For simplicity, we have assumed a situation involving one-price, open seating. Let us also assume that the maximum seating capacity of the auditorium is 1,500.

From this chart, we can read off the number of admission tickets that would be sold at a given price, from which it is quite simple to calculate the resulting gross revenues, as shown in Table 16.2.

From this table we can see that a strategy of revenue maximization would lead us to charge an admission price of $7.50, thus yielding gross revenues of $7,125. But, at this price the hall would only be 63 percent full (950 divided by 1,500). If we charged $3.00, we would expect to sell out the house and to have to turn away 500 people; but we would only take in $4,500. Looking at the chart, we can see that to feel confident of selling 1,500 admissions (the capacity of the hall), we should set the price at about $4.50, which would generate the same revenues as a $5.00 price—$6,750.

By studying the curve we can see that at high prices the vertical slope is fairly steep, signifying that demand is relatively price inelastic—in other words, a 25 percent cut in price (from $20.00 to $15.00) attracts only 17 percent more people. At a lower price level the same percentage cut, from $10.00 to $7.50, attracts 46 percent more people—so in this price range we can say that demand is relatively price elastic. Toward the bottom end of the price scale demand is again becoming more price inelastic—a 67 percent cut in price from $3.00 to $1.00 generates only a 50 percent increase in revenues.

The significance of this chart lies in its ability to help us understand the trade-offs between revenue maximization and attendance maximization. Between a $4.50 and $5.00 price, and again between a $12.00 and $20.00

FIGURE 16.1

**Demand Schedule for Auditorium Admissions
(based on data in Table 16.1)**

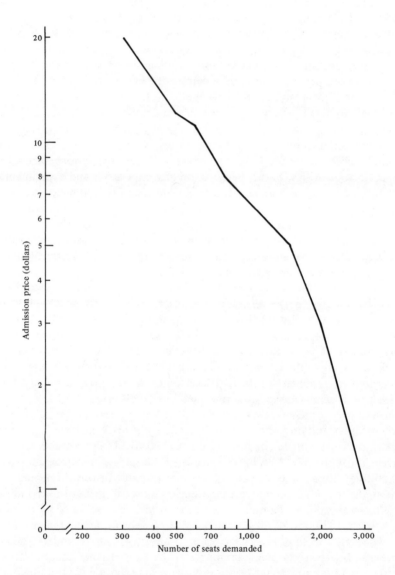

Note: Ratio (logarithmic) scales have been used on both axes.

TABLE 16.2

Potential Gross Revenues

Price (dollars)	Number Demanded	Potential Gross Revenues	Gross Revenues with 1,500-seat Constraint
20.00	300	$6,000	$6,000
15.00	400	6,000	6,000
12.00	500	6,000	6,000
10.00	650	6,500	6,500
7.50	950	7,125	7,125
5.00	1,350	6,750	6,750
4.50	1,500	6,750	6,750
3.00	2,000*	6,000	4,500
1.00	3,000*	3,000	3,000

*Demand exceeds supply.

price, the loss of admission is exactly compensated by the increased price paid by each attender—here we can say that the price-elasticity ratio is unity. It may be useful to group prospective attenders into market segments, based upon their willingness/ability to pay particular prices. For instance, the table shows that 400 new people would be attracted by lowering the price from $7.50 to $5.00 and that another 650 would want to come if the price were dropped from $5.00 to $3.00. An important question facing the marketing manager is to determine who the people are in each of these price segments.

Most theaters and auditoriums do not have a single, fixed admission price for performances—rather, they vary that price according to the location of the seats. In establishing prices for different blocks of seats, it is important to determine what the demand level for each price category will be in order to determine the appropriate number of seats to offer at that price and thus minimize the risk of many empty seats in some price categories and overdemand for other types of seats.

An interesting example of experimentation in attempting to determine price sensitivity is provided by New York's Brooklyn Academy of Music (BAM), which offers a range of musical and theatrical performances. As reported by Ricklefs (1979), BAM commonly sends test mailings offering the same series at two different prices and then compares the results:

One group may receive a leaflet for the "Spectacular $20 Symphony Sale," while another gets a leaflet for the "Spectacular $25 Symphony Sale." If the lower price is finally chosen, those who responded at the higher price receive a refund check—which many gratefully return as contributions, another handy source of income.

BAM says it tends to choose the lower price if it will increase the audience enough to make up the price difference. But oddly enough, higher prices sometimes draw better. "Price is often seen as a statement about quality and the expected scarcity of seats," an official says.

Break-Even Analysis

The total contribution received from additional sales at any given price should be related to the cost of supplying the product(s) in question, since managers need to know whether a new product will be financially self-supporting.

Supposing, to cite our earlier example of ticket sales to an auditorium, that the cost of staging a show is $4,000. The contribution margin per ticket sold is the price of that ticket less any taxes or sales commissions. Dividing $4,000 by the unit dollar margin will tell us how many tickets we need to sell at that price to break even—that is, cover the costs of staging the show. The required sales volume can then be related to market size, price sensitivity, and level of competition.

Just covering the costs of a particular show, or even making a surplus on it, does not necessarily guarantee financial solvency for the organization. There are also fixed-cost overheads to be covered, such as rent, utilities, administrative salaries, et cetera. For the organization to remain solvent either the total surpluses achieved on all shows must be sufficient to cover these fixed costs or grants and donations must be sought to bridge the gap. The value of break-even analysis is that it relates the demand characteristics of the market to the cost characteristics of the organization. It is a particularly useful tool when deciding on whether to make an addition to the organization's product line and, if so, what price to charge.

PRICING AS PART OF MARKETING STRATEGY

Before proceeding further with a discussion of pricing the arts, it is important to put pricing itself into context as an element of marketing strategy. A simple economic model of exchange transactions suggests that the monetary price of a product is what the purchaser gives up in exchange for the benefits that the product offers. In practice, however, there are many other types of costs.

Utilities and Disutilities

The benefits (or utilities) that a product offers can be categorized into five groups:

1. Form utilities—desirable sensory attributes (appearance, feel, sound, smell, and taste) of the offering,

2. Psychic utilities—the ability of the offering to stimulate a positive psychological state of mind in the customer,

3. Place utilities—convenience and other desirable attributes of the location(s) where the product is displayed, sold, performed, used, et cetera,

4. Time utilities—characteristics relating to time convenience (of sale, performance, usage, et cetera) and also ability to pass an appropriate amount of time in a pleasant fashion, and

5. Monetary utilities—inherent monetary value of the product (Does a physical good offer the opportunity for profitable resale? Does receipt of a particular service—for example, education—enhance someone's earning power?).

Set against these benefits are the costs (or disutilities) of obtaining them. Classical economic theorists—and even many marketing practitioners—consider only monetary price in examining the quid pro quo of a transaction. In practice we can divide disutilities into the same five categories used for classifying utilities:

1. Form disutilities—undesirable sensory attributes of the offering,

2. Psychic disutilities—negative psychological states of mind generated by the offering,

3. Place disutilities—inconvenient, unattractive aspects of the location(s) where the product is displayed, sold, performed, used, et cetera,

4. Time disutilities—inconvenient scheduling and time-wasting aspects of purchasing or using the product, and

5. Monetary disutilities—monetary cost of purchasing or using the product.

Figure 16.2 shows a simple way of thinking about the benefits and costs arising from a particular transaction, as perceived by a potential customer. Note that we are concerned with perceptions rather than "reality." People make decisions on the basis of how they perceive a situation, which may be highly subjective and even inaccurate. One of the tasks of marketing communication is to ensure that people are correctly informed about basic, factual details and thus correct any misperceptions.

If the perceived benefits outweigh the perceived costs (of all types), then the customer can be expected to agree to a transaction unless another, competing alternative is perceived as offering greater net positive utility.

This model helps us to understand that marketing's task is threefold: (1) Maximizing the perceived benefits to the customer and (2) minimizing the perceived costs to the customer, within the constraint of (3) ensuring that the marketer receives an acceptable flow of relevant positive utilities (monetary and other) in return.

FIGURE 16.2

A Cost-Benefit Model of the Customer's Willingness to Engage in an Exchange Transaction

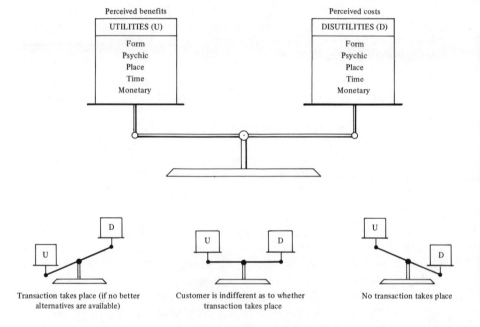

Nonmonetary Costs

It is not difficult to see how monetary pricing strategies can be incorporated into an overall marketing plan, and most of our discussion will focus on this. But how can arts managers deal with the other four types of "costs" facing their prospective patrons?

For many people, time is a central element in the decision whether to attend a particular performance or other arts event. Time is a scarce commodity; the customer may not always have any time to spare, because of competing demands placed by work, personal business, or other competing activities. A second aspect of time costs concerns the total amount of time involved in attending an arts event, including making the arrangements, making reservations and purchasing tickets, and traveling to and from the event location. Even if a performance is scheduled at a convenient hour, other time-related factors may prove a barrier. This raises the question of what can be done to simplify purchase and reservation procedures and perhaps improve transportation access from more distant points.

Location is obviously closely related to time in certain respects, because it has an impact on how far people have to travel. A location in an unfamiliar part of town may also discourage patronage. Sometimes this cannot be helped, but the "cost" to customers can be reduced by providing good instructions (maps and/or directional street signs) and making sure that the facility and parking lot (if any) are well signed, lighted, and protected.

Psychic and form disutilities are, perhaps, inevitable in the arts because of differing tastes and expectations. Education and exposure may be able to change opinions over time, but first arts managers need to study their market to learn the likes and dislikes of different segments, so that realistic programming decisions can be made.

FORMULATING A PRICING STRATEGY

By now it should be clear that determining monetary pricing strategies in a nonprofit organization requires making decisions on a range of different issues. These, in turn, must be based on both a clear understanding of the arts organization's objectives and sound information on a range of relevant inputs.

Pricing Issues

Table 16.3 summarizes seven major issues relating to monetary pricing decisions, each of which can be further subdivided. This table indicates that pricing extends far beyond just the question of *how much* to charge for admission.

TABLE 16.3

Some Pricing Issues

Basic Question	Alternative
How much should be charged for tickets?	Alternative bases for pricing decisions
	Spread between top and bottom prices
	Discount to be offered from basic prices to specific market segments
Who should sell tickets?	The arts organization (manufacturer)
	The auditorium, et cetera (distributor)
	A specialist intermediary (ticket retailer)
Where should tickets be sold?	The location of the event (box office)
	A retail outlet downtown
	A back office somewhere
	The purchaser's home (by mail or phone)
When should tickets be sold?	At what times of day
	What days of the week
	How far in advance of a performance
How should tickets be paid for?	Cash
	Check
	Credit card
	Vouchers
When should tickets be paid for?	In advance, with reservation
	Day of performance
	After the event
How should prices be communicated to the target audience?	Medium
	Message
	Emphasis on pricing element
	Timing

Note: This table focuses on the sale of single tickets. Similar questions can, of course, be raised for subscription sales.

The issue of who should collect payment from the customer is closely tied to the subsequent issues of where, when, and how prices should be paid and to the circumstances under which patrons actually experience the arts event. An important goal for the marketer is to make it simple and convenient for customers to obtain information, make reservations, and purchase tickets. Sometimes this is best accomplished by delegating these functions to specialist intermediaries (such as a travel or ticket agency) that can serve prospective customers through convenient retail locations.

Verwey (1978) demonstrates the need to reach out to people who have

heard of or read about a play but who do not want to make a special effort to go to the box office to purchase tickets, or try to get through by phone, or risk postal delays. Some prospective theater goers, he points out, have never had any experience in buying tickets at a theater; others only want to go to the theater in a party; still others are simply absentminded and forget to arrange for tickets in advance. To attract these people, he argues:

> A theater will have to have more than an efficient box office with staff primed to suggest alternatives when an enquirer's initial choice of seats are not available. It will have to do more than . . . make ticket allocations available to agencies in the town.
>
> It will need to ensure that it is making tickets available at points which are easily accessible to the majority of people in its catchment area (e.g., in the high street [main street], in shopping centers and department stores); that their availability at these agencies is publicized; that the staff in them are well informed about the theatre and its productions and are active in trying to sell tickets. [P. 2]

This may be just as important in a U.S. context as in a British one. Morison and Fliehr (1968) suggest that one reason for the Guthrie Theater's success in attracting neophyte theater goers to a Molière play was the fact that they were able to pick up tickets at the local food store when doing their weekend shopping.

Convenience in payment relates not only to the time and location of making monetary transactions but also to how payments are made. Paying in cash is often an inconvenience. Many people do not like to carry large amounts of cash on them, preferring to use checks or credit cards.

Some people find that their available monetary resources are highly time bound—they want to buy now, but find it inconvenient to pay until later. The use of credit helps to bridge this gap. A growing number of arts organizations are now willing to accept credit cards—a practice that is being coupled with telephone reservation services in some cities and that is credited with generating an increased demand for theater seats.

In New York it is estimated that more than 25 percent of all Broadway receipts represent credit card purchases, both by telephone reservation and through window sales. Hummler (1978) quotes Bernard B. Jacobs president of the Schubert organization, as saying:

> To a large extent, I think the explosion in Broadway attendance over the past several years is directly related to the ways in which we have simplified ticket buying, especially through credit cards.

A different type of payment is seen in the use of vouchers or coupons good for all or part of the cost of a ticket. Examples include the distribution of two vouchers to Stanford students at registration, one allowing the bearer

free admission to a performance sponsored by the Lively Arts at Stanford program, the other entitling admission for only a 50¢ charge. Another is the redemption of trading stamps for tickets to the Guthrie Theater in Minneapolis cited by Morison and Fliehr (1968). Both schemes were aimed at encouraging trial attendance by people who were not generally committed arts goers.

Finally, there is the question of how prices should be communicated to the target market(s). This requires decisions on the choice of communications media, which may range from a sign at a ticket outlet to information in an advertisement or a brochure. For some types of arts events people may need to know the actual price well in advance of purchase; they may also need to know how, where, and when that price is payable. When price is an important element in a customer's decision, then communications messages may need to relate the price asked to the benefits. Newman (1977) is a strong advocate of flamboyant approaches to publicizing discounted series tickets. Certainly, proclaiming a big price savings is a way of grabbing people's attention.

It may also be appropriate to relate the price to costs of competing leisure or entertainment activities or alternative ways of spending one's money. Table 16.4 shows the relative costs of different types of recreational and entertainment activities in Boston and how they have changed over the past 20 years.

This shows that for all but the best seats an evening at the ballet or symphony is much cheaper than going to a rock concert and about on a par with an ice hockey game. Note that the spread of prices is greater for ballet and symphony than for all other events save basketball. Moreover, the cost of the lowest priced seats has been held almost constant in recent years for ballet and symphony concerts, whereas they have risen proportionately much faster than top-priced seats (from 50 to 200 percent) for other entertainments and sports. Finally, it is interesting to note how expensive Boston's commercial theaters have become.

Inputs to Pricing Decisions

Appendix A to Chapter 16 lists some of the questions that must be answered before a pricing strategy can be finalized. Relating the costs associated with staging a performance to any subsidies that may be available helps to determine the net monetary cost that needs to be recovered from customers. In the meantime the time dimension is incorporated into planning by considering what capacity constraints exist (which may limit the number of theater goers who can be admitted at any one time) and reviewing the organization's cash flow needs. An early need for funds, due to shortage of working capital, may dictate a need for advance sale of series subscription

TABLE 16.4

Prices of Arts, Entertainment, and Sporting Events in Boston, 1959–79

		Cost (dollars)					Percent	
		1959	1964	1969	1974	1979	10-Year Increase (1969–79)	20-Year Increase (1959–79)
Opera	High	n.a.	n.a.	18.00	25.00	27.00	50	n.a.
	Low	n.a.	n.a.	4.00	6.00	8.00	100	n.a.
Ballet[a]	High	n.a.	4.00	7.00	9.38	11.50	64	n.a.
	Low	n.a.	3.50	3.50	3.00	3.75	7	n.a.
Symphony	High	n.a.	n.a.	10.00[b]	11.00	14.00	40[c]	n.a.
	Low	n.a.	n.a.	4.50[b]	5.00	5.00	11[c]	n.a.
Theater—drama	High	4.95	6.00	8.00	9.00	15.00	88	203
	Low	1.65	2.20	3.50	3.50	8.00	129	385
Theater—musical	High	6.25	4.95	10.00	12.50	20.00	100	220
	Low	2.20	2.90	3.00	3.50	9.00	200	309
Movies (downtown)		1.50	n.a.	2.25	3.00	3.75	67	150
Rock concerts	High	n.a.	4.50	7.50	9.50	10.50	40	n.a.
	Low	n.a.	2.50	4.00	7.50	8.50	113	n.a.
Baseball games	High	2.75	3.75	4.50	5.50	7.00	56	155
	Low	0.75	1.00	1.00	1.25	2.00	100	167

TABLE 16.4 (continued)

		Cost (dollars)					Percent	
		1959	1964	1969	1974	1979	10-Year Increase (1969–79)	20-Year Increase (1959–79)
Pro football games	High	n.a.	8.00	7.50	10.00	12.50	67	n.a.
	Low	n.a.	2.50	4.00	5.00	6.00	50	n.a.
Ice hockey games	High	4.00	4.00	6.00	9.00	11.00	83	175
	Low	1.00	1.00	2.00	4.00	4.50	125	350
Basketball games	High	3.00	4.00	6.00	7.00	10.00	67	233
	Low	1.50	2.00	2.00	3.00	4.00	100	167

n.a.: not available

[a] Average price per performance for 3 or 4 performance series ticket

[b] 1971.

[c] Eight-year increase.

Source: "20 Years of Ticket Prices" (1979). The data on the Opera Company of Boston has been added by the authors.

tickets at a discount, in preference to selling full-price tickets on a performance-by-performance basis.

Understanding the customer's perspective is the key. As already noted, the elasticity of demand for product may vary according to both its perceived quality and where and when it is available. Different market segments will probably have different price elasticities. Many arts events involve significant supplementary costs; for instance, attending a concert may involve travel to and from home, parking, a meal in a restaurant, a babysitter, and purchase of a printed program. Customers may make their decision on the anticipated cost of the total package, not just the price of admission. Establishing payment procedures also requires knowledge of customer behavior patterns and preferences. For instance, how many have credit cards and which specific cards do they use?

Competitive activities may serve as an important determinant of an organization's pricing strategies. Considerations include not only the price levels charged by competitors but also payment procedures and their use of any special pricing promotions (such as coupons or other discounts).

Finally, the organization must recognize that it is not operating in a static environment—changes may be taking place on a variety of fronts that will affect the organization itself, the markets that it seeks to serve, its competitors, and its funding sources (if any).

Research Needs

The data needed to develop the pricing inputs have to come from somewhere. Appendix B to Chapter 16 outlines some research needs facing arts managers responsible for pricing decisions.

Determination and allocation of costs is a difficult task that falls under the province of cost accounting. It is particularly problematic in service operations such as arts exhibitions and performances, because of the difficulties of deciding how to assign overhead costs. For instance, a museum might assign overheads to its special exhibits wing on the basis of the percentage of total floor space that it occupied, the percentage of employee hours or payroll that it accounted for, or the percentage of total patrons visiting it. Each of these methods would probably yield a totally different fixed-cost allocation; one might make the special exhibits wing appear a terrible financial drain; another, make it seem a break-even operation; and a third, make it look highly profitable.

A number of the research needs noted in Appendix B to Chapter 16 involve collecting data based, in part, upon past experience (or perhaps the experience of comparable organizations) and then developing mathematical models of price-demand relationships under varying assumptions of different types of presentations, audience size and structure, competitive activities, and general economic conditions.

Surveys of consumers may also be needed to understand their purchasing behavior, their preferences, and their anticipated response to changes in both product and pricing variables. It should be cautioned, however, that actual behavior under specific, real-world conditions often differs from stated intentions given in a mail, telephone, or personal interview.

CONCLUSION

Developing pricing strategies is a key element in marketing, with important implications for the organization's ability to meet its nonfinancial objectives while also remaining in a financially sound condition.

We have tried to show that pricing involves much more than just setting a dollar price. Within the sphere of monetary prices it also involves decisions on how, where, and when prices are to be paid, as well as how prices should be communicated to customers and who should take responsibility for actually collecting payment.

We also pointed out that the costs (or disutilities) to the customer involved in attending an arts event extend beyond the purely monetary ones. There are also time, form, place, and psychic costs, some of which may constitute major barriers to participation. The possible presence of such costs should never be ignored, and they are particularly significant in situations where arts activities are offered at either a nominal financial price or free of charge. Identifying, understanding, and trying to minimize these other costs is also part of the marketer's task.

The need to earn more income from audience sources is a pressing one. Developing *realistic* pricing policies in the arts requires an understanding of the organization's cost structure, formulation of a clear set of objectives, and an appreciation of the price sensitivity of different market segments. Progressive arts organizations are often characterized by their willingness to innovate and to conduct pricing experiments. But creativity must be combined with economic realism, sensitivity toward the marketplace, and integration of pricing within an overall marketing strategy.

APPENDIX A TO CHAPTER 16

Some Inputs to Pricing Decisions

1. Fixed and variable costs
2. Availability of internal/external funds to subsidize a performance
3. Total capacity available
4. Institution's need for up-front money
5. Potential market size for a specific offering, reflecting:
 a. Type of show/performance
 b. Location
 c. Scheduling
6. Additional costs (beyond ticket price) incurred by audience to attend
7. Price elasticity of potential audience by market segment for different types of offerings
8. Ticket purchasing behavior of potential audience members:
 a. How far in advance attendance decision is made
 b. Preference for advance reservations or series/season ticket purchases
 c. Preferred procedures (in person versus phone or mail; cash versus check or credit card)
9. Extent and nature of competition in any given situation
10. Pricing policies of competitors

APPENDIX B TO CHAPTER 16

Some Research Needs

1. Determination and allocation of fixed costs; determination of variable costs
2. Determination of market size (in total and by segment)
3. Determination of price elasticity coefficients for different segments for specific offerings
4. Determination of what constitutes competition for different segments
5. Predicting competitive reaction to pricing changes
6. Evaluating alternative pricing schemes of varying complexity (and communicating complex schemes to both patrons and staff)
7. Evaluating relative impact on demand of:
 a. Price levels and payment methods
 b. Quality; reputation of performance/show
 c. Scheduling/location of ticket sales/performance
 d. Level/type of communications/promotional efforts
8. Determining when consumers make decision to purchase and their preferences for alternative purchasing procedures

REFERENCES

Boardman, Jules. 1978. "Pricing and Concessions." In *The C.O.R.T. Marketing Manual*, edited by G. V. Robbins and P. Verwey. vol. 2. London: Council on Regional Theatre.

Hummler, Richard. 1978. "Credit Cards Spark Broadway B. O. Boom." *Variety*, October 4, pp. 99–103.

Morison, Bradley G., and Kay Fliehr. 1968. *In Search of an Audience*. New York: Pitman.

Netzer, Dick. 1978. *The Subsidized Muse*. New York: Cambridge University Press.

Newman, Danny. 1977. *Subscribe Now!* New York: Theater Communications Group.

Ricklefs, Roger. 1979. "High Class Hoopla. A Cultural Institution Succeeds by Marketing Its Wares Aggressively." *Wall Street Journal*, January 23, pp. 1, 35.

Ryans, Adrian B., and Charles B. Weinberg. 1978. "Consumer Dynamics in Nonprofit Organizations." *Journal of Consumer Research*, September, pp. 89–95.

"20 Years of Ticket Prices." 1979. Boston *Globe*, January 11.

Verwey, Peter. 1978. "Ticket Selling beyond the Box Office." In *The C.O.R.T. Marketing Manual*, edited by G. V. Robbins and P. Verwey. vol. 3. London: Council on Regional Theatre.

Weinberg, Charles B. 1979. "Marketing Mix Decision Rules for Nonprofit Managers." In *Research in Marketing*, edited by J. N. Sheth. vol. 3. Greenwich, Conn.: Jai Press.

17

MARKETING CONTROL AND EVALUATION: A FRAMEWORK FOR STRATEGIC ARTS ADMINISTRATION

Michael P. Mokwa

When I talked with the director of education for the Endowment about the need for sound evaluation . . . I came away from the conversation feeling that a series of roadblocks and detour signs had been placed in my path.

Elliot W. Eisner,
"Is the Artist in the School Program Effective"

Arts administrators, to preserve and develop the arts and an artistic environment within their organizations, increasingly face the challenge to change crisis-oriented administrative styles to more responsive strategic management systems (compare Raymond and Greyser 1978).

Control and evaluation are fundamental elements of a responsive and strategic arts management system. However, they are sensitive decision areas replete with misconceptions. Most arts administrators appear to misunderstand the basic nature of managerial control and evaluation; therefore, many relevant considerations have been ignored or circumvented in practice. Furthermore, only cursory attention has been directed toward such considerations within the developing arts administration literature. As a result, poor control policies and a lack of decision-oriented evaluation characterize most arts organizations. However, the changing administrative and funding environments suggest that these decision areas will continuously become more salient.

The purposes of this chapter are to explore the nature and role of control and evaluation and to formulate a prescription for strategic marketing control and evaluation policies for the arts organization. To begin, the potential benefits and problems will be outlined.

BENEFITS OF EXPLICIT MARKETING CONTROL AND EVALUATION

The arts are facing a rapidly changing environment in which financial and management problems are evident and administrative adjustments are needed. Few arts organizations have found effective, much less comfortable, strategies for coping with the increased turbulence. Many arts organizations apparently do not understand their strategic situation and the demands (necessities) it presents. "Budget-bound" planning and control processes are leading many organizations into indiscriminate "dollar-stretching" and "expense-pruning" tactics, which do not solve the real problems and which often have negative consequences, including behavioral repercussions such as poor artistic morale and decreased program quality. More emphasis needs to be directed toward the strategic issues of better matching the arts organization's desires and resources with market opportunities and demands.

Most solutions advocated to solve the problems facing the arts involve the infusion of more money, the development of bigger audiences, and better management practices focusing on financial, marketing, and funding issues. The three advocated solutions are undoubtedly interdependent. Fundamental to each of these prescriptions is a more objective, systematic, and comprehensive understanding of the arts organization, its market relationships, and its environment. Marketing control and evaluation technologies provide an approach and a consciousness to generate this fundamental knowledge, to integrate and utilize it in planning and programming, and to make it available for relevant external sources, such as funding groups.

The most fundamental benefit of marketing control and evaluation for the arts organization is that it can provide an excellent point of leverage for generating strategic policy and the responsive policy changes necessary for dealing effectively with the turbulent, and often adverse, environment. Some specific policy benefits include: goal clarity, consensus, and communication; organized, systematic information generation and feedback; better organizational communication; quicker problem and opportunity recognition; efficient direction, coordination, and motivation; and increased flexibility and resource mobility.

While the list of potential benefits can be extended easily, there are numerous problematic issues that must be addressed.

PROBLEMATIC ISSUES

Control and evaluative systems can be difficult to design, implement, and develop. They require capable management skills and administrative commitment including effort, time, and money—scarce resources within the

arts organization. A good information system is a necessity and an analytically driven managerial decision-making process is important (compare Herzlinger 1977). Within most arts organizations these conditions do not exist currently; however, as suggested, a strategy-oriented marketing control system can be the point of leverage to generate these conditions. Therefore, other problems may be more serious threats.

Control involves the specification of goals and performance standards, and, typically, arts organizations have resisted explicit goal and policy statements, raising arguments that formal policies threaten the aesthetic climate and limit creativity and flexibility. As such, many arts organizations have become internally oriented and myopic, making it difficult for them to respond effectively to the increasing demands of a broadening and changing environment.

Another problem involves questions of measurement. Measurement issues have been vigorously debated with little resolution. Few arts administrators or scholars have attempted to address systematically or comprehensively this critical topic or even to conceptualize the appropriate dimensions of the measurement issue. A notable exception is Toffler's (1970) presentation, which describes a social measurement system for the arts; however, the presentation neglects specific organizational issues, and it has not stimulated much additional work.

At the root of the problematic issues is the changing definition of the role of the arts within society and the concepts of effectiveness for the arts organization. Rhetoric rather than analysis dominates. As a result resource allocation and accountability considerations are in a state of flux, threatening the viability and the autonomy of many arts organizations. Most arts administrators, as well as other organizational personnel, perceive the ambiguity of a changing system, and they attempt to protect and insulate themselves and their organizations. A better concept of organizational effectiveness is critically needed to direct policy development.

Until these basic issues are more systematically resolved, arts organizations will be skeptical of new management technology. As such, the development of control and evaluation systems will continue to be perceived as threatening, and arts administrators will think cautiously and seriously before making any resource commitments or policy changes.

STRATEGY AND METHODOLOGY OF CONTROL AND EVALUATION

All arts administrators make evaluations about their organizations' activities and use these as a basis for policy decisions, particularly control decisions. Often, evaluations are based upon emotions, feelings, or unexpressed values, and, frequently, related control strategies are ambivalent and

reactive. Methods of explicit control and evaluation attempt to deal with subjectivity and to facilitate systematic and objective inquiry and decision making. These methods warrant careful consideration by the arts administrator.

Control

Control is a pervasive management process that is often oversimplified in elementary discussions. Within such discussions it is usually defined as the management process of making sure that performance conforms with plans (compare Donnelly, Gibson, Ivancevich 1978). This implies that it is a distinctive management process that follows planning, although the two processes do interact as plans provide control parameters and control generates new planning guidelines. This view is presented in Figure 17.1.

Certainly, this perspective captures an important, fundamental dimension of the control concept, but, like planning, the concept has many dimensions and varies widely in operational complexity (compare Steiner 1969). A comprehensive concept of control would include all purposive activities that direct or coordinate organizational efforts in the pursuit or maintenance of goal-oriented performance. Therefore, control can be viewed as the most encompassing management process.

Paraphrasing Bellman (1964), control is more a state of mind than any specific aggregate of methods. The term can be defined to include any purposive approach used to cope with or overcome the uncertainties and adversities of the environment. The broad objective of a control theory or method is to make a system (an organization) operate in a more desirable way—to make it more reliable, more convenient, more economical, more responsive, or, in general, more effective. Therefore, the management process is essentially a control process, and any managerial function such as planning, structuring an organization, or developing operating policies are control devices. Anthony (1965), for example, in his classic discussion of the policy-making process, has formulated a framework in which administrative and operating control processes actually encompass traditional planning activities.

Bearing in mind the pervasive scope of the concept, the remainder of this chapter will focus on the elementary role of control as one distinctive component of the policy development process, specifically focusing on strategic marketing considerations.

Marketing Control and Evaluation

Marketing control involves the systematic monitoring and evaluation of marketing decisions and activities and of market outcomes and impacts and

FIGURE 17.1

Elementary Management Process

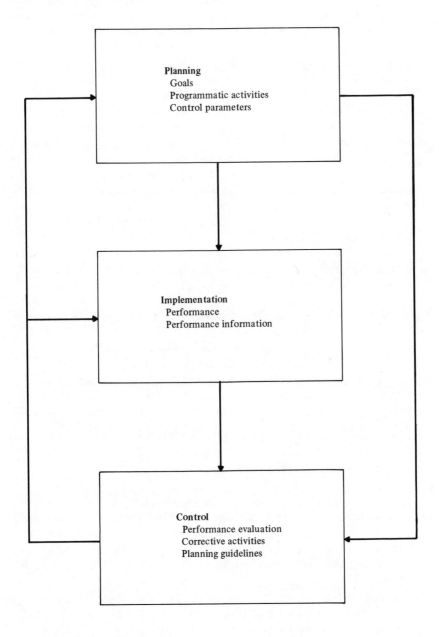

Source: Constructed by the author.

the formulation and activation of corrective policies. It can be operationally distinguished from the other fundamental management policy processes—goal formulation, planning, and execution—and from the other basic marketing management functions—seeking, matching, programming, and consummating. However, it is interrelated with the other policy processes and marketing functions through interactive management decisions.

Marketing control is an action-oriented evaluative process. Evaluation is an inherent social process of judging or asserting value. According to Suchman (1967). "This process is basic to almost all forms of social behavior, whether that of a single individual or organization. While it implies some logical or rational basis for making judgments, it does not require any systematic procedures for marshaling and presenting objective evidence to support the judgment" (p. 7). Thus, the process of evaluation is intrinsically subjective. Yet, it can contribute to marketing control policies to the extent that it is analytically anchored and operationally objective. To accomplish this the valuation process and the decision rules of the evaluator must be made explicit, and the decision process must be systematic and relatively comprehensive. These premises represent the fundamental principles of evaluative research.

Evaluative research can be defined as the utilization of "scientific" (valid and objective) research strategies and technologies for the purpose of formulating and executing an evaluation (compare Suchman 1967; Weiss 1972). As such, it is oriented toward investigating empirical realities, particularly cause and effect relationships, such as the effect of a price change or a new promotional campaign on ticket sales or the satisfaction level of an audience after a performance. Principles of evaluative research can be used to formulate a normative framework for grounding marketing control systems and policies. The crucial developmental problem is to formulate a process that integrates evaluative research and administrative decision systems—a difficult task within the arts sector, given evidence from the public sector and other noncommercial organizations.

The Evaluative Research Process

As an applied management tool for the arts administrator, the evaluative research process begins with a value formulation and explication process. This leads into the specification of a set of goals or objectives that can be translated into sets of performance measures or criteria. The administrator formulates programmatic activities in expectation of actualizing the objectives. The activities should be related to the objectives through the creation of the performance measures or criteria. Next, programmatic activities are implemented and produce actual performance information, which can be compared with the criteria. Specific criteria can be defined in terms of measures of effectiveness (explicit goal accomplishment), efficiency

(resource utilization), or responsiveness (flexibility, adaptability). Performance can be described in terms of organizational effort, specific outcomes, or more generalized impacts. Through definition, measurement, and comparison processes, the organization monitors and evaluates its efforts and activities, and information is generated to stimulate appropriate change and corrective actions. This cycle is presented in Figure 17.2.

This framework stresses the interrelationship among the processes of goal development, planning, operating, evaluation, and, ultimately, goal attainment or goal adjustment. The entire process functions as a system, and ignoring any step can upset the system's balance and risk goal attainment or invalidate an evaluative effort. This indicates the importance of explicit control and evaluative processes for arts organizations and suggests the need to define carefully an appropriate scope of control and complementary evaluative methodologies.

Control Focus and Evaluative Methodology

There are various typologies used to categorize evaluative efforts. The most elementary means of categorization are derived from the basic operational objective. Two types of policy objectives can be identified easily. The first is concerned explicitly with the operational development of the organization or program as it continues to operate. This is called formative evaluation. It is characterized by its close linkage with the total policy-making process. It generates a systematic stream of feedback and corrective action that is incorporated within an operating program or organization.

Simplistically, it is an evaluative process addressing the problem of making an operating program or system work better, without measuring the composite value or "worthwhileness" of the program. On the other hand, summative evaluation is directed at analyzing a program or organization as it is and determining the basic value or worth of the program. The summative objective indicates identification, measurement, and judgment of the composite value or total system (or program) effects. Thus, formative evaluations can fit neatly into operational strategic control systems or can be used to develop them. Summative evaluations often are more difficult to relate directly to organizational decision processes and require more careful utilization strategies.

Another method of categorizing is to identify a focus of control and relate it to a specific evaluation methodology (compare Perkins 1977). The focus of control can be derived from basic elements of the management process and from basic dimensions of organizational performance. Within marketing, these can include:

1. Marketing decisions and decision processes (strategic and tactical), such as the commission of an audience research study or the selection of a season series of performances;

FIGURE 17.2

The Evaluative Cycle

LEGEND:
——— Decision flow
— — — Feedback

Source: Adapted from Suchman (1967).

2. Market actions (programs, program elements, and their implementation), such as ticket selling or the execution of a promotional campaign;

3. Market outcomes, such as ticket sales or the size and composition of an audience; and

4. Market impacts, such as an audience's satisfaction with a performance, an increased contribution from a satisfied patron, or the economic benefits generated by a community arts center.

The focus of control can be defined in relationship to any of the multiple dimensions of marketing policy making and performance. Selection

of (an) appropriate dimension(s) is a critical administrative decision and affects the choice of an evaluative methodology.

Alternative evaluative methodologies are different research designs used to define and structure investigation and analysis. The basic methodologies include descriptive monitoring, auditing, survey research, quasi experimentation, and experimentation. The designs have been listed in ascending order of their potential scientific rigor.

In theory any focus of control can be related to any methodology or multiple methodologies. In practice, however, less rigorous designs are used most frequently and more rigorous designs are advocated most frequently. A truly comprehensive system would include an expansive control focus interrelating elements from each management process and from each performance dimension, and it would employ multiple methodologies. An audit methodology of evaluation is less rigorous than some other designs, but it appears to offer the most comprehensive and robust perspective for investigating the broadest scope of interrelated management processes and performance dimensions. The logic derived from the preceeding discussion can be used to formulate a strategic marketing control and evaluation prescription for arts organizations.

In summary, marketing control should be an analytical and systematic process. It involves the establishment of performance expectations and standards, which are derived from organizational goals. These standards serve as criteria to judge the relative adequacy of marketing performance. Information that indicates the level of marketing performance and that permits an appraisal must be generated and collected. A comparison between the performance standards (goals) and market performance must be made, and decisions that affect future policies, activities, and performance should be formulated and implemented.

PRESCRIPTION FOR STRATEGIC EVALUATION AND CONTROL

A strategic marketing perspective can facilitate more responsive and effective arts administration. However, a marketing orientation will be adopted only if it is compatible with established patterns of policy development or if it provides a relative advantage over past efforts.

The author proposes that formative evaluation research represents the best point of leverage for the development of strategic marketing policy and control systems in the arts organization. Goal formulation and planning processes are often guarded closely by artists, artistic directors, and arts administrators; and rigorous summative evaluations can be highly threatening for most arts organizations. However, formative evaluation is a systematic mechanism for exploration, investigation, and policy development. Because its emphasis is directed toward improving effectiveness in decision

making and programming rather than toward critically judging the overall value or worthwhileness of an organization or its programs, arts administrators should be receptive to this novel policy technology as they face adverse environments.

The most useful framework for developing a marketing-oriented formative evaluation is the marketing audit (compare Kotler 1977; Kotler, Gregor, and Rogers 1977; Mokwa 1979). A marketing audit is a comprehensive, systematic, and constructive appraisal process. As a formative process, it is an excellent mechanism for raising marketing consciousness and for planning marketing-oriented policy within the arts organization. Also, the audit process can be an interesting research framework for empirically exploring the dynamics of the policy-making processes of arts organizations and, thus, facilitating the adaptation and refinement of marketing philosophy, policy, and practice in an operational arts environment.

Marketing Audit

The marketing audit is a diagnostic process in which the total marketing management system market position and market environment are explored and appraised. It is constructed upon a basic premise that an organization's marketing policy position is not static. Thus, a prognostic dimension in which there is speculation about organizational and environmental momentum and change and a search for potential market opportunities is included. As such, the marketing audit is an attempt to describe the current marketing situation, to speculate about the relevant future, and to analyze the organization's marketing performance and potential. Within an audit objective analysis of organizational marketing practices and performance is integrated with subjective probing and appraisal of basic managerial assumptions, philosophies, and expectations.

The primary purpose of a marketing audit is to develop a comprehensive analytical profile of the organization's total marketing position. This profile represents a formative evaluation and should be used to facilitate and enhance future management decisions. Thus, the marketing audit is an important linkage relating control and evaluation to goal formulation and planning decisions. The emphasis of the audit is placed upon improving the organization's overall strategic market position by explicitly examining the total strategic process. Thus, the aggregate marketing management process is the most appropriate focus of control for analysis within the strategic marketing audit.

Market Audit Matrix

The strategic marketing audit can be defined as a comprehensive, systematic, and objective formative examination and analysis of an organi-

zation's marketing mission and management, position, programs, performance, and potential. The elements can be conceptualized in terms of a matrix framework, as presented in Figure 17.3. The basic elements presented within the matrix include a diagnostic profile, which describes the current marketing policy situation and addresses the questions, Where has the organization been? and Where is it now?; a prognosis, which speculates about the relevant future and organizational momentum by addressing the questions, Where are we going? and Where can we go?; and policy suggestions, which serve as prescriptive market planning premises addressing the questions, Where should we go? and How can we get there?

Within the diagnostic profile three dimensions of each marketing policy decision and activity can be distinguished for examination and appraisal: specific policy contents; the management decision processes, which formulate the policies; and management value premises, which indicate the reasons for policy and decision processes. There are two critical dimensions within the prognosis: the identification of environmental and organizational trends and policy speculations and expectations that define the organization's momentum and critical success factors. Finally, suggestions should be developed in terms of specific policy content and appropriate analytical management processes, which facilitate policy formulation.

An entire series of questions can be framed for each strategic marketing decision along each profile dimension. As such, an operational audit framework can be developed by interrelating each specific strategic marketing management function with each analytical dimension of both the diagnostic profile and the prognosis and then formulating a systematic series of detailed normative questions concerning the comprehensive marketing management process. Thus, each cell of the matrix represents an evaluative question or series of questions, which must be analyzed before generating the suggestions. An exemplary list of questions for an arts organization is presented in the Appendix to Chapter 17. A comprehensive diagnostic profile and prognosis can be developed by formulating "answers" to each of the questions. Then, a set of action-oriented suggestions should be formulated. The suggestions are used to guide the strategic market planning process and to make appropriate corrective decisions.

Managing the Audit

Administration of a marketing audit can be a difficult task if it is not managed carefully. Three important decisions must be made. Initially, the scope of the audit must be determined. Next, the specific data collection methods must be defined. Third, an auditor must be selected. These decisions are interactive.

While the norms of market auditing suggest a comprehensive evaluation, the audit can be modularized. The methods of data collection and

FIGURE 17.3

A Comprehensive Strategic Marketing Audit Matrix

Strategic marketing decisions	Diagnostic Profile — Where are we now? Where have we been?			Prognosis — Where are we going? Where can we go?		Suggestions — Where should we go? How can we get there?	
	Policy content (what?)	Management processes (how?)	Management premises (why?)	Trends	Policy expectations	Policy content (what?)	Management processes (how?)
Organizational mission and management processes							
Market dynamics (seeking)							
Market position (matching)							
Market program (programming)							
Market performance (consummating and control)							

Source: Constructed by the author.

depth of analysis are important factors related to the scope decision. "Checklist" conceptualizations of the audit are available in some elementary marketing texts (for example, Enis 1977; Hughes 1978; Kotler 1976). When conscientiously applied by a relatively knowledgeable administrator, they can serve as a departing point. However, when the desired scope is broad and analytical depth is desired, a marketing professional is a necessity. Given the nature and potential impact of a marketing audit, an investment in a marketing professional can be as important as those made in lawyers or accountants.

Audit Outcomes

A completed marketing audit provides a profile that isolates strategic problem areas and identifies organizational strengths, weaknesses, and market opportunities. It initiates a flow of systematic market information. Planning suggestions formulated within the audit that concern goal development provide a framework for explicit value formation, goal setting, and translation. Thus, the critical elements for establishing or enhancing a strategic control system for the arts organization can be generated.

Potentially, the marketing audit will suggest and facilitate a strategic orientation that will allow an arts organization to more flexibly, responsively, and effectively match its desires and resources with its environment and market. Therefore, both strategic and marketing consciousness can be heightened. Then, the organization can direct attention to issues of administrative and programmatic control in their proper context.

Administrative control can be enhanced by including detailed and extensive activity analyses within the strategic audit. The appropriate role for decision processes such as budgeting and program evaluation can be prescribed in relationship to strategic planning and managerial control systems. Other control technologies such as management by objectives and consumer attitude tracking can be developed and implemented. A simple framework for developing a control orientation is presented in Table 17.1. Given the turbulence of the arts environment, arts administrators are strongly advised—*urged*—to think strategically and to apply appropriate marketing technology. Formative evaluation such as a strategic marketing audit can provide a foundation for better planning and better administrative and programmatic control policies.

CONCLUSION

Issues of marketing control and evaluation have been investigated. A strategic approach to evaluation is advocated for arts administrators. Using the marketing audit as a control framework, marketing and strategic consciousness and, ultimately, marketing precision can be generated and

TABLE 17.1

A Systematic Approach to Marketing Control

Level of Control	Control Technology	Planning Input
Strategic	Marketing audit	Strategic plan
Administrative	Marketing management by objectives Zero-based budgeting Operations budgeting Cost/effectiveness analysis	Operating plans
Programmatic	Audience analysis Performance tracking Program budgets Contribution (marginal) analysis Program "evaluations"	Program plans

Source: Compiled by the author.

developed. Within this context administrative and programmatic control issues can be related to more critical strategic considerations facing arts organizations.

There are many directions for further development and future research. The most significant issue concerns the role of arts organizations in society. The goal structure of arts organizations is tied to this question. Further, this question suggests the need for a concept of organizational effectiveness related to arts organizations. Finally, the arts are plagued with operating problems, and the concept of marketing-oriented administrative control can be developed more comprehensively.

APPENDIX TO CHAPTER 17

A Marketing Audit for Arts Organizations

I. Diagnostic profile

 A. Organizational mission and administrative systems

 1. What is the organization's fundamental mission or purpose? (How was the mission developed? Why has management defined the purpose in this manner?)
 2. What is the basic nature of the needs and desires that the organization serves?
 3. What are the organization's artistic, technical, and business goals?
 4. Are the artistic, technical, and business capabilities of the organization appropriately balanced?
 5. Does the organization develop formal long-run and operating plans? How are the plans developed, communicated, and utilized?
 6. Does the organization systematically generate, collect, organize, and disseminate the necessary information to formulate administrative policies?

 B. Market profile

 1. Who are the organization's important constituents—relevant markets and publics?
 2. How does the organization interact with its suppliers, facilitators, regulators, and special influence groups?
 3. Who is the audience?
 4. Have audience segments been identified on the basis of characteristics, expectations, or needs and desires?
 5. Is there a current estimate of total audience potential?
 6. Does the organization think competitively? Does their perspective of competition include both artistic and "nonartistic" activities?
 7. Who are the organization's competitors, and what are their patterns of relevant competitive behavior?
 8. What technical, political, economic, and societal trends have been identified to affect significantly the organization by providing opportunities, threats, or constraints?

 C. Strategic market position

 1. What resources—financial, technical, material, and human—are available to the organization? How are these resources allocated?
 2. Is there an explicit strategy for fund raising and for attracting other resources, including volunteers?
 3. What are the organization's relevant strengths, capabilities, and weaknesses? Has the organization developed a distinctive advantage within its market?

4. Does the organization have an identifiable core strategy? What are its critical strategic success factors?
5. What product/market domain decisions has the organization made?
6. Are explicit target segments identified and then selected according to accessibility, responsiveness, and, significance criteria?

D. Marketing program

1. What artistic programs are presented, and how is the program mix selected?
2. Is programming balanced—matching the organizational objectives, both artistic and financial, with appropriate target markets? Are special events and novel programming mixed with traditional programs?
3. Are the peripheral elements of the artistic product—facilities, social atmosphere, staff, printed programs, and other services—consciously managed as a part of the product?
4. Is the facility and its location appropriate, accessible, and convenient for the audience? Can outreach programming be used to develop the audience or for special events?
5. What are the pricing objectives of the organization? What cost, demand, and contribution factors are considered when setting prices and seating the house? Are factors of price sensitivity considered?
6. What are the outlets and mechanisms through which tickets are sold? Are these accessible and convenient for diverse audience segments?
7. Does the organization have a promotional strategy? Are messages developed specifically for target audiences and are multiple media used? Is promotional effectiveness measured?
8. Does the organization market test programs, promotional campaigns, or pricing policies?
9. Are specific, measurable performance objectives established for all marketing activities?

E. Market performance

1. Are organizational decisions implemented as they have been planned? What activities are implemented without plans?
2. What is the image of the organization?
3. What is the current level of organizational sales performance? How is sales performance measured—by subscriptions, performances, series, or relative to capacity?
4. What is the level of earned income generated by organizational activities, particularly performances? Is it consistent with the organization's purpose, price objectives, and cost expectations?
5. Does the organization attempt to measure audience satisfaction? How? What is the apparent level of satisfaction/dissatisfaction?
6. How does the organization monitor its sales performance, evaluate its programs and critical activities, and appraise its community impact?

II. Strategic Prognosis and Suggestions

A. Strategic Prognosis

1. What evolving environmental, market, and organizational trends or forces can effect the future mission, market, position, program, and performance of the organization?
2. What specific opportunities, threats, and constraints can be identified?
3. What are the expectations of critical relevant publics and policy makers concerning the future of the organization?
4. How will strategic policy evolve or change to adapt successfully to these trends and expectations?
5. How should strategic policy evolve or change?
6. What will be the organization's critical strategic success factors? What resources, capabilities, and competencies will be needed?
7. How can these resources, capabilities, and competencies be acquired or developed?

B. Marketing strategy suggestions

1. What reasonable strategic policy changes and reforms will improve the organization's mission, market position, programs, and performance?
2. How can the organization generate these improvements?
3. What will be the organizational costs of improvements?
4. What should be the timing of policy change?
5. What information and analytical marketing management processes will facilitate improved strategic policy making? What are the costs of such improvements?
6. How can improved analysis be integrated with the current policy making processes?

REFERENCES

Anthony, Robert N. 1965. *Planning and Control Systems: A Framework for Analysis.* Boston: Harvard University Press.

Bellman, Richard. 1964. "Control Theory." *Scientific American*, September, pp. 185–92.

Donnelly, James H.; James L. Gibson; and John M. Ivancevich. 1978. *Fundamentals of Management: Functions, Behavior, Models.* Dallas, Tex.: Business.

Enis, Ben M. 1977. *Marketing Principles: The Management Process.* 2d ed. Santa Monica, Calif.: Goodyear.

Herlinger, Regina. 1977. "Why Data Systems in Nonprofit Organizations Fail." *Harvard Business Review*, January–February, pp. 81–86.

Hughes, G. David. 1978. *Marketing Management: A Planning Approach.* Reading, Mass.: Addison-Wesley.

Kotler, Philip. 1976. *Marketing Management: Analysis, Planning, and Control.* Englewood Cliffs, N.J.: Prentice-Hall.

————. 1977. "From Sales Obsession to Marketing Effectiveness." *Harvard Business Review*, November–December, pp. 67–75.

Kotler, Philip.; William Gregor; and William Rogers. 1977. "The Marketing Audit Comes of Age." *Sloan Management Review*, Winter, pp. 25–43.

Mokwa, Michael P. 1979. "Strategic Marketing Evaluation for the Social Action Organization: A Formulative Policy Study." Ph.D. dissertation, University of Houston.

Perkins, Dennis N. T. 1977. "Evaluating Social Interventions: A Conceptual Schema." *Evaluation Quarterly*, November, pp. 639–56.

Raymond, Thomas J. C., and Stephen A. Greyser. 1978. "The Business of Managing the Arts." *Harvard Business Review*, July–August, pp. 123–32.

Steiner, George. 1969. *Top Management Planning*. New York: Macmillan.

Suchman, Edward A. 1967. *Evaluative Research*. New York: Russell Sage Foundation.

Toffler, Alvin. 1970. "The Art of Measuring the Arts." *Journal of Aesthetic Education*, January, pp. 53–72.

Weiss, Carol H. 1972. *Evaluation Research: Methods of Assessing Program Effectiveness*. Englewood Cliffs, N.J.: Prentice-Hall.

APPENDIX

MARKETING THE ARTS: ISSUES, PERSPECTIVES, AND PRAGMATICS

September 28–30, 1978

Spring Hill Center
Wayzata, Minnesota

Participants

J. Thomas Bacchetti
 General Manager
 Atlanta Symphony Orchestra

John W. Blaine
 Director
 Cultural Arts Council of Houston

Richard T. Bryant
 Public Relations Director
 Milwaukee Repertory Theatre

Richard M. Cisek
 President
 Minnesota Orchestra

Jack G. Cohan
 Director
 Jorgenson Auditorium
 University of Connecticut

Ted L. Cramer
 Marketing Director
 Division of the Arts
 State of North Carolina

William M. Dawson
 Executive Director
 Association of College, University
 and Community Arts Administrators

Professor Ben M. Enis
 Department of Marketing
 College of Business and Public
 Administration
 University of Missouri

Professor Stephen A. Greyser
 Marketing Science Institute
 Harvard University

Mark Hanna
 Graduate Student
 Center for Arts Administration
 University for Wisconsin-Madison

Professor Paul Hirsch
 Graduate School of Business
 University of Chicago

Phillip Hyde
 Graduate Student
 John F. Kennedy School of Government
 Harvard University

Professor Gene R. Laczniak
 Department of Marketing
 Marquette University

Professor Eric Langeard
 Institut d'administration des Entreprises
 University of Aix-Marseille III

Kathi Levin
 Graduate Student
 Center for Arts Administration
 University of Wisconsin-Madison

Professor Sidney J. Levy
 Graduate School of Management
 Northwestern University

Professor Christopher Lovelock
Graduate School of Business
Harvard University

Dick Markgraf
President
Markgraf and Wells

Professor Michael P. Mokwa
Graduate School of Business
University of Wisconsin—Madison

Bradley G. Morison
President
Arts Development Associates

Professor Patrick Murphy
Department of Marketing
Marquette University

Kent Nakamoto
Graduate Student
Center for Arts Administration
University of Wisconsin—Madison

Professor John R. Nevin
Graduate School of Business
University of Wisconsin—Madison

Halsey M. North
Executive Director
Arts and Science Council of Charlotte

Professor Steven Permut
School of Organization and
Management
Yale University

Professor Robert Peterson
Graduate School of Business
University of Texas

Professor E. Arthur Prieve
Director
Center for Arts Administration
Graduate School of Business
University of Wisconsin—Madison

P. David Searles
Deputy Chairman for Policy and Planning
National Endowment for the Arts

Toni Fountain Sikes
Assistant Director
Association of College, University
and Community Arts Administrators

Louis Spisto
Graduate Student
Center for Arts Administration
University of Wisconsin—Madison

Professor Roger A. Strang
Department of Marketing
Graduate School of Business
University of Southern California

Warren K. Sumners
Director
University Activity Center
Gammage Auditorium
Arizona State University

Professor Charles Weinberg
Graduate School of Business
Stanford University

Lawrence J. Wilker
Vice President
Eugene O'Neill Memorial Theatre
Foundation

Jerry G. Willis
Public Events Manager
California Institute of Technology

James H. Wockenfuss
Director
Hancher Auditorium
University of Iowa

About the Editors and Contributors

MICHAEL P. MOKWA is Assistant Professor of Marketing, the School of Business Administration at Arizona State University. His teaching interests focus on strategic marketing and marketing management in noncommercial and service organizations. Current research is directed toward marketing the arts and the design of marketing audit and planning technology for public sector and nonprofit organizations.

WILLIAM M. DAWSON is Executive Director of ACUCAA. Former Professor of Theatre and Director of the Wisconsin Union Theatre at the University of Wisconsin-Madison, he was also a lecturer in the Center for Arts Administration in the Graduate School of Business. A frequent workshop leader in the arts, Dr. Dawson has provided consultant services to a wide variety of community, state and federal arts agencies.

E. ARTHUR PRIEVE is Professor of Management and Director of the Center for Arts Administration, Graduate School of Business, University of Wisconsin-Madison. Currently, he is conducting and directing research in the not-for-profit areas. Special projects focus on boards of directors, older Americans, audience development, and the economic impact of the arts.

STEVEN E. PERMUT is Assistant Professor of Marketing and Director of Undergraduate Studies, Yale University's School of Organization and Management. Currently, he teaches the core graduate course in marketing management and courses in consumer behavior. He is a consumer behavior consultant to the Board of Governors of the Federal Reserve System, and has published over 40 articles in a variety of journals.

HARRY L. DAVIS is Professor of Marketing at the Graduate School of Business, University of Chicago. Dr. Davis' research interests are in the areas of consumer decision making, new product development, and personal selling. He is the author of *Management and Behavioral Science in Marketing*, as well as articles for the *Journal of Consumer Research*, *Harvard Business Review* and other journals.

PIERRE EIGLIER is Maître de Conférence Agrégé at the Institut d' Administration d' Enterprise at the Université de Droit, d'Economie, et de Science of d'Aix Marseille, where he teaches marketing. Dr. Eiglier has published numerous articles and his current interests focus mainly on the marketing of services.

BEN M. ENIS holds the Bailey K. Howard World Book Chair in Marketing, University of Missouri. Dr. Enis is the former National Vice President of Education of the American Marketing Association. The author of five books and a wide number of research articles, he has also served widely as a consultant in the areas of banking, retailing, publishing and government.

STEPHEN A. GREYSER is Professor of Business Administration at Harvard Business School where he teaches advertising and consumer behavior. Dr. Greyser is also Executive Director of the Marketing Science Institute and serves as Editorial Board Secretary of the Harvard Business Review. He is responsible for eight books and numerous journal articles, including co-authorship of *The Business of Managing the Arts*. The founding faculty member of the Harvard Institute in Arts Administration, a national consultant, he is also a director of the advertising agency Doyle, Dane Bernbach.

JONATHAN GUTMAN is currently an Associate Professor of Marketing, Graduate School of Business Administration, University of Southern California. His published research is mainly in the areas of marketing research and consumer behavior. Dr. Gutman has worked on projects for many companies and organizations, including the National Broadcasting Company, Columbia Pictures, and the School of Performing Arts at USC.

PAUL HIRSCH is Associate Professor of Sociology, Graduate School of Business, University of Chicago. His interests include complex organizations, mass media, marketing communication and business policy; during the last several years he has directed those interests to studying arts organizations and audiences in conjunction with Harry L. Davis. He has written frequently on these topics.

PHILLIP HYDE is currently a consultant to the Metropolitan Cultural Alliance of Boston. He has worked extensively in theatre, as well as with the New York State Council on the Arts and the National Endowment for the Arts. He is presently writing a marketing handbook for small arts organizations in Massachusetts.

PHILIP KOTLER is the Harold T. Martin Professor of Marketing at Northwestern University. The author of *Marketing for Nonprofit Organizations*, as well as numerous other books and articles, Dr. Kotler's research efforts have centered on market analysis, new product development, marketing strategy, and market planning and control. He is a former director of the American Marketing Association and trustee of the Marketing Science Institute.

GENE R. LACZNIAK is Assistant Professor of Business, Marquette University. He is presently conducting several research projects in the business and society area, including a study of the ethical aspects of marketing decision making. He is co-author of a forthcoming book in marketing management and has published numerous articles.

ERIC LANGEARD is Maître de Conférences Associe de l'Université de Droit, d'Economie et des Sciences d'Aix-Marseille, France. He teaches marketing at the Institut d'Administration des Entreprises. Professor Langeard has been associated with several schools both in Europe and in the United States, and has co-authored two books on marketing and retailing and published more than 20 papers in American and European journals. He

is a director of three firms and a consultant to several others. He is a member of the French Ministry of Finance Commission des Comptes Commerciaux de la Nation.

SIDNEY J. LEVY is Professor of Behavioral Science in Management, Graduate School of Management, Northwestern University. A registered psychologist, his central interests include studying human behavior in everyday life activities, consumer behavior, cultural influences, and complex motivation in personality. His published books and articles are numerous, including "Broadening the Concept of Marketing" for which he and Philip Kotler received the Alpha Kappa Sigma award.

CHRISTOPHER H. LOVELOCK is Associate Professor of Business Administration, Harvard Business School. He has had several years' experience in both consumer and industrial marketing, working for the J. Walter Thompson Co. in London and for a large chemical company in Montreal. His present consulting and research interests focus on marketing consumer services in the public and private sectors. He is the author of three books and numerous articles.

PATRICK E. MURPHY is Assistant Professor of Marketing, Marquette University. His research interests center around the social aspects of business, marketing nonprofit organizations, and marketing and public policy issues. A number of his articles have appeared in professional journals and he coauthored *Marketing the Performing Arts* which appeared in the Atlanta Economic Review.

KENT NAKAMOTO is currently a doctoral candidate in Marketing at the Graduate School of Business, Stanford University. He is the co-author of *Marketing The Arts: A Selected and Annotated Bibliography*, and has conducted several research projects in audience studies.

JOHN R. NEVIN is Associate Professor of Marketing, Graduate School of Business, University of Wisconsin-Madison. His research interests are in channels of distribution, pricing, survey research methodology and financial institutions. Numerous articles have been printed in professional journals. He has presented at workshops and national conferences for arts administrators, and served as a consultant to the Western States Arts Foundation, and other arts agencies.

ROBERT A. PETERSON is Professor of Marketing Administration, Graduate School of Business, University of Texas. His interests are in consumer behavior, marketing research, promotion, and quantitative methods. He has published more than 60 articles, books, and monographs; currently the President of the Southwestern Marketing Association, his work has included serving on editorial review boards and as book review editor for *Journal of Marketing Research* and *Journal of Marketing*.

P. DAVID SEARLES is currently Deputy Chairman for Policy and Planning at the National Endowment for the Arts. He also served as Assistant Chairman of the NEA and as Deputy Director of the Peace Corps.

Prior to these experiences, he was Director and Vice President of Glendinning Companies and worked in consumer advertising and promotion at Proctor and Gamble.

ROGER A. STRANG is Assistant Professor of Marketing, Graduate School of Business, University of Southern California. His current research includes studies of promotion effectiveness and issues in retailing and marketing strategy. His business background includes sales analysis and marketing research for a leading New Zealand food manufacturing company, and consulting in consumer, product and promotion research for companies in New Zealand and the United States.

CHARLES E. WEINBERG is Associate Professor of Marketing and Public Management at the University of British Columbia. His research interests are primarily in management science and marketing for both public and private organizations. The author of more than 40 articles and books, he has published recently three articles relating directly to the performing arts. He has consulted for the American Conservatory Theatre.